W9-DJE-532

# STUDIES IN THE HISTORY OF ART AND ARCHITECTURE

*General Editors*

ANTHONY BLUNT     FRANCIS HASKELL
CHARLES MITCHELL

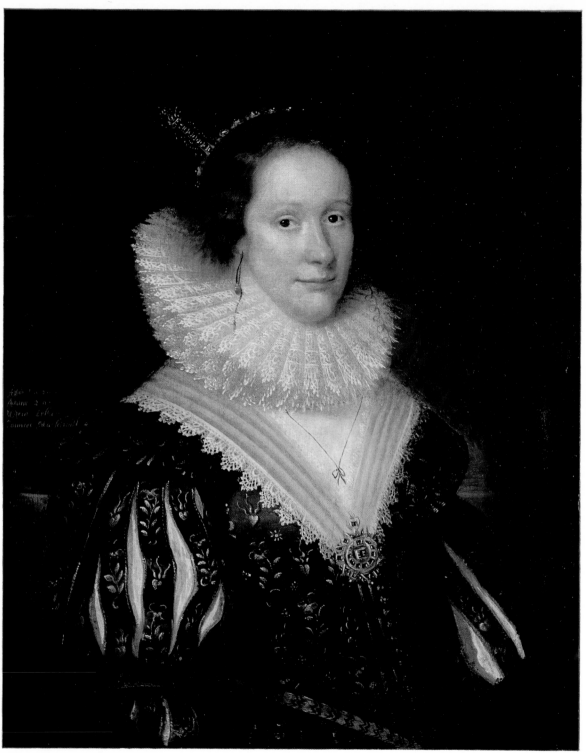

Jamesone: *Mary Erskine, Countess Marischal*, 1626 (Catalogue, 9). Edinburgh, National Gallery of Scotland

# THE LIFE AND ART OF

## GEORGE JAMESONE

DUNCAN THOMSON

CLARENDON PRESS · OXFORD
1974

66255

*Oxford University Press, Ely House, London W.1*

GLASGOW NEW YORK TORONTO MELBOURNE WELLINGTON
CAPE TOWN IBADAN NAIROBI DAR ES SALAAM LUSAKA ADDIS ABABA
DELHI BOMBAY CALCUTTA MADRAS KARACHI LAHORE DACCA
KUALA LUMPUR SINGAPORE HONG KONG TOKYO

ISBN 0 19 817337 7

© OXFORD UNIVERSITY PRESS 1974

*All rights reserved. No part of this publication may be reproduced, stored in a retrieval system, or transmitted, in any form or by any means, electronic, mechanical, photocopying, recording or otherwise, without the prior permission of Oxford University Press*

PRINTED IN GREAT BRITAIN BY
WILLIAM CLOWES & SONS, LIMITED
LONDON, BECCLES AND COLCHESTER

*For my mother*
*Jane McFarlane Wilson*
*and in memory of my father*
*Duncan Murdoch Thomson*

# PREFACE

I N this book I have attempted to set the record straight on George Jamesone. Like some painters of much greater significance Jamesone, for a variety of reasons, has had a long, popular reputation in his own country. Many of the legends which have resulted, often in themselves interesting for the light they shed on changing attitudes to the arts, have therefore had to be discarded. Jamesone, however, remains an intriguing figure and a vitally important one in the early history of painting in Scotland.

One other result of this popular esteem has been the indiscriminate attribution to Jamesone of a bewildering variety of early seventeenth-century portraits. Like the myths, many of these paintings have had to go. Because of the manner in which these attributions were made they are often now of little significance, but this is not so in the case of a group of portraits which I have attributed to the resurrected figure of Adam de Colone, Netherlandish in background but born and reared in Scotland.

In a belief that it is important to have as rounded a picture as possible of a painter's activity I have examined, in what might be considered an unusual degree of detail, Jamesone's personal life and his social and historical background. No artist exists in a creative vacuum: Jamesone, one senses, grew from a settled social tradition, the qualities of which remained with him even as his horizons widened to include the leading figures of his time and as he himself was caught up in the political turmoil which characterized the 1640s.

One aspect of the illustrations I have used may require some explanation. I have included a relatively high proportion of comparative material, principally in an attempt to convey both the character of Jamesone's artistic origins and the context in which he worked, fields which are largely unfamiliar and unexplored. It is also an unfortunate fact that many of Jamesone's surviving pictures have suffered ill-treatment of one kind or another: because of this, little seemed to be gained by illustrating paintings which, though not necessarily irretrievably lost, have undergone considerable alterations to their original appearance.

In the course of preparing this book, and the thesis from which it has grown, I have found myself deeply in debt to a great many people and institutions. I would like to mention particularly the late Professor David Talbot Rice and Professor Giles Robertson of the University of Edinburgh, who both encouraged and helped me from the very beginning. Professor Robertson's continuing keen interest and personal kindness are recorded with deep gratitude.

I should also like to express my sincere thanks to the many private owners who have allowed me to examine their pictures. Their friendliness and hospitality have been an added pleasure throughout the work. I am grateful both to them and to the trustees of public collections for permission to reproduce paintings in their possession.

I am indebted to all my colleagues in the National Galleries of Scotland who have helped me in a variety of ways. I must also thank for their assistance the staffs of the Scottish Record Office, the National Library of Scotland, the library of the University of Edinburgh, the library of the Society of Antiquaries of Scotland, the National Museum of Antiquities of Scotland, the library of King's College, Aberdeen, the Rijksbureau voor Kunsthistorische Documentatie in The Hague, and the National Portrait Gallery in London.

For help with specific problems I must thank the following: Mr. Keith Andrews; Miss Lia de Bruyn in The Hague; Mr. Angus Buchanan, who drove me to see many pictures in remoter parts of the country; Mr. John Dick; Professor Gordon Donaldson; Miss Christine Haddow, who typed the entire book and who took immense trouble to correct details which had escaped me—the book owes much to her thoughtfulness and care; Professor Ian S. Hodkinson; Mr. Robin Hutchison; Dr. Walter Makey, archivist of the city of Edinburgh; Sir Oliver Millar; Mr. John Nicoll; Mr. David Piper; Miss Margaret Rust, lately in charge of the archives of the city of Aberdeen; Dr. Margaret Sanderson; Mr. Tom Scott, who gave me great help with photographs; Mr. Basil Skinner; Mr. Robert Snowden; Mr. Jon Stallworthy of the Clarendon Press; Mr. Colin Thompson; Mr. H. R. H. Woolford.

I must also record a particular debt to Professor Ellis Waterhouse for many kinds of help and to The Paul Mellon Centre for Studies in British Art (London), which generously undertook to finance the publication of this book. A grant from The Carnegie Trust for the Universities of Scotland has made possible the inclusion of the colour illustration.

Finally, to my wife I give my warmest thanks for the journeys we made together in quest of Jamesone.

DUNCAN THOMSON

*Edinburgh*

# CONTENTS

66255

# LIST OF PLATES

1628 (mural). Chapel Royal, Stirling Castle. Crown copyright: reproduced by permission of the Department of the Environment.

79. Jamesone: *Isabel Hamilton, Countess of Airlie*, 1634 (Catalogue, 66). The Earl of Airlie. Photograph: Tom Scott.

80. Jamesone: *Margaret Douglas, Marchioness of Argyll*, 1634 (Catalogue, 69). Edinburgh, Scottish National Portrait Gallery. Photograph: T. & R. Annan.

81. Unknown artist: *Archibald Campbell, Earl of Argyll*, 1633 (canvas, 34 × 24 in.). Collection unknown. Photograph: Tom Scott.

82. Unknown artist: *John Rainolds, c.* 1616–18 (mural). Oxford, Bodleian Library. Photograph: Thomas-Photos.

83. Jamesone: *Lady Marjory Stewart*, 1635 (Catalogue, 71-(i)). Collection unknown. Photograph: Tom Scott.

84. Studio of Rubens: *Isabella Brant, c.* 1620 (panel, $38\frac{1}{4} \times 26\frac{3}{4}$ in.). The Hague, Royal Picture Gallery, Mauritshuis. Photograph: Foundation Johan Maurits van Nassau.

85. Jamesone: *Self-portrait, with Wife and Child, c.* 1635–40 (Catalogue, 114). The Fyvie Trustees. Photograph: Tom Scott.

86. Jamesone: *Lady Janet Stewart*, 1635 (Catalogue, 73-(1)). Collection unknown. Photograph: Tom Scott.

87. Jamesone: *Lady Margaret Douglas*, 1635 (Catalogue, 74-(2)). Collection unknown. Photograph: Tom Scott.

88. Jamesone: *Lady Marjory Stewart*, 1635 (Catalogue, 75-(3)). Collection unknown. Photograph: Tom Scott.

89. Jamesone: *Lady Marjory Colquhoun*, 1635 (Catalogue, 76-(4)). Collection unknown. Photograph: Tom Scott.

90. Jamesone: *Lady Katherine Ruthven*, 1635 (Catalogue, 78-(6)). The Dowager Countess of Breadalbane. Photograph: Tom Scott.

91. Jamesone: *Lady Marjory Edmonstone*, 1635 (Catalogue, 77-(5)). Collection unknown. Photograph: Tom Scott.

92. Jamesone: *Sir Thomas Burnett of Leys, c.* 1636 (Catalogue, 107). The National Trust for Scotland, Crathes Castle. Photograph: Tom Scott.

93. Jamesone: called *Sir William Forbes of Monymusk, c.* 1636 (Catalogue, 108). The National Trust for Scotland, Crathes Castle. Photograph: Tom Scott.

94. Jamesone: *Genealogy of the House of Glenorchy*, 1635 (Catalogue, 93). Edinburgh, Scottish National Portrait Gallery. Photograph: Tom Scott.

95. Jamesone: *William Keith, 7th Earl Marischal*, 1636 (Catalogue, 94), after removal of old repaint and before restoration. Photograph: Tom Scott.

96. Jamesone: detail of head from *William Keith, 7th Earl Marischal*, after removal of old repaint and before restoration (Plate 95). Photograph: Tom Scott.

97. Jamesone: *William Keith, 7th Earl Marischal*, 1636 (Catalogue, 94). Edinburgh, Scottish National Portrait Gallery. Photograph: T. & R. Annan.

98. Jamesone: *William Graham, 7th Earl of Menteith and 1st Earl of Airth*, 1637 (Catalogue, 96), and *Archibald Napier, 1st Baron Napier*, 1637 (Catalogue, 97). Edinburgh, Scottish National Portrait Gallery. Photograph: Tom Scott.

# ABBREVIATIONS

Certain frequently quoted books and manuscripts are cited throughout in an abbreviated form. A list of these shortened forms with their full titles, as well as other frequently used abbreviations, is given below.

| | |
|---|---|
| AR | City of Aberdeen Records |
| *The Black Book of Taymouth* | Cosmo Innes (editor), *The Black Book of Taymouth with other papers from the Breadalbane Charter Room*, Edinburgh, 1855 |
| Brockwell | Maurice W. Brockwell, *George Jamesone and some Primitive Scottish Painters*, London, 1939 |
| Bulloch | John Bulloch, *George Jamesone, the Scottish Vandyck*, Edinburgh, 1885 |
| Carnegie to Musgrave | British Museum, Additional MS. 6392 Plut. CLXXIII, i, fos. 123–5, 'Catalogue of some of the works of George Jamieson Painter': a list of paintings and a brief life communicated by Alexander Carnegie to Sir John Sinclair and thence to Sir William Musgrave, 1797 |
| Caw | James L. Caw, *Scottish Painting, Past and Present (1620–1908)*, Edinburgh, 1908 |
| *Complete Baronetage* | G.E.C. (editor), *Complete Baronetage*, 5 volumes and Appendix, Exeter, 1900–9 |
| Earl of Buchan's MS. | The Society of Antiquaries of Scotland, MS. 597, 'Catalogue of Portraits of Illustrious or Learned Scots compiled by the Earl of Buchan from authentic information Jan. 22d. 1781' |
| ER | City of Edinburgh Records |
| GRO(S) | General Register Office (Scotland) |
| Musgrave | British Museum, Additional MS. 6392 Plut. CLXXIII, i, fos. 1–121, 'Catalogues of Painted Portraits in many of the capital Mansion houses of Scotland ranged Alphabetically without regarding the Counties': collected from correspondents by Sir William Musgrave, 1793–9 |

| | |
|---|---|
| Pennant (1769) | Thomas Pennant, *A Tour in Scotland MDCCLXIX*, London, 1790 |
| Pennant (1772) | Thomas Pennant, *A Tour in Scotland MDCCLXXII*, Part II, London, 1790 |
| Pinkerton's *Correspondence* | Dawson Turner (editor), *The Literary Correspondence of John Pinkerton*, 2 volumes, London, 1830 |
| Pinkerton's *Iconographia Scotica* | John Pinkerton, *Iconographia Scotica*, London, 1797 |
| Pinkerton's *Scottish Gallery* | John Pinkerton, *The Scottish Gallery*, London, 1799 |
| *The Scots Peerage* | Sir James Balfour Paul (editor), *The Scots Peerage founded on Wood's edition of Sir Robert Douglas's Peerage of Scotland*, 9 volumes, Edinburgh, 1904–14 |
| Smith's *Iconographia Scotica* | John Smith, *Iconographia Scotica*, London [1798] |
| SNPG | Scottish National Portrait Gallery |
| SRO | Scottish Record Office |
| Walpole | Horace Walpole, *Additional Lives to the First Edition of Anecdotes of Painting in England* [London, 1768] |

# I

# THE GROWTH OF A LEGEND

GEORGE Jamesone has generally been felt to be a figure of particular significance in the history of Scottish painting and has even been allowed some standing in the history of painting in Britain as a whole. In the narrower context he has stood and will continue to stand as a landmark, though ultimately a historical rather than an aesthetic one. His career began in Scotland at a time when easel paintings, though not by any means unknown, were relatively scarce, and in the course of a short productive life, stretching from 1620 to 1644, he produced a body of work which became widely known throughout his own country and brought him considerable contemporary fame. That he was a native of the country also has historical significance, for while easel pictures, usually portraits, were a common enough accompaniment to the civilized life in England during the same period, they were very largely painted by immigrant artists. In the broader context, as representative of an emerging and, for a time, thriving native tradition, Jamesone has a real claim to a more than local interest.

Local conditions, however, played a crucial role in Jamesone's emergence. In his poor and sparsely populated country, peace was a luxury newly acquired after decades of civil strife. This new climate saw the stirring of an interest in the commissioning and collecting of pictures which was to become commonplace among the nobility and lesser ranks by the middle of the seventeenth century. The growth of this tradition is inevitably first noticed at the Court, but in 1603 King James VI, now also James I of England, departed for London. Though this put an end to the short-lived school of Court painting, and the widening influence it had begun to have, the greatly increased contacts with the southern kingdom were another kind of stimulant in this field. The demand for portraiture increased and quickly communicated itself to those who were only marginally more aware of the south; but economic conditions were such that the rewards were hardly likely to attract painters with the standards of those working in England. Jamesone, and the extensive patronage which he received, may therefore be seen as the forcing of a local, and economically viable growth to meet this new need.

In some respects there had been quite marked similarities between the two countries before this development had taken place. Each had a well-established tradition of

decorative painting carried on by native painters, while at the level of sophisticated, life-size portraiture each relied on Continental products. There was of course a vast difference in the scale of this patronage, and in the Scottish case the pictures seem at first to have been imported rather than painted by visiting artists. To place against the great numbers of Elizabethan portraits Scotland can offer only rare items like the *Darnley Memorial* (Plate 2), painted for propaganda purposes in London in 1568 by Lieven de Vogeleer, a native of Antwerp,[1] the portrait of George, 5th Lord Seton with his family (Plate 3), painted by Frans Pourbus, the elder, in 1572,[2] or the bright, elaborate portrait of the same sitter (Plate 4), painted retrospectively in the 1570s, and almost certainly also an importation.[3]

In the latter years of the sixteenth century and early years of the seventeenth, the tendency became more marked in England for the incoming painters to settle and develop styles of painting with a greater degree of local feeling, especially in the second generation, though Continental origins remained obvious. The notable examples are the members of the Gheeraerts, de Critz, and Oliver families. Here again there are Scottish equivalents: principally the two still rather obscure Flemings, Arnold Bronckorst and Adrian Vanson, active at the Scottish Court in the years before 1603, both of whom will be discussed again.

The pattern of immigrant painters more or less settling in England continued well into the seventeenth century. They included men of the calibre of Paul van Somer, a native of Antwerp, in England by the end of 1616 and resident there for the remaining four or five years of his life; Daniel Mytens from Delft, widely employed in England after 1618; Cornelius Johnson, born in London to parents who had fled from Antwerp, closely following the standards set by these other painters; and ultimately, of course, Van Dyck. The immense abilities of these painters must have seriously hampered the growth of anything that could be termed a specifically English spirit. Suggestions of such a development in the work of George Gower, Sergeant Painter to Queen Elizabeth from 1581, or Robert Peake, painter to Prince Henry and later a Sergeant Painter, or in that of William Larkin, who flourished in the decade 1610–20,[4] are quite tenuous and were swamped by the painters already referred to. Sir Nathaniel Bacon, the more than gifted amateur, free of the requirements of patronage, is in some ways an exception, but his output was small and he died in 1627. The formation of a truly native style was to be postponed until the appearance of William Dobson in 1642.

Again, if it had not been for the activities of Jamesone, the pattern, on a smaller

[1] See Oliver Millar, *The Tudor, Stuart and Early Georgian Pictures in the Collection of Her Majesty The Queen*, London, 1963, pp. 75–7.

[2] National Gallery of Scotland, no. 2275.

[3] National Gallery of Scotland, no. 2274; the last digit of the date has been cut away.

[4] For Larkin see Roy Strong, *The English Icon*, London/New York, 1969, pp. 313–36; and the same author's exhibition catalogue, *The Elizabethan Image*, London, Tate Gallery, 1969, pp. 60–4.

scale, might have been repeated in Scotland. Here the single representative of the Netherlandish tradition was the Scottish-born Adam de Colone, who was probably either Vanson's son or his nephew, active in the 1620s: he too must be examined in greater detail below. That his paintings were subsequently so often confused with Jamesone's indicates that their style was not purely Continental. But either death or, more likely, economic forces took him from the Scottish scene in 1628 and his identity was virtually lost.

It is in this context of the painfully slow emergence of an indigenous art in the British Isles that Jamesone, born in Aberdeen and trained in Edinburgh, from about 1620 produced during the next twenty-four years many scores of portraits of the Scottish nobility, scholars, and leading burgesses in a style which is basically native but not naïve.

This relative degree of primacy has, however, had curious results historically. His contemporary fame and undoubted uniqueness in the Scotland of his day have gradually been enlarged into what can only be described as a 'Jamesone legend'. In the quite narrow field of Scottish painting, he has become a notable example of the desire of Time to find heroes among his artists: notable achievement has been elevated into something like divine genius. The legend that has been built up round his name has given his art associations which are quite foreign to it and in this way its unpretentious merits have been obscured. By a process of repetition, tradition, hearsay, and speculation have been erected into fact and those facts which can be accepted unequivocally have been lost sight of. It is therefore of some importance to trace the history of writings on Jamesone in order to see how the romantic notion has been formed.

The roots, or rather the seeds, of the legend are to be found in Jamesone's surprisingly frequent appearances as a protagonist in the Latin verse produced during his own lifetime in the academically inclined north-east of Scotland. Arthur Johnston's *Epigrammata* published at Aberdeen in 1632[5] contains a short poem pretending to instruct Jamesone on how to paint Anne Campbell, daughter of the Earl of Argyll:

> Illustres, ars quotquot habet tua, prome colores,
> Pingere Cambellam si, Iamisone, paras.

> Jamesone, bring forth the finest colours of your art,
> If you hope to paint the Lady Campbell.

Following a highly idealized description of the lady, Johnston calmly compares the painter, favourably, to Apelles.

Later, in his series of 'Encomia Urbium' of 1642,[6] in a poem in praise of New

---

[5] *Epigrammata Arturi Ionstoni Scoti, Medici Regii Abredoniae*, Aberdeen, 1632, pp. 20–1. See Documents, 79(a).

[6] *Arturi Ionstoni Scoti Medici Regii Poemata Omnia*, Middelburg, 1642.

Aberdeen, Johnston describes the ornamental garden which Jamesone had formed on the outskirts of the town:

> Inde suburbanum Iamesoni despicis hortum,
> Quem domini pictum suspicor esse manu.

> From there you view Jamesone's suburban garden,
> Painted, I would guess, by the master's hand.

In this particular poem it is noteworthy that Jamesone's is the only name to occur in what aims to be a celebration of the magnificence of the town (indeed putting Rome in the shade!) Despite the rather inflated sentiments of these poems it is significant that Jamesone is placed on a level with the nobility and the learned and is obviously seen to be quite different from the painter/craftsman.

In the same year Sir John Scot of Scotstarvet, the Director of Chancery, received a gift of a series of epigrams from an unidentified versifier, William Forbes: these, though largely in praise of Scot, are in fact addressed to Jamesone, who had apparently just painted him.[7] And two years later, on Jamesone's death, David Wedderburn, the aged schoolmaster of Aberdeen, brought out his elaborate obituary 'Sub Obitum Viri Spectatissimi Georgii Jamesoni, Abredonensis, Pictoris Eminentissimi, Lachrymae'.[8] It contains the lines:

> Aemula si Belgis Italisve peritia dextrae
> Artifici laudem conciliae queat:

. . . the skill of a hand that emulated the Flemings and the Italians . . .

The growth of the legend has quickened.

Less than twenty years after Jamesone's death James Gordon accompanied his map of New and Old Aberdeen of 1661 with a manuscript in Latin, 'Abredoniae Utriusque Descriptio'. After a long list of eminent citizens of Aberdeen the author asks licence to add to their number 'Georgium Jamesonum pictorem regium qui primus Mortalium artem pictoriam Abredoniam invexit'.[9] The meaning is plain enough yet in a MS. translation in another but contemporary hand adjoined to Gordon's MS. we read '. . . George Jamesone, one of King Charles the Firsts paynters quho wes the first man quho made the excellencie of the airt of painting knowne in the north of Scotland'.[10] The original perhaps exaggerates a little but in the translation one detects that subtle elaboration of fact into fancy in its early stages which has affected Jamesone's reputation ever since. And whatever the intended meaning of the phrase 'one of King Charles the Firsts paynters', it was inherent with romantic possibilities.

---

[7] Documents, 79(b).

[8] Documents, 79(c); see also J. P. Edmond, *Aberdeen Printers*, Aberdeen, 1884–6, p. 79.

[9] National Library of Scotland, MS. Bibl. Adv. 34.2.8 (W.2.20.), fo. 93.

[10] Ibid., fo. 101v. Printed in Cosmo Innes (editor), *A Description of Both Touns of Aberdeen by James Gordon Parson of Rothemay*, Spalding Club, 1842, p. 8.

There is then a gap of rather more than a hundred years until 1768 when Horace Walpole included a life of Jamesone among the additional lives supplementing the first edition of his *Anecdotes of Painting in England*.[11] The legend had clearly been thriving, however obscurely, for Walpole presents it more or less fully grown. As he indicates, the source of his information was a 'Mr. John Jamesone wine-merchant in Leith'. Jamesone, who had communicated with Walpole in 1762 or soon after, either through the Earl of Breadalbane or the latter's cousin and legal adviser John Campbell, was 'determined to have [Jamesone's] name inserted . . . in his proper place in Mr. Walpole's book . . .'.[12] He was also intimate with the Edinburgh painter John Alexander, who believed himself to be a descendant of Jamesone's, and it appears that these two together concocted some of the more colourful episodes which Walpole put into his own persuasive form: 'George Jamesone was the Vandyck of Scotland, to which title he had a double pretention, not only having surpassed his countrymen as a portrait-painter, but from his works being sometimes attributed to Sir Anthony, who was his fellow-scholar; both having studied under Rubens at Antwerp.'[13] Walpole is not of course stating that Jamesone's works are of equal merit to Van Dyck's but simply that each was the leading painter in his own circle, though their respective works can sometimes be confused through their having had a similar training. The latter part of this proposition, as will be seen later, has no basis in fact. There is simply no evidence to substantiate it and a comparison of styles should show how inappropriate it is. It was no doubt, however, the lack of precision on Walpole's part that led to the attribution to Jamesone of so many Scottish (and other) portraits having the stamp and costume of the period 1620–40. An idea was introduced which, when taken up by less experienced connoisseurs than Walpole, was elaborated into a travesty of the truth.

[11] Horace Walpole, *Additional Lives to the First Edition of Anecdotes of Painting in England* [London, 1768], pp. 2–6. For the rather complicated history of the publication of Walpole's *Anecdotes* see A. T. Hazen, *A Bibliography of the Strawberry Hill Press*, New Haven, 1942. The *Additional Lives* was printed as a separate pamphlet with independent pagination but it is usually found bound in at the end of volume II or III. Hazen (op. cit., p. 61) believes that it must have been prepared in the summer of 1765. It was advertised in December 1767 and reviewed in *The Critical Review* for January 1768. A letter to Walpole from the Rev. William Cole dated 14 May 1768 mentions the notice and a subsequent one: 'What an impudent pack of scoundrels are the Critical Reviewers! The month before your *Historic Doubts* appeared, you was highly in their favour for giving a print and speaking well of a Scotch painter, one Jameson; the very next month, I think, showed their nationality, if I may use the expression.' (W. S. Lewis and A. Dayle Wallace (editors), *Horace Walpole's Correspondence with the Rev. William Cole*, I, London, 1937, p. 139.)

[12] So Jamisone had written to Campbell (cashier of the Royal Bank of Scotland and usually referred to as 'Campbell of the Bank') on 5 July 1762. Among the anecdotes Jamisone has included in a 'Life' which he hopes the Earl of Breadalbane will transmit to Walpole is one stating that Jamesone was persuaded by Sir Colin Campbell of Glenorchy to go abroad and study under Rubens. In his draft reply of 10 July 1762 from Taymouth, Campbell seems unwilling to involve the Earl of Breadalbane. The two letters are unsorted items in the Scottish Record Office (hereafter SRO), GD 112.

[13] There appears to be a link between Jamesone's name and Rubens prior to Walpole. In a list of pictures at Mavisbank House (Clerk of Penicuik) of February 1750 is: 'The picture of Mr. Calderwood the historian done by Jamesone a scholar of Rubens' (transcript in Scottish National Portrait Gallery (hereafter SNPG)).

Walpole then goes on to give a summary of the facts of Jamesone's life which clearly bear the mark of his correspondent. While some of these traditions should perhaps be treated with a certain respect, there are also glaring errors of fact. To cite one obvious example, the year of Jamesone's birth is given unequivocally as 1586, though in July of that year his parents had a daughter.[14] Again, there is no knowledge of Jamesone's apprenticeship in Edinburgh, but that Michael Wright had been his pupil is known: yet both these facts are contained in the same register of apprentices.[15] One may therefore speculate on the existence of a reliable tradition concerning the relationship between Jamesone and Wright.

Another example of this ambivalence is found in Walpole's statement: 'When King Charles visited Scotland in 1633, the magistrates of Edinburgh, knowing his majesty's taste, employed Jamesone to make drawings of the Scottish monarchs, with which the King was so much pleased, that inquiring for the painter, he sat to him and rewarded him with a diamond ring from his own finger.'[16] It is true that Jamesone was involved in the public celebration of this visit, for the Town Council minutes record a substantial payment to Jamesone 'for his extra ordiner paynes taiken . . . in the tounes effaires at his Maiesties entrie within this burgh'.[17] Unfortunately his pains are not specified, but as will be seen below, some of the street decorations described by Spalding—'At the wast end of the tolbuith he (King Charles) saw the royall pedigree of the Kingis of Scotland fra Fergus the first, delicatelie painted . . .'[18]—were the work of Jamesone. What survives are the twenty-six portraits of Scottish monarchs (Catalogue, 40–65) preserved until recently at Newbattle Abbey, which probably formed the facings of a triumphal arch. There is therefore some understanding of a real situation in the first part of Walpole's remarks, but the latter part is quite unconvincing.

Walpole next points to the patronage which Jamesone received from Sir Colin Campbell of Glenorchy and is able this time to quote from an original source, the so-called 'Black Book of Taymouth', which is basically a family genealogy.[19] Here, under the year 1635, are records of payments to Jamesone for two groups of portraits, royal and family. Besides stating that Sir Colin had been 'the chief and earliest patron of Jamesone', Walpole goes on to remark that Jamesone 'had attended that gentleman on his travels'. The patronage is proven but the travel episode has never been

[14] Documents, 5.      [15] Documents, 11 and 48.

[16] Walpole, p. 3. The story of the diamond ring may stem distantly from a very Dutch-looking portrait of a man with a ring held towards the spectator, which was once believed to be a self-portrait of a Scottish painter called Scougall (National Gallery of Scotland, no. 2032; Shorter Catalogue, 1970, p. 89). Jamisone of Leith (see note 12) had been 'informed that King Charles the first sat to [Jamesone] when in Scotland and greatly caressed him': this information appears to have been supplied by the painter Alexander.

[17] Documents, 32.

[18] John Spalding, Memorialls of the Trubles in Scotland and England 1624–1645, Spalding Club, 1850, vol. i, p. 34.

[19] See Cosmo Innes (editor), The Black Book of Taymouth with other papers from the Breadalbane Charter Room, Edinburgh, 1855.

substantiated: this was relayed to Jamisone the wine-merchant by John Campbell, and probably resulted from the latter's rather casual examination of the records in the Taymouth charter room.[20] This is a matter that is discussed more fully in Chapter II, but it seems likely that it is these words which have given rise to considerable elaboration on the part of later writers, notably John Bulloch, and have entered the literature as a visit to Italy in 1633.

There is one final point in which Walpole seems to nourish the growing legend. A will written by Jamesone in 1641 is mentioned. So much detail of the contents of this will is given that it is difficult to believe that it is a fabrication, but the will itself is no longer known. It is not impossible that such a will had been seen and its contents noted or remembered.[21] It is also known from other sources[22] that Jamesone did, as Walpole remarks, 'provide kindly for his wife and children'. He did not, however, as far as one can be certain, make 'handsome provision for his natural daughter' as Walpole also remarks. This rather *de rigeur* view of the waywardness of artists has also been generally accepted, the natural daughter being equated with Elizabeth. She, however, as the records show, was baptized on 6 February 1639 as a quite legitimate child.[23] Finally, Jamesone had died in Edinburgh and had been buried in Greyfriars' churchyard, without, conveniently, a monument to mark his grave.

The next signs of the growing interest in Jamesone are to be found in three nearly contemporaneous manuscripts: a 'Catalogue of Portraits of Illustrious or Learned Scots' compiled by David, 11th Earl of Buchan prior to 1781;[24] a brief biography of Jamesone with a list of some ninety pictures, compiled by Alexander Carnegie, Town Clerk of Aberdeen;[25] and a 'Catalogue of Painted Portraits in many of the capital Mansion houses of Scotland', put together from the lists of correspondents by Sir William Musgrave in the years 1793–9.[26]

Buchan's wider aim was to create some kind of record of outstanding national figures. Referring to the Society of Antiquaries, he asks: 'Should not the Secretary of the Society be ordered to request in the name of the Society a correct list of all the known Portraits of the collection [Bothwell Castle] with the Painters names where known super added?'[27] In this spirit he himself made a series of copies of portraits,

---

[20] 'The Tradition in this Family is, and I have a faint remembrance of seeing it somewhere amongst their old writings, That Sir Coline Campbell eight Laird of Glenorchy, carried Mr. Jamesone with him in his Travels abroad. . . .' There is probably a confusion here with the first laird of Glenorchy who was a Knight of Rhodes and had apparently visited Rome (see *The Black Book of Taymouth*, p. ii).

[21] The Commissary records for the Burgh of Aberdeen prior to 1715 were destroyed by fire in 1721 and the Sheriff Clerk's Register of Deeds from August 1643 to September 1649 is lost.

[22] Documents, 69, 70, and 71.      [23] Documents, 54.

[24] The Society of Antiquaries of Scotland, MS. 597, dated 22 January 1781.

[25] Carnegie's MS. was communicated to Musgrave by Sir John Sinclair and forms an appendix to his lists: it was, however, originally undertaken for Sinclair's vast project *The Statistical Account of Scotland*.

[26] British Museum, Add. MS. 6392 Plut. CLXXIII, i, fos. 1–121. There is a transcript in the SNPG.

[27] Earl of Buchan's MS., p. 2.

largely of the early seventeenth century, in Scottish collections. He was apparently doing this in the 1760s; in 1795 he made copies of some of these for transmission to John Pinkerton for use in his books of engraved portraits, and especially in *The Scottish Gallery*. Jamesone is the only artist's name occurring on these, in a fair number of cases quite justifiably.

Buchan's catalogue contains a separate list of Jamesone's works consisting of sixty-nine pictures, with three more noted separately. Where relevant these are referred to in the present Catalogue but it is interesting to notice some of the odder items here, for example the entry: 'a Perspective view of the City of Edinburgh with a Neptune in the foreground by Jamieson where is it?'[28] This may refer to the view of Edinburgh recorded as being part of the street decorations in the town during Charles I's triumphal entry in 1633, but it probably also reflects the growing tendency to attribute all old pictures to Jamesone. He also includes in his list two portraits, the full-lengths of George Heriot and Lord Spynie (Plate 27) which it now seems surprising could ever have been attributed to Jamesone.[29]

Buchan's list is by no means a travesty and is of some interest as being the first in a number of such catalogues that were being put together at this time. He did, however, repeat the supposed connection with Rubens which he probably took from Walpole.

Alexander Carnegie's short biography of Jamesone seems at first a little more circumspect than Walpole's, on which it is partly based, and he adds a parochial touch to the romance. Instead of a definite year of birth we have: 'He was born of respectable parents about the end of the 16th century.' He repeats, however, that Jamesone studied under Rubens, and the romantic description of his painting Charles I is taken almost directly from Walpole. Carnegie does include some quite particularized information about Jamesone's descendants which is obviously based on real local knowledge; and he does contribute one significant date. He states that after the time spent with Rubens, 'About the year 1620 he returned to his native city, where he settled as a portrait painter.'[30] This certainly pin-points as far as is still known the beginning of Jamesone's career.

Musgrave's interest in Jamesone is indicative of the trend. It has to be remembered, however, that his catalogue is uncritical as he had seen, as far as is known, none of the pictures in question. His list does emphasize the tendency to name Jamesone as the artist of all Scottish portraits which appeared to be of the early seventeenth century, the Duff of Muldavit portraits then in Duff House, being a case in point.[31] Musgrave

[28] Earl of Buchan's MS., p. 5.
[29] *George Heriot*: George Heriot's School, Edinburgh; *2nd Lord Spynie*: Private collection.
[30] Sir John Sinclair (editor), *The Statistical Account of Scotland*, vol. 19, Edinburgh, 1797, p. 228.
[31] *John Duff of Muldavit*, dated 1643, and *Agnes Gordon* (his wife), also dated 1643: now in Kinnaird Castle. Musgrave's correspondent may have been misled by the fact that both are 'signed': *G. Jamesone faciebat*!

includes in his lists seventy-six portraits as being the work of Jamesone, though some were unconsciously duplicated. He does not attempt to comment on Jamesone.

Much of Lord Buchan's knowledge of Scottish portraiture found its way into John Pinkerton's iconographical studies, the Jamesone material mainly into *The Scottish Gallery*.[32] Their exchange of letters over a picture which Buchan claimed to be a fourteenth-century French portrait of the patriot Wallace, a view which Pinkerton emphatically asserted to be mistaken, suggests that Pinkerton must be taken more seriously as a connoisseur than Buchan.[33] His introduction, however, while reinforcing the legend growing around Jamesone, 'who burst forth at once with meridian splendour', adds little to Walpole's picture, though the return from Rubens's studio is placed as late as 1628. His notes on the portraits contain some quite percipient comments on the series of Campbell of Glenorchy ancestor portraits at Taymouth. These comments originated with the Newcastle artist Robert Johnson, who was copying them in 1796 for Pinkerton.[34] According to Johnson, and this is now clear, only the female portraits were by Jamesone (Catalogue, 71-(i) to 78-(6)). He also rightly excluded the portraits of Sir Colin Campbell and his wife, which were dated 1633, as 'stiff and poor'. Pinkerton had a justifiable faith in Johnson's judgement but he was tempted to interpolate that perhaps after all Jamesone did do them—'It seems unlikely that two painters should have been employed at Taymouth in 1633.'[35] Pinkerton has blundered here simply because there had been no published reference to the still unidentified 'Germane painter' recorded in the Black Book of Taymouth under the year 1633. Otherwise, of the ten plates specifically attributed to Jamesone it is possible to quarrel with only one, the portrait of Sir Alexander Fraser.

Allan Cunningham's life of Jamesone appeared in 1832 and must take a good deal of blame for the later form of the legend. This indeed is its only claim to notice for it is patently little more than fiction. This is evident in the opening sentence, where he states that Jamesone was born on the same day that Mary Queen of Scots was executed (8 February 1586). Thereafter he embellishes the plot with a mass of picturesque detail, and ends with the astonishing remark: 'That he stands at the head of the British school of portrait-painting there can, therefore, be no question; nor had England an artist of her own worthy of being named above him in his own walk before the days of Reynolds. . . .'[36]

Cunningham acknowledges a debt to David Laing the antiquarian, but there is

[32] John Pinkerton, *The Scottish Gallery*, London, 1799.

[33] Dawson Turner (editor), *The Literary Correspondence of John Pinkerton*, London, 1830, vol. i, pp. 246–247, 368.

[34] Johnson died while making these copies: see Pinkerton's *Correspondence*, vol. i, pp. 423–5.

[35] Pinkerton's *Scottish Gallery*, pp. 34, 80.

[36] Allan Cunningham, *The Lives of the Most Eminent British Painters, Sculptors and Architects*, vol. v, London, 1832, pp. 1–33.

little evidence of the latter in his 'Life', for Laing in a set of unpublished notes[37] reveals himself as probably the only person to have looked at Jamesone from a properly historical standpoint. He put together a series of notes on aspects of Jamesone's life based purely on searches of records. It is now difficult to get any coherent picture from these, but his method is worth noticing. On the question of the will Laing is quite clear: 'As to the Will of George Jamieson, by the following Notes it will be seen that it cannot now be found.' He records a gap in the Minute Book of the Register of Deeds between 1640 and 1650 and in the Register itself between August 1643 and September 1649; and he records the loss of the Commissary records prior to 1715. The records were searched at other possible points, 'but without success'. Although his researches were negative in many ways, Laing must take credit as the first to make a real attempt to replace the legend by fact.

Towards the end of the nineteenth century John Bulloch brought out his book which has long been accepted as the standard work.[38] Perhaps the two most notable features of Bulloch's book are its confident style and regular omission of sources. The legend is perpetuated in the sub-title, 'the Scottish Vandyck', and while admitting that a problem exists regarding the Rubens episode, he goes on to say: 'But while there is no positive evidence, there is at the same time no moral doubt.'[39]

Bulloch gives a definitive form to one important feature of the legend which has persisted to the present—the visit to Italy with Sir Colin Campbell in 1633.[40] This, as has already been mentioned, probably had its origins in remarks made by John Campbell of the Bank, and the use made of them by Walpole in his 'Life'. The story was repeated by Allan Cunningham. Bulloch elaborates it into an intimate friendship with Campbell of Glenorchy, derived it would seem almost wholly from the latter's patronage of Jamesone. Further, one new source was available to Bulloch, the diary of Alexander Jaffray.[41] In this Jaffray recounts that in the latter part of 1633 he visited London in the company of a small group of Aberdonians which included Jamesone. It is this which seems to have set Bulloch's imagination alight. The wide range of his fancy includes a meeting with Van Dyck in London, a visit to Florence and Rome, and a return journey via Antwerp, where Rubens was visited. The whole journey is reckoned to have taken place between August and the end of the year. It is sufficient at the moment to note that in the months of September, October, and November of 1633 Jamesone appeared as a witness (or godfather) at baptisms in Aberdeen.[42]

Thereafter Bulloch is on slightly surer ground, though he repeats in a very close

[37] Edinburgh University Library, Laing MSS., La.IV.26. These are unsorted and unnumbered so it is not possible to give detailed references.

[38] John Bulloch, *George Jamesone, the Scottish Vandyck*, Edinburgh, 1885.

[39] Ibid., p. 44.    [40] Ibid., pp. 76–81.

[41] John Barclay (editor), *Diary of Alexander Jaffray*, Aberdeen, 1856.

[42] Documents, 78 (22, 23, and 24).

paraphrase the details of Jamesone's will found in Walpole, and ends his story with a touching but quite imaginary description of his death.

Bulloch provides a catalogue of 189 items, but any consideration of these is left to the present Catalogue. He concludes with an appendix of original source material taken mainly from the Aberdeen Burgh Register of Sasines. These documents throw a little light on biographical problems, but Bulloch was either proceeding on extracted material supplied to him, or else he read his records very carelessly. In his extract No. 4, dated 25 January 1625, he has failed to notice elsewhere in the instrument from which he quotes that Isobel Tosche, whom it had always been assumed married Jamesone in November 1624, is described as his future wife, 'iam in sua pura virginitate existeñ'.[43] It must also be emphasized that these documents as quoted contain many inaccuracies which turn them in parts into nonsense. To quote only one example, part of his extract No. 2, describing in the normal form the position of the dwelling-house in Aberdeen with which Jamesone is first directly associated, reads: 'Inter terra anteriore quondam Davidis Indeaucht nec vero roberti forbes te mendatarii de Monymusk ex orientali ex vica terra quondam Adami Moir ex occiendatali partibus ab altera terra Interiorem Andree Watsoun fabri liguarii vertis borea et toiem viam regiam vertis austris.' This should in fact read: 'Inter terram anteriorem quondam Dauidis Indeaucht nunc vero Roberti Forbes commendatarii de Monymusk ex orientali ex vna, terram quondam Adami Moir ex occidentali partibus ab altera, terram Interiorem Andree Watsoun fabri lignarii versus boream et communem viam regiam versus austrum.'[44] This degree of error continues throughout these extracts.

There are also records that neither Bulloch nor those who later used him as an authority examined. The most important among these are the parochial registers of baptisms, marriages, and deaths. Some biographical data had been extracted from these at various times,[45] and Bulloch made use of this knowledge, but a great deal of information was still to be found there, including facts which enable Jamesone's date of birth to be set within close limits, as well as the dates of birth of eight of his children.

It is, however, as a persuasive weaver of fact, tradition, and legend into something like a definitive shape that Bulloch is most significant and has had such a marked influence, both on subsequent writings on Jamesone and on his popular reputation. He is quoted as a reliable authority by J. M. Gray in the *Dictionary of National Biography*, by James Caw in 1908[46] and in Maurice Brockwell's notes published as recently as 1939.[47]

---

[43] Bulloch, p. 188; Documents, 18.    [44] Bulloch, p. 187; Documents, 8.
[45] See *Analecta Scotica*, First Series, Edinburgh, 1834, pp. 289–90.
[46] James L. Caw, *Scottish Painting, Past and Present (1620–1908)*, Edinburgh, 1908.
[47] Maurice W. Brockwell, *George Jamesone and some Primitive Scottish Painters*, London, 1939.

While Gray follows Bulloch in almost every point, Caw presents a much more balanced view. In 1906 it had been published that Jamesone had been apprenticed, not to Rubens, but to the obscure decorator John Anderson;[48] and from that time the legend waned. Caw also had searches made in the archives at Antwerp, but without result; yet he was still reluctant to give Rubens up for he also believed he had discovered that the apprenticeship with Anderson had been broken by 1616,[49] after which time a visit to the Continent might have been made. And it is undeniable that there is no record of Jamesone's movements between 1617 and 1620.

Brockwell's main purpose was to publish Musgrave's lists, which he does with a fair degree of accuracy, though somewhat arbitrarily. While providing some useful documentation on the subject of provenance, Brockwell's contribution is negligible. He had clearly seen few of the pictures concerned and as a result his annotations are sometimes quite inappropriate. An example of this is his willingness to accept a portrait of Sir Duncan Campbell, dated 1619 (then in Breadalbane possession; Plate 14), as the earliest known Jamesone.[50] A bare knowledge of his subject would have saved him from this error; and had he seen this collection he might also have noted the significance of the series of 'fancy' portraits of the Glenorchy ladies.

This chapter might appropriately be ended by reverting to a remark made by Caw, which to some extent summarizes persistent aspects of the literature on Jamesone: 'From then [1620] until 1644, when he was laid in a nameless grave in Greyfriars churchyard, the incidents of his career, gleaned from old account-books, letters, diaries, deeds, and the signatures on pictures, have been pieced together by Mr. Bulloch, and, if the mosaic thus made shows blanks here and suppositions there, it is perhaps all we shall ever know of the earliest Scottish painter.'[51] Here there is still an echo of the national legend, the enduring but unwarranted faith in Bulloch, and also the hint, implicit in many writers, that records are now insufficient to throw any more light on Jamesone. These records, however, are not quite so few as had been believed; and indeed, considering the time and the subject, they might be considered plentiful though, it must be added, they refer with only a few exceptions to the biographical aspects rather than the painterly. From the one hundred and fifty or so contemporary references to Jamesone, some admittedly very slight, it is possible to build up a picture of his life with some exactness.

[48] Francis J. Grant (editor), *The Register of Apprentices of the City of Edinburgh 1583–1666*, Scottish Record Society, 1906, p. 98.

[49] Caw, p. 9. Caw was, however, mistaken in this supposition: see below, p. 20, note 48.

[50] Brockwell, p. 25. The painting is now in the SNPG, no. 2165: see below, p. 53.

[51] Caw, p. 9.

# II

# THE LIFE

## (i) EARLY YEARS

On 3 December 1607 Andrew Jamesone, mason in Aberdeen, settled the rights in his two houses in the Schoolhill in the north-west corner of the burgh. One of these was a tiled building of two or three storeys situated on the north side of the street. The other, roofed with turf, lay on the south side, somewhere near the north transept of St. Nicholas Church, on the corner formed by the Schoolhill and the street running north to it from the Town Hospital. This was the house in which Jamesone himself and his wife Marjory Anderson were then living. In both these dwellings he now gave his wife liferent rights.[1] To his eldest son Andrew he gave hereditary possession of the family house, reserving its use, however, during their lifetime, to himself and his wife.[2] The house (or foreland) on the north side, which stood on land belonging to Andrew Watson, a carpenter, whose own house (or inland) stood behind, he conveyed, with similar reservations, to his second son George.[3]

Andrew Jamesone and Marjory Anderson had been married on 17 August 1585.[4] On 27 May of the following year Andrew acquired the dwelling-house on the north side of the Schoolhill, just described, from the carpenter Andrew Watson.[5] The neighbour in the house to the east was one of the bailies of the burgh, David Endeaucht, who three years later was to be deputy commander of a ship called the *Nicholas* which sailed out under the auspices of the burgh to join those other ships escorting James VI and his Queen, Anne, back from Denmark.[6] Among the eight witnesses to the ritual transfer of the property by the physical handing over of earth and stone were Endeaucht, David Anderson, who may have been Marjory's father, and William Anderson, his son.

The Jamesones' first child, a daughter Elspeth, was baptized on 30 July 1586.[7] This date must be very close to the actual date of birth as it is unlikely, considering the hazardous nature of birth at that time, that baptism would be long delayed. Whether another child was born between Elspeth and the next recorded child, a son called David, baptized on 17 October 1588,[8] is not known, but the lapse of time is great

---

[1] Documents, 8.    [2] Documents, 9.    [3] Documents, 10.    [4] Documents, 2.
[5] Documents, 3.
[6] See City of Aberdeen Records (hereafter AR), Council Register, vol. 33, pp. 598, 736.
[7] Documents, 5.    [8] Documents, 6.

enough for this to be possible. Later, on 9 May 1591 another son, William, was born.[9] In this second interval there is just enough time for two children to have been conceived and born, though it is rather unlikely. William survived until 1632, so when in 1607 at the settlement of the heritable properties a son Andrew is described as eldest and George as second son, it follows that their births must be located somewhere in these two stretches of time. If Andrew was born in the first, as seems most likely, then George must have been born sometime between September 1589 and June 1590. If, however, both Andrew and George were born in the second of these two intervals, remembering that Andrew is the elder, George's birth would have to fall in June or July of 1590. The onus of probability, however, makes it reasonable to conclude that George Jamesone was born at some time between the autumn of 1589 and the middle of 1590.[10]

It is not clear why Andrew Jamesone should have reordered his affairs in 1607 for he was to live for some years yet; there was clearly, however, some necessity to provide for his wife in the event of her widowhood. Nor is it clear why William, who was sixteen by this time, was overlooked. David, who was older than George and even perhaps older than Andrew, must have died prior to this time. Nothing certain is known about George during these years. His future role would indicate that he attended the Grammar School which lay only some hundred 'walking paces' to the west of his parents' house. The Rector of this school prior to 1602 was David Cargill, burgess since 1597[11] and author of a Latin poem on James VI's escape from the Gowrie conspirators. The Rector after 1602 was David Wedderburn, later a teacher in Marischal College[12] and Jamesone's future panegyrist. There were other schools, which taught only reading and writing. On 4 September 1603 two of these had to be officially sanctioned because 'thair is sic ane multitude of schoollis takin up be sindrie wemen in this toune having doctouris to teiche the Bairnis baith Ladis and Lassis';[13] this was judged prejudicial to the livings of the two authorized schoolmasters. It should not be entirely discounted that Jamesone attended a school of this type.

His father, Andrew Jamesone, was clearly a prosperous and prominent mason in the town and very likely came of a long line of mason-craftsmen. In 1541 a William Jamesone, mason, became a burgess[14] and on 28 March 1573 the death is recorded of a William Jamesone, possibly the same person, who is described as a mason and master

[9] Documents, 7.

[10] These calculations are based on an absolute minimum of ten months between births. Thus a period of at least twenty months between two established births is required before it can be stated with any likelihood that another child could have been born between them; similarly, a period of at least thirty months between known births is required for the possible birth of two other children.

[11] AR, Council Register, vol. 36, pp. 765, 773. See also *Miscellany of the New Spalding Club*, vol. i, New Spalding Club, 1890, p. 92.

[12] See William Kennedy, *Annals of Aberdeen*, London, 1818, vol. i, p. 125.

[13] SRO, Aberdeen Kirk-Session Records, CH 2/448/2.

[14] AR, Council Register, vol. 16, p. 590. See also *Miscellany of the New Spalding Club*, vol. i, p. 57.

mason of the kirk and bridge works.[15] The latter was certainly Andrew Jamesone's father for just a few months after, on 6 August, 'Androw Jamesoun sone naturall to vmquhill Wilzeam Jamesoune' was entered as apprentice to an Andrew Bethlem, mason.[16] The apprenticeship was for seven years but Andrew was bound to serve Bethlem for a further two. Thus his marriage came some three years after the ending of this contract.

His own name occurs frequently in the Kirk & Bridge Works Accounts, especially in 1609, when he conducted his business in conjunction with a William Massie. On 17 April 1610 payments are made to Jamesone for 'building of the Bow brig'.[17] This work had been under way as early as 1586. One of the two masters of work appointed by the town was the David Endeaucht who owned the house next to Jamesone's. The contract with Jamesone specified that the bridge should have two arches[18] and this is how it is clearly depicted on Gordon of Rothiemay's map.

The masons were comprised in the same incorporated trade as wrights, coopers, carvers, and painters. Each incorporated trade had the right to elect a deacon who could take part in the election of the town council. This right had a long and chequered history and attempts had been made to abolish the deacon's powers or to limit them to the inspection of work; however, the right to vote was reinforced in 1587 in the agreement known as the Common Indenture.[19]

Prior to this year there had been a good deal of friction between the wealthy burgesses of gild, merchants and traders, and the craftsmen, less wealthy but more numerous. The annual town council elections had degenerated into a process of self-election: in the period 1590 to 1610 the families of Menzies, Cullen, and Rutherford between them provided eighteen out of a total of twenty-one provosts.[20] The discontent of the craftsmen at their lack of power came to a head in 1587 and led to the arbitration which produced the Common Indenture. Basically, the trouble was over the lack of trading rights of the craftsmen. Among the sixty-nine craftsmen who appeared in St. Nicholas Church on 2 July 1587 as procurators for their trades was Andrew Jamesone.[21] The result of the discussions with the gild burgesses produced the right of the craftsmen to trade in Scottish wares within the realm of Scotland.

There is no record of when Andrew Jamesone died, but it must have been between 1612, when George was apprenticed in Edinburgh, and 1617 when he is described as

---

[15] General Register Office (Scotland) (hereafter GRO(S)), Parochial Registers, Aberdeen, 168A, vol. 18: 'Wilzem Jamesone mayson & maister mayson to the kyrk & bryg wark . . . diparttit the xxviii day of Marche 1573 zeir.'

[16] Documents, 1.

[17] AR, Kirk & Bridge Works Accounts 1571–1670, under date.

[18] See Miscellany of the New Spalding Club, vol. i, p. xxxvii, where the artist's father is mistakenly called William.

[19] See William Kennedy, op. cit., vol. ii, pp. 235–8, 247 (referring to the corporation which included painters), 449–53.

[20] Ibid., p. 232, where the provosts are listed.     [21] Ibid., p. 450.

the late Andrew Jamesone. In this same document George is described as the eldest (that is, eldest surviving) son.[22]

It is very likely that George's elder brother Andrew died in 1613 soon after his marriage. A marriage is recorded on 31 January between an Andrew Jamesone and Agnes Drum.[23] On 14 November of the same year Agnes Drum had a son, also called Andrew, but the father Andrew is now deceased.[24] The principal godfather was Andrew Watson, probably the carpenter who had sold the elder Jamesone the house on the north side of the Schoolhill. A further confirmation that this refers to George's elder brother is provided much later, in 1628, when George Jamesone appeared as a godfather to a daughter born to Agnes Drum and her second husband.[25] It may be doubted whether George would have been able to proceed to Edinburgh in 1612 if Andrew's death had taken place a year or so earlier. George eventually succeeded to his elder brother's property in the Schoolhill, but not until 1625, which may indicate that their mother's liferent rights were operant until that year.

The population of Aberdeen in the early years of the seventeenth century was probably in the region of 5,000. For administrative purposes the town was divided into four quarters: Futtie, the Green, the 'Cruikit' quarter, and the 'Evin' quarter. In a Stent Roll of 1608[26] under the 'Cruikit' quarter the name of Andrew Jamesone appears listed against a taxation of 33s. 4d. The lowest amount payable is 6s. 8d., and the highest £10. The numbers of taxed persons in these quarters respectively were 123, 103, 180, and 145, a total of 551. The total payment of £352 for the 'Cruikit' quarter was also relatively bigger than the payments of the others. The much more sparsely housed Green quarter in the south-west corner of the town paid only £226.

Although Gordon of Rothiemay's map and panorama, and his text,[27] describe Aberdeen as it was in the middle of the seventeenth century, they also illustrate a settled town, and it is unlikely that it had changed a great deal since the first decade of the century. The town was dominated by the 'Great Church' of St. Nicholas, a medieval building, which in 1513 had been crowned with a tall spire with four distinctive pinnacles clustered round its base. After previous mutilations a wall was built between the choir and the nave, in order to produce two churches, the Old and New

---

[22] Documents, 12.

[23] GRO(S), Parochial Registers, Aberdeen, 168A, vol. 12: 'Andro Jamesone and Agnes Drum mareit 31 January 1613 be Mr. Ja. [Ross].'

[24] Ibid., vol. 2: '14 Novembris 1613 Umquhill Andro Jamesone and Agnes Drum ane sone nomine Andro   Andro Watsone   George Andersone   Andro Howatt and Andro Blakhall witnesses.'

[25] Documents, 78(1).

[26] See Louise B. Taylor (editor), *Aberdeen Council Letters*, vol. i, London, 1942, pp. 392–406. Throughout the present work values are in pounds Scots unless indicated otherwise. The pound Scots was valued at one-twelfth of the pound sterling: a merk was two-thirds of the pound Scots.

[27] Cosmo Innes (editor), *A Description of Both Touns of Aberdeen by James Gordon Parson of Rothemay*, Spalding Club, 1842. This contains a fair facsimile of the map; there is a print in the National Library of Scotland.

Kirks.[28] The large burial ground around the church was, according to Gordon, 'planted about with great ash trees': trees indeed were a notable feature of the town. Nearby stood the Grammar School, the Music School, and, at the east end, the Town Hospital.

The town was bisected north and south by the Broadgate and the Gallowgate. The Broadgate had originally been what its name indicates, a street of unusual width, but a line of houses had been built down one side of it, producing a new street called the Guestrow. At the top of the Broadgate was the house of the Greyfriars, the conventual buildings of which had been erected into a College by the Earl Marischal in 1593. To the east of the south end of the Broadgate lay the Castlegate which was more an open space than a street, being about a hundred yards in length and fifty across. In the north-west corner stood the Town House; besides being the administrative centre it was also a prison. On the south side of the Castlegate stood the residence of the Earl Marischal which, as Gordon's map shows, was some kind of tower-house.[29]

To the west of the main axis the streets were less open and regular. From the north end of the Broadgate ran the Overkirkgate, terminating in a 'port' or gate which separated it from the Schoolhill. Further to the south, and like the Overkirkgate leading towards St. Nicholas, lay the Netherkirkgate, also halved in its length by a port. South of the Great Church was the Green, relatively thinly populated: on the water's edge of the harbour stood the Tradesmen's Hospital.

The majority of the houses were probably of three storeys with an attic level. Behind the forelands which fringed the streets there were usually inlands, entered by closes running through part of the foreland. Behind each inland there normally stretched a long plot of ground. These properties were the burgesses' main capital at a time of shortage of currency and a lack of investment opportunities. Gordon's description of the houses may be a trifle idealized but he depicts a place which can still just be sensed in the present town: 'It is easie to conjecture that the closses, lanes, and streets, have not been at first chaulked out or designed by any geometricall rule. The buildings of the toune are of stone and lyme, rigged above, covered with slaits, mostlie of thrie or four stories hight, some of them higher. The streets are all neatlie paved with flint stone, or a gray kind of hard stone not unlike to flint. The dwelling houses are cleanlie and bewtifull and neat, both within and without, and the syde that looks to the street mostlie adorned with galleries of timber, which they call fore-staires. Many houses have their gardings and orcheyards adjoyning. . . .'[30]

---

[28] See William Kelly, 'Four Needlework Panels attributed to Mary Jamesone in the West Church of St. Nicholas, Aberdeen', *Miscellany of the Third Spalding Club*, vol. ii, Third Spalding Club, 1940, pp. 162–3.

[29] This is confirmed in Gregory Sharpe's Prospect of 1732: engraved for *A Description of Both Touns of Aberdeen* (as cited).

[30] *A Description of Both Touns of Aberdeen* (as cited), p. 9.

The oligarchic town council represented one side of a double-edged control over the lives of the citizens: the omnipresent kirk-session represented the other. Each on occasion represented the superstition and brutality of the time, though both had a leavening of humanity. Beggars were permitted in the town, but 'strange' beggars were to be driven out. A system of provision for the poor and sick certainly existed: on 20 May 1610 the kirk-session ordained 'tua merkis to be gewin to the support of the Lipper woman laitlie put in the Lipper hous, becaus she will not gett ony of the rent of the said hous till Martenmas nixt'.[31] Yet earlier, in 1584, many were put to death as witches in an attempt to appease the plague, the men hanged, the women drowned. In 1586 a John Greyne and three women were convicted of poisoning an illegitimate child: Greyne was hanged and quartered and his head fixed on the Justice Port, the women were publicly drowned. Yet another aspect of the inhabitants is seen in contributions made in 1598 to relieve the distress in Haddington which had been destroyed by fire.[32] And we can read a simple awareness of the fleeting nature of life in the proclamation of a fast in August 1610, because of the 'visitatioun of the young childrene with the plage of the Pocks quhairof many children are already diceissed'.[33]

The more private areas of the citizens' lives were kept in strict check by the kirk-session. Of the usual eight to ten matters recorded in the minutes of a meeting of the session as many as half might well deal with adultery or fornication. Monetary penalties (for the use of the poor) were always exacted, usually about £5, and repentance in public was required. On 17 July 1603 Andrew Jamesone appeared as cautioner to find five merks for someone involved in such a case.[34] For more extreme degrees of transgression imprisonment could be imposed, the church vault being frequently used as a prison. Women tended to be treated more harshly than men and for repeated offences branding on the cheek might be ordered; the victim would then be carted through the streets wearing a paper crown and expelled from the burgh. An offence which carried a substantial fine, about £20, was failure 'to accomplish the band of mariage'. That the session and the civic government were in effect aspects of the same power can be seen in judgements against 'contentious playing' (disorder), in proscriptions against fishing on Sunday, and in sanctions to enforce church attendance.[35]

This was the town in which George Jamesone spent his childhood and schooldays, and the days which followed, and which he temporarily left in 1612. Balancing some of the harsher sides of burgh life are Gordon's limpid picture of the town and Arthur Johnston's praise of the burghers:

[31] SRO, Aberdeen Kirk-Session Records, CH 2/448/3, fo. 14.
[32] See William Kennedy, *Annals of Aberdeen*, London, 1818, vol. i, pp. 139–41.
[33] SRO, Aberdeen Kirk-Session Records, CH 2/448/3, fo. 19.
[34] Ibid., CH 2/448/2, under date. See also under 21 August 1603.
[35] Based on examination of Aberdeen Kirk-Session Records, 1602 to 1609, SRO, CH 2/448/2 and 3.

Martia mens illos commendat et aurea virtus
  Rebus et in dubiis saepe probata fides.
Hospita gens haec est et comis et aemula Divum,
  Quaeque regunt alios, huic famulantur opes.
Si locus est meritis, urbs haec Regina vocari
  Et dominae titulum sumere iure potest.[36]

A sturdy heart and matchless virtue graces them,
  And loyalty tested often in perplexity.
Their welcome and their courtesy is like the angels';
  Where wealth rules others, they are served.
For due reward, this town could take upon herself
  A sovereign's role, and bear the name of Queen.

## (ii) APPRENTICESHIP

When Jamesone was entered as an apprentice to John Anderson in Edinburgh on 27 May 1612[37] he was about twenty-two years of age. No explanation has been forthcoming for the lateness of his entry. He was initially entered for eight years but the indenture may have lapsed before the full period was completed. In the circumstances it is likely that Anderson was a relative of Jamesone's on his mother's side but there is no certain proof of this. On 6 October 1601 a John Anderson was entered as a gild burgess of Aberdeen;[38] he was designated 'pictor', and son of the deceased Gilbert Anderson.

Anderson took up residence in Edinburgh some time between 8 May 1611 and 1 August of the same year. On the earlier date he appeared with 'ane furnisht hagbuit', his contribution towards the peace-keeping obligations of Edinburgh's citizenry, and was made burgess. He had evidently still to settle in Edinburgh for he required a guarantor that he would take up residence before Lammas (1 August). [39] However, on the same day that he became burgess, Anderson was paid by the city treasurer for 'paynting and gilting of the twa brods of the knok [clock] at the Netherbow'.[40] This is either pure coincidence or else the burgess-ship was in some way connected with his carrying out this work. It does indicate the normal character of Anderson's painting and shows him to be in the same class of decorator-cum-artist as the other recorded painters working in the Lowlands at this time. Those whose names recur most frequently are James Workman, John Binning, John Sawers, and Valentine

---

[36] Quoted from Sir William Geddes (editor), *Musa Latina Aberdonensis*, vol. ii, New Spalding Club, 1895, p. 277.

[37] Documents, 11.

[38] AR, Council Register, vol. 40, pp. 208 (minute of admission) and 799 (list of burgesses Michs. 1601-2). See also *Miscellany of the New Spalding Club*, vol. i, p. 96.

[39] City of Edinburgh Records (hereafter ER), Register of Burgesses, vol. 2, under date. Listed in Charles Boog Watson (editor), *Roll of Edinburgh Burgesses 1406-1700*, Scottish Record Society, 1929, p. 32.

[40] ER, Council Register, vol. 12, p. 125. Printed in Marguerite Wood (editor), *Extracts from the Records of the Burgh of Edinburgh 1604-1626*, Edinburgh, 1931, p. 73.

Jenkin, who was an Englishman.[41] The majority of recorded payments are for work in the royal palaces, but there must have been a good deal of burghal work of the kind quoted above, and much of the unattributable decorative painting in country houses must be from their hands.

Although the nature of his own work was to be very different, there are indications that Jamesone was in no way out of place in this *milieu*. There were clearly painters of this class working in Aberdeen, the names Mellin[42] and Strachan occurring quite frequently in the records. What may have been a quite sophisticated piece of painting, though probably stylized and lacking any creative content, is a record of 1587 that John Mellin painted in the Great Church 'the bak of the ruid loft in tapesserie vark'; at the same time he painted 'the est horloge with owyll'.[43] In 1611 Andrew Mellin, though described as a glasswright, painted 'the new beir' in the same church.[44] Work of a much more advanced type than either of these examples is suggested in the words of an accusation by the kirk-session in 1604 against a 'Johne Melvill paynter . . . for paynting of a crucifix to the Burial of the Ladye of Gicht quhilk wes borne at hir buriall . . . thairby being the ground and occasioun of the fostering of Idolatrie and superstitioun'.[45]

In 1613 Andrew Mellin married an Isobel Jamesone, who may well have been a relative of Jamesone's;[46] and prior to the year 1617 Andrew Strachan, a painter whose name, as will be seen below, occurs more than once at a later period in the same context as Jamesone's, married a Margaret Meling (i.e. Mellin).[47] There are therefore indications that Jamesone had connections with decorative painters before his own career was fully under way; and it will be seen that such connections were continued, even when fully occupied by portrait painting.

Though Jamesone's apprenticeship with John Anderson was probably relaxed after four or five years there is no reason to believe that it was officially broken.[48]

[41] SRO, Accounts of the Masters of Works, vols. xiii, xv.

[42] The forms Mellin, Melvill, Melville, and Melving are variants of the same name.

[43] AR, Kirk & Bridge Works Accounts 1571–1670, under 3 July 1587.         [44] Ibid., under 1611.

[45] SRO, Aberdeen Kirk-Session Records, CH 2/448/2, under 13 May 1604.

[46] GRO(S), Parochial Registers, Aberdeen, 168A, vol. 12, under 21 January 1613.

[47] Ibid., vol. 2, under 29 April 1617: birth of a daughter to these two. The remaining documentation of Andrew Strachan, other than those instances where his name occurs in the same place as Jamesone's, is as follows: (i) AR, Kirk & Bridge Works Accounts 1571–1670: 'The Compt of the Money debursit on the brig of Don as followis Sept 17 [1642] Item to Androw Straquhane for Illuminating Sir Alexander Hayis Name and airmis on the brig with gold 2 dollors—£5. 6. 8.'; (ii) ibid.: '1642 Mair to Andro Straquhin for virnesing the thrie pulpitis and the reid loft in the gray foer kirk [of St. Nicholas] £12. 0. 0.'; (iii) ibid.: '1643 Item to Androw Straquhin for painting of tuo sone horloges & the tounis armis upon the south & northe end of the new kirk £6. 13. 4.'; (iv) AR, Register of Sasines, vol. xl, under 13 February 1645: instrument of sasine in favour of John Forbes and Agnes Strauchane of lands of 'Andree Strauchane pictoris burgi de Abridein' and his wife Margaret Melving.

[48] This idea originated in Caw, p. 9, on the basis of the supposed discovery of Anderson being raised from simple to gild burgess on 6 September 1616 (listed in *Miscellany of the New Spalding Club*, vol. i, p. 116). Anderson, however, as already noted, was entered a gild burgess in 1601. The John Anderson entered in 1616 is very likely the John Anderson who had been made a simple burgess on 20 October 1614 (*Miscellany*, vol. i, p. 112).

On 25 March 1617 the Privy Council demanded of the Marquess of Huntly, for whom Anderson was working at Strathbogie, that he send Anderson to Falkland Palace so that work might be carried out in preparation for the approaching visit of James VI and I on his first (and only) journey to Scotland after 1603. Anderson himself is commanded to be there 'with his workeloomes and otheris necessaris . . . within sex dayis . . . under the pane of rebellioun'.[49] There is no record of Anderson appearing at Falkland, even though working for someone as powerful as Huntly was hardly likely to provide an acceptable excuse for his absence. On 3 June of the same year he was again in trouble with the Privy Council for not appearing to work at Edinburgh Castle though he had entered into an agreement with the Master of Works. Not only had he not appeared but 'by ane idill and frivolous excuse returnit be him . . . he seems to pretend some impedimentis quhairfoir he may not fulfill the conditioun undertane be him . . .'.[50] In this instance, however, he certainly followed the dictates of the Council, for on 16 June he was paid £100 'for painting the rowme quhair his Majestie wes borne'. This work in the Castle he carried out in the company of John Sawers and James Workman: the painting done seems to have been mainly armorial in nature but also included some imitation marble on doors and chimneys.[51] In so far as it can be seen what kind of work Anderson was capable of, it must be assumed that Jamesone had a training in similar work.

That the relationship of master and apprentice between John Anderson and Jamesone had virtually come to an end by this time is further suggested by a document dated 26 November 1617. On that date Jamesone lent 100 merks to Alexander Jamesone, a tailor in Aberdeen, and received as security (the process known as wadsetting) a property in the Green. That Jamesone was in a position to do this is suggestive, but it is important to note that he was not personally present to take sasine of the property: this was done on his behalf by a David Anderson.[52]

Jamesone may at this time have been engaged with John Anderson in some other part of the country, but his apparent financial independence makes this unlikely. If he was not, and since he was absent from Aberdeen, one is led to speculate on his movements in the last two years of the decade, years for which there are no existing records of any kind. The tradition of his having travelled abroad is, as will be seen, more or less discounted by the records of later years, but if there is any basis for it this is the one period when it would clearly have been possible. But in 1620, the year in which his apprenticeship officially ended, his career as a portrait painter began with a portrait of Paul Menzies, later Provost of Aberdeen (Catalogue, 1; Plate 20). Jamesone was now thirty years of age.

---

[49] *The Register of the Privy Council of Scotland*, vol. xi, Edinburgh, 1894, p. 75.    [50] Ibid., p. 143.
[51] SRO, Accounts of the Masters of Works, vol. xv, fo. 58.    [52] Documents, 12.

## (iii) EARLY CAREER IN THE NORTH

Apart from the date on the portrait of Menzies there are no documentary records of Jamesone's activities in Aberdeen until 12 March 1624. On that date he personally received repayment of the 100 merks he had lent to Alexander Jamesone in 1617. In 1623 the right to redeem the property had been assigned to the David Anderson who had earlier represented him.[53] When Jamesone took repayment of his loan, sasine of the property was granted in favour 'sui avunculi Dauidis Anderson'— Anderson is therefore the brother of Marjory Anderson, Jamesone's mother.[54]

Among Jamesone's sitters in the mid-twenties were James Sandilands, Rector of King's College (Catalogue, 2; Plate 22), John, Earl of Rothes (Catalogue, 6; Plate 23), Lady Rothes with her daughters (Catalogue, 7; Plate 24), Mary Erskine, Countess Marischal (Catalogue, 9; Frontispiece and Plates 39, 40), and Arthur Johnston, physician and poet (Catalogue, 27; Plate 57). Adding the powerful burgess figure of Menzies to this list, it gives some indication of the quite wide range of sitters that Jamesone had at the outset of his painting life.

On 12 November 1624 intimation was made in the parish church (the Old Kirk) of 'ane promeis of mariage' between George Jamesone and Isobel Tosche.[55] There is no record of the required second and third calling of banns and the marriage for some reason had not taken place by 25 January 1625 when Isobel's procurator in a joint conveyance of property to her and George Jamesone acted in the name of the 'future sponse ipsius Georgii'.[56] They were, however, married before the middle of 1627, and probably much nearer the earlier date.

The conditions of the marriage must have been very carefully ordered for on 25 January 1625, although not yet married, they took joint possession of two properties, one on either side of the Schoolhill. As heir, Jamesone took sasine of the house which had belonged to his late brother Andrew, but in order to fulfil a clause in his marriage contract, he resigned it so that he and Isobel Tosche could take joint possession, as was also done in the case of the 'tiled foreland' on the north side of the street which he already owned. It may be that Jamesone's mother died about this time, as there is no mention of her liferent rights in the properties.[57]

On this occasion Isobel was represented by her uncle James Tosche, a name which later occurs many times in the same context as Jamesone's. He is probably the same James Tosche, merchant, who in 1621 mortified along with his mother, a considerable sum of money to the use of the kirk-session.[58] Isobel Tosche was the daughter of Alexander Tosche and Marjory Meassone (Mason) and there is some reason to

---

[53] Documents, 13.    [54] Documents, 14 and 15.    [55] Documents, 16.
[56] Documents, 18.    [57] Documents, 17 and 18.
[58] AR, Mortifications, M¹ 22. Referred to in P. J. Anderson (editor), *Charters and other writs Illustrating the History . . . of Aberdeen*, Aberdeen, 1890, p. 405, where the date is wrongly given as 1624.

think that she might be the unnamed daughter born to an Alexander Tosche on 22 September 1608,[59] making her about seventeen when she married Jamesone, about half his age. She certainly had a brother James, born on 16 July 1614,[60] and a sister Elizabeth, both of whom were dead by 7 June 1627 when she inherited the remaining half of a tenement in the Overkirkgate, the other half being already in her possession. This is also the first occasion on which she is described as the wife of George Jamesone, burgess of Aberdeen, who takes conjunct infeftment of the property.[61]

On the same day that Isobel inherited the house in the Overkirkgate, Jamesone acquired a fourth property which seems to have lain at the junction of the School-hill and the street running north from the west end of St. Nicholas, that is, very close to the Grammar School on the western edge of the town.[62] As this house was acquired directly in a sense that the others were not, two reasons may be surmised: Jamesone may either by now have needed a further investment for accumulating capital or else he required the house for a special purpose. When its openness to light on three sides is considered it may be proposed that Jamesone bought this house as a workplace. At any rate, in the earliest years of their marriage George Jamesone and Isobel Tosche owned between them what appear to have been four substantial properties.

In their rather less than twenty years of marriage Jamesone and his wife were to have at least nine children, five boys and four girls. After the first birth for which there is an actual record, that of William in July 1629,[63] offspring appeared with fair regularity down to the year of Jamesone's death. William was followed by four other boys.[64] None of these sons survived very early childhood, a fact which must have blighted the parents' lives, though a fatalism induced by the plain uncertainty of life must have offered some protection. Latterly came three daughters, Elizabeth, Isobel, and Mary,[65] all of whom survived their father, though only Mary grew to adulthood. There was, however, another daughter, Marjory, who appears on her father's death with these three as heir to his estate. The first three were mere infants at the time but Marjory had been married some time before this to an advocate, John Alexander; they had a child themselves at the beginning of 1645.[66] It is almost certain, then, that Marjory was the first-born child, probably born about 1627–8.

Less than four months after the birth of his first son, Jamesone had a brief preview of a man who was to leave, more than most, an indelible stamp on the coming years of civil strife. On 4 November 1629, James Graham, Earl of Montrose, still only seventeen years of age, was entered as a burgess of Aberdeen along with eight of his

---

[59] GRO(S), Parochial Registers, Aberdeen, 168A, vol. 2: '22 Septembris 1608 Alexander Tosh ane daughter nomine [blank] Alexander Jaffray and Robert Alshinor and Robert Burnett witnesses.'
[60] Ibid., under date.  [61] Documents, 19 and 20.  [62] Documents, 21.
[63] Documents, 22.  [64] Documents, 25, 31, 45, and 51.  [65] Documents, 54, 63 and 68.
[66] GRO(S), Parochial Registers, Aberdeen, 168A, vol. 3, under 9 January 1645: 'Mr. Jhone Alexander & Meriorie Jamesoun ane dochter named Isobell . . .'; the godfathers included James Tosche.

entourage.[67] Among these was his personal servant John Lambie, who later recorded in his accounts a payment 'for my Lords portrait drawen in Aberdeen'.[68] It is impossible even to speculate on how long the sitting lasted, but Montrose seems to have been in Aberdeen only three days. It was not until December that the portrait (one of the few to bear Jamesone's signature) was brought to Kinnaird Castle, where Montrose was now living with his wife Magdalen Carnegie, so the opportunity for working on it would have existed after the original sitting. As we assess the evidence now, Jamesone was at the height of his powers and the delicacy of his perception formed a memorable image of the quiet depths of the smiling boy, with no hint of potential disasters (Catalogue, 25; Plate 52).

Jamesone acquired rights in a fifth dwelling in May 1630, this time lying in the broad Castlegate, somewhere near the Earl Marischal's town house.[69] A more important event, however, must have been the birth of his son Paul in October of that year. The list of seven godfathers gives some indication of the circles Jamesone by now moved in. The principal godfather, whose name the child was given, was Paul Menzies of Kinmundy, Provost of the town and in the middle of an extended period of office lasting from 1623 to 1634. Another of the godfathers was Alexander Jaffray, one of the leading bailies of the town and a later Provost. The remainder consisted of David Wedderburn, former Rector of the Grammar School, Robert Petrie, one of the town's law agents who is later found playing some part in Jamesone's legal affairs, and three rather less elevated citizens, one of whom, Andrew Strachan, has sometimes been thought to be the Professor of Divinity at King's College.[70] This is certainly wrong, however, and the likelihood is that he should be equated with the 'Andrea Straquhon pictore in Aberdein' who witnessed an instrument of sasine in favour of Jamesone in 1633.[71] Patrick Jack was a 'litster', or dyer, and one of the more than respectable elder members of the kirk-session: his name (as is that of James Tosche) is prominent over the years at this time as a collector for the poor at the church door. Finally, Patrick Ferguson's presence at the baptism is indicative of the tightly knit character of Jamesone's family circle: he was the second husband of Jamesone's widowed sister-in-law, Agnes Drum Jamesone himself had been godfather to one of their children two years earlier.[72]

Jamesone and Isobel Tosche were dealt a particularly heavy blow in the midwinter of the following year. On 6 January 1631 'ane berne of George Jamesouns' was buried; exactly a fortnight later the following laconic entry was made in the Kirk & Bridge Works Accounts: 'ane vther berne of George Jamesouns burit'.[73] Thus in a handful of days they lost their sons William and Paul, the latter having

---

[67] See *Miscellany of the New Spalding Club*, vol. i, p. 153.        [68] Documents, 23.
[69] Documents, 24.        [70] See Bulloch, p. 60.        [71] Documents, 35.        [72] Documents, 78(1).
[73] Documents, 26 and 27.

lived scarcely ten weeks. Some time after, Jamesone made a contribution of £70 for the maintenance of a minister in the kirk of Futtie, the little fishing community lying near the mouth of the Dee;[74] he also appeared as godfather at two baptisms in the month after his personal tragedy.[75] The events may or may not be connected: certainly they characterize the continuity of life in the face of a bleak fate.

These happenings do not quite close this period in his life, for at some time in 1632 his brother William died. On 23 January 1633 Jamesone, as executor to the late William Jamesone, writer in Edinburgh, handed over to the Professor of Mathematics, on the instructions of the Town Council, a collection of mathematical instruments and books which William had left in legacy to the College.[76] It is not known when William took himself to Edinburgh, but he was apparently still in Aberdeen at the beginning of 1621 when he lent £14 to Alexander Garioch, a flesher.[77] He was a resident of Edinburgh sometime before the end of 1626 when, in a document concerning his rights to draw an annual rent of 300 merks from lands in Inveresk for a loan of 3,000 merks, he is described as 'servitor to Archbald Prymrois writter and clerk to his Majesties taxatiounes'.[78] By the time this money was repaid to him in mid-1631 he was no longer Primrose's servitor[79] and in a deed of July 1632 concerning lands in Kirkliston in which he had had financial interests he is recorded as deceased.[80] Between 1626 and 1628 he had been able to dispose in forms of investment sums amounting to 8,000 merks. Apparently unmarried, it is not unlikely that his modest wealth came to his brother George on his death.

## (iv) EDINBURGH AND ABERDEEN

After 1633 Jamesone seems to have moved in a rather wider orbit, or rather in two orbits, one now centred on Edinburgh and the older one which still revolved around Aberdeen. There is no question of the association with Aberdeen being broken and certainly the personal part of his life still found its focus there. In January 1633 his son George was baptized in the parish church and on this occasion the godfather whose name the child was given was George Keith, the second son of the Earl Marischal (as the entry carefully records), again indicative of the unusual social status attained by a mere painter. The son, however, in whom fresh hopes must have rested, survived for only two years.[81]

---

[74] Documents, 28.  [75] Documents, 78(10) and (11).  [76] Documents, 30.

[77] AR, Baillie Court Book (Council Register), vol. 49, p. 827.

[78] SRO, Particular Register of Sasines, Edinburgh, vol. 11, fo. 338: instrument dated 6 November 1626, registered 1 December 1626; see also vol. 12, fo. 41.

[79] Ibid., vol. 17, fo. 327v.

[80] Ibid., vol. 12, fo. 59v., vol. 14, fo. 29v., and vol. 19, fo. 205v.: on the date of last reference (registered 30 July 1632, dated ten days earlier) an annual rent of the property in question (Brokhous) is renounced by John Chisholm, the property having been wadset by him and 'be umquhill William Jamesone wreitter in Edinburgh Quha had richt fra me . . .'.

[81] Documents, 40.

66255

It seems likely that Jamesone was in Edinburgh some time before the visit of Charles I for his Scottish coronation, which took place on 18 June 1633. There is even some indication that Jamesone had started a form of painting business which supplied needs other than portraiture: this is suggested in the Dean of Guild Revenue Accounts concerning the redecoration of the 'kyngis loft' in the kirk of St. Giles, not by Jamesone himself but by 'his man'.[82] As this work was almost certainly done prior to June and before Jamesone was entered a burgess of Edinburgh on 28 August,[83] it may be that he was actually invited to Edinburgh by the Town Council to help them prepare for the coming public celebrations. This is suggested by a payment on 23 August of sixty dollars (about £168) 'for his extraordiner paynes taiken . . . in the Tounes affaires at his Maiesties entrie within this burgh'. Unfortunately, at no point in the Town Treasurer's Accounts are these 'paynes' specified; they must fall somewhere within the total expenses 'towardis his Majesties entrie and receptioun within this citie in erecting of padgines propyne banqueit and uther thingis than incident', which amounted to rather more than £41,000.[84]

That painted decoration played a part in these events is indicated by one particular entry in the Accounts, a payment to four men for erecting 'peices of paynterie about the counsall and banquet houssis', a task which occupied them for six days.[85] Although the Council were probably aware of Charles I's predilections for the visual arts there were many precedents. In 1561, on Queen Mary's entry into the town, she came through an archway 'coloured with fine colours', to be met by a child stepping from an opening quatrefoil cloud, who handed her the keys of the town.[86] When the young James VI made his first ceremonial entry into Edinburgh in 1579 'the fore-howsis of the streits be the whilks [he] passit, war all hung with magnifik tapestrie, with payntit historeis, and with the effegeis of noble men and wemen'. On this occasion the cloud was replaced by a globe. There was also some kind of erection at the Salt-Market Cross, 'quharupon was erectit the genealogie of the Kings of Scotland'.[87]

More than fifty years later, in the summer of 1633, the tradition was still alive, especially that part of it that concerned the veneration of the antiquity of the king-ship. The annalist Spalding's brief description of the painted street decorations calls to mind something similar to that which the King's father had seen in the previous century. William Drummond of Hawthornden, as part of his official duties, com-posed a speech of welcome which summarizes the allegorical flavour of these hap-

[82] Documents, 29.        [83] Documents, 33 and 34.        [84] Documents, 32.

[85] ER, Town Treasurer's Accounts 1623–1636, p. 960 (referring to year 1632–3): 'Item to Alex<sup>r</sup> Baxter and Thomas Younger with thair tua men 6 dayes for putting up the Kairtis and peices of paynterie about the counsall and banquet houssis to thame selfis ane merk ilk day and to ilk ane of thair servandis 12s. a day Inde xv lib. iiii s.'

[86] See *A Diurnal of Remarkable Occurents . . . within the Country of Scotland*, Bannatyne Club, 1833, pp. 67–8.

[87] Sir Patrick Walker (editor), *Documents Relative to the Reception at Edinburgh of the Kings and Queens of Scotland 1561–1590*, Edinburgh, 1822, pp. 30–1.

penings: 'This age seeth no prince greater, no man better. The verye thornes will by your presence haiv a birth of Roses. Evrye where Sir you are Welcome but most welcome heer to this old Toun, the seatt of your royall progenitours. . . .'[88] Yet, though Jamesone supplied a series of portraits of these royal progenitors, presumably to fix on the triumphal arch at the west end of the Tolbooth, he had probably himself moved far enough away from the decorative tradition to be able to echo Drummond's remark on his own share in the work: '. . . so I haiving addressed my self to write . . . for pageantes and such divises, beheld my selfe some thing disfigured'.[89]

Among those crowding into Edinburgh on this occasion were Paul Menzies the Provost of Aberdeen, who was knighted by the King, and Alexander Jaffray, the son of the bailie who had been godfather at the baptism of Jamesone's son Paul. Jaffray later wrote a diary-cum-autobiography and records in it that he returned to Aberdeen in July for the birth of his own first son, and that shortly after he 'went again to London, in company with Robert Skene, Andrew Birnie and George Jamieson'.[90] He had been to London a year before this with Skene and Birnie, whom he describes as merchants. Knowing that his father would be unlikely to send him to London in the company of anyone who was not entirely respectable, it seems likely that this Robert Skene is the same person as the church deacon who is described in the session records as both a glasswright and a painter. Jaffray goes on: 'I staid some time longer, and . . . on my return, went off the road, and visited the University of Cambridge by the way.' There is perhaps some slight indication here that the visit of the other three to London was a short one. This is further borne out by Jamesone's appearance as a godfather at a baptism in Aberdeen on 21 September, the child in question being a daughter of the same Robert Skene.[91] This visit must therefore have taken place between 28 August, when he was installed as a burgess of Edinburgh, and 21 September. No further details are known.

It has been stated, quite unwarrantably, that during the period of Charles I's visit to Edinburgh, Jamesone formed a friendship with Sir Colin Campbell of Glenorchy and that in the latter part of the year they visited Italy together, after passing through London.[92] During their preparations for the royal visit the Town Council of Edinburgh had written to Sir Colin requesting him to send them 'some Vennisone and Caperkealzies . . . quhen we ar better acquented with his Majesties dyett'; silver table-ware was also requested.[93] In these circumstances it would not be surprising if Sir Colin had visited Edinburgh. It would seem that he certainly intended to, for on 30 May his agent in Edinburgh, Archibald Campbell, wrote to him: 'I have spokin the Lord Cancellar and Hadintoun quho thinkis it most necessar if it be possible that yow cum heir to sie the king your master.'[94] However, the earldom which was

[88] National Library of Scotland, MS. 2061, fo. 162.   [89] Ibid., fo. 168.   [90] Documents, 37.
[91] Documents, 78(22).   [92] See Bulloch, pp. 76–80.   [93] SRO, GD 112/39/493.
[94] SRO, GD 112/40/Box 1, unsorted.

apparently expected did not materialize, and on 1 June Archibald Campbell wrote:
'. . . I culd wisch yow to remane at home quhill new advertisement.'[95] The remainder
of this voluminous correspondence from his agent, in which there are repeated refer-
ences to the frailty of Sir Colin's health, does not remark on the subject again, but
the indications are that he indeed stayed at home. This conclusion is given added
weight by a letter which Sir Colin wrote to the Privy Council on 9 January 1635,
referring to a charge to appear before them regarding disorders in his part of the
Highlands: 'May it please your lordis It is weill knawin That this Thrie yeir bygane
I have not bene able to travell ane myle from myne owin house for ane paine I have
in my leg quhilk makis me altogidder vnable to travell.'[96] If this is not conclusive
proof that he did not visit Edinburgh, it does make a Continental journey more than
unlikely. It has already been noted that Jamesone appeared at baptisms in September,
October, and November of 1633. This excludes the possibility of any such foreign
travel on his part in this particular year, and there is no evidence that he ever made
such a journey.

Jamesone was, however, patronized by Sir Colin to a quite considerable extent,
though the first evidence of this does not appear until 25 October 1634. In a letter
written by Archibald Campbell to Glenorchy which shows that the latter had serious
intentions of collecting works of art (and which, in the remark, 'The church men
reulis all for the present', summarizes the coming way of affairs in the State) we learn
that Jamesone had agreed to undertake the painting of unspecified pictures for Glen-
orchy.[97] Three days later Archibald Campbell wrote again, this time enclosing
Jamesone's note of his prices (twenty merks for the picture, thirty if framed); and
he asks Glenorchy to confirm his intentions at once 'For les he [Jamesone] sweiris to
me he can not teike'.[98] There is a strong suggestion here that Jamesone already had
more than enough work on hand. On 15 March 1635 Campbell writes to Glenorchy
about the imminent completion of a commission and, following on a request by
the painter, asks that three or four horses be sent to Edinburgh for carrying the pic-
tures north.[99] There is then no further mention of Jamesone (or any other painter) in
this fairly continuous correspondence until 24 June 1636, and then only the unreveal-
ing sentence: 'Pleis yow receave the painters answer.'[100] This almost certainly refers
to Jamesone and, if nothing else, indicates the continuation of the contact over almost
two years.

Two other sources throw some further light on this subject: the entries in the Black
Book of Taymouth, which is a mixture of genealogy, house-journal, and account-
book; and two letters written to Sir Colin by Jamesone himself, which, although
dated with the day and month, do not include the year.

[95] SRO, GD 112/40/Box 1, unsorted.      [96] SRO, GD 112/39/563.      [97] Documents, 38.
[98] Documents, 39.      [99] Documents, 41.      [100] Documents, 50.

As the Black Book of Taymouth shows, between 1632 and 1634 Campbell of Glenorchy spent about £3,500 on tapestries and furnishings for his houses of Balloch and Finlarg. In 1633 he employed 'ane Germane painter, quhom he entertanit in his house aucht moneth' to paint posthumous portraits of kings and queens, as well as Sir Colin's own portrait and those of his predecessors. It is not absolutely clear how many pictures were involved but it appears to have been forty-one. The total payment was £1,000, which would mean an individual price of over £24.[110]

Under the year 1635, Jamesone 'painter in Edinburgh' is paid a total of £440 for twenty-two pictures, which is an individual price of £20.[102] There is no obvious explanation for this apparent discrepancy in the rewards given to the two painters: their pictures were generally of the same size but some now lost may have differed, which would offer a partial answer. The conditions under which the German painter worked are not known but these may have necessitated a larger payment. What remains of his work are the eight 'fancy' portraits of Sir Colin's ancestors (not including his father Sir Duncan Campbell) and it is the companion female portraits pendant from seven of these which are the most interesting surviving manifestations of Jamesone's activities on this occasion.

It is into this series of records that Jamesone's two incompletely dated letters to Sir Colin Campbell must be fitted. They are also of course the only two documents which give any real degree of psychological information on Jamesone.[103] Both letters were written after some work had already been done. That dated 13 October acknowledges receipt of 100 merks for work completed and refers to pictures still to be carried out, clearly portraits of contemporaries, which cannot be started until January, 'except that I have the occasione to meit with the pairties in the North, quhair I mynd to stay for two moneths'.

The letter dated 23 June acknowledges receipt of an order for sixteen pictures. Jamesone then explains in some detail his price structure for waist-length portraits which might imply that he had not painted anything of this nature for Glenorchy before. But he does say that his price will be 'bot the ordinarie' and continues: 'Thus I deal with all alyk: bot I am moir bound to have ane gryte cair of your worships service, becaus of my gouid payment for my laist imployment.' Jamesone concludes by appearing to refer to portraits of contemporaries, and also seems to suggest that Glenorchy should write to them asking them to sit: some, however, he has painted already and

---

[101] *The Black Book of Taymouth*, p. 75: 'Anno Domini 1633   Item, the said Sir Coline bestowit and gave to ane Germane painter, quhom he entertanit in his house aucht moneth, and that for painting of threttie broads of the Kingis of Scotland, France and Ireland, and tua of thair Maiesteis Queins of gude memorie, and of the said Sir Coline his awin and his predecessors portraitis, quhilkis portraitis ar sett up in the hall and chalmer of daes of the house of Balloch, the soume of ane thousand pundis.' The Black Book of Taymouth, a volume of c. 7 × 5 in., is still in the possession of Armorer, Countess of Breadalbane.

[102] Documents, 47.     [103] Documents, 46 and 49.

he will duplicate these, giving him the first version. The sixteen pictures he undertakes to complete in the three months from July to September.

In the light of the other Glenorchy records and the pictures remaining from these years, it is suggested that the letter of 13 October should be dated 1635. The payment acknowledged must in fact be part payment for the mainly 'fancy' portraits which are recorded in the Black Book under 1635. Other than the portraits of Charles I and his Queen (and these were almost certainly also 'fancy' portraits) and Sir Colin Campbell's own portrait, there are no other references to portraits of living sitters in this part of the Black Book; but in an inventory of 1640 there is recorded a total of thirty-four pictures of lords and ladies of Glenorchy, 'and uther noblemen'.[104] This total cannot be explained by portraits of ancestors and must be made up by a series of portraits dated 1636 or 1637, originally at least eleven in number and clearly by Jamesone, which remained intact in this particular collection until the nineteenth century. When these eleven are added to the German painter's nine Campbell portraits and the nine which the Black Book appears to give to Jamesone, the total is only five short of that in the 1640 inventory. They include portraits of the Earl Marischal (Catalogue, 94; Plate 97), with whose family Jamesone has been seen to have had some intimacy, the Marchioness of Hamilton (Catalogue, 99), the Earl of Airth (Catalogue, 96; Plate 98), Lord Napier (Catalogue, 97; Plate 98), and the Earl of Loudon (Catalogue, 103). Some of these then would be among the portraits to be started in January —of 1636.

The complete dating of the letter of 23 June need be less tentative. It has already been noted that in a letter of 24 June 1636 Archibald Campbell had written to Glenorchy: 'Pleis yow receave the painters answer.' This obviously refers to an enclosure, and Jamesone's letter of 23 June, which has very much the character of an answer, has thus a very good claim to being that enclosure. The letter also has a theme in common with the previous letter—portraits of contemporaries—which makes it likely that the 'laist imployment' referred to is the group of portraits of contemporaries dated 1636; while the portraits of subjects in the country and those 'that are heir in town', as well as those 'quhois picturis I hawe allreadie', would be the pictures which

---

[104] SRO, GD 112/22/4, with drafts at GD 112/35/2 and GD 112/1/7/527. This inventory, dated 17 September 1640, was made up by Sir Colin's heirs, Sir Robert Campbell and his son John. It contains many items of jewellery—including 'Item ane stone of the quantitie of half a hens eg sett in silver . . . quhilk Sir Coline Campbell first Laird of Glenvrquhy wore quhen faught in Battell at the Rhodes agaynst the Turks he being ane of the knytis of the Rhodes'—as well as the following: 'Item of silk beddis ane conteining four Curtaines of rid Spanisch taffite fassit with rid and blew silk fasses. . . . Ane greine London cloath bed pasmentit with greine and orange silk laice. . . . Ane uther silk bed of changing taffite greine and yellow Off Arras work hanginges ii stand conteining xi peices and of comon hinginges iiii stand conteining xvi peices. . . . Mair of turkie work Cuschiounes—xii. . . . Item off pictures of the kings and Queenes of Scotland—xxiiii and of pictures of the Lairds and Ladies of Glenvrquhy and uther noblemen come of the house of Glenvrquhy—xxxiiii   Item ane great Lairge paintit genealogie broad of the Lairds of Glenvrquhy and these that ar come of the house of Glenvrquhy. . . .'

were to be dated 1637. This does not explain the total of sixteen proposed pictures, especially if portraits of contemporaries had already been supplied, though if they are added to the eighteen Campbell portraits mentioned above, the total in the 1640 inventory is reached. It is conceivable that the 'laist imployment' in fact refers to the large genealogical painting, the *Glenorchy Family Tree* (Catalogue, 130; Plate 101) which bears the date 1635 and for which there is no record of payment.

Sir Colin Campbell, after these extraordinary years of artistic patronage and family codification, died in 1640. On 29 August Archibald Campbell wrote to him: 'I receavit your letter frome this bearer bot finding it subscryvit be ane wther hand nor your awine god knowes it was no small greiff to me.'[105] He died eight days later.

Latterly he seems to have been unwillingly involved in the growing religious strife of the time, mainly through the intermediary of his brother, Robert Campbell of Glenfalloch. On 10 June 1639 the Earl of Argyll had written to Glenfalloch requesting men, boats, and weapons 'for defenc of ther religiones lyves', his reasoning being 'Because it is the best way for peace to be readie for Wars'.[106] He demanded that all of Glenorchy's men should be informed of the situation. And on 22 June Archibald Campbell had written to Glenorchy saying he had been forced to send a certain young man to him so that he could be conducted to Argyll. It typifies, in a small way, both the times and Glenorchy's standing as a patron of the arts of civilization that Archibald Campbell remarks that he has ordered the boy to pretend 'That he goes to yow for ane painter and let him be thought so whill he is with yow the trueth is that he is sent to the Earle for ane expert gunner.'[107]

The general impression of Jamesone's movements in these years is that he spent a good deal of time in Edinburgh or in the south of the country, especially the summer months. He did not own property in Edinburgh but was, by May 1635, tenant of what is described as 'the second hous within the former [east] turnpike' in a fore-tenement which lay on the north side of the High Street near the Netherbow Gate.[108] One of Jamesone's co-tenants in the building was 'Clemens Touris glasenricht'—a trade which had tenuous connections with that of painting. Jamesone was still a tenant in June 1642 when the property was disposed of by a Robert Mason who was a carver (also a trade with painterly connotations) and son of Jamesone's original landlord.[109] The list of tenants in these years was completed by an armourer, Thomas White. Jamesone's actual landlord was, and continued to be, Mason's mother who had a liferent of the 'lodgeing' which he occupied. When the property was disposed of again in 1650, this lodging was still described as pertaining to Mason's mother and, 'sumtyme possest be umquhill George Jamesone painter'.[110]

[105] SRO, GD 112/40/Box 2, bundle 1640–9. His testament, dated 4 May 1638, is at GD 112/3/Box 1.
[106] SRO, GD 112/40/Box 2, bundle 1630–40.
[107] Ibid., bundle 1640–9.  [108] Documents, 42.  [109] Documents, 65.
[110] Documents, 74.

In the trades of the tenants sharing the house with Jamesone there is perhaps some indication of a reason, other than pure chance, why he should be living in this particular place. It is also interesting to note that one of the earlier owners of the property had been Archibald Primrose, the writer by whom Jamesone's brother William had once been employed. It is therefore just feasible that his tenancy of the house dated back to the period of this association.

It was also presumably in this lodging that Jamesone took as apprentice in April 1636 Michael Wright, son of James Wright tailor and citizen of London, the indenture being made out for five years.[111] Although it is hardly possible to argue that Wright must have come north to learn painting because of Jamesone's reputation, the possibility should not be entirely ruled out. Some contact could have been made on Jamesone's brief visit to London, or Wright may have had Scottish connections. Whatever reasons brought him to Scotland from London, it was not (as it still is not) the usual direction to travel. Wright may have been born in 1617, which would have made him eighteen or nineteen years of age when his apprenticeship began.[112] There are no further records of him in Scotland; indeed he is not recorded again until he reached Rome in 1648.[113]

The year immediately after the advent of Michael Wright was probably the high-water mark of Jamesone's achievement. In 1637 he painted three of the Carnegie brothers, David, 1st Earl of Southesk (Catalogue, 116; Plate 117), John, 1st Earl of Northesk (Catalogue, 117; Plate 118), and Sir Alexander Carnegie of Balnamoon (Catalogue, 118; Plate 119). Southesk had been knighted in 1603 for accompanying James VI and I's Queen, Anne of Denmark, and her children to London on the removal of the Court; and he had been raised to the earldom by Charles I in Edinburgh in 1633. Jamesone, as has already been noticed, had established connections with this family in 1629 by painting Montrose just prior to his marriage to Magdalen Carnegie, daughter of Southesk (then Lord Kinnaird), as well as the youngest of the four brothers, Sir Robert Carnegie of Dunnichen.

A more tenuous connection with this family may have played some part in the painting of two other signed portraits in this year, those of Sir George Stirling of Keir (Catalogue, 119; Plate 112) and his second wife Margaret Napier (Catalogue, 120; Plate 113), whom he married in 1637. Lady Stirling's mother, who had married the 1st Lord Napier, was Margaret Graham, sister of the future Marquess of Montrose. It might therefore be surmised that Stirling of Keir and his new wife had their portraits painted by Jamesone on the occasion of their marriage at the suggestion of Margaret's uncle who had had his painted on a similar occasion. These portraits were

[111] Documents, 48.

[112] See Ellis Waterhouse, *Painting in Britain 1530–1790*, Harmondsworth, 1962, p. 66. For the rather dubious facts of Wright's early life see Philip Bliss (editor), *Reliquiae Hearnianae: the Remains of Thomas Hearne*, London, 1857, vol. i, pp. 343–4.

[113] Ellis Waterhouse, op. cit., p. 66.

probably done in the south of the country, in the same year as that of Sir William Nisbet of Dean (Catalogue, 122; Plate 121), who had earlier been Lord Provost of Edinburgh. This to some extent illustrates a different social level of patronage, as indeed does the recorded portrait of Sir Thomas Hope of 1638. The sittings for the latter portrait, which cannot certainly be equated with any existing portrait, were on two occasions, 20 and 27 July 1638, as Hope records in his diary. Strangely, the artist is called 'William' Jamesone, but this must be an absent-minded confusion on Hope's part with Jamesone's brother William, of whom Hope as Lord Advocate must have known something in the narrow legal circles of Edinburgh.[114]

In these years as his activities increased, Jamesone's status as a man of substance also grew. His acquisition of property, or rather his investment in property, now extended outside Aberdeen itself. The farmlands and buildings of Fechil, in which he acquired the wadset rights on 22 October 1633, was the first of two such properties.[115] Fechil lies some eleven miles north of Aberdeen in the south-east corner of the parish of Ellon, near the banks of the River Ythan. Jamesone acquired the estate, which was farmed by three tenants (along with the 'priwiledge of ferieing wpoun the watter of Ythane'), from a John Gordon of Buckie for 14,000 merks: it was, however, to become redeemable after three years. This John Gordon was not, however, the proprietor of the lands, for he had himself only held them as a security; the transfer took place 'cum consensu Robert Gordoune de Straloche' (the geographer and cartographer), who was the actual owner. Part of the estate (presumably about a quarter) which was called Craighall, Jamesone granted to his wife in liferent.[116] He appeared personally, and among the witnesses of the actual conveyance were Robert Petrie, Aberdeen's agent in Edinburgh, and Andrew Strachan, painter in Aberdeen. These two in a sense typify both Jamesone's widened horizons and his continuing attachment to the circle of decorative painters of his native town.

This estate still pertained to Jamesone in 1638, when Robert Gordon 'for fatherlie love and kyndnes' assigned his rights to his second son, John Gordon: and indeed Jamesone went on drawing income from it until its eventual redemption by Gordon in 1640.[117]

Two small facts which are recorded at this time, again concerning property, might be indicative of a curious mental tidiness on Jamesone's part: they are certainly strong evidence that in these years he and his family used as their own dwelling-house the foreland on the north side of the Schoolhill which he had inherited from his father in 1607. These facts are, firstly, his acquisition on 29 May 1635, of the feu-duty which burdened the property, and secondly, his acquisition of the close that ran between his house and the inland behind.[118]

Of much greater and more picturesque interest is the so-called 'Playfield', for

---

[114] Documents, 53.     [115] Documents, 35.     [116] Documents, 36.
[117] Documents, 52, 56, and 57.     [118] Documents, 44.

possession of which Jamesone successfully petitioned the Town Council on 13 May 1635.[119] This lay beyond the western edge of the town, beside the Denn Burn. Gordon of Rothiemay's translator describes it thus: 'Next to the well of Spaa, hard by it, ther is a four squair feild, which of old served for a theater, since made a gardyne for pleasur by the industrie and expense of George Jameson, ane ingenious paynter quho did sett up therin ane timber hous paynted all over with his owne hand.'[120] For a nominal sum Jamesone was granted 'tolerance to mak sic building, policie, and planting within and about the said plott of ground . . . to the effect the same may redound to the publict wse and benefitt of the toune'. It is this garden which is among those notable features of Aberdeen singled out by Arthur Johnston in his poem in his series of 'Encomia Urbium' of 1642. Jamesone agreed that the garden should revert to the town's use on his death but in fact, at the beginning of 1645 his son-in-law John Alexander, advocate in Edinburgh (and husband of Marjory), claimed that the ground 'buildit . . . in a garden, is now vnprofitable' and was granted the land in feu.[121] It is difficult here to suppress a sense of one generation supplanting another by turning its back on the earlier's achievements. Whatever the subsequent fate of the place, in which, the evidence suggests, Jamesone may even have done some decorative painting himself, it is still clearly depicted in Gordon's map, its reputation perhaps outliving its real existence.

## (v) FINAL YEARS

As will be seen, during the last five years of Jamesone's life there was a diminution in the quality and probably in the quantity of his work, but not in his material wealth. These, however, were years in which the very act of living became a hazard and particularly for a citizen of Aberdeen. So far as the facts of this period in his life are known, it can be lightly traced in political, material, and personal terms.

When Charles I was crowned King of Scots in Edinburgh on 18 June 1633 there was some uneasiness among onlookers at the splendour of the event and at the bowing of certain bishops before a crucifix. While he listened to the sermon given by the Bishop of Brechin, the King sat on a 'chair of crimson velvet embroidered with gold . . . sett betwixt the stage and communion table with footstool and cusheons conforme befor which was a little table covered with crimson velvet fringed and laced with gold on which was laid a rich covered Bible'.[122] The King's love of splendour, for both Crown and Church, allied to his constitutional innovations in the

---

[119] Documents, 43.

[120] Cosmo Innes (editor), *A Description of Both Touns of Aberdeen by James Gordon Parson of Rothemay*, Spalding Club, 1842, p. 10.

[121] Documents, 72.

[122] SRO, 'A Short accompt of the manner of the solemn Coronation of King Charles the 1st att Holyroodhouse 18th June 1633', GD 54/1/489.

coming years, provoked an intense hostility from the nobility and the ministers which was to lead, in the long term, to the destruction of the monarchy.

The disaffection of the nobles had many other causes: firstly, perhaps, a sense of frustration and impotence at what seemed a growing distance from the Court and their lack of understanding with the King; secondly, a fear for the stability of their material wealth, stemming from the King's revocation of all Crown properties and his indrawing of all temporal lordships erected on former ecclesiastical properties; and thirdly, they saw their positions being usurped by prelates. Edinburgh became a bishopric in 1633, the see for a time being filled by William Forbes of Aberdeen, one of the most ecclesiastically reactionary of the clergy. In 1635 John Spottiswoode, Archbishop of St. Andrews, was made Chancellor—'This wes thocht strange, and markit be many to sie ane bischop maid chancelair and his sone president [of the College of Justice] both at ane tyme, quhilk bred gryt truble. . . .'[123] Bishops also began to play a far more obvious role in the proceedings of the Council.

Resentment was caused at another level by the King's interference in the election of the provost of Aberdeen in the years 1634 to 1636. In the latter part of 1634 Patrick Leslie had broken the traditional hold of the Menzies family on this office. However, Leslie's dealings at the previous Parliament were considered seditious, and the King wrote bluntly to this effect: '. . . we wish yow to mak choice of Sir Paull Mengzes, who wes formerlie in that chairge'.[124] Under threat of losing privileges the Town Council quickly reversed their decision and conformed to the King's wishes. There was, however, a danger the following year that Leslie would be re-elected and the Bishop of Aberdeen intervened as a member of the Privy Council, and against a majority of the Town Council forced a temporary postponement of Aberdeen's elections. When the elections did take place a fortnight later there were grotesque scenes in the Town House as the Menzies faction tried physically to prevent Leslie from voting. Ten of the retiring Council eventually withdrew in protest, while the remaining nine proceeded to elect a new Council with Robert Johnston as Provost. This Council was in turn overthrown in January 1636 by a decree of the Privy Council and Alexander Jaffray was forced on the town as Provost, while the previous Council was reimposed, but without Patrick Leslie.[125] In this way the forces of conservatism were bolstered in the north, and Aberdeen, to its cost, was to remain staunchly royalist.

At an ecclesiastical level the King's innovations focused on the new Prayer Book which was introduced on 23 July 1637, and this in turn became a focus for the country's discontents. The nobility, led by the Earl of Rothes, to serve their own ends,

---

[123] John Spalding, *Memorialls of the Trubles in Scotland and England 1624–1645*, Spalding Club, 1850, vol. i, p. 57.

[124] *Extracts from the Council Register of the Burgh of Aberdeen 1625–1642*, Scottish Burgh Records Society, 1871, p. 71.

[125] Ibid., pp. 80–95.

seem deliberately to have confused the move to greater ceremonial and more elabor-
ate dress with the deep-rooted fear of a resurgence of Catholicism.[126] Violence was
fostered, and not only at the centre: in November in Brechin, the Bishop, who had
previously used the English service without opposition, was forced to flee. The
contemporary annalist Spalding adds ominously: 'So sone spred the distructioun of thir
bookis and bischopis also, as ye may reid. . . .'[127] The King's arbitrary refusal to with-
draw the Prayer Book led directly to the formulation of the National Covenant,
which was first subscribed in Greyfriars' Church in Edinburgh on 28 February 1638.
From the beginning subscription of the Covenant had an element of compulsion
about it which contrasted with its opposition to the royal prerogative and its belief
in the rule of Parliament.

The Covenant was presented to Aberdeen for signing on 16 March 1638, but this
was refused.[128] The town refused again as a body on 20 July when Montrose and three
ministers put in an appearance; though on this occasion some did sign, including
Patrick Leslie the deposed Provost.[129] On 15 August the Council received letters of
thanks from the King and the Marquess of Hamilton, the latter asking them 'to
hinder the subscriptioune thairof by anie within your toune'.[130] In September, how-
ever, the King did revoke the Prayer Book and permitted a General Assembly to be
called. But the movement seemed to have gathered a spontaneous momentum and
the Assembly which met in Glasgow (and which the nobility had carefully packed),
inspired by the fanatical Johnston of Wariston, ended by abolishing episcopacy,
something far beyond the original aims of the movement.

Armed conflict thus grew more likely and Aberdeen as traditional supporters of
episcopacy took precautions. Captains were chosen for each quarter of the town;
ditches were ordered to be dug 'in consideration of the intelligence gewin to the towne
that thair is ane great armie coming hither from the south for persute and inva-
sion . . .';[131] arms were bought from the Marquess of Huntly for over £3,000, and
arrangements were made to hide the town records. Meanwhile, the acts of the
Assembly were being published throughout the parish churches of Scotland 'except
brave Abirdein wold onnawayes heir nor suffer the saidis actis to be publishit within
thair kirkis whill thay war compellit . . .'.[132]

The forces of the Covenant gathered in Montrose in early March with the express
purpose of moving on Aberdeen to enforce acceptance of the Covenant, and to pro-
claim the acts of the Glasgow Assembly. At this point the Marquess of Huntly (whose
authority in the north now went unheeded) and the Council of Aberdeen decided

---

[126] See Gordon Donaldson, *James V to James VII*, Edinburgh, 1965, p. 306.
[127] Spalding, op. cit., vol. i, p. 82.
[128] See Louise B. Taylor (editor), *Aberdeen Council Letters*, vol. ii, London, 1950, pp. 88–9.
[129] See Spalding, op. cit., vol. i, p. 92.
[130] *Extracts from the Council Register of the Burgh of Aberdeen 1625–1642* (as cited), pp. 133, 134.
[131] Ibid., p. 149.       [132] Spalding, op. cit., vol. i, p. 125.

to send two commissioners each to discover the aims of this force. One of Huntly's commissioners was Robert Gordon of Straloch. Aberdeen sent William Johnstone, Professor of Mathematics in the College, and George Morison, bailie and one of the town's Captains. They also sent George Jamesone to 'assist thame in the said commissioun'.[133] Besides making an offer of the Cathedral in Old Aberdeen, or the parish church, for proclamation of the acts, on the condition that the Covenanters' forces remained as far from the town as Huntly's, the commissioners were also to seek help from the Earl Marischal, who had arrived at Dunottar in February. It would seem more than likely that Jamesone was given this task because of his degree of familiarity with Marischal's family. Nothing is recorded of the outcome of this part of the embassy, but in fact Marischal had declared himself a Covenanter in the middle of February. The outcome of the first part of the mission was also negative. Huntly disbanded his forces and in despair the citizens undid their precautions, declaring the town to be undefendable. On 30 March, Montrose, the Earl Marischal, Kinghorne, General Leslie, and others, with an army of 6,000 men, entered the town; Kinghorne and 1,800 men were left in occupation while the main body of the army passed south to Inverurie. The town was then disarmed and their precious twelve cannons ordered to be delivered to the Earl Marischal's house in the Castlegate. On 9 April the Provost, Alexander Jaffray, told the townspeople that a tax of 100,000 merks (£66,000) was to be imposed; this was so far beyond their means that in desperation they asked for a month in which to entirely abandon the town. On the following day came the final humiliation, recorded laconically in the Council Register: 'The quhilk day, eftir sermone . . . the toune for the most pairt subscryvit the nobilities covenant.'[134]

During the remainder of the year Aberdeen was caught in the cross-fire of the opposing factions and suffered real privation. The town now became a target for the northern 'anti-Covenanting' lairds. By June five armies consisting together of about 13,000 men had spent a total of some thirty days in the town. As a consequence a large number of citizens had fled, which only served to increase the burden of the exactions which had to be paid by those who remained, in order to avoid plunder. By June, however, Aberdeen was actively supporting the King again, under the leadership of Huntly's son Viscount Aboyne, but on 19 June Montrose met Aboyne at Brig of Dee and the latter's army 'both horse and futt, left the feildis and fled'.[135] Thereafter the town paid another 7,000 merks to escape pillage, though by this time a partial peace had been concluded in the south. When in August the town fruitlessly petitioned the King on the subject of the losses they had sustained in this first phase of the troubles, they put the figure at some £12,000 sterling.[136]

---

[133] Documents, 55.
[134] *Extracts from the Council Register of the Burgh of Aberdeen 1625–1642* (as cited), p. 157.
[135] Ibid., pp. 172–5.
[136] Ibid., pp. 184–6.

Despite the pacification, humiliations and exactions were still to be endured in 1640—this notwithstanding that Patrick Leslie was now Provost and a Covenanting faction in office.[137] A general subsidy was imposed on the entire country to pay the cost of the troubles but the contributions already made by Aberdeen were not taken into account. Leslie gave up to Marischal a bond of allegiance to the King which the citizens had signed, and Marischal destroyed it. A company of soldiers, in the event raised with difficulty, was demanded by Marischal and his new confederate, General Major Robert Monro, who arrived at Dunottar with an army in May. Slowly throughout the year the citizens signed the Covenant and general bond. At the end of May Monro and Marischal presented the so-called 'Articles of Bonaccord' which, among other things, demanded the names of those who had still not signed the Covenant;[138] at the same time Monro's soldiers harried the lairds in the vicinity.

Individual acts of violence increased. On 10 June Marischal and Monro gathered together in the Tolbooth a group of five lairds and nine burgesses and accused them of 'being contrarie myndit to the good causs'.[139] Among the burgesses were George Jamesone and George Morison who, whatever their personal positions, through their mission of 1639 were identified with the anti-Covenanters. Their explanations were not accepted and the following day they were sent in custody to Edinburgh where they were imprisoned in the Tolbooth, prior to being brought before the Tables. It is to the credit of Provost Leslie that intervention on their behalf was made with the Town Council of Edinburgh, but with no effect. A council letter to the Aberdeen Commissioner at Parliament, the late Provost Alexander Jaffray, states that they had all in fact signed the Covenant in April 1639 which, if true, makes their treatment even more arbitrary. No immediate decision was reached as to their fate. In August, Jaffray, who was this time in Edinburgh as the burgh's Commissioner to the Committee of Estates, was instructed to 'deall with the committee of estait as effectualie as possiblie ye can in favor of our nightbors that ar lying in ward within the tolbuith of Edinburgh'. It is unlikely that the imprisonment was particularly rigorous for on more than one occasion remonstrances were sent to commissioners or to meetings of the Estates which do not refer to the prisoners—the town was still more concerned with the continued presence of troops, now considered to be unnecessary. This is borne out by a remark of Leslie's on 22 November in a letter to Aberdeen: 'Al our nightbors in ward ar weill and thay stay in on serimonies.' On the other hand, in the last council letter in which the affair is mentioned, written on 1 December, Leslie does seem to suggest that they were in real danger, for he reports: '. . . god be thanked we ended fair without blood.' In the event, fines of £1,000 were imposed on some; George Morison was conditionally released and Jamesone was released 'til a new sitation on

---

[137] See Spalding, op. cit., vol. i, pp. 230–1.
[138] *Extracts from the Council Register of the Burgh of Aberdeen 1625–1642* (as cited), pp. 222–5.
[139] Documents, 58.

aught dayes'. Leslie regretted that he had been unable to do more but promised the same day 'to mak a new onset for them'.[140] He wrote again before the end of December but does not refer to the matter,[141] and there it seems to have ended.

Jamesone, however, appears once more in this context. A Privy Council paper of 1641 includes his name in a roll of 'delinquents' which comprises 222 names, a list which shows the extraordinary scope of the revolution.[142] Besides national figures like Traquair, Airth, and Huntly, and the names of seven 'pretended' bishops, the roll includes eighteen individuals described as burgesses of Aberdeen, the only major burgh mentioned. It is also interesting to note that Jamesone's designation by trade, 'paynter', is the only such detail in the entire document—surely some indication of his contemporary fame.

Whatever terrors these events held, and worse was to come, Jamesone was certainly back in Aberdeen by 13 March 1641.[143] In September and October he and his wife suffered an almost identical tragedy to that undergone ten years before: the death, this time within three weeks of each other, of his last two sons, Alexander and Andrew, aged five and six.[144] This was offset in a small way by the birth of a daughter, Isobel, three days later. She joined another baby sister, Elizabeth, born at the beginning of 1639, to whom George Morison, Jamesone's comrade in the troubles, had been a godfather. Very close to his own death in 1644, another daughter, Mary, was born:[145] all three, as well as the already married Marjory, survived Jamesone.

Besides a failing in his own vigour in these final years, the conflicts and disturbances must have militated against a large output of paintings. The pattern of frequent visits to Edinburgh, especially in the summer, probably continued—certainly he still possessed the room in the tenement near the Netherbow Gate in the middle of 1642. In 1641 he had painted the new Glenorchy laird, Sir Robert Campbell (Catalogue, 140; Plate 123), and the following year his son, Sir John (Catalogue, 141; Plate 124). Few other paintings can be ascribed with certainty to these last years but in 1644 he certainly painted Anne, wife of the 3rd Earl of Lothian (Catalogue, 143; Plate 125), a family firmly on the side of the Covenant. A portrait at Yester, which is probably the companion to this (Catalogue, 144; Plate 126), also painted in Jamesone's final year, shows even more strikingly the complete falling away of his powers.

Money, however, still remained to be invested and there are no records of Jamesone divesting himself of his properties in these years. In the autumn of 1641 he had acquired a foreland in the Guestrow of Aberdeen from James Tosche, his wife's uncle, who remained as a tenant, presumably a simple device to relieve Tosche of

---

[140] Documents, 59(i–vii).

[141] For this undated letter see Louise B. Taylor (editor), *Aberdeen Council Letters*, vol. ii, London, 1950, pp. 227–8, where it appears to be wrongly placed: on internal evidence it must be dated between 1 and 22 December 1640.

[142] Documents, 60. This paper, though dated 1641, must refer to the events of the latter half of 1640.

[143] Documents, 78(55).        [144] Documents, 61 and 62.        [145] Documents, 54, 63, and 68.

financial distress.[146] And two years later came perhaps the largest of all such investments, his acquisition under reversion of the estate of Mains of Esslemont and Bourhills which, like Fechil, lay near the River Ythan in the parish of Ellon.[147] The sum of money involved was considerable, 16,000 merks, and the contract was to last for five years. The other party to the contract was Gilbert, the twelve-year-old Earl of Erroll and Lord High Constable of Scotland, whose family fortunes were under great pressure at this time. Jamesone himself was present to take sasine of the 'manor-place, fortalice, gardens and orchards', as well as the half-lands of Bourhills.

In the years 1641 to 1644 Aberdeen was able to return to a more settled conduct of its everyday affairs: the shelters built by Monro for his soldiers in the market place were taken down, the town's College repaired. The conflict, however, was in fact moving on to a new phase of civil war as a split gradually showed itself among the Covenanters. A desire to presbyterianize England also began to stir, culminating in the Solemn League and Covenant of September 1643, which was followed by a military agreement to provide Scottish forces to aid the English Parliament in its struggle with the King.[148] These moves were again so far beyond the original aims of the Covenant that by the beginning of 1644 a civil war had virtually begun. Montrose, now many years away in experience from the smiling boy of Jamesone's portrait of 1629, found it impossible to reconcile these new aims with the original meaning of the Covenant he had supported and switched allegiance to the other side; on 1 February 1644 the King appointed him Lieutenant-General of Scotland.

Aberdeen was by now collectively on the Covenanting side and as a result was to suffer once again for its stance. On the early morning of 19 March, Gordon of Haddo, Irving of Drum, and his brother Robert, three of the northern lairds who had been enrolled as delinquents along with Jamesone, carried out a surprise raid on the town. The houses of Leslie, who was again Provost, and Alexander Jaffray were wrecked and they were taken off as prisoners.[149] On 25 March, George Morison, again in his role as the town's envoy, went south to Inverurie with two other commissioners in order to find out the intentions of Huntly—the latter, however, entered the town on the same day with 6,000 men.[150] The worst trouble came in September. Although royalist strategy was collapsing, Montrose temporarily reversed this position. After a victory at Tippermuir, he headed north with a mainly Irish force, and on 13 September appeared before Aberdeen.

Montrose, after sending an unheeded warning to the citizens, faced the garrison of

[146] Documents, 64.
[147] Documents, 66 and 67.
[148] See Gordon Donaldson, *James V to James VII*, Edinburgh, 1965, pp. 329–31.
[149] See *Extracts from the Council Register of the Burgh of Aberdeen 1643–1747*, Scottish Burgh Records Society, 1872, pp. 17–18. See also: John Barclay (editor), *Diary of Alexander Jaffray*, Aberdeen, 1856, pp. 47–8, and John Spalding, *Memorialls of the Trubles in Scotland and England 1624–1645*, Spalding Club, 1850, vol. ii, pp. 324–5, 333.
[150] See *Extracts from the Council Register of the Burgh of Aberdeen 1643–1747* (as cited), pp. 19–20.

3,000 just outside the town to the south-east, at the Justice Mills.[151] 'It is to be remembrit, but nevir without regrait, the great and heavie prejudice and lose quhilk this burghe did sustaine by the cruell and bloodie feicht . . .'—so the writer of the Council Register describes the outcome.[152] The opposing forces fell fighting within the town itself, and in victory Montrose's troops sacked the city—'the enemie entring the toune immediatlie, did kill all, old and young, whome they fand on streittes . . . enterit in verie many houssis and plunderit thame, killing sic men as they fand within'.[153]

Whether Jamesone was in the town when these events took place is not known. It is likely that he was in Aberdeen in the middle of July when his last child was born, less than two months before the violence. His death must certainly have been very close to these tragic events (if not occasioned by them), and prior to 11 December 1644, on which date three of his four daughters, Marjory and the two youngest, were served heirs to the *late* George Jamesone in the lands of Esslemont and Bourhills.[154]

Jamesone's death did not go unnoticed. Clearly a unique citizen, even a rather surprising countryman, had died. David Wedderburn, the aged retired Rector of the Grammar School, published a broadsheet poem on his death, printed before the end of the year by Aberdeen's sole printer, Edward Raban.[155] No matter how inflated these stylized verses are, something had been felt to be far enough from the ordinary to merit the poet's highest degree of comparison, both in terms of myth and Scottish cultural history:

> Gentis Apollo suae fuit ut Buchananus, Apelles
> Solus eras Patriae sic, Jamesone, tuae.
> Rara avis in nostris oris: . . .

In the words spoken at the grave there is nothing to suggest that Jamesone had died anywhere other than in his native town:

> Conditur hic tumulo Jamesonus Pictor, & una
> Cum Domino jacet hic Ars quoque tecta suo.
> Hujus ni renovent cineres Phoenicis Apellem;
> Inque urna hac coeant Ortus & Interitus.

## (vi) POSTSCRIPT

For some reason Jamesone's daughter Elizabeth was not served as an heir to his estate

---

[151] For Montrose's letter to the town and the town's reply see Louise B. Taylor (editor), *Aberdeen Council Letters*, vol. ii, London, 1950, p. 380.

[152] *Extracts from the Council Register of the Burgh of Aberdeen 1643–1747* (as cited), p. 28.

[153] Ibid., p. 29. See also Splading, op. cit., vol. ii, pp. 406–7: 'Thair wes littill slauchter in the fight, bot horribill wes the slauchter in the flight . . . his [Montrose's] men hewing and cutting down all maner of men thay could overtak within the toune, vpone the streites, or in thair houssis. . . . And nothing hard bot pitifull hovlling, crying, weiping, mvrning, throw all the streittis. Thus, thir Irishis contynewit Frydday, Setterday, Sonday, Mononday.'

[154] Documents, 69.     [155] Documents, 79(c), with translation.

outside Aberdeen: this went to her three sisters. On 6 January 1645, however, she replaced her adult sister Marjory as heir with Isobel and Mary to three houses in the burgh: that in the Guestrow, that on the south side of the Schoolhill which, it has been suggested, Jamesone may have acquired as a workplace in 1627, and the house on the north side of the Schoolhill, which was probably the family house.[156] The latter had been held jointly by George Jamesone and his wife, yet on this occasion there is no mention of her rights in the property. This does not, however, indicate that she was dead, and indeed she probably continued to live in this house with her three young daughters. Isobel Tosche married again, on 12 June 1649, her second husband being Robert Cruikshank, a merchant and one of the town's bailies.[157] She became a widow for a second time prior to 16 April 1667 when she entered a financial contract with a George Cruikshank, probably a relative of her late husband.[158] Her cautioner in this contract was her daughter Marjory, now John Alexander's widow. At what must have been a considerable age she was buried in Aberdeen on 12 October 1680,[159] having outlived Jamesone by some thirty-six years.

In September 1653 Marjory and Mary were confirmed in their possession of the tenement in the Guestrow, but only in order to sell it.[160] This was one of the houses in which Elizabeth had had a share: she, however, had died a good deal before this, at some time prior to 12 September 1645 when a payment of £3 was made for the burial of 'ane chyld of Geo. Jamesons' in St. Nicholas kirk.[161]

On 17 July 1655 Mary and Marjory, and John Alexander the latter's husband, disposed of the house on the south side of the Schoolhill in which Jamesone had probably been born.[162] On 16 February of the following year these two sisters were secured in their rights in Esslemont. In the meantime the Earl of Erroll must have redeemed part of the estate (wadset in 1643), for it is now only a third part which is involved. Isobel, the other remaining sister, had probably died not very long before this date, since Marjory and Mary are described in the instrument as 'tua douchters aires portioners of the deceist George Jamesone painter burges of Edinburgh, and are the onlie tuo lawfull sisters and airs portioners of the deceist Issobel Jamesone thair third sister'.[163]

Mary Jamesone was married at least twice, to John Burnet of Elrick, a bailie of Aberdeen, on 12 April 1664, and to George Aedie on 28 October 1677;[164] she had children by both marriages. Her name has been traditionally associated with the production of four large embroideries which now hang in the west vestibule of St.

[156] Documents, 71.
[157] GRO(S), Parochial Registers, Aberdeen, 168A, vol. 12: 'Robert Crukschank balzie and Issobell Toche mariet the 12 day of Junij [1649].'
[158] SRO, Register of Deeds, Dalhousie Office, vol. 21, p. 301 (Warrant 1403).
[159] GRO(S), Parochial Registers, Aberdeen, 168A, vol. 18: 'Issobel Toish Relick of the decessit Robert Cruikshank lait baillie of Aberdein was Intered the 12 day of October 1680.'
[160] Documents, 75.     [161] Documents, 73.     [162] Documents, 76.     [163] Documents, 77.
[164] GRO(S), Parochial Registers, Aberdeen, 168A, vol. 12, under respective dates.

Nicholas, but there is only a mere hint of evidence to substantiate this.[165] Mary was buried on 7 July 1684.[166]

Marjory, if born about 1627–8, is hardly likely to have been married to John Alexander by 8 October 1641 when he was a godfather at the baptism of her sister Isobel, but they had a daughter, significantly also called Isobel, who was baptized on 9 January 1645.[167] Alexander was the son of Robert Alexander, a merchant burgess of Edinburgh, and was admitted to the Faculty of Advocates on 22 December 1642.[168] Thereafter he acted as one of the Aberdeen Town Council's agents in Edinburgh, and latterly (in 1660) was, for a short space of time, town-clerk of Aberdeen.

Alexander, however, appears to have died early in 1661,[169] and certainly before 24 June of that year when Marjory, 'relict of the deceist Mr. Johne Alexander advocate', borrowed £334 from a painter, Robert Porteus the Snowdon Herald.[170] She received some support in her later years from her brother-in-law Andrew and her two sons by Alexander, John and George. She appears as a party to many deeds, with an almost yearly frequency down to 1678, including one signed at London;[171] and finally twice in June 1683, when she borrowed sums of 500 and 100 merks from the clerk to the session in Aberdeen.[172] These two deeds, however, were not registered until October 1689, which suggests that she had recently died and that an effort was then contemplated to get repayment from her heirs. Thus the first-born of George Jamesone's children had outlived the entire family.

[165] See William Kelly, 'Four Needlework Panels attributed to Mary Jamesone in the West Church of St. Nicholas, Aberdeen', *Miscellany of the Third Spalding Club*, vol. ii, Third Spalding Club, 1940, pp. 161–82; he also gives details of Mary's children.

[166] GRO(S), Parochial Registers, Aberdeen, 168A, vol. 18: 'Mairie Jameson spows to George Aedie Laitt decon of gild was Intered the sewent day of Julii 1684.'

[167] Documents, 63, and p. 23, note 66.

[168] See Sir Francis J. Grant (editor), *The Faculty of Advocates in Scotland 1532–1943*, Scottish Record Society, 1944, p. 4; see also *A Diary of the Public Correspondence of Sir Thomas Hope of Craighall*, Bannatyne Club, 1843, p. 183.

[169] See P. J. Anderson (editor), *Charters and other Writs Illustrating the History . . . of Aberdeen*, Aberdeen, 1890, p. 412, who states, quoting from a Minute Book, that Alexander died on 21 March 1661.

[170] SRO, Register of Deeds, Mackenzie Office, vol. 4, pp. 661–2 (Warrant 318).

[171] Ibid., vol. 37, pp. 290–1 (Warrant 483): written by George Chalmers, student, and witnessed by James Donaldson, merchant in London, and George Alexander, writer in Edinburgh—dated 30 April 1675 and registered 15 June.

[172] SRO, Register of Deeds, Dalhousie Office, vol. 70, p. 303, and p. 301 (Warrants 224 and 222): the creditors were William More and his wife, Isabella Alexander, probably Marjory's daughter.

# III

# ORIGINS AND DEVELOPMENT OF
# JAMESONE'S ART

## (1) BRONCKORST, VANSON, AND SOME NATIVE PAINTERS

The rather obscure and fragmentary nature of the history of easel painting in the later decades of the sixteenth century in Scotland has already been referred to in Chapter I. Easel paintings, whether produced in the country itself, or imported from England or the Continent, were isolated phenomena, or so it now seems. In the surviving evidence there is no hint of anything that could be called a tradition of painting, either native or foreign. During the last two decades of the century, however, the picture changes somewhat and, coinciding with the youth and early manhood of James VI, a tradition of Court painting can be traced. This tradition is embodied in two personalities whose activities begin to assume a certain coherence, Arnold Bronckorst and Adrian Vanson. There is quite substantial pictorial evidence for Bronckorst; for Vanson the evidence is almost exclusively documentary, though some reasonable speculations can be made on the appearance of his art.

To some extent independent of these two painters of Netherlandish origin, though inevitably influenced by their relatively greater sophistication, are the native painters whose activities also begin to be manifest, especially in the early years of the seventeenth century. Stemming from, and indeed still part of the native decorative tradition, they provide the more immediate background for Jamesone. Apart from what he may have known of individual pictures brought into Scotland, these two traditions together—the school of Court painting which had virtually ended by 1603 and the developing native portrait—are the substantial roots of Jamesone's art.

Bronckorst is first clearly identified in a Scottish context just prior to 1580 when he is recorded as having been sent to Scotland as an agent for Nicholas Hilliard and another painter, Cornelius Devosse, in order to search for gold.[1] Although apparently successful, he was prevented by the Regent, the Earl of Morton, from exploiting his discoveries, and to support himself he 'was forced to become one of his Majesties

---

[1] See Stephen Atkinson, *The Discoverie and Historie of the Gold Mynes in Scotland, written in the year 1619*, Bannatyne Club, 1825, pp. 33–5. For Hilliard's obsession with gold (and alchemy) see Erna Auerbach, *Nicholas Hilliard*, London, 1961, pp. 33, 48.

sworne servants at ordinary in Scotland, to draw all the small and great pictures for his Majesty'. This office was granted to him on 19 September 1581 'for all the dayis of his Lyvetime' and carried a yearly pension of £100.[2] He was, however, employed by the King more than a year before this. In April 1580 a payment of £130 was allowed in the Treasurer's Accounts for 'certane portratouris paintit be him to his grace';[3] and at some time before 9 September 1580 he had requested payment of £64 for three pictures 'delyverit laitlie to his Hienes'. These consisted of one of the King 'fra the belt upward', 'ane other' portrait of George Buchanan (which might be interpreted as a version of a portrait previously painted), and a full-length of the King. The prices were, respectively, £16, £8, and £40. The Treasurer was ordered to pay this debt as well as 100 merks of the pension 'quhilk we have grantit him and as ane gratitude for his repairing to this countrey'.[4]

Pictures painted by Bronckorst would, however, have remained little more than guesswork but for the discovery of a signed and dated example. This is the portrait of the 1st Baron St. John of Bletso (Plate 5) which bears the autograph: AR (monogram) BRONCKORST FECIT 1578.[5] It was therefore painted very soon before Bronckorst's departure for Scotland. The aged head is painted with much refinement and an economy of tonal variation which relate it to the finest miniatures of the period. The skin stretches subtly on the bone and the drawing of the eyes is imbued with an understanding which is both anatomical and psychological. It is on the basis of this portrait, rather than the document quoted above, that the small panel of *James VI holding a Falcon* (Plate 8), in the Scottish National Portrait Gallery, can be attributed to Bronckorst.[6] In this the pigment of the face is slightly transparent, and there is some damage, but it has the same sensitive variation of tone and the same rather precise drawing— the line between face and collar, for example, has the same almost tender quality. Yet the falcon, the belt at the King's waist, and his right hand and cuff are placed with a naturalness and painted with a richness of light and suppression of detail which have more in common with a large easel painting than with a miniature.

A painting which fits into this stylistic context is the life-size three-quarter length portrait of the 4th Earl of Morton (Plate 7) in the same collection,[7] the man with whom Bronckorst had treated for four months about the removal of the gold he had

    [2] SRO, Register of the Privy Seal, PS 1, vol. xlvii, fo. 40; partially printed in *Archaeologica Scotica*, vol. iii, Edinburgh, 1831, p. 313.
    [3] SRO, Accounts of the Treasurer of Scotland, E 21/61, fo. 19.
    [4] Ibid., fo. 43; the King's precept, dated 9 September 1580 at Holyroodhouse, is E 23/5/6.
    [5] The signature is placed vertically midway along the right edge of the panel. This picture was first referred to by Erna Auerbach, 'Some Tudor Portraits at the Royal Academy', *The Burlington Magazine*, vol. xcix, 1957, p. 10; exhibited London, Tate Gallery, *The Elizabethan Image*, 1969, no. 52.
    [6] No. 992. This is very faintly inscribed IACOBVS along the top edge to the right of the head: it could be in Bronckorst's hand.
    [7] No. 1857.

discovered. Morton stands by a table in front of a high, draped balustrade, beyond which is visible a pale green landscape. There are many correspondences of detail in the drawing, and the picture has the same gentle gravity of mood as the two portraits already discussed. Morton's left hand, which is clasped on a sword-hilt, has a similar angular quality to that of James's gloved left hand, while their right hands are formally almost identical—the index and little fingers splayed, the middle fingers drawn together. The fingers generally share a sinuous plumpness, with pronounced tapering at the tips.

Bronckorst's pension was entered regularly in the Treasurer's Accounts until Martinmas (11 November) 1583.[8] He may have left Scotland rather earlier than this for he is recorded in London during the same year.[9] In any case, his place at Court had been taken by Adrian Vanson before May 1584 when the latter, 'in place of Arnold Brukhorst', was allowed a half-yearly fee of £50.[10] Like Bronckorst, Vanson had been given employment at Court before being granted official status. In June 1581 he was allowed £8 10s. by the Treasurer for two pictures which were despatched to Theodore Beza at Geneva.[11] The year before this Beza had brought out his *Icones* which contained woodcut portraits of many of the heroes of the Reformation. As a frontispiece he used a rather stylized half-length profile of the young James VI in armour (Plate 9), which bears a fair degree of resemblance to later portraits. The only other Scot represented was John Knox (Plate 10).[12] The date of the payment has been thought to rule out equating the two portraits in the Accounts with original patterns for the engravings, but given the nature of the Treasurer's accounting procedures it is not at all unlikely that the work had been done some time earlier.[13] It therefore seems quite feasible that Vanson's two pictures were of the King and Knox: the small sum implies that the paintings themselves were small. The woodcuts may then be a pale reflection of the kind of art of which Vanson was capable.

[8] The only payment other than his pension after 1580 is £46 in September 1581 for 'certane picturis'— SRO, Accounts of the Treasurer of Scotland, E 21/62, fo. 151v. From November 1581 to November 1583 his pension is entered at E 21/62, fo. 162v.; E 21/63, fo. 46; E 21/63, fo. 95; E 22/6, fo. 97v.; E 22/6, fo. 134.

[9] *Returns of Aliens Dwelling in the City and Suburbs of London . . .*, Huguenot Society Publications, vol. x, pt. ii, 1900, p. 336: 'Arthur Bruntkhurst Duche Painter', living in the Langbourne ward in 1583—the Christian name is curious but it is also the one given by Atkinson (loc. cit.). Some other references to Bronckorst in England are given in Erna Auerbach, *Tudor Artists*, London, 1954, pp. 151–2.

[10] SRO, Accounts of the Treasurer of Scotland, E 22/6, fo. 184. His name is perhaps more correctly Van Son, but the naturalized form found in all the documents has been retained.

[11] Ibid., E 21/62, fo. 135v.: 'Item to Adriane Vaensoun fleming painter for twa picturis paintit be him and send to Theodorus Besa conforme to ane precept as the same producit vpoun compt beris—viii lib. x s.'

[12] Theodore Beza, *Icones id est Verae Imagines Virorum Doctrina simvl et Pietate Illvstrium . . .*, Geneva, 1580: the King at fo. *i v., Knox at fo. Ee ij v. The image of the King is close to that on the Scottish gold £20 coin of 1576 (see Ian Halley Stewart, *The Scottish Coinage*, London, 1967, Plate XIV, no. 186).

[13] There is a fascinating account of these procedures by A. L. Murray, 'Notes on the Treasury Administration' in *Accounts of the Treasurer of Scotland*, vol. xii, 1566–1574, Edinburgh, 1970, pp. xii–xliv.

One remaining piece of evidence enables the payment to Vanson to be interpreted slightly differently: this is a letter dated 13 November 1579 sent to Beza by Peter Young, one of the King's tutors. It refers generally to Beza's request for portraits of reformers and specifically to a portrait of Knox which has already been requested from a certain artist. He ends the letter: 'Quum hasce obsignarem commodum advenit pictor qui mihi una pyxide Buchananum et Cnoxum simul expressos attulit.' (Just as I am signing this letter, an artist has opportunely come in, and brought in one box the likenesses of Knox and Buchanan.)[14] These then (and they also seem to be little pictures) may be the ones to which the payment to Vanson refers. The simplest explanation of the discrepancy is that Young has made an error, but it is also possible that a portrait of the King had already been sent (his interest in the proposed work is referred to in the letter). Beza did not include a portrait of Buchanan.

Vanson was active at the Court until at least 1601, when he was paid £20 for a portrait of the King, presumably a miniature fixed to a chain made by the goldsmith George Heriot, which was sent to the Duke of Mecklenburg.[15] Much of his work was of a humbler nature, exemplified by his painting four trumpeters' banners for the Queen's coronation in 1590,[16] yet the evidence implies that he was the only painter at Court to be entrusted with portraiture.[17] It is therefore difficult to doubt that he is the author of a portrait of the King dated 1595 (Plate 11), now in the Scottish National Portrait Gallery.[18] Another painting which falls into this stylistic category is a portrait of the Countess of Argyll in the same collection, which is dated 1599 (Plate 12).[19] This speculation is given added weight by the fact that the latter picture is, more clearly than the portrait of the King, a forerunner (though more primitive) of a group of portraits of the 1620s which can now be quite firmly attributed to Adam de Colone, who was probably Vanson's son.[20]

---

[14] The original letter is published in P. Hume Brown, *John Knox*, London, 1895, vol. ii, pp. 322–4; the translation by the same author was printed in *The Scotsman*, 20 May 1893.

[15] SRO, Accounts of the Treasurer of Scotland, E 21/75, fo. 90v.: there is a payment of £611 13s. 4d. in the same month (December 1601) to George Heriot, goldsmith, 'for ane greit cheinzie of gold with his hienes portrait hingand thairat quhilk wes gevin to ane gentilman that come fra the duik of Magilburgh' (ibid., fo. 89).

[16] SRO, Accounts of the Treasurer of Scotland, E 21/67, fo. 202 (the payment was £66 13s. 4d.); he had been paid £2 3s. 4d. in December 1587 for the even humbler task of painting two spears (ibid., E 21/66, fo. 92).

[17] There is one apparent exception, recorded in the Treasurer's Accounts for January 1581: 'Item to my lord Seytonis painter for certane picturis of his majesties visage drawin be him and gevin to the sinkare to be gravin in the new cunze [coinage], . . . x li.' (E 21/62, fo. 169v.). This may, however, refer to Vanson, before the Treasurer became aware of his name in June 1581. Lord Seton was exactly the kind of man to bring a painter from abroad; see also the remark on the coinage in note 12.

[18] No. 1109.

[19] No. 1409.

[20] See below, pp. 55–9.

Vanson's pension was paid with increasing irregularity,[21] and it appears that both pension and other payments were still due in 1610 when his widow Susanna de Colone was granted an enquiry by the King into what was owing to her.[22] Unlike Bronckorst, Vanson received some form of civic patronage, for on 30 December 1585 he had been freely admitted as a burgess of Edinburgh 'for guid and thankfull seruice to be done to the guid towne', and also under the express condition that 'he tak and Instruct prenteisses'.[23] This apparent encouragement of painting by the Council of Edinburgh rather forecasts the change of emphasis that inevitably took place after the departure of the Court in 1603. Whether Vanson (or Bronckorst) did instruct apprentices is not known, but these two minor Netherlandish painters must have left a residue of influence which prepared the ground for further developments.

And there is a handful of surviving portraits which have the appearance of being a native development of this tradition. Though Bronckorst and Vanson appear to have monopolized the production of portraits at Court the other painters who worked there with them, Walter Binning, and James and John Workman,[24] may well, especially after 1603, have been attracted into this field at a rather lower social level. Among the most interesting of these portraits are a group at Oxenfoord of three small heads painted on panel which may have been cut from larger portraits and probably represent Thomas Hamilton of Priestfield (born before 1549), father of the 1st Earl of Haddington, and two of his family. They must date from the first decade of the seventeenth century. The faces and collars contain a great deal of white pigment which has contributed to their preservation. The method of painting is most readily visible in that of Hamilton himself, which depicts the frail features of a man of great age (Plate 6). There is no indication of the head having been built up in glazes: instead, it is thickly and directly drawn with the point of the brush, the shadows and

[21] From November 1584 to November 1586 his pension (or fee) is entered in the Treasurer's Accounts at: E 22/6, fo. 219; E 21/64, fo. 69; E 21/64, fo. 105v.; E 21/65, fo. 64v.; E 21/65, fo. 101v. There is no further reference to his fee until 1595 when the King relieved the Treasurer of an obligation to pay £100 to Vanson for the years 1585 and 1586 (E 21/70, fo. 200). Vanson had therefore in fact only been paid in part for these years (for an explanation see A. L. Murray, loc. cit.). Nevertheless, Vanson was able to stand surety in May 1594 with the ambassador of the Confederate Provinces in sums amounting to £3,000 regarding the activities of certain Dutch sailors (see *Register of the Privy Council of Scotland*, vol. v, Edinburgh, 1882, p. 622).

[22] National Library of Scotland, Adv. MS. (Denmilne MSS.), 33. 1. 1/40; printed in *Letters and State Papers during the Reign of King James the Sixth*, Edinburgh, 1836, pp. 191–2. She was apparently in London when she petitioned the King 'alsueill for wages as work done': the King's instructions to the Scots Privy Council (known only in this draft) were dated 6 July 1610 at Whitehall.

[23] ER, Council Register, vol. vii, fo. 219v.; see also the Guild Register, vol. 2, under date. The first is printed in *Extracts from the Records of the Burgh of Edinburgh 1573–1589*, Edinburgh, 1882, p. 446; the second is quoted wholly inaccurately in Charles B. Boog Watson (editor), *Roll of Edinburgh Burgesses 1406–1700*, Scottish Record Society, 1929, p. 503.

[24] Between 1577 and 1603 there are references in the Treasurer's Accounts to these painters at E 22/2, fo. 92; E 22/3, fo. 75v.; E 21/68–9, fo. 129; E 21/68–9, fo. 213; E 21/70, fo. 112; E 21/72, fo. 73; E 21/76, fo. 276 (payment to John Workman in May 1603 for painting the coach in which Anne of Denmark departed for England).

highlights interlocked in series of small zigzag lines of paint. Forms are never implied but, as in the curved wispy beard, are virtually scored in in groups of repeated outlines. Actual anatomy is not very clearly understood but there is an honest endeavour to trace the interplay of bone and flesh: though basically primitive, in the end an image of moving quality does result. The picture's bold textures and preponderance of light colours probably derive from the art of the decorator, yet one senses that the painter's ultimate aims were not all that different from Bronckorst's in his *Baron St. John of Bletso*.

A portrait of similar type, which could be from the same hand, is that of James Murray (formerly at Polmaise Castle) which bears the date 1610 (Plate 13).[25] There is an even stronger sense here of a painter being required to turn to portraiture from decorative and heraldic work—and again on behalf of a sitter of relatively minor social status. That this was the type of painter is evident in the drawing of the hand clasping a glove, which is quite linear and formless and has more in common with something from a coat-of-arms.

Evidence of influence from a rather more mannered foreign tradition can be surmised, though not very clearly traced, in a three-quarter length seated portrait of the inventor of logarithms, John Napier of Merchiston (Plate 44).[26] This portrait (dated 1616) has a diversity of parts, and yet a clarity in the composition, which suggest something of more sophisticated Continental methods, though there is an almost inevitable lack of ease. The hands are drawn with a fair degree of understanding, the curvature of their surfaces conveyed by a smooth gradation of tone which is not far removed from certain aspects of northern mannerism. Curiously, this form of chiaroscuro, which was presumably derived from prints, will be met with in the one substantial example of the work of Jamesone's master, John Anderson.[27]

There is thus a certain degree of knowledge of the kinds of painting being done in the south of Scotland, in effect Edinburgh, during the later years of the sixteenth century and the early years of the seventeenth—the period immediately prior to Jamesone's apprenticeship there. There is no comparable evidence for the north, which is a simple reflection of its distance from a court. Nevertheless, Aberdeen did not lack an interest in the arts of civilization: in literature and certain branches of learning it seemed to lead the south, and paintings and statues, spoken of as having been in the chapel of King's College, were probably imported from the Low Countries.[28] It was also clearly a centre for a school of decorative painters and actual practice seems to have fallen almost wholly within the decorative tradition.

Some notice has already been taken of the kind of painting done in Aberdeen

---

[25] Sold by Dowell's, Edinburgh, 10/11 October 1956, lot 269.

[26] SNPG, no. L 147 (on loan from the University of Edinburgh).

[27] See below, pp. 51-2.

[28] See Francis C. Eeles, *King's College Chapel Aberdeen Its Fittings Ornaments and Ceremonial in the 16th Century*, Aberdeen, 1956.

during these years, especially in the persons of John and Andrew Mellin (or Melville) and Andrew Strachan, a circle of painters with whom Jamesone had personal links.[29] Much of their work seems to have been repetitive and largely unimaginative, though one would wish to know more about the nature of the crucifix which John Melville painted for the younger laird of Gight in 1604, and which brought upon the painter the wrath of the kirk-session.[30] Surviving examples of religious paintings, which may well have been done by one of these painters, for they are clearly local, are the painted ceilings in Provost Skene's House in Aberdeen.[31] These consist of large rectangular panels (surrounded by elaborate painted cartouches) containing scenes of the *Annunciation*, *Adoration*, *Crucifixion* (Plate 15), and *Resurrection*. There is some doubt about the dating of these paintings, but even if they are as late as the 1620s, they are clearly part of an established tradition of bold, somewhat bucolic, narrative art with very distant roots in Renaissance painting. It seems more than likely that Jamesone was from an early age familiar with work of this type.

It remains difficult to link any of these north-eastern painters with particular works, but an attempt can be made in at least one case. The ceilings of Delgatie Castle near Turriff bear the initials 'JM' and the dates 1592 (or 3) and 1597.[32] There is therefore a strong possibility that these were painted by the John Mellin who had been paid in 1587 for painting imitation tapestry in St. Nicholas Church.[33] The ceilings of the bedroom are crudely but richly painted with heraldic devices, arabesques, an elephant and even sphinxes (Plate 16). Certain of the details here are also found at Crathes Castle, where the so-called 'Muses' Room' is dated 1599.[34] If not actually by Mellin, the work here was almost certainly done by someone from the same circle and, particularly on the 'Nine Nobles' ceiling, it is interesting to see the development of a crude figural tradition (Plate 18). Especially in the hands and facial details of these full-length figures, there is a simplicity and surety of purpose which is not far removed from the style of the native portraiture discussed above. And one may even begin to detect traces of a loose, rather peremptory type of drawing that can occasionally be traced much later in the painting of Jamesone himself.

## (ii) JOHN ANDERSON AND JAMESONE'S TRAINING

Whether Jamesone's master, John Anderson, was capable of portraiture remains speculation, though what has been said above concerning the development of native portraiture would seem to suggest that he was. If the frequency of documentary

---

[29] See above, p. 20.    [30] Ibid.

[31] See E. Meldrum, 'Sir George Skene's House in the Guestrow, Aberdeen', *Proceedings of the Society of Antiquaries of Scotland*, vol. xcii, 1961, pp. 85–103.

[32] See A. W. Lyons, 'Further Notes on Tempera Painting in Scotland, and other Discoveries at Delgaty Castle', *P.S.A.S.*, vol. xliv, 1910, pp. 247–52.

[33] See above, p. 20.

[34] See *A Guide to Crathes Castle*, National Trust for Scotland, 1963.

references to him is any guide, he appears to have been the outstanding decorative painter of his day. Having been entered a burgess of Aberdeen as a painter on 6 October 1601, he presumably carried on his activities there or in the vicinity until his appearance in Edinburgh in 1611. It is intriguing that the records of him in the years 1611–12 concern the painting of the shutters of a public clock, and his acquisition of George Jamesone as an apprentice.[35]

Although the late age at which Jamesone was entered is surprising (he was about twenty-two), the fact that the son of a mason was to become a painter probably appeared less so at the time, as painters, and indeed carvers, had always belonged to the same incorporated gild as the masons. It may be that the indenture was little more than a disguised business arrangement, and the likelihood of a family relationship between them should not be overlooked.

Anderson's residence in Edinburgh seems to have been spasmodic. His disagreement with the Privy Council in 1617 over his activities at Strathbogie (Huntly Castle) has already been noticed, and one may detect a certain awkwardness of character in that episode.[36] There are now only the merest traces of painting at Strathbogie, but a decorative scheme was still visible in 1780. A description, written in that year, almost certainly gives a clue to the nature of Anderson's work there: '. . . their curious ceilings, are still preserved pretty entire. They are painted with a great variety of subjects in small divisions: a few lines of poetry underneath each, describe the subject of the piece. In these the virtues, vices, trades, and pursuits of mankind, are characterized by emblematical figures, which though not the most elegant, are expressive. In the chamber which was appointed for a chapel, or place of worship, the parables and other sacred subjects are represented in the same style.'[37] This description suggests a good deal of figural work and the last item (Huntly was a Catholic) is particularly interesting. If a date in the 1620s is accepted for the religious paintings in Provost Skene's House in Aberdeen, the possibility of Anderson having painted them must be quite strong.

The work in Edinburgh Castle, which, according to the Privy Council, required 'so quick and present dispatche and expeditioun', was undertaken by Anderson before any legal remedy was necessary: some of it still survives. Above the lower panelling on the west wall of the small room in which James VI is said to have been born, and rising some feet to the ceiling, is a vigorous depiction of the royal arms of Scotland (Plate 19). The vitality of the normally remote unicorns is marked, as is the emphatic and smooth use of chiaroscuro on their bodies. This latter feature is, suggestively, exactly the same treatment of light and shade that has already been noted in the portrait of John Napier (Plate 44), painted in the previous year.[38] The rectangular

---

[35] See above, p. 19.    [36] See above, p. 21.
[37] Rev. C. Cordiner, *Antiquities and Scenery of the North of Scotland*, London, 1780, pp. 9–10.
[38] See above, p. 49.

coffers of the ceiling are decorated with painted thistles, crowns, and royal initials, while the remainder of the frieze bears bold, almost baroque cartouches, one of which, that on the south wall, carries the date of the King's birth (Plate 17). For this particular part of the exercise Anderson was paid £100. He was also paid a much smaller sum for simulated 'marble dures and chimnayes',[39] that almost universal decorator's deceit.

Working with Anderson, and almost certainly his equal in status, were James Workman and John Sawers, each of whom also produced a royal-arms, Workman's apparently outside, above the inner gate. It is interesting to note the materials and colours they used: oil, 'skrows' (clippings of parchment to make glue), paper and flour, indigo, 'vergus' (green), orpiment, 'rois aparice', and two horse loads of chalk.[40] It is, at this level, simply the world of the interior decorator, yet Workman was also the Marchmont Herald;[41] and, towards the end of his active life, in 1634, we find Anderson engaged in a relationship of real intimacy with Sir John Grant of Freuchie.

The evidence for this relationship is slight,[42] but it seems to bring the two worlds of portraiture and decorative painting into close contact, the kind of contact that is sensed as a formative influence on Jamesone, though difficult to specify; the lateness of the evidence is probably only an accident of survival. On 10 December 1634 Sir John Grant wrote from Inverness to his 'werie good freind Johne Andersone paynter in Aberdein', requesting him to send back with the bearer of the letter four portraits which he had sent to Anderson to be 'mowlerit' (framed): he also asked how they should be treated on their return. He then goes on to propose to Anderson that he should come to Ballachastell (his home near Inverness) in the following spring to undertake the painting of the ceilings of his gallery: '. . . I pray yow hawe fyne colours for paynting of the same and gold also for painting of the four storme windowes in readines againe my adwertisment.' In a postscript he promises that he will give this kind of work to no other painter while Anderson is alive, and asks for news of the Court since Anderson in Aberdeen is nearer.

Through its chance survival it gives a unique insight into the relations between a decorative painter and his patron; indeed it suggests a greater degree of intimacy than that between Jamesone and Sir Colin Campbell at about the same time. Unfortunately the letter does not indicate who the four portraits were by, but there must be some possibility that they were by Anderson himself. Anderson was to outlive Jamesone, being

---

[39] SRO, Accounts of the Masters of Works, vol. xv, fo. 58.
[40] Ibid., fo. 53.
[41] See Francis J. Grant (editor), *Court of the Lord Lyon 1318–1945*, Scottish Record Society, 1945, p. 33.
[42] It consists principally of two letters, the one quoted from and one written three days earlier by Grant to his mother which also discusses the bringing home of the four portraits; later, on 14 May 1638, Anderson corresponded with Grant's son and successor, Sir James Grant (all three letters are at SRO, GD 248/46/2).

still alive in 1649.[43] He had thus seen the whole aspect of painting in Scotland transformed, largely through the activities of his own pupil.

Of portraits painted at about the time that Jamesone's apprenticeship was due to end, and which once more seem offshoots of the decorative school, one of the most striking is the three-quarter length of Sir Duncan Campbell of Glenorchy (Plate 14), dated 1619 below the prominent coat-of-arms.[44] The facial features are drawn in with an implacable firmness—what is lacking in knowledge is compensated for by a good eye; and if the creams, pinks, and oranges of the face show an almost heraldic interest in colour for its own sake, they certainly do not lessen the vigour of expression in the face of this elderly but still gleaming man. The sitter is best remembered for certain barbaric acts, but there is evidence to show that he spent some time on the new arts of civilization and that he had some paintings in his castle at Finlarg.[45] Looking forward, his son Sir Colin Campbell (Jamesone's principal patron), was to spend vast sums of money on the decoration of his houses.

Jamesone's training in decorative circles may go some way towards explaining the technical inadequacies of his work—inadequacies as far as their survival is concerned. The thin, and now rather rubbed nature of his portraits, particularly in the shadow areas, is almost a distinguishing characteristic. This is one factor which seems to speak against any proper training in a Netherlandish method. It has been usual to assume that the paint surface has suffered an unusual degree of attrition by cleaning and other abuse, and a frailty in the actual binding medium has been suggested as an explanation: gouache-like tempera or tempera with soap added to improve the emulsion have been put forward as possibilities. A connection with the type of painting done in Cullen House and Provost Skene's House, where a distemper type beginning is followed by glazes of a resinous type, has also been suggested.[46]

The recent cleaning of one picture, the *7th Earl Marischal* of 1636 (Catalogue, 94; Plates 95–7), and the examination of paint samples from both it and the *Robert Bruce* of 1633 (Catalogue, 48; Plate 75) have, however, gone far in clarifying this problem.[47] As far as the binding medium of the pigment is concerned, in both

---

[43] His wife was buried on 20 December 1634 (AR, Kirk & Bridge Works Accounts 1571–1670, under date). Anderson sold properties in Aberdeen on 2 June 1647 and 21 June 1649 (SRO, Minute Book of Aberdeen Register of Sasines 1573–1694).

[44] SNPG, no. 2165.

[45] Principally a portrait of himself dated 1601 (still in family possession). See also SRO, GD 112/22/4, a volume of inventories of Balloch and Finlarg 1598–1610.

[46] In the early stages of my initiation into these problems I derived great benefit from conversations with H. R. H. Woolford, formerly restorer for the National Galleries of Scotland, and Ian S. Hodkinson, now of the Queen's University, Kingston, Ontario.

[47] The problem has been clarified particularly by John Dick, restorer for the National Galleries of Scotland, who cleaned the portrait of the 7th Earl Marischal. I have benefited immensely from his help in formulating the statement given here, though the responsibility for any failures of expression is mine. I am also grateful to J. C. McCawley of the National Museum of Antiquities of Scotland, who examined paint samples taken from the same painting, and Stephen Rees Jones of the Courtauld Institute of Art, who examined samples from the *Robert Bruce*.

instances it is revealed as undoubtedly oil based: in the latter case it further appears that the oil contains a high proportion of added resin—the oil used being perhaps linseed, though walnut or poppy are possibilities. The evidence regarding the composition of the ground is more equivocal: in the *Robert Bruce* the ground appears to contain linseed oil, while in the *Earl Marischal* the ground is a chalk-size gesso, not oil bound, though slightly tinted with yellow ochre.

A much better understanding of Jamesone's method of painting has been gathered in the process of cleaning the *Earl Marischal*. It appears that the paint, applied with considerable freedom, was even originally exceptionally thin and lacking in body, except where white was used in the lighter areas and highlights; the middle tones were little more than uncovered ground. Consequently the slightest rubbing has tended to remove pigment, revealing even more ground; the ground itself was thin, both in volume and body, and not being oil bound was easily penetrated by water. The highest parts of the woven canvas were necessarily most vulnerable and when the ground on these areas was abraded it tended to be entirely carried away.

The conclusions reached regarding these two paintings go a good way towards explaining the present appearance of many of Jamesone's pictures. In those which have not been subjected to repaint the thinness of pigment can usually be explained by damage of the sort described: it is also partly explained by Jamesone's own chosen method of painting. It appears, however, that during the eighteenth and nineteenth centuries this relative frailness of Jamesone's work proved less and less acceptable and restoration, necessary perhaps in certain parts of a picture, was often carried out uniformly over the entire picture. An extreme example of this kind of treatment is the *Sir William Forbes* (Catalogue, 8; Plates 35, 36) now released from nineteenth-century repaint.

It is necessary to keep these factors in mind when the qualities of Jamesone's portraits are being assessed. Basically his technique was a traditional one for easel paintings, but with dangerous aspects in terms of their survival. The free application of thin pigment on a warm ground, which was often left incompletely covered, appears to have been essential to his original intentions.

## (iii) THE BEGINNING OF JAMESONE'S CAREER AND THE INFLUENCE OF A PAINTER IDENTIFIED AS ADAM DE COLONE

It is difficult to gain a very clear impression of Jamesone's activities in the years immediately following the official completion of his apprenticeship in 1620. From the first half of the decade there now remains a mere handful of portraits, mostly in rather equivocal condition. The earliest of these is the *Sir Paul Menzies* of 1620 (Catalogue, 1; Plate 20). It is a stiff, certainly provincial, portrait with the head

placed centrally, the background an unconsidered wilderness. The probably rather later portrait of Robert Gordon of Straloch (Catalogue, 4; Plate 21) is of the same type, except for the ambitious introduction of the sitter's right arm and hand, a feature which Jamesone later usually avoided. It is possible to see some tenuous similarity to the paintings of the same period of Cornelius Johnson but this may be little more than a shared hesitancy in interpretation: there is in 1620 a distinct Dutch quality in Johnson's work which is not visible in Jamesone.

The purely local quality of his painting at this time is emphasized by two rather similar portraits, the *James Sandilands* of 1624 (Catalogue, 2; Plate 22) and the *Unidentified Man* of about the same date (Catalogue, 3; Plate 29). In the latter there is even some evidence of the benefits to be derived from being free of a too close reliance on an established tradition—the head has a compelling forthrightness and a strange timelessness. Yet to the following two years belong two full-lengths, the *Earl of Rothes* (Catalogue, 6; Plate 23) and the *Countess of Rothes with her Daughters* (Catalogue, 7; Plate 24), which reveal Jamesone as an adherent, though a rather awkward one, to the Jacobean Court tradition, especially as personified by Robert Peake and the younger Gheeraerts.

The relative increase in sophistication that this development implies may well be partly due to an increasing knowledge of the work of these two painters, as well as that of the more modern (or more Netherlandish) Paul van Somer and Mytens. This knowledge may have been filtered through prints; it could have been derived from direct contact with the actual paintings, either in Scotland or in London itself— his sole recorded journey to the south is unlikely to have been an isolated affair. There is now evidence, however, that Jamesone was exposed much more immediately to certain aspects of the style of these painters. This was through a group of portraits of Scottish subjects painted in the years 1622–8 which exhibit an unusual combination of Anglo-Netherlandish, true Netherlandish, and provincial features, and which are now attributed to a painter called Adam de Colone.[48]

It is vital to define the qualities of these paintings (listed in Appendix B), both because many of them have for long been traditionally attributed to Jamesone, and also so that their influence on Jamesone can be assessed. That the painter in question, working at the highest level so far as Scottish patronage was concerned, vanished completely from the scene after only six years of activity is also of the greatest significance, though perhaps in a negative sense, for the rest of Jamesone's career. The continued competition of a basically more skilful painter might well have spurred Jamesone to efforts which his near-monopoly situation never required.

---

[48] The writer has benefited greatly from help given by Robin Hutchison and Sir Oliver Millar in the reconstruction of this painter's career. The latter had first drawn attention to five of the paintings in the group (mentioning Jamesone as a possible author) in 'Marcus Gheeraerts the Younger, a Sequel through Inscriptions', *The Burlington Magazine*, vol. cv, 1963, p. 541.

The first consideration in disentangling these pictures from Jamesone's work has been stylistic, but support is provided by more measurable characteristics. With the exception of two full-lengths of James VI and I they fall into two categories of size: 'head size' canvases (24 by 20 inches) are used for head and shoulder portraits, while the 'small half-length' canvas (44 by 34 inches) is employed for three-quarter length portraits. These are sizes commonly used by the Anglo-Netherlandish painters.[49] A few of Jamesone's portraits are near to the former size, but this seems usually due to reduction, and he appears never to have used the second size. Further, the majority of the paintings have inscriptions in a distinctive calligraphy. The letters are always upright block, and the 'Æ' of 'ÆTATIS', twice the height of the other letters, is also rather upright. On the extremities of each letter are characteristic spiky serifs, always particularly pronounced on the letter 's'. In the year, the initial digit 'I' always has a long tapering tail which curves away to the left (see Plates 50 and 51). These forms are quite unlike the genuine calligraphy on Jamesone's paintings (Plate 54). Finally, all those pictures in the group which bear dates fall between the years 1622 and 1628.

For identification of the painter, the key pictures are the three-quarter length at Keith Hall of the 3rd Earl of Winton with two of his sons, dated 1625 (Plate 34), and another three-quarter length of the same sitter at Traquair, which is dated 1628. Winton kept a personal account book between 1627 and 1630 in which he records payments made in London, as well as payments concerned with his newly-built house of Winton.[50] Unfortunately, it is not clear whether the two entries which are relevant here refer to London or Scotland. The first reads: 'Item gewine to Adame the painter for my Lord Erroll, my Lady Hay, and James Maxwells portraits, 86 lib. 13s. 4p.' The second, which follows a payment for plasterwork ceilings at Winton and precedes one made to the keeper of the monuments at Westminster, is: 'Item gewine to Adame the painter for my aune portraitte gewine to my sister, 40 lib.' Both payments seem to fall between 10 February and 2 July 1628. The portraits of Winton at Keith Hall and Traquair are the only known portraits of him, and it is therefore difficult to avoid linking them with the 'Adame' of the accounts. The latter payment also suggests a portrait larger than head and shoulders (for which Jamesone was charging £20 framed in the 1630s), and so the portrait which Winton gave to his sister may be that at Traquair.[51]

If 'Adame' was active in London, could he be the Adam Colone who was paid £60

---

[49] See the list of paintings by Gheeraerts given by Oliver Millar, loc. cit., pp. 533–8.

[50] Extracts are printed in the *Second Report of the Royal Commission on Historical Manuscripts*, London, 1871, p. 199. The account book then belonged to James Forbes Leith of Whitehaugh: an attempt to trace the original has been unsuccessful.

[51] Winton's sister, Isabell Seton, died before her brother. The picture may have come into the possession of his eldest son George who in 1639 married Henrietta, daughter of the 2nd Marquess of Huntly; she married secondly John Stewart, 2nd Earl of Traquair.

at Whitehall on 4 July 1623 'for 2 pictures of his Maiesty'?[52] The evidence for equating the two with some certainty is provided by two full-lengths of the King, at Hatfield House[53] and Newbattle Abbey (Plate 28), both of which are dated 1623 and represent a new, if not entirely original, pattern.[54] There are also two three-quarter length versions known which are not dated. All of these exhibit formal and stylistic characteristics which fit them easily into this group, as will be seen when some are examined in greater detail.

The figure of the painter himself is given a good deal of substance by the only other known record referring to him directly—it also places him squarely in the context of Scottish painting and points his relevance to Jamesone. This is a general request for protection issued to him by the Scots Privy Council on 3 February 1625 prior to an intended journey to the 'Low Cuntreyis of Flanders for some of his adois' (business).[55] The document reveals that 'Adame de Coline sone to vmquhyle Adriane de Coline our paynter' had been born in Scotland; on approaching manhood he had gone to the Low Countries 'for his better inhabling' in his father's calling. After spending several years there he returned to find some employment at Court (presumably in 1622); when the royal protection was issued he had been in Scotland for several months. On completion of his proposed foreign journey his intention was to return and 'sattle his aboad in [the] said kingdome of Scotland'.

The journey appears to have been postponed. Whether the portraits painted between 1625 and 1628 were done in Scotland or after a return to Court remains unclear: they are mainly of Scots who were active in Court circles. The reference in de Colone's passport to the earlier Court in Edinburgh is also rather unclear. There is no reference to an 'Adriane de Coline' at that Court, but there was, as we have seen, an Adrian Vanson, active between 1581 and 1601.[56] The writer of the protection may simply have made an error, intending Adrian Vanson.[57] If this was the case, the explanation for the form of the son's name might lie in the fact that Vanson's wife was, it will be recalled, a Susanna de Colone. Adam de Colone could be the latter's nephew, but the more likely explanation is that he was her son and for some reason adopted her name after she became a widow. Whether or not he eventually departed for the Continent also remains uncertain but there is no further trace of him after 1628.

[52] Public Record Office, PC 2/32. Printed in *Acts of the Privy Council of England 1623–1625*, London, 1933, p. 50.

[53] Given tentatively to John de Critz the Elder, after Paul van Somer, by Erna Auerbach, *Paintings and Sculpture at Hatfield House*, London, 1971, p. 83. De Colone does have a great deal in common with Van Somer (compare the latter's *Countess of Kent* in the Tate Gallery with the portrait called *Lady Yester* (Plate 41)) but he is not quite so accomplished.

[54] It appears to be a derivation from Paul van Somer's full-length of 1618, now at Holyroodhouse.

[55] SRO, Register of the Privy Council of Scotland, PC 7/3, fos. 34v.–35. Printed in David Masson (editor), *The Register of the Privy Council of Scotland*, vol. xiii, Edinburgh, 1896, pp. 698–9.

[56] See above, pp. 46–8.

[57] The document survives only in the transcript inserted in the Privy Council Register, where the error could easily creep in unnoticed.

The career of de Colone, which the Scots Privy Council document traces, explains the threefold aspect of his work which has already been mentioned. The earliest dated portrait establishes a connection with Gheeraerts: this is a posthumous copy of the latter's portrait of the 1st Earl of Dunfermline which was painted in 1610.[58] De Colone's copy is clumsy by comparison: though the details of the inscription have been updated, the subject remains precisely the same age. He has also introduced fringed curtains in both top corners, a favourite and distinguishing device.

His portrait of the 1st Earl of Haddington of 1624 (Plate 42) is competent in a rather Dutch manner, stemming from the Miereveld tradition.[59] The understanding of form is not so assured as Miereveld's and the insistence on detail is comparatively old-fashioned, but he shares the Dutch painter's sobriety. The similarities to Gheeraerts are more immediately recognizable: the disposition of mass and light are close to his *Sir Henry Savile*[60] and *Richard Tomlins* (Plate 43) in the Bodleian at Oxford; the rather stiffly drawn hands, particularly those clasping gloves, are a common detail. Though the *Haddington* has a sense of profound gravity in the head, it tends to not quite match the extreme sensitivity with which Gheeraerts, as in these two pictures, paints the face and subtly probes character.

De Colone's *3rd Earl of Winton with two Sons* (Plate 34) and the later single portrait share a quality of tense immobility. In both pictures Winton's head has a pronounced diagonal tilt with an axis of intense, compact shadow running from just above the left eye-socket down the side of the nose, and down the left half of the beard; the eyeballs tend to be hooded by the upper lids, while the lower lids are rather straight, both characteristic features of de Colone's portraits.

The group portrait, probably the most complex of his known paintings, though ineloquent in almost the sense given to the word by Berenson, has both a surface richness and a power to move. The figures, set in a shallow niche formed by the typical gold-fringed, dull pink curtains, are illuminated by a strong light source which picks out the meticulously painted details of lace, braiding, and ribbons. Winton's just sufficiently articulated right arm and hand, protectively clasping the younger child, are both physical and emotional extensions of his intensity of expression; while his left arm and hand, foreshortened and partly covered by a cloak, transmit a degree of support from the elder son to the father. In this picture the three strands of de Colone's art are seen brought together in one place: the setting and the figure of Winton are derived from the Jacobean Court style; on the other hand the younger child, in grey and blue doublet and holding a carnation, is distinctly provincial in feeling, while the elder son, dressed in similar dull crimsons and vermilion

[58] SNPG, no. 2176.

[59] The un-Jamesone qualities of this portrait (and, by implication, others in the group) were first noticed by Ellis Waterhouse, *Painting in Britain 1530 to 1790*, Harmondsworth, 1962, p. 42.

[60] See Mrs. R. Lane Poole, *Catalogue of Portraits . . .*, vol. i, Oxford, 1912, p. 32 and plate III; see also the Library's *Portraits of the Sixteenth and Early Seventeenth Centuries*, 1952, p. 5 and plate 14.

to the father, is painted with a poise and freedom which looks towards the Continent —the pigment of Winton's face is rather thick, the brushwork slow and decisive, whereas this son's face is loosely painted and has much less sense of following a preconceived pattern.

The structure of Winton's head in this last portrait is very closely paralleled in a portrait of the 6th Earl of Buchan (Plate 49). The forms are similarly compact, the line of the right jaw and the inside of the collar made up of a series of small transverse brush strokes tightly knitted into one another. Here the tendency to hood the eyes by painting the upper lid in the form of a stretched curve is particularly marked, as it is in the portrait called *Lady Yester*, dated 1628 (Plate 41). The latter painting is in especially good condition, and clearly shows the rather dry use of paint which de Colone favoured, especially in the wispy highlights of the hair, painted over a darker layer beneath.

All these pictures have a weight of pigment not usually found in Jamesone, except in the second half of the 1620s. There are signs, as will be seen below, that de Colone's influence was strong during this period when he acted as a channel conveying the Jacobean manner to Jamesone, but that it rapidly waned after about 1630 when the latter moved on to a manner rather less circumscribed, in a sense rather less dogmatic. While de Colone's portraits at their best have a quiet depth and authority never attained by Jamesone, they rather lack physical atmosphere, a quality which Jamesone with his much freer, thinner handling was to attain easily in his better work. Finally, Jamesone was to replace his austere, even somewhat inaccessible view of character with a simpler version of human personality.

## (iv) JAMESONE'S PAINTING BETWEEN 1625 AND THE EARLY 1630s

Jamesone's shift away from the provincial type of portrait towards something broader in outlook is a very subtle process. Whether or not he ever had any actual contact with Adam de Colone, the latter's work must have come to his attention during this period. Though Jamesone was settled in Aberdeen, and de Colone presumably in Edinburgh (however briefly), the latter included among his sitters members of the north-eastern nobility with whom Jamesone soon began to make contact. In the same year that de Colone painted the elderly Earl of Mar,[61] Jamesone was to paint his daughter Mary Erskine, Countess Marischal. Again, in the same year, de Colone appears to have painted Margaret Graham, Lady Napier[62] whose brother, the future Marquess of Montrose, Jamesone was to paint in 1629. Nevertheless, Jamesone was certainly not swamped by de Colone's influence and their works are easily distinguished.

[61] See Appendix B, no. 18.    [62] See Appendix B, no. 17.

The most immediate manifestation of this influence in the two Rothes full-lengths (Catalogue, 6 and 7; Plates 23 and 24) is the attempt to fill out the picture area with draperies, especially in the portrait of the Countess and her two daughters, where the curtain is of the same kind that de Colone frequently used. Although the two rooms in which the figures are placed are described in a good deal of detail, there is little sense of actual depth: in this respect Jamesone would have had little help from de Colone, whose settings are minimal. The general disposition of the interior is rather reminiscent of Gheeraerts, who was more inclined to depict the character of a setting, but again like de Colone, and the other Jacobean painters, had little ability to suggest space. The portion of stained-glass window to the left of the Countess and the series of small paintings on the rear wall, which the window illuminates, suggest some knowledge of Dutch interiors, perhaps of the type showing a picture-dealer's room.

The linking of the figures in the group portrait and the expression of family tenderness also seem to show a debt to de Colone, particularly to his *3rd Earl of Winton with two Sons* painted a year earlier (Plate 34), and its probable companion at Traquair.[63] The naïve drawing of Jamesone's children seems directly related to the treatment of the younger child in the former of these two pictures. There must also have been at one time a comparable surface richness but both Rothes pictures are now badly damaged. The jewellery worn by the Countess, as well as some of the embroidery on her dress, has been less badly affected and the minuteness of treatment, and solidity of pigment, again suggest de Colone. Jamesone was to retain this particular method so far as jewellery was concerned (though treated with growing freedom) long after de Colone's influence in other respects had disappeared.

Although in what is probably Jamesone's finest surviving picture, the *Mary Erskine, Countess Marischal* (Catalogue, 9; Frontispiece and Plate 39) one can again specify certain features which seem to stem from de Colone—the seriousness of feeling, the diagonal bias, the love of detail, notes of quite bright colour, and thickish pigment—there are also undertones of Netherlandish vision which give it a sense of atmosphere and even a sensuous quality which are personal to Jamesone and which, for a moment at least, almost bring it into the mainstream of European art.

At this point Jamesone also seems to invite comparison with the sensitive, unpretentious head and shoulder portraits of Cornelius Johnson. Yet finer technician as Johnson was, his portraits at this time are curiously circumscribed, as though he were perfectly willing to accept the limitations imposed by the class which patronized him. Indeed, they are often physically circumscribed, the sitter placed plaintively behind a painted oval frame, an illusionist but certainly not realist device. This device was used equally unmeaningfully by a contemporary of Johnson's, the English-

---

[63] See Appendix B, nos. 10 and 11.

man John Souch, in his portrait of George Puleston in the Tate Gallery (Plate 47).[64] In this the extraordinarily bright, smooth finish with which the subject is painted has the effect of seeming to pull him in front of the marbled frame. And even when the arrangement is used by a genuine realist like Sir Nathaniel Bacon, who, in his *Self-portrait* (Plate 48) of the mid-1620s,[65] paints the oval opening as though chipped slightly on its edges, it still has the effect of divorcing the sitter from a real ambient light and atmosphere.

This form was apparently either unknown to Jamesone at this period, or else he had no use for it. In the *Mary Erskine* there is no marked sense of the sitter being in one world and the spectator in another, such is the subtlety by which an actual light and an actual atmosphere are implied. There is also a suggestive interplay of shadow and accents of light, both between the parts of the figure and between the sitter and the background, which brings the vulnerability of this rather plain woman, and even her place in time, immediately into the viewer's awareness.

This freedom from too great a concern with surface realism and from one of the conventions of the time had perhaps even more individual and interesting results in the portrait of the young Earl of Montrose, painted near the end of 1629, virtually on the eve of the subject's marriage (Catalogue, 25; Plates 52 and 53). The picture is (unusually) on panel and is in surprisingly good condition, though the pigment has become somewhat transparent. The initial impression is of a loaded brush handled with considerable verve. The brushstrokes follow the forms of the face in inter-mingled series of pink and cream lines, fading sensitively into the more thinly painted shadows on the left half of the sitter's face. The drawing can scarcely be faulted in its ability to convey a vivid face, often by the merest suggestion; it only hardens into emphasis where required, as in the sharp inside edge of the right nostril. The hair is a brown/olive extension of these forms, its soft texture conveyed by the slightest of highlights. In the collar and the doublet there is barely a hint of seeking out detail for its own sake. The background lacks any concrete detail, but it is divided by an almost casual pale ochre light, running from just above the head down to the left shoulder which, though not really explicable in terms of the light source, has a right-ness in tone and in placing which turns the slightly smiling face into immediate focus; and, as in the *Mary Erskine*, the sitter is placed credibly in space, and also in time.

These are considerable claims to make for any painting and imply a power of under-standing found only in painters with real imaginative insight. Yet on comparing this portrait with others of the period, produced in a similar context, the impression is certainly not dispelled. The freshness and quite individual manner of Sir Nathaniel Bacon, which in a very real sense inaugurated (despite the obvious Utrecht influence) a more or less new and native manner of painting in England, is undeniable. Yet the

---

[64] No. 6247. Souch was a Chester painter; see Ellis Waterhouse, op. cit., p. 38.
[65] London, National Portrait Gallery, no. 2142.

self-portrait already mentioned has an almost cloying (admittedly vigorous) wealth of detail. This was Bacon's taste, for patronage was not involved. It is a clear, un-blinking view of the physical world—but was it perhaps slightly reactionary in terms of methods, the descriptive realism almost self-defeating?

The relative freedom from tradition that can be seen in the *Montrose* is further emphasized when it is compared with Adam de Colone's *6th Earl of Buchan* (Plate 49), painted a year or two earlier.[66] De Colone's influence, though now perhaps fading, can still be traced in the composition and lighting and in the manner of conveying recession in the foreshortened side of the face, but the *Montrose* has a much greater feeling of solution-seeking, as opposed to the more certain, more authoritative style of the *Buchan*.

Cornelius Johnson's little panel of an *Unknown Man* in the Tate Gallery (Plate 56),[67] which must date from a year or two later than the *Montrose*, has many points of at least superficial resemblance: the handling is free and the manner of drawing into the facial features is also similar. Yet by comparison the handling has a greasy directness and the drawing a schematic simplicity which have little power of sugges-tion; and the collar is painted with a startling degree of detail which is quite old-fashioned and throws the picture out of balance.

These minor claims for Jamesone's creative capacity must be balanced against his curious tendency to regression. The calm, precise insight of the *Mary Erskine*, the gentle immediacy of the *Montrose*, were scarcely to be repeated. Falling between these two paintings is the bleak *Sir Thomas Hope* of 1627 (Catalogue, 18; Plate 46). The stiff, remote figure, derived perhaps from Gheeraerts or de Colone (it has much in common with his seated *1st Earl of Kinnoull*)[68] seems unwilling to quit the Jacobean world. No doubt Hope was old-fashioned and in that respect Jamesone has fulfilled his function, but it is scarcely a work of imaginative sympathy.

Belonging to the years immediately after the *Montrose* are the *Unidentified Man* (Catalogue, 32; Plate 61) and the *Lady Binning* (Catalogue, 31; Plate 60), both at Oxenfoord. They appear so much painted to a formula that there is a temptation to feel that Jamesone had already tacitly taken advantage of de Colone's disappearance. Part of the formula was already present in the *Montrose* but here it has become mechanical. Allowing for the differences of the costume, the same compositional outline bounds the figures; the light spreads from exactly the same point, the shadows fall in precisely the same places and with the same emphasis. There is also a creeping gaucheness in the drawing and a carelessness of relative proportions.

In the *Montrose*, from which the pattern is taken, there is a sense of delight in the few vagaries that the costume suggested: the minute upward curve of the crisp lace on the edge of the collar, the loop in one of the two band-strings, the stiff creases

---

[66] See Appendix B, no. 23.      [67] No. T. 744.      [68] See Appendix B, no. 14.

between breast and arm with the consequent slight misalignment of the body slash, and the way in which light and shadow relate in the deep openings on the sleeves. On the other hand, in the *Unidentified Man*, making allowance for damage, it seems that even originally the costume must have been painted with a lack of excitement: the slashed openings on the doublet are little more than white lines, each given the same emphasis, and this has the effect of bringing the more distant arm too near to the picture plane. This adds considerably to the awkwardness which this arm, cut off just above the inside of the elbow, tends always to have in portraits of this pattern. The *Lady Binning* also illustrates these tendencies, especially if it is compared with the *Mary Erskine*: her costume completely lacks the interesting surface and colouristic richness of the earlier portrait; and the more complicated nature of the lace collar and fill-in, which cover the breast and shoulders, has deceived Jamesone into broadening the shoulders unnaturally, a tendency that was to recur in quite a number of later portraits.

The manner in which the vision of the earlier portraits has been watered down in these two later ones demands some explanation. At a personal level the evidence is perhaps too slight to draw any conclusions: in any case, these were years of hope for Jamesone, with marriage, and then his first three children still alive.[69] Montrose was painted in Aberdeen, and so almost certainly was Mary Erskine, the Countess Marischal (the Earl Marischal had a house in the town)—indeed the *Montrose* may owe some of its vigour and directness to the clear possibility that it was painted rapidly during the three days of the subject's visit to Aberdeen in early November 1629.[70] However, the history and probable identity of the two Oxenfoord pictures suggest that they were painted in the south of the country, and before Jamesone had in any way established himself there. It may be that the fall in quality is explicable in terms of his being peripatetic and his distance from the normal focus of his painting activities. From the point of view of patronage, there is no reason to believe that Montrose and the Countess Marischal would demand more 'style' than the others, though their possibly rather higher social status (at least in Jamesone's own eyes) may have played a part.

That the reasons for this variation in quality were external rather than internal is borne out by the portrait of Patrick Dun (Catalogue, 37; Plate 62) which was probably painted in 1631. Skinned and transparent as it now is, this portrait has a brooding power which looks forward to some of the striking statements of character in portraits painted about 1636 or 1637, such as the *Earl of Menteith and Airth* (Catalogue, 96; Plate 98) or the *Earl of Southesk* (Catalogue, 116; Plate 117). Indeed the forms would seem originally to have been put down on the panel with such precision that even what now remains of them is sufficient to imply what has disappeared behind a curtain

[69] See Documents, 16, 22, and 25.
[70] See Documents, 23.

of exposed wood-grain. Dun was personally close to Jamesone and this intimacy may well have called forth the deeply felt portrait that this must originally have been. It is of course seen to be a rather provincial portrait when one makes wider comparisons. It has much in common with portraits like Gilbert Jackson's *Robert Burton* in Brasenose College, Oxford, which is dated 1635 (Plate 63).[71] Jackson may indeed be seen as an English equivalent of Jamesone but he must have had experience of developments in London,[72] which only slowly filtered through to Jamesone, or were known fleetingly. Yet by comparison with the *Patrick Dun*, Burton is little more than a sprightly effigy.

## (v) EDINBURGH, 1633

In the years before 1633, when Jamesone's principal centre of activity shifted to Edinburgh, the vast majority of his sitters were members of the northern nobility, with a sprinkling of minor lairds or academic figures with whom he had personal links. The most obvious exceptions are the three portraits belonging to Lord Stair which probably represent members or connections of the Haddington family (Catalogue, 31–3; Plates 60–1) and a further group of three sitters, each known in two versions: the Lord Advocate, Sir Thomas Hope (Catalogue, 18–19; Plates 45–6), his son Sir John Hope (Catalogue, 20–1) and his daughter-in-law, Margaret Murray (Catalogue, 22–3). All of these were probably painted in the south of Scotland, where Jamesone's reputation was presumably spreading. The Lord Advocate is perhaps the most likely figure to have forged the connection between Jamesone and the Council of Edinburgh in 1633.[73]

Hope was the son of a leading Edinburgh merchant. He rose quickly in the law and by the late 1620s he had acquired a position of great influence in the realm and also in the affairs of Edinburgh. His relationship with Thomas Hamilton, the 1st Earl of Haddington (and a former Lord Advocate) is interesting in the context of patronage and Jamesone's appearance in the south. Hope acted for Haddington, like himself a denizen of the Cowgate in Edinburgh, when the latter was negotiating the purchase of the lands of Tyninghame in late 1627.[74] As has already been noticed,[75] Haddington (while still Lord Melrose) had had himself painted in 1624, presumably in London, by Adam de Colone. In 1618 he had been painted by Mytens or a painter in the

---

[71] See Mrs. R. Lane Poole, *Catalogue of Portraits . . .*, vol. ii, Oxford, 1925, p. 251.

[72] See Rachel Poole, 'Gilbert Jackson, Portrait Painter', *The Burlington Magazine*, vol. xx, 1911/12, p. 38.

[73] A member of the Council of Edinburgh in 1632–3 was 'Thomas Quhyt, armorer', who was one of the tenants in the building in which Jamesone had lodgings: see Documents, 65; see also Marguerite Wood (editor), *Extracts from the Records of the Burgh of Edinburgh 1626 to 1641*, Edinburgh, 1936, p. 114.

[74] See Rev. Robert Paul (editor), *Twenty-four Letters of Sir Thomas Hope*, Scottish History Society, 1893, pp. 95–103.

[75] See above, p. 58.

Mytens tradition.[76] On the later occasion he chose a painter who could provide him with a similarly sophisticated image: the fact that de Colone was a Scot by birth and upbringing was probably less important. On the other hand when Hope, with narrower horizons and little knowledge of painting, had his portrait painted in 1627, probably to mark his becoming sole Lord Advocate (the position had been shared), he chose Jamesone. He would be unlikely to look beyond Scotland; and any real choice he had would have been between de Colone (if still in Scotland), Jamesone, and those decorative painters who were capable of portraiture.

Hope, however, appears to have patronized Jamesone again, much later, in 1638.[77] When he misnames the artist 'William' Jamesone he probably reveals an intimacy with Jamesone's late brother William, who had practised as a writer in Edinburgh. As the contents of William Jamesone's library indicate, he was probably a man of some learning and capable of making an impression on Hope. It was perhaps through the agency of William that Hope made contact with the painter.

Jamesone's labours on Edinburgh's behalf in the town's preparations for the triumphal entry of Charles I when he returned to the land of his birth, where he was to be crowned King of Scots, must have added greatly to his contemporary fame, though the array of 'fancy' monarchs now has little aesthetic interest. The fact that he was able to undertake the work serves as a reminder that he had grown from the decorative tradition and that he still had contacts with decorative painters. It remains curious, however, to see someone who was capable of producing such a 'modern' portrait as the *Montrose* regressing to paint the bright, vapid images that these monarchs are, or more accurately, were (Catalogue, 40–65; Plates 67, 69–75).[78]

Such series are often associated with the more primitive stages of portraiture. There are a number of English precedents for groups of commemorative portraits, occasionally of ecclesiastical or scholarly figures or holders of particular offices, but usually of royal subjects. Among the latter type are the full-length kings on the choir stalls of St. George's, Windsor, the group of British kings from Baston House in Kent, and another series once in Kirkoswald Castle, all of the late fifteenth century.[79] The only surviving Scottish series from before the seventeenth century is the set of small panels depicting the Scottish Kings, James I to V.[80] They are quite impersonal in style, their surface textures and colour tending to associate them with heraldic painting, though there is some understanding of three-dimensional form. They seem to date a few

---

[76] In the collection of the Earl of Haddington. O. Ter Kuile, 'Daniel Mijtens', *Nederlands Kunsthistorisch Jaarboek*, vol. 20, 1969, p. 103, relegates it to an appendix of works not acceptable as by Mytens. Sir Oliver Millar, however, reaffirms his belief that it is by Mytens in a letter to the editor of *The Burlington Magazine*, vol. cxv, 1973, p. 330.

[77] See Documents, 53.          [78] See above, p. 27.

[79] See Edward Croft Murray, *Decorative Painting in England 1537–1837*, vol. i, London, 1962, pp. 14–16, 158–9, 174, 176; see also Eric Mercer, *English Art 1553–1625*, Oxford, 1962, p. 159, for some discussion of later manifestations of galleries of famous men.

[80] SNPG, nos. 682–6.

decades later than the death of the latest subject, James V in 1542; they may derive from manuscript illuminations. That they had antecedents is very strongly implied by what is known of the long history of the image of James III (Plate 67).[81] Were they perhaps part of a much larger series, extending the national history well beyond the reaches of memory? Are they perhaps a remnant of the series of 'effigeis of noble men and wemen' that decorated the streets of Edinburgh in 1579, at the entry of the young James VI? Their size and lack of carrying power might seem to rule this out, but the minute scale of burghal life at the time is a factor which makes this far from improbable.

The need for commemorative portraiture was deep-rooted and had an extended history. For the employment of a painter of Jamesone's status on this kind of work, there is some kind of parallel in Mytens having to produce for Charles I portraits of Margaret Tudor, James IV, and Mary, Queen of Scots;[82] even Van Dyck had been obliged to devise a portrait of James VI and I from a Van Somer prototype.[83] These, with the apparent exception of the *James IV*, were full-lengths; they were also full-blooded images in a sense that the vast majority of Jamesone's decorations were not. In the final analysis Jamesone's monarchs, or more precisely those of them which seem to be pure invention, have much more in common with the tempera decorations of ceilings in the larger Scottish houses. These simple faces with their long, curling moustaches and staring eyes are much nearer in type to the nine full-length nobles astride the ceilings at Crathes (Plate 18), or the mounted monarchs rearing above the blue fields of the ceiling at Stobhall (Plate 76).[84] Their vermilion or pale green draperies, with accents of cerulean, belong so much more to the heraldic painters' repertory of effects that Jamesone's use of chiaroscuro seems almost an intrusion. The armoured heads and bodies of some of these kings are quite surprisingly close to the 'parochial-classical' warriors who besiege Troy on the coved ceiling of Cullen House (Plate 77);[85] and this strain of classical imagery was strongly present in the general presentation of the pageants and decorations that welcomed the King.

The tantalizing records of a servant of Jamesone's working for the space of twenty days on the scaffolding erected in the King's gallery of St. Giles, and of a John Levingstoun supplying books of gold-leaf and varieties of oil-paint,[86] would seem to suggest that Jamesone had helpers in his part of the undertaking. This would not be

---

[81] See below, p. 100.

[82] See Oliver Millar, *The Tudor, Stuart and Early Georgian Pictures in the Collection of Her Majesty The Queen*, London, 1963, pp. 16, 84–5. The *James IV* (canvas, $37\frac{7}{8} \times 24\frac{1}{2}$ in.), formerly in Charles I's collection (see Oliver Millar, op. cit., p. 84), is now in the collection of Col. W. J. Stirling of Keir.

[83] See Oliver Millar, op. cit., pp. 92–3.

[84] See A. W. Lyons, 'Tempera Paintings in Scotland during the Early Part of the Seventeenth Century', *Proceedings of the Society of Antiquaries of Scotland*, vol. xxxviii, 1904, pp. 162–3.

[85] See also M. R. Apted, *The Painted Ceilings of Scotland 1550–1650*, Edinburgh, 1966, frontispiece and plates 38 and 57: this book is a useful, well-illustrated, brief survey of the work of the decorative painters.

[86] See Documents, 29.

surprising, as at this time the number of monarchs credited to Scotland was 109 and it seems unlikely that the mystic significance could be realized by only a selection. Yet Jamesone's hand is perfectly in evidence in the surviving twenty-six, some of them signed, which may either mean that he did in fact provide them all himself (hence the 'extraordiner paynes' for which he was paid) or else that only those from his own hand were preserved. However, the payment of sixty dollars, about £168, made to Jamesone on 23 August 1633[87] seems unlikely to be the whole payment, for even for twenty-six pictures this represents a remarkably low price per painting— about half of what he would charge Sir Colin Campbell in 1636 for an unframed waist-length portrait. The nature of the work makes this just feasible.

On the same occasion and for the same reasons the leading decorative painters were active in Edinburgh, but under the jurisdiction of the Master of Works. One can now only guess at the nature of their work, but there was certainly feverish activity in the Castle and in the Palace of Holyroodhouse (which was in the burgh of Canongate). John Anderson painted the Council house at Holyrood, for which he was paid £290; he was also paid a further £116 for 'bywarkes . . . besyde', which is disappointingly vague.[88] John Sawers was being paid on a similar scale 'for paintrie work done be him at the castell of Edinburgh';[89] while Robert Telfer was active in the cold rooms of Holyroodhouse, where, between 22 April and 20 May, he was provided with five loads of coal.[90] In early June James Workman was paid for 'gilting painting and furneisching of gold and oyle to ellevine double badgis gilt on both sydes and also for quhytting and graying of four rowmes in my Lord Marqueis [of Hamilton] luidging [in Holyroodhouse] and for gilting of nyne theanes . . .'.[91] Also involved, though probably to a lesser extent, were Mungo Hanginschaw, who was brought from Glasgow, and the Englishman Valentine Jenkin.[92]

These painterly preparations were not confined to Edinburgh, for the King was to visit the other royal palaces. At Linlithgow for instance, although one cannot envisage the end product, the whole action can be followed in rather touching detail:[93] a boy carries a letter to Edinburgh to summon the painter, Alexander Law (earlier in the year Law had been paid by the Council of Edinburgh 'In Arles [that is, earnest-money] to attend the penting of the staiges');[94] he now arrived at Linlithgow to paint the King's throne. It is interesting to note that all his materials were provided by the John Levingstoun who supplied Jamesone's assistant when working in the King's gallery at St. Giles. These materials included twelve ounces of 'best blew', eight ounces of vermilion, red-lead, 'caddes' (cotton waste) and ten books of gold-leaf— for these the boy, again, had to run between Linlithgow and Edinburgh.

[87] See Documents, 32.    [88] SRO, Accounts of the Masters of Works, vol. xxv, fo. 45v.
[89] Ibid., vol. xxviii, fo. 29v.    [90] Ibid., vol. xxv, fos. 19, 31.    [91] Ibid., vol. xxv, fo. 38v.
[92] Ibid., vol. xxv, fo. 9v.    [93] Ibid., vol. xxvi, fo. 12v.
[94] ER, Town Treasurer's Accounts 1623–1636, p. 858.

Unfortunately, the accounts do not give much information on the actual appearance of this kind of work, once it was completed. It was probably, however, very much of the type of work done by Valentine Jenkin at Stirling Castle in 1628, which is more clearly recorded and some of which survives (Plate 78). Jenkin's instructions requested 'the kingis bedchalmer the window brodis [boards] hie and low to be layit over and set af and the armes and letteris to be set af in thair awin cullouris with gold and aisser and the borderis to be helpit and the dores and chymnayis to be marbillit and the pend of the windowes and skenschonis to be weill layit over with ane blew gray ... the haill pannallis of the sylring [of the low gallery] to be layit over in ane fresche cullour ... the pannallis [of the Queen's chamber] above the hingingis round about the sylring to be fair wrocht with armes [and] antikis ...'.[95] This work was clearly an amalgam of arms, natural and abstract motifs, and debased classical imagery.

One tantalizing record of Charles I's visit remains to complete this attempted reconstruction of that part of the visit concerned with painting, in which Jamesone had played a central role. On 8 July, soon after the King's departure, the Master of Works paid someone 'for carying of the kinges fyve pictures out of the abay to Leith'.[96] Were these pictures which the King had brought with him or were they pictures he had acquired in Scotland? Were they portable religious pictures or were they portraits? The vital question is, perhaps, were they contemporary and local pictures in any way connected with the royal visit? Unfortunately, these questions remain unanswered.

## (vi) SIR COLIN CAMPBELL; THE ADVENT OF MICHAEL WRIGHT

Sometime in the late summer of 1633 Jamesone made his only recorded journey outside his own country—a visit to London which lasted little more than three weeks, including the time spent on travelling. It is difficult to draw conclusions from the nature of the men who accompanied him, Jaffray, Birnie, and Robert Skene, though the last was a painter and glasswright, probably on the lower levels of the craft.[97] It is improbable, however, that this visit to London was as isolated as it seems. In 1636, for instance, Jamesone would take as apprentice Michael Wright, the son of a London tailor, while, at a much later date, in 1675, we find Jamesone's daughter and his grandson George Alexander in the midst of what appears to have been a little Aberdonian community in London.[98] The journeyings of apparently insignificant individuals like Jaffray, Birnie, and Skene should probably be seen as parallel to the frequent comings-and-goings of the nobility; it would be mistaken to think of London being a vast distance from Scotland.

[95] SRO, Accounts of the Masters of Works, vol. xxi, fos. 30–2.          [96] Ibid., vol. xxv, fo. 45v.
[97] See above, p. 27.          [98] See above, p. 43, note 171.

There is no hint as to why Jamesone visited London on this occasion. Perhaps a result of the visit is the rather more pronounced evidence of influence from Cornelius Johnson in two portraits painted in 1634, the round, simple, *Countess of Airlie* (Catalogue, 66; Plate 79) and the quite creamy *Marchioness of Argyll* (Catalogue, 69; Plate 80). Van Dyck had been in London for rather more than a year, but there is really no indication of any kind of influence from this source, either in work done immediately after the visit or at any later time in Jamesone's career.

Apart from the portraits mentioned, and one or two others, there are no very revealing records of Jamesone's activities until October 1634, when he was about to come under the extensive patronage of Sir Colin Campbell of Glenorchy—he appears, however, to have been in Aberdeen until the spring, and again in the winter of the year.[99] There is no Scottish parallel to the nature and extent of the commissions which Jamesone was to receive from Campbell in the course of the next two years. The type of collection which Campbell set out to create is, however, presaged in England by, especially, the vast portrait collections of Lord Lumley which were installed in Lumley Castle towards the end of the sixteenth century.[100]

Campbell must have been motivated to a great extent by the spectacle that Jamesone had created in Edinburgh for Charles I's triumphal entry in 1633. His first step was the creation of a gallery of Scottish monarchs, which must have aped the public display. These were painted, as we have seen, not by Jamesone but by the crude and forthright 'Germane painter'. Campbell then continued at a personal level with a series of his own progenitors, or 'predicessors'. These are bright, solidly and coarsely painted images with little individualization, the subject placed behind an oval band inscribed with his identity (Plate 81).[101] Though probably only a result of their type and function, visually they are near to the mural portraits illustrating the history of learning in the Bodleian picture gallery, painted about two decades earlier (Plate 82).[102] It is difficult to connect the German painter's work with any known Continental style: it has a certain vacuousness which can be recognized in a variety of contexts where work of this type was produced.

In his series of thirteen monarchs (now largely lost) and in the eight ladies of Glenorchy which Jamesone provided as pendants to Campbell's male progenitors, he accepted for the first time the form of the painted oval. In style the ladies fall somewhere between his Edinburgh monarchs and his conventional portraits. They are painted with some verve; the quite bright primary colours often seem included purely for their own sake, that is, decoratively. Hands are introduced, something Jamesone normally tried to avoid; the fingers are long and thin, and curve with a

---

[99] See Documents, 78 (25–30).

[100] See Lionel Cust, 'The Lumley Inventories', *Walpole Society*, vol. vi, 1917/18, pp. 15–50.

[101] See above, p. 29, note 101. This group was dispersed at the Invereil House sale on 3 March 1969.

[102] See *The Bodleian Library Record*, vol. 3, October 1950, no. 30, pp. 82–91 (J. N. L. Myres); vol. 3, August 1951, no. 32, pp. 201–7 (E. Clive Rouse); vol. 4, April 1952, no. 1, pp. 30–51 (J. N. L. Myres).

mannered, almost Baroque elegance. It may indeed be as a result of a need to explain certain odd stylistic features of these pictures that the legendary apprenticeship of Jamesone to Rubens was conceived. Comparing what is perhaps the best of the group, the pink and silvery *Marjory Stewart* (Catalogue, 71-(i); Plate 83) with the Rubens studio portrait of about 1620 of his wife, Isabella Brant, at The Hague (Plate 84),[103] one finds the same rather swaggering draperies, and fingers with the same curving sinuousness: these are features which could be taken from engravings. There is also a sense in which Jamesone's thin, swiftly brushed backgrounds seem to derive from Rubens, at what remove it is difficult to say. There is in these pictures, as in the best of his other works, a basic interest in form as constructed by colour and light, by summary rather than painstaking depiction of detail which, though comparatively trivial in the final result, does link his manner with the development of Baroque painting and its Venetian beginnings. Yet the Glenorchy ladies also have a quite patent *naïveté*. In two only is there a move towards a more concrete image: the *Marjory Stewart*, where the idealizing process appears to have had some interest for the painter (the subject bears a quite strong resemblance to Jamesone's wife (see Catalogue, 114; Plate 85)); and the *Katherine Ruthven* (Catalogue, 78-(6); Plate 90), a subject who had died in 1588 and whose traces of individuality may have been inspired by some already existing image.

These were the beginnings of the busiest years in Jamesone's life. This is epitomized by the urgency of the request of Campbell's agent in Edinburgh that he should quickly confirm his acceptance of Jamesone's conditions, 'For les he sweiris to me he can not teike'.[104] He must have been resident a good deal of the time at this juncture in Edinburgh, though the evidence is not definite until May of 1635.[105] Yet in this same month Jamesone acquired the Playfield in Aberdeen, which in the next few years he was to erect into an ornamental garden,[106] an activity which has a Flemish, even Rubensian, ring to it. He is now clearly something of the grand man, a potential benefactor of a unique place to his native town. His letter of 13 October 1635 to Campbell of Glenorchy does, however, give the impression that he had settled semi-permanently in Edinburgh, for he speaks of the north in terms of 'quhair I mynd to stay for tuo monethes'.[107] He had by this time agreed to undertake the series of portraits of living sitters, those which the Balloch inventory of 1679 describes as 'noblemen all which are Descended of the family of Glenvrchy'.[108]

All that certainly survives of the group of at least eleven portraits are the rather feeble *3rd Earl of Haddington* (Catalogue, 95), the *7th Earl Marischal* (Catalogue, 94; Plates 95–7), the *Earl of Menteith and Airth* (Catalogue, 96; Plate 98) and the *Baron Napier* (Catalogue, 97; Plate 98). The portrait of the Earl Marischal shows an ease and fluidity, an immediacy, which the portrait of his mother Mary Erskine, Countess

---

[103] Royal Picture Gallery, Mauritshuis, no. 250.    [104] Documents, 39.    [105] Documents, 42.
[106] See above, pp. 33-4.    [107] Documents, 46.    [108] SRO, GD 112/22/4.

Marischal (Catalogue, 9; Plate 39), painted ten years earlier, tends to lack. It is, however, a rather less profound portrait—though it seems to express admirably the rawness and precipitancy of this youth about to be involved in violent political upheaval. It also lacks the surface richness of the earlier portrait, though this must be balanced against the delicacy of handling of the very thin pigment and the subtlety with which the silvery light is brushed around the figure and into the forms. The compositional type is well established: cut off at the waist, wide shoulders despite the foreshortening, the right arm and shoulder forward, the left sloping steeply to the bottom right of the picture, and the head held straight but turned slightly more towards the spectator than the plane of the body; light flows across the right arm from the left side, leaving the typical broad bar of carefully modulated light on the right breast.

The formula is followed in the *Napier* and in the *Airth*. Despite damage and discolouring varnish, both heads retain a considerable power; indeed they are far more forthright images than, for example, the tentative *Lady Binning* (Catalogue, 31; Plate 60) and *Unidentified Man* (Catalogue, 32; Plate 61) of just a few years earlier. The intense, brooding face of Airth is quietly compelling, and the small ruff allows the structure of the body to be more clearly perceived than in the case of Napier. Indeed, the parts of the picture have been integrated with feeling, and it has a formal sophistication which gives some justification for comparing it with a contemporary portrait by Miereveld. The latter's *François van Aerssen* which is dated 1636 (Plate 99)[109] is of exactly the same format, both in linear composition and in terms of lighting. Jamesone never had the sure grasp of bone and muscle structure in the face that Miereveld had, nor indeed could he integrate colour into a design in the way that the green and purple patterning on van Aerssen's right arm is made part of the whole picture. Yet he comes remarkably close in this instance to arriving at an effect that Miereveld and his school could produce with ease. This spectacle of a remote provincial painter in the north of the British Isles producing work which, if only for a moment, seems to stand in some proximity to a sophisticated Dutch model, leaves unanswered questions about the sources of Jamesone's eclecticism.

The *Glenorchy Family Tree* (Catalogue, 93; Plate 94), which is dated 1635, is not mentioned in any of the documents which throw a fitful light on this phase of Jamesone's career. In view of what has just gone before, it seems to represent another example of regression on Jamesone's part for, at a certain level, this immense collection of genealogical information set out on brightly coloured discs held in the branches of some strange kind of cherry tree has, despite the portraits included, more in common with the art of the herald painter. It again illumines Jamesone's decorator origins, and his flexibility. In terms of scale and inventiveness, it has no Scottish

---

[109] The Hague, Royal Picture Gallery, Mauritshuis, no. 750.

counterpart.[110] That someone who had established the relatively new art of portrait painting in Scotland, and had by this time painted many of the leading figures in the country, should be required to do this work, shows, in comparison with England, the very different conditions prevailing north of the border. Although the English painter (with the exception of Van Dyck) was still regarded as a craftsman, it is inconceivable that painters like Mytens or Johnson, or even Jackson, would be asked to undertake such a painting, or indeed would be capable of doing it.

In the midst of these undertakings for Campbell of Glenorchy, on 6 April 1636 Jamesone took what was apparently his first apprentice, Michael Wright.[111] Wright really belongs to a different generation of painters and was to be noteworthy in post-Restoration England for being a native painter practising among a continued influx of foreign painters. In this, and seemingly in this sense only, can he be seen as a continuator of a tradition represented by Jamesone.

One picture which must date from soon after Wright's appearance in Edinburgh is the curious conversation piece, the *Haddington Family Group* (Catalogue, 130; Plate 101). The compositional devices and the drawing it required were beyond Jamesone's abilities. Structurally it has a distant kinship with the large Mytens of *Charles I and Henrietta Maria departing for the Chase* at Hampton Court (Plate 102);[112] in mood and drawing it has an affinity to the quaint, naïve group of the royal family engraved by William Marshall (Plate 103).[113] It is also in a picture like this that Jamesone comes closest in feeling to the work of Gilbert Jackson. The figures of the two brothers on the extreme left have the same unsure pose and primitive drawing of Jackson's full-length of a child, the *William Hickman* of 1634 (Plate 104). In the Haddington picture, though the round forms are treated with a more modern chiaroscuro, the drawing is if anything more ill-conceived in respect of the articulation of necks, hands, and legs. The bright, almost pretty colour and the failed grandiosity are features that appear in Jackson's strangely domestic full-length *Lord Belasyse*, which bears the date 1636 (Plate 105). The provincial qualities of the Haddington group are, however, most closely paralleled by a much larger picture, *The Salusbury Family*,[114] probably painted about 1640 by an unknown painter active in the Welsh Marches. In this the figures are in some ways marginally more accomplished but in other respects it has an airless, metallic quality.

[110] David Piper has pointed out to the writer that it is a very late variant of the Tree of Jesse theme, of which there are a number of earlier English examples (e.g., the family-tree of Sir Nicholas Bacon of 1578, illustrated in colour in his *Personality and the Portrait*, BBC Publications, 1973, p. 22). This measures $25\frac{1}{4} \times 20$ in.; a later, rather larger ($34\frac{5}{8} \times 26\frac{3}{8}$ in.) Scottish version is the Neaf family-tree, dated 1616 'Apud Edinburgh', in Stockholm, Statens Historiska Museet.

[111] See Documents, 48.

[112] See Oliver Millar, *The Tudor, Stuart and Early Georgian Pictures in the Collection of Her Majesty The Queen*, London, 1963, p. 86.

[113] See M. Corbett and M. Norton, *Engraving in England*, Part III, Cambridge, 1964, pp. 108–9.

[114] Exhibited London, Tate Gallery, *The Age of Charles I*, 1972, no. 149: see Oliver Millar's catalogue of the exhibition, pp. 94–5.

The open background of Jamesone's group is, however, remarkably successful, the near tree and the distant woods painted in finely modulated greens and browns, the sky in quite intense harmonies of yellow, pink, and varied warm greys. These soft harmonies and the low horizon are features which recur in Michael Wright's painting. Wright's favoured sky of low horizontal bars of pink, rather abruptly overlapped by broader bars of grey, is very close to the sky in Jamesone's picture. Was Wright in any way responsible for this apparent development in Jamesone's art, or did the younger painter derive it from his master? The full-length *Earl of Dalhousie*, here attributed to Jamesone (Catalogue, 106; Plate 100) and perhaps a year or two earlier, does show an undoubted ability on Jamesone's part to open up the rear of the picture space, though the rendering of the landscape is here more literal, less expressive of mood.

Looking at Wright's masterpiece, the *Colonel Russell* of 1659 (Plate 106)[115] with its grand elegance of pose and its minute elegance of treatment of surfaces, its brilliantly controlled colour scheme of ochre, orange, and vermilion, one is certainly aware of moving in a quite different sphere of sophistication from the humble stereotypes that Jamesone's portraits often are. Yet a similar cast of features, a similar rather sensual arrogance can be detected in Jamesone's *Earl of Menteith and Airth* (Catalogue, 96; Plate 98). The slightly flattened head that is just discernible in the *Colonel Russell*, the rather long, rather large, lemon-shaped eyes, that are so characteristic of Wright, may just conceivably be derived from Jamesone's influence. And despite his eventual knowledge of the most progressive artists of the seventeenth century, it could be from Jamesone that he gained an early understanding of a plastic, non-linear treatment of form.

Of the still small, but increasing number of portraits probably painted in Scotland in the late 1630s and early 1640s which are decidedly not by Jamesone, the most interesting in the present context is another Haddington portrait, a near half-length of the young, future 4th Earl of Haddington (Plate 107). He wears armour, the surfaces of which are treated with that almost loving attention to texture and minor detail which is typical of Michael Wright's later paintings. The face is quite simple but is seen with delicacy, the rather thin, creamy paint slowly exploring the forms. The outlines of the eye openings have the large, flattened oval shape which was to become a feature in Wright's portraits, the contours joining to a quite precise point towards the centre of the face, but finishing rather vaguely apart on the outside. The sky background is almost identical to the imminent sunrise in the *Colonel Russell*.

On the stylistic basis of his later work, it is the only known painting from these years which can be ascribed to Wright; and the implication is, of course, that he in fact completed the period of his apprenticeship and practised independently in Scotland,

[115] Victoria and Albert Museum: exhibited in Ham House.

for a short time at least. It may be that his hand appears, though indecipherably, in some of Jamesone's own paintings of the period of the apprenticeship.

## (vii) SELF-PORTRAITS AND LAST PORTRAITS

As a visual counterpart to Jamesone's reputation in the mid-1630s there exists a group of four self-portraits, none surviving, unfortunately, in anything like prime condition. The least altered, and that from which the others perhaps derive, is that which still remains in Aberdeen (Catalogue, 111; Plate 1). The painter, holding a miniature portrait of a woman in his right hand, turns from it towards the spectator. Apart from the hand and the wide-brimmed hat, the overall pattern of this picture does not vary greatly from his commissioned head and shoulder portraits, though there is a faint spiralling movement within the figure caused by the slight forward tilt of the head. The much smaller self-portrait in Edinburgh (Catalogue, 113; Plate 111) follows this, though the hand holds gloves in place of the miniature, but it is so restored as to be perhaps nearer the work of John Alexander, who restored it, than Jamesone himself.

Quite different, though Jamesone's own figure tends to be repeated, are the *Self-portrait with Wife and Child* at Fyvie (Catalogue, 114; Plate 85) and the *Self-portrait in a Room hung with Pictures* at Cullen (Catalogue, 112; Plates 108 and 109). The former of these has been completely repainted but apparently with enough understanding of the original image, and with enough skill of a sort, for it to retain its interest as a document with personal and social implications. The subject of the picture is in fact Isobel Tosche rather than Jamesone himself. Her central role is significant and would appear to point to an esteem beyond the mere rights and apparent equality granted to her in the marriage contract and other documents.[116] The admittedly suspect evidence of the portrait is also that she was a physically impressive woman, and that Jamesone (as Rubens) makes great play of presenting his prize to the world's scrutiny. Sometime after this portrait was painted Jamesone, as we have seen,[117] was chosen to act as a minor diplomat for the city of Aberdeen in its dealings with the forces of the Covenant. Did he, as a man of this social eminence, intimate with the leading noble family in Aberdeen, creator of an ornamental garden within the town when such a thing was a rarity within the kingdom, owner of many houses in the town and an estate outside, capable (in 1643) of lending a large sum of money to the High Constable of Scotland, and married to a beautiful and much younger wife, feel himself to be another Rubens? No positive answer can be given, but these facts and the evidence of the self-portrait make this distinctly possible, no matter how tenuous and second-hand his knowledge of Rubens might have been. It was, after all, almost an artistic

[116] See above, p. 22.
[117] See above, p. 37.

fashion to ape Rubens: both Van Dyck and Lucas Vorsterman had done so.[118] In this way the legendary association with Rubens, first given clear shape by Walpole, would have some further grounding in reality.

The Cullen *Self-portrait* is expressive of the same or a similar pretension. The implication is that the portraits ranged on the rear wall, as well as the two landscapes and the picture of a *Chastisement of Cupid* (Plate 109), were actually painted by Jamesone, though they may in fact reveal him as a dealer in pictures; there is, however, no other evidence for this.

The year 1637 seems to have been the busiest in Jamesone's productive life, and while there is evidence intermittently from then until his death that his standards were capable of dropping catastrophically, there are also portraits which bear comparison with his early masterpieces, the *Mary Erskine* and the *Montrose*. Foremost among these are the companion portraits of the three Carnegie brothers: the *1st Earl of Southesk* (Catalogue, 116; Plate 117), the *1st Earl of Northesk* (Catalogue, 117; Plate 118), and the *Sir Alexander Carnegie of Balnamoon* (Catalogue, 118; Plate 119). The first and last of these are especially potent; they are in the same mould as the earlier *Dr. Patrick Dun* (Catalogue, 37; Plate 62), but are in much better physical condition. Southesk seems to seethe with a latent energy, his massive, firmly constructed head set off by the extreme delicacy of the painting of his ruff. The portrait of his brother, Sir Alexander Carnegie, is perhaps marginally less compelling, but shows the same grave delicacy. Both are painted in terms of a quite broad chiaroscuro, the light lingering, perhaps to a formula but effectively, on upper arm, right breast, and the favoured detail of band-string tassels; the collars and faces are more fully lit, the bone structure of the heads given an almost blade-like exactness without recourse to line. It is in the face of such accomplishment that one views with some dismay a quite vacuous portrait of the 4th Earl of Haddington (Catalogue, 129), which must date from about the same time.

Also painted in 1637 is the unusually expressive portrait of Sir William Nisbet of Dean (Catalogue, 122; Plate 121). It is a particularly direct, unflattering look at a fat, red-faced burgher, the wateriness of the eyes and the faint smile traced with economy and sympathy. Each form has a quality of consistent roundness, the whole treated with that same freedom one can see in the *Montrose* of a decade earlier. Indicative perhaps of a more mundane aspect of patronage is the Jacobean importance given to the large coat-of-arms placed unceremoniously in the upper right quarter of the picture. Its sheer spirit transcends its provincialism; here is something of a truly native manner, something which anticipates the direct, earthy quality of the Tradescant

---

[118] See Julius S. Held, 'Rubens and Vorsterman', *The Art Quarterly*, vol. xxii, 1969, pp. 111–29, for a convincing discussion of this subject, with reference to Van Dyck's portrait of Vorsterman in Lisbon, Vorsterman's own engraving after it and Van Dyck's etching of Vorsterman for his *Iconographia*; he concludes: '... what is inescapable is the conclusion that Vorsterman used various devices to look like Rubens'.

portraits at Oxford, and particularly that of *John Tradescant the Younger as a Gardener* (Plate 122):[119] like this, its qualities are not best understood if it is discussed purely in terms of either foreign influence or provincialism. Jamesone, however, could not leave his formula far enough behind him, or vary it enough, to be able to produce portraits quite so brilliantly eccentric, as formally uninhibited, and as freshly moving as the Tradescant portrait.

How this burst of activity might have continued had the political situation in the country not deteriorated so disastrously is difficult to say. Jamesone was now a rich man and his activities would perhaps have lessened for this reason. His pre-eminence in producing what the limited sensibilities of his patrons required apparently inhibited the appearance of other portrait painters. The conclusion seems inevitable that some of the many decorative painters were capable of developing in this direction and that they were responsible for some of the portraits which, although close to Jamesone, cannot be accepted as by him. Nevertheless, throughout the twenty-four years of his active life, written records point to only three other painters certainly producing portraits, Adam de Colone, the so-called 'German painter', and Jamesone's own apprentice, Michael Wright. The intriguing document already discussed,[120] the letter written by Sir John Grant of Freuchie at the end of 1634 to Jamesone's former master, John Anderson, just fails to reveal the kind of information sought for, the authorship of the four portraits in Anderson's possession.

The political situation, however, blurred whatever possibilities were inherent, both in the passage of time and in Jamesone's abilities. The upheaval, as has been seen, [121] struck Aberdeen harder than most other parts of the country. In the circumstances that the Privy Council roll of delinquents aptly summarizes, the demand for portraiture dwindled. Yet Jamesone once more confronted that central figure, Montrose, painting (perhaps in England) the now much altered portrait dated 1640 (Catalogue, 133; Plate 120). With the successive deaths of his sons, there may also be a sense in which Jamesone's own vitality dried up. This is what one is tempted to read into the vague, ephemeral, later Henderson portraits (Catalogue, 137–8). The two Glenorchy portraits of 1641 and 1642, the *Sir Robert Campbell* (Catalogue, 140; Plate 123), and his son *Sir John Campbell* (Catalogue 141; Plate 124) do represent a rallying, and this perhaps stresses the psychological aspect of Jamesone's deterioration, for they after all represented a secure link with the near past of Sir Colin Campbell and the paintings which his patronage had inspired.

The period seems to end in fragments. Two portraits alone now represent the last two years of Jamesone's life: the *Anne, Countess of Lothian* (Catalogue, 143; Plate 125), and one which is almost certainly the companion portrait of her husband

---

[119] See *Catalogue of Paintings in the Ashmolean Museum*, Oxford, 1961, pp. 43–5. John Tradescant, the younger, was born in 1608 and died in 1662.
[120] See above, p. 52.     [121] See above, pp. 34–9.

(Catalogue, 144; Plate 126), both dated 1644. In this, the first climactic year of the revolution, it was perhaps only a family like the Lothians, whose taste ran in the direction of Continental painters like Louis-Ferdinand Elle and Miereveld,[122] who would have a strong enough interest in art to continue seeking pictures. Jamesone, though his talents had dissipated, was perhaps the only painter available. The portraits in question are loosely constructed, broadly painted but flat, latent faults in the drawing of earlier years no longer latent. There is a sense of breaking up; his art, though perhaps from causes only indirectly related, is an analogue of the breaking up of the social order of these years.

The last record of Jamesone as a living man[123] seems to continue the symbolism: a damaged baptismal entry from which his child's name has vanished, a record where Jamesone appears for the last time identified by only two syllables of his name; clearly identified indeed only by the presence of the name of Isobel Tosche, whom Jamesone himself had perhaps seen as part of that legendary status he had attained in his own lifetime.

[122] See SRO, GD 40/Portfolio XVIII/1/2 and 22.     [123] Documents, 68.

# CATALOGUE RAISONNÉ

THE Catalogue includes all those pictures of which I have knowledge and which I believe to be the work of George Jamesone. Nearly all of these have been examined personally. Paintings known only in photographs have been included only when it was felt certain that examination would confirm the evidence of the photograph. A few paintings have been included solely on the strength of contemporary documents. Inclusion therefore does not necessarily mean that the picture is known to still exist. Of the 144 items included in the Catalogue, nineteen are categorized as lost pictures: the names of these (mainly pictures painted for Campbell of Glenorchy) are printed within quotation marks. Unfortunately, even during the period in which the Catalogue has been compiled, some of the most interesting groups of Jamesone's pictures have been dispersed from the collections in which they had been since they were painted in the seventeenth century: these include pictures formerly in the Rothes, Breadalbane, and Lothian collections. Consequently, though not categorized as lost, the present location of some pictures which have been examined quite recently, as well as those others included on the strength of records made since about 1939, is not known. The Catalogue entries (and details of pictures mentioned in the main text) are as accurate as possible up to July 1973.

Inscriptions are assumed to be contemporary, unless qualified by the word 'later'. If the subject's name is preceded by the word 'called', there is a specific doubt as to the traditional identity. The arrangement of pictures is basically chronological on the framework of firmly dated works.

1. *Sir Paul Menzies of Kinmundy* (1553–1641)
Canvas: 29 × 24¾ in. (Plate 20).
Coat of arms top left surrounded by initials: *SPM*; inscribed beneath: *Kinmundy/VIVE VT VIVAS/Anno 1620/Ætatis 67*. Inscribed (later) bottom right: *No. ii*.
*Collection*. Marischal College, University of Aberdeen.
*Provenance*. Unrecorded before 1781 (Earl of Buchan's MS.) but probably in the College since the 17th century.
*References*. Earl of Buchan's MS., p. 10: 'Sir Paul Menzies (Marischal College)' in list of Jamesone's works; Carnegie to Musgrave, fo. 124v.; Bulloch, p. 59 and no. 23; Sir William Geddes (editor), *Musa Latina Aberdonensis*, vol. i, New Spalding Club, 1892, p. 138 and plate opp. p. 140; *Description of the … Portraits … in … Marischal College*, Aberdeen, 1896, no. 166; Brockwell, p. 34.

The inscription, like much of the picture, has been strengthened. There is much discoloured varnish; the face is now a rather warm orange, the mouth and ear almost vermilion. The doublet area is obscure but it has wings and perhaps sham hanging sleeves. It is a stiff and angular portrait compared with Jamesone's work of the late 1620s and the 1630s but the rather small head, the forms of the eyes, the outline of the figure and its relationship to the picture area are characteristics of work of that period.

Jamesone may have been connected by marriage to the powerful Menzies family. On 24 May 1623 Paul Menzies was witness at the baptism of a son of William Menzies and an Isobell Jamesone (GRO(S), Parochial Registers, 168A, vol. 2, under date). In 1630 Menzies was godfather to Jamesone's son Paul (Documents, 25), and in 1634 they appeared together as godfathers at another baptism (Documents, 78(25)).

Menzies represented the conservative faction in Aberdeen politics (see p. 35). His tombstone is in St. Nicholas Church and records that he was eighty at the time of his death in December 1641 (see *Scottish Notes and Queries*, Aberdeen, 1888, vol. i, p. 52).

2. *James Sandilands* (b. *c.* 1587)
Canvas: 26¾ × 21¼ in. (sight). (Plate 22).
Inscribed top left: *Anno 1624/Ætatis 37*; and upper right at forehead level: *SPLENDENTE VIVO_/SECEDENTE PEREO_*; above this are painted a pink and a sun-in-splendour.
*Collection*. King's College, University of Aberdeen.
*Provenance*. Probably in the College since painted.
*References*. Carnegie to Musgrave, fo. 124v.: 'Professor Sandilands King's College Aberdeen'; Bulloch, no. 15; Brockwell, p. 34.

The compound ruff with regular sets is rather old-fashioned for the date. The face is generally warm, the forehead less so; there is a narrow area of pale grey/green round the head. There is an area of damage along the top edge, the right side of the head has been holed and repaired, the sun-in-splendour has been damaged and repainted in parts and there are other small areas of damage. Two vertical joins in the canvas about 1½ in. apart run from top to bottom, passing through the centre of the face.

Rather tight in handling, stiff in pose and not sure in drawing or expression, this is nevertheless the most interesting of Jamesone's early works. It has more assurance than the *Sir Paul Menzies* (Catalogue, 1; Plate 20) but lacks the simple ease of *Mary Erskine* (Catalogue, 9; Plate 39). The unaltered calligraphy of the inscription top left should serve as a standard for comparison.

Sandilands, a doctor of civil and canon law, was Rector of King's College in 1623. He was clerk to the General Assembly of the Church, but in Glasgow in 1638 he was replaced by Johnston of Wariston because he was 'aiged and had excused himself by sicknesse'.

3. *Unidentified Man*
Canvas: 27 × 21½ in. (Plate 29).
Inscribed top left: *Anno* (remainder indecipherable).
*Collection*. John Forbes-Sempill, Esq., Craigievar Castle, Aberdeenshire.
*Provenance*. See below.
*References*. Probably Bulloch, no. 170 (collection of Lord Sempill at Fintray House).

Painted on a noticeably rough-textured canvas and quite rubbed. The very rubbed shadow on the ruff below the chin could conceivably be a reduced beard: Bulloch probably read it as such. The complexion is rather dark but the face is finely modelled by carefully placed highlights which are rather grey/blue in colour. The hesitant

outline of the figure is of a kind that was to become typical of Jamesone.

The sitter has traditionally been identified as William Forbes (d. 1627), father of the 1st Baronet of Craigievar, but this is impossible as he was already a man of substance by 1610 when he started the final building phase of Craigievar. The present portrait must be dated in the early 1620s. As well as being stylistically close to Jamesone's portrait of James Sandilands of 1624 (Catalogue, 2; Plate 22)—the calligraphy of the inscription is perhaps also the same—the sitter bears a striking resemblance to Sandilands, though he is younger and his hair is less receding. If Sandilands had a son by about 1605 (he had a second son in 1610) it is just conceivable that this is who the picture represents. Sandilands was on intimate terms with Patrick Forbes, Bishop of Aberdeen, who was the brother of the William Forbes mentioned above: this is the only explicable path by which such a portrait could have entered Craigievar.

### 4. *Robert Gordon of Straloch* (1580–1661)
Canvas: $27\frac{1}{2} \times 23\frac{3}{8}$ in. (Plate 21).
Coat of arms top right.
*Collection.* Robert Gordon's College, Aberdeen.
*Provenance.* Bequeathed by Alexander Gordon of Parkhill.
*Exhibitions.* Aberdeen, *Archaeological Exhibition*, 1859, no. 131 (lent by John Gordon of Pitlurg).
*References.* Bulloch, no. 89.
*Copies.* A copy is recorded in Marischal College, 'made in 1707 for £10 Scots by Charles Whyt . . . of a picture by Jamesone now in Robert Gordon's College, Aberdeen' (*Description of the . . . Portraits . . . in . . . Marischal College*, Aberdeen, 1896, no. 119). There are two later drawn copies by the 11th Earl of Buchan (SNPG, nos. 1632 and 1633) but they may be after Whyte's copy, as Buchan's MS. (p. 10) quotes the picture as being in Marischal College.

The face is a dark, bricky red. Despite varnish and dirt the condition is fair (an inscription on the reverse states that it was cleaned and lined in 1860). The facial forms are drawn with some subtlety and, despite the differing expression, look forward to the *Montrose* of 1629 (Catalogue, 25; Plates 52, 53): the left eye is similarly soft and well-observed. The date must be close to 1625.

Jamesone probably knew Gordon, who was proprietor of Fechil which Jamesone acquired in security in 1633 (Documents, 35 and 52). Gordon is perhaps best known for his work in conjunction with his son James and Sir John Scot of Scotstarvet in preparing the map of Scotland (based on work by Timothy Pont) which was published by the Bleaus at Amsterdam in 1654. His son has been noted (p. 4) as one of the earliest creators of a Jamesone legend.

### 5. *William Forbes of Tolquhoun* (fl. 1595–1633)
Canvas: $24 \times 21$ in.
Inscribed (later) upper right: *TOLQUHON*; and lower left: *By JAMEISON*.
*Collection.* Lord Saltoun, Cairnbulg Castle, Aberdeenshire.
*Provenance.* The sitter's daughter married Alexander Fraser of Philorth who in 1669 succeeded as heir of line to the Lordship of Saltoun; presumably by descent through these families.
*References.* Carnegie to Musgrave, fo. 123v.; Bulloch, no. 168; Brockwell, p. 32.

Head and shoulders, to the right; a rather lined face with moustache and short, squarish beard. He wears a skull-cap and a falling ruff with flattened figure-of-eight sets.

Much repainted. There are traces of Jamesone's handling round the eyes (similar to the *David Calderwood* (Catalogue, 70) and the picture called *Alexander Skene* (Catalogue, 110)). The outline, though sharp with repaint, is also characteristic. Costume and the general tentativeness of the drawing suggest an early date, not later than 1625.

### 6. *John Leslie, 6th Earl of Rothes* (1600–1641)
Canvas: $83 \times 57$ in. (Plate 23).
Inscribed lower left on base of pillar: *Effigies Nobilisimi Domini Ioannis Rothesiæ Comitis/ Domini leslei et coet. quam ad viuum depinxit/ G. Jamsonus Abredonensis Anno 1625/Ætatis 25.* Inscribed (later) bottom left: *John 6th Earl of Rothes Co* [. . .] *from the Scots at the Treaty of Rippon.*
*Collection.* Unknown.
*Provenance.* Family ownership until the sale of Leslie House to Sir Robert Spencer-Nairn; sold by Alastair Spencer-Nairn at Christie's, 8 December 1967, lot 2/2 (bought Twining); Christie's, 22 June 1973, lot 16 (bought Fine Art Society).
*References.* Perhaps Musgrave (Leslie House list),

no. 21; engraved in Rothes's *A Relation of Proceedings Concerning the Affairs of the Kirk of Scotland from 1637 to July 1638*, Bannatyne Club, 1830: this engraving records the inscription, now almost illegible: see also p. iii where the possibility of fire damage in 1763 is mentioned; Bulloch, no. 163 (mistakenly called 5th Earl).

The sitter's doublet is generally rather dark but lightens to dull green; there are sharp yellow highlights on the right breast and arm. The plain grey stockings have blue sash garters just below the knees. The shoes, also rather blue, appear to be open sided and have large pink roses. The fringed drape above the sitter and the tablecloth to his left are a similar red. The floor-tiles are green/black and ochre.

The picture is very damaged, rubbed and repainted and has a recent heavy varnish.

Despite its crudities this must have been a bold attempt at the Jacobean type of full-length (cf. the portrait of Sir Thomas Parker of about 1620 (Plate 25) attributed to Marcus Gheeraerts (Saltram House)). It is, however, very much an 'attempt' rather than the product of any settled tradition. It is not possible to say with certainty what Jamesone knew of other full-lengths but a comparison with the *Lord Spynie* (Plate 27) is inevitable. This, which may have been in Scotland by 1625, has been attributed to Jamesone (Catalogue of the *Exhibition of Scottish Art*, Royal Academy, 1939, no. 11) but it has a confidence and plasticity which the present conspicuously lacks. It is, however, more likely that Jamesone had seen the works of the painter of the *3rd Earl of Winton with two Sons*, who flourished between 1622 and 1628 and who is almost certainly identical with Adam de Colone (see pp. 54–9). There are marked similarities in the treatment of the hands; and the fringed drapery, so conspicuous in the present and its companion (Catalogue, 7), occurs in the Winton group (Keith Hall) and the three-quarter length also of Winton at Traquair: the former is dated 1625.

Rothes succeeded to the title in 1611. In 1617 he carried the sword of state before James VI and I on his visit to the Scottish Parliament. He was made a burgess of Aberdeen in August 1623. Later he was active on behalf of the forces of the Covenant. He died suddenly at Richmond on 23 August 1641. He married about 1614 Anne, daughter of the Earl of Mar, subject of the next entry.

7.  *Anne Erskine, Countess of Rothes* (d. 1640) *with her Daughters Lady Margaret and Lady Mary Leslie*
Canvas: 83 × 57 in. (Plates 24, 26).
Inscribed bottom centre: *Effigies Nobilissimæ Anna Rothessæ/et Leslei Domina et [coet. quam] ad vivum [? depinxit] Geo . . ./Jamsonus Abredonensis Ao 1626*; and beneath the child on the left: *Ætatis 6*, and beneath the child on the right: *Ætatis 5*. Inscribed (later) bottom left: *Lady Ann Erskine 2d Daughter of John/Earl of Marr, Married to John 5th [sic] Earl of Rothes*; and below each child: *Lady Margaret Leslie*: *Lady Christian [sic] Leslie*.
*Collection.* Unknown.
*Provenance.* As for 6 above; Christie's, 22 June 1973, lot 17 (bought Fine Art Society).
*References.* Perhaps in Musgrave (Leslie House list) as three separate items, nos. 18–20; Bulloch, no. 164.

Companion to 6 above. Of considerable interest (as is the companion) for the detailed picture it gives of a noble Scottish interior and the costume of the period, the only evidence of quite this scope. The eight painted portraits on the rear wall are of a distinctly Jamesone type; the larger picture of two seated, embracing figures appears to be a standard early 17th-century Rinaldo and Armida composition. The leaded window on the left through which the sun shines has a rather Dutch look. The floor is tiled as in the companion, and the fringed drape and the tablecloth are a similar red to the same features in 6.

The mother's dress is basically black though it is heavily and elaborately embroidered in gold; the slashed sleeves expose a white chemise and are tied with blue ribbons at the elbow. The children's dresses are similar, that on the left a dark green/blue, the one on the right a strong yellowish orange with elaborate dark leaf embroideries contrasting with the bright vermilion fruit clutched in the apron.

In the same general condition as 6; the Countess's face, though repainted down the contour of the nose and on the eyebrows, is in better condition than those of the children; in style and feeling it is close to the *Mary Erskine* (Catalogue, 9; Plate 39).

Rothes and Anne Erskine had two daughters, Mary, the elder, and Margaret (see *The Scots Peerage*, vol. vii, p. 299). The later inscription is therefore doubly inaccurate.

8. *Sir William Forbes of Craigievar* (c. 1590–1648)
Canvas: 26¾ × 21½ in. (Plates 35, 36).
Inscribed top left: [*Anno*] *1626*/ [*Ætatis 3*]*6*.
*Collection.* John Forbes-Sempill, Esq., Craigievar Castle, Aberdeenshire.
*Provenance.* Probably family ownership since painted; the Forbes baronetcy merged with the Sempill peerage in 1884.
*Exhibitions.* Aberdeen, *Archaeological Exhibition*, 1859, no. 31.
*References.* Bulloch's no. 170 (collection of Lord Sempill at Fintray House) is called Sir William Forbes of Craigievar, but his description seems to better suit another portrait now at Craigievar (Catalogue, 3).

Now freed from heavy overpaint which completely disfigured the original painting. A photograph of 1859 (Plate 35) shows a quite different face, nose convex instead of concave, the hair flat and parted in the centre, the expression arrogant, and the paint handled in a 19th-century manner. There are many minor repairs in the armour areas; a *pentimento* is visible at the top of the head.

The face is very warm, the armour is a pale grey/blue, and the engraved floral patterns are picked out in pale yellow. The embroidery on the gold-coloured shoulder belt is also picked out in yellow pigment.

The picture has much in common with Jamesone's portrait called *General Alexander Hamilton* at Tyninghame (Catalogue, 15; Plate 31): the mood and drawing of the face are near to the *Mary Erskine* of 1626 (Catalogue, 9; Plate 39) and the tilt of the body, the outline of the left side of the face and the expression anticipate the *Montrose* of 1629 (Catalogue, 25; Plate 52).

The sitter, son of the merchant who built Craigievar, was created a Baronet of Nova Scotia in 1630. The picture must antedate this as he would certainly have worn the order. Style reinforces the reading of the damaged date as *1626*: apparent age agrees with the reading of *36*. These readings do not make identification certain as his date of birth is not otherwise known. There is no obvious reason why he should be wearing armour, though he was later active on the Covenanting side.

9. *Mary Erskine, Countess Marischal* (b. c. 1597)
Canvas: 26½ × 21½ in. (Frontispiece and Plates 39, 40).
Inscribed on left, above shoulder: *Anno 1626.*/ *Ætatis 29.*/*Maria Ersken*/*Countess Marschaill.*
*Collection.* Edinburgh, National Gallery of Scotland, no. 958.
*Provenance.* Perhaps through Treasurer Mar's son Sir Charles Erskine of Alva and Cambuskenneth to the latter's grandson James Erskine, Lord Alva; thereafter by descent to Alexander Erskine-Murray, from whom purchased 1908.
*Exhibitions.* Royal Academy, *Exhibition of Scottish Art*, 1939, no. 13.
*References.* Earl of Buchan's MS., p. 8: 'Countesses of Kinghorn Rothes, & Marishall & Lady Binning belong to Lord Alva . . .'; Musgrave: 'at Drumsheugh, in the County of Edinburgh, belonging to the late James Erskine, A Lord of Session, by the title of Lord Alva . . . the list taken 12 August 1796 . . . 8. Lady Mary Erskine, wife first of William, sixth Earl Marischall (he died 1635) secondly of Patrick, first Earl of Panmure'; Carnegie to Musgrave, fo. 123v.; Bulloch, no. 143; Caw, p. 10; Brockwell, pp. 16, 31; catalogues of the National Gallery of Scotland, 1957 edition, p. 135, and 1970 edition, p. 47.

Relined and restored about 1935; the corners have been blanked off. Rubbed to some extent; the left side of the sitter's mouth damaged and restored. In condition it contrasts sharply with the others of the group with which it is associated (see below). This is presumably mere good fortune, though a suspicion must remain that a certain degree of strengthening has taken place.

It has a simplicity and sense of rightness, as well as a surface richness, rare in Jamesone's work as it survives. Taken with the *Montrose* of three years later (Catalogue, 25; Plate 52) which it resembles in its gentle, human terms, Jamesone is seen as a perceptive craftsman in a vaguely Dutch manner which emphasizes the unanswered questions about his width of painterly education.

Jamesone appears to have been on quite intimate terms with the sitter's family. Her second son George was in 1633 godfather at the baptism of Jamesone's own son George (Documents, 31).

Mary was the daughter (probably the eldest) of John Erskine, 2nd Earl of Mar (Treasurer Mar) by his second wife, Marie Stewart; she married the Master of Marischal (later 6th Earl) after a contract of 1609, at an apparently very early age.

This portrait is recorded in 1796 by Musgrave as one of a group of eleven in the possession of James Erskine, Lord Alva. It is no. 8 in the group, described thus: 'The following eleven portraits, of the children of John seventh Earl of Marr, Lord High Treasurer of Scotland, by his second wife Lady Mary Stewart, are done by Jamieson, in eleven separate pictures.' The group was intact in the late 19th century, with the exception of nos. 1 and 2, James and Henry Erskine, the eldest sons (see Bulloch, pp. 162–5: see also 14 in this Catalogue). The group is presently depleted by one other item only, the present, which left the family in 1908. These nine pictures are all similar in size and bear (with the exception of Anne, no. 9 in the list) later inscriptions in the same hand. Old photographs of the present picture show that it too had the same type of inscription before restoration. (Only the present picture now bears an acceptable contemporary inscription.) All this would suggest a consciously created and maintained family gallery of portraits, but for the following factors: the *Charles Erskine* (no. 4 in the list) is of mid-17th-century date and is not by Jamesone; the others fall into two groups, certainly acceptable as by Jamesone despite their condition, one of the mid-1620s, the other of the mid- or late 1630s. Doubts also arise about some of the traditional identifications, and it may be that the late inscriber transposed some of them (besides making other errors). These matters are discussed under the individual entries of the present Catalogue, where the earlier group is numbered as follows: Mary, this entry; Alexander, 10; John, 11; Margaret, 12; Catherine, 13; and the later group thus: Arthur, 126; William, 127; Anne, 128.

10.   Called *Colonel Alexander Erskine of Cambuskenneth* (d. 1640)
Canvas: $25\frac{1}{2} \times 22$ in. (Plate 32).
Inscribed (later) top left: *Alex. Erskine*; and top right: *of Cambuskeneth*. Perhaps traces of original inscription upper right, beneath later inscription.
*Collection*. Lord Elibank, Sunningdale, Berkshire.
*Provenance*. Perhaps through Treasurer Mar's son

Sir Charles Erskine of Alva and Cambuskenneth to the latter's grandson James Erskine, Lord Alva; by descent to Alexander Erskine-Murray, grandfather of the late Lord Elibank.
*Exhibitions*. Edinburgh, *Scottish National Portraits Loan Exhibition*, 1884, no. 81.
*References*. Musgrave (Drumsheugh list), no. 3: 'Sir Alexander Erskine, the hero of the well-known ballad, Lady Anne Bothwell's lament, perished at the blowing up of Dunglass Castle, 1640'; Carnegie to Musgrave, fo. 123v.; Bulloch, no. 147 (stated to be inscribed 'Anno 1638 Ætatis 26'; Brockwell, pp. 16, 31 (with mis-reference to Bulloch).

The pigment of the elaborately embroidered sash has a gritty texture and the colour is rich: gold, red, yellow, and white. The only light on the armour is a pale blue/grey, through which a warm ground is visible. Condition is generally bad; widely cracked, but upper face and collar less so, which suggests repaint; there is a slash across the sitter's left forehead.

Third son of the Earl of Mar by his second marriage in 1592, Erskine applied for service with the Prince of Orange in 1624. In 1625 he appeared at the court of Elizabeth, ex-Queen of Bohemia at The Hague. Killed in the explosion at Dunglass Castle in 1640.

The full-length portrait in the National Gallery of Scotland inscribed *Robert Mester Erskine, anno 1627, Aetate 38* (no. 1973), is almost certainly of the same sitter (Plate 30). This has been attributed to Jamesone (it is so inscribed) but, despite its ruinous condition, it has a formal sophistication which is not consonant with Jamesone's full-length *Rothes* of 1625 (Catalogue, 6; Plate 23). It seems possible that Jamesone derived the present and the replica at Tyninghame (Catalogue, 15; Plate 31) from the full-length which could be a Continental painting of the period of Erskine's visit. One might further speculate that, if Jamesone worked from it, he also restored it, for it does seem to have some of his characteristics. The date which Bulloch records on the present picture is unlikely, while the inscription on the full-length gives a date of birth of *c.* 1589, before his parents' marriage. It is, however, rather more likely that the inscriptions have been misread and altered than that the identification is necessarily wrong.

11. Called *John Erskine of Otterstoun* (d. before 1668)
Canvas: 25 × 22½ in. (Plate 33).
Inscribed (later) top left: *Sir Jn°. Erskine,*; and top right: *of Otterstoun.*
*Collection.* Lord Elibank, Sunningdale, Berkshire.
*Provenance.* As for 10 above.
*References.* Musgrave (Drumsheugh list), no. 5: 'Sir John Erskine of Otterstown'; Carnegie to Musgrave, fo. 123v.; Bulloch, no. 148 (stated to be inscribed 'Jamesone'); Brockwell, pp. 16, 31.

The condition is rather bad; a good deal of retouching round eyes, mouth, etc.; much rubbing and cracking, both in original paint and later layers of varnish. The corners of the canvas seem to have been blanked off prior to the addition of the inscriptions.

Costume places this picture in the later 1620s: in style it falls very near to the *Mary Erskine* of 1626. The sitter is scarcely youthful, yet John Erskine seems to have been born later than 1604. His name does not appear in a list of Mar's children in a Naturalization Act of 27 June 1604 (*Letters of Denization and Acts of Naturalization for Aliens in England 1603–1700,* Huguenot Society, vol. xviii, 1911, p. 2). He appears to have been Mar's fifth son by his second marriage in 1592 (*The Scots Peerage,* vol. v, p. 622) and to have married in 1640. There must therefore be very considerable doubt about the traditional identification.

12. Called '*Martha*' Erskine, Countess of Kinghorne (b. after June 1604)
Canvas: 27½ × 22¾ in.
Inscribed (later) top left: *Lady Martha Erskine*; and top right: *Count.s of Kinghorn & Strathmore.*
*Collection.* Lord Elibank, Sunningdale, Berkshire.
*Provenance.* As for 10 above.
*References.* Earl of Buchan's MS., p. 8 (quoted at 9 above); Musgrave (Drumsheugh list), no. 10: 'Lady Margaret Erskine, wife of John Lyon, second Earl of Kinghorn . . .'; Carnegie to Musgrave, fo. 123v.; Bulloch, no. 145; Brockwell, pp. 17, 31.

Nearly half-length, to the right; elaborate decolletage and jewellery round neck and on breast. Almost completely repainted; relined on larger canvas. The corners have been blanked off at some period; her repainted left sleeve is continued into the bottom corner.

The 2nd Earl of Mar's daughter Margaret

(whom the inscriber must have intended) married the 2nd Earl of Kinghorne after a contract of 1618. The sitter agrees well enough in appearance with a small portrait of Margaret Erskine formerly in Leslie House.

13. Called '*Elizabeth*' Erskine, '*Countess*' of Haddington (d. 1635)
Canvas: 26½ × 21¾ in.
Inscribed (later) top left: *Lady Eliz.bth Erskine*; and top right: *Count.s of Haddington.*
*Collection.* Lord Elibank, Sunningdale, Berkshire.
*Provenance.* As for 10 above.
*References.* Earl of Buchan's MS., p. 8 (quoted at 9 above); Musgrave (Drumsheugh list), no. 11: 'Lady Catherine Erskine, first wife of Thomas, second Earl of Haddington'; Carnegie to Musgrave, fo. 123v.; Bulloch, no. 146; Brockwell, pp. 17, 31 (with mis-reference to Bulloch).

Nearly half-length, to the right; wears plain spreading collar, elaborate jewels on right side of head and breast, and necklace. Condition poor, only face relatively free of overpaint. The corners have been blanked off.

The inscriber must have intended Catherine, who married Lord Binning in 1622 (she never in fact became Countess of Haddington). The costume, as in 12, suggests a date of *c.* 1625–30. A comparison with Jamesone's portrait of Lady Binning at Oxenfoord (Catalogue, 31; Plate 60) while not conclusive, does not discount the traditional identity.

14. *Henry Erskine, styled Lord Cardross* (d. *c.* 1636)
Canvas: size unknown.
*Collection.* Unknown.
*Provenance.* Perhaps through Treasurer Mar's son Sir Charles Erskine of Alva and Cambuskenneth to the latter's grandson James Erskine, Lord Alva; thereafter untraced.
*References.* Probably the second item in a list of Jamesone's works in the Earl of Buchan's MS., p. 7: 'Henry Erskine 1st Lord Cardross in Lord Buchan's Collection. & in Lord Alva's'; probably Musgrave (Drumsheugh list), no. 2: 'Henry, Lord Cardross . . .'; probably Carnegie to Musgrave, fo. 123v.: 'Henry Erskine, of Dryburgh —Drumsheugh-ho'; Brockwell, pp. 16, 32 (wrongly annotating Carnegie's Henry Erskine at Drumsheugh as Bulloch, no. 50).

This picture is unrecorded after *c.* 1950 and is only known in a photograph of that date.

Head and shoulders, to the right. A youngish man with rather raised eyebrows, high forehead, long nose, moustache, and pointed beard. Wears a lace-edged falling band (casting a pronounced shadow) and an elaborately embroidered doublet. Clearly the same sitter as 34 below.

See commentary to 9 above, *Mary Erskine*. This is probably the missing Henry Erskine from the group of eleven portraits of the children of Treasurer Mar at Drumsheugh. It presumably left this collection between Carnegie's record in 1797 and its non-appearance in Bulloch in 1885. The lighting, and the painting of the embroidery, relate it closely to the *Mary Erskine*, and it appears to be of about the same date. Notably, the corners have been blanked off like others in this group (though an attempt has been made to round them into a painted oval).

15. Called *General Alexander Hamilton* (d. 1649)
Canvas: 22¼ × 17¾ in. (Plate 31).
Inscribed (later) upper left: *General/Alexander Hamilton*; and upper right: *Jameson p̣ᵗ.*
*Collection.* The Earl of Haddington, Tyninghame, East Lothian.
*Provenance.* Unrecorded before 1885 (Bulloch) but probably family ownership since painted.
*Exhibitions.* Edinburgh, *Loan Exhibition of Old Masters*, 1883, no. 89.
*References.* Bulloch, no. 100; Sir William Fraser, *Memorials of the Earls of Haddington*, Edinburgh, 1889, vol. i, p. 376, no. 35.

The face is warm, the hair a rich brown. The sash across the right shoulder is brown to gold, the ridges of the folds in the lit area picked out in thick yellow pigment. Rubbed in the shadow areas; probably slightly cut down.

The pattern, and almost certainly the subject, are the same as 10 which is identified as Colonel Alexander Erskine (Plate 32). The only obvious differences are that rather less of the right shoulder and three plates of the pauldron, as against five, are visible in the present; the sash also lacks embroidery.

Alexander Hamilton was the half-brother of the 1st Earl of Haddington. He was in Paris in 1615, probably studying, and therefore quite young. From about 1624 he was a soldier, and seems to have served on the Continent almost continuously until 1634 (see Fraser, op. cit., pp.

27–33). Stylistically the portrait seems earlier than the latter year, and consequently the sitter appears too old.

The provenance of 10 and its relationship to National Gallery of Scotland's no. 1973 (Plate 30) suggest that the present should be identified as Alexander Erskine. Its presence in the Haddington collection may be explained by the fact that Erskine was the 2nd Earl's brother-in-law: they were together at Dunglass Castle in 1640 and both fatally injured in the explosion (Fraser, op. cit., pp. 197–8).

The outline of the head and drawing of the eyes (cf. *Sir Thomas Hope*, Catalogue, 18; Plate 46) point clearly to Jamesone and the late 1620s. The quality is perhaps rather higher than 10, but it need not be the first version.

16. Called *Anne Campbell, Marchioness of Huntly* (1594–1638)
Canvas: 26 × 23 in.
Inscribed (later) top left: *Lady Anne Campbell/IIᵈ Marchioness of Huntly*; and top right: *1626:Æᵗ18.*
*Collection.* The Duke of Richmond and Gordon, Goodwood, Sussex.
*Provenance.* Probably family ownership since painted.
*References.* Perhaps in Earl of Buchan's MS., p. 10: 'four portraits of the Huntly family Gordon Castle'; probably Musgrave (Gordon Castle list): '. . . æt. 18 an. 1630. By Jameson'; probably Carnegie to Musgrave, fo. 124 (with annotation: 'æt.18, 1630'); Catalogue of Pictures at Gordon Castle, March 1877 (copy in SNPG), no. 20; Bulloch, no. 158 (as inscribed '1626 Æt 18'); Brockwell, pp. 20, 33.

Nearly half-length, to the right. The rather immature, small-featured face is pale pink; she has dark brown hair decorated with a large jewel. The bodice of her dress is embroidered with pink flowers with stems and leaves of olive green. Wears a dark gown, tied at the waist by a ribbon sash, and a three-layered standing band which covers much of the breast and shoulders.

The small, rather flattened head and wide shoulders, and their placing, are very characteristic of Jamesone as are the felicities of handling in the lower part of the face. It anticipates the quality of naïve gentleness of the *Montrose* of 1629 (Catalogue, 25; Plate 52).

The identity is very uncertain. Jamesone certainly painted Anne Campbell at some time during

this period as is shown by Arthur Johnston's epigram 'Ad Iamisonum Pictorem, De Anna Cambella, Heroina' (Documents, 79(a)). She was, however, born in 1594 and married in 1607 (*The Scots Peerage*, vol. iv, p. 546) which is hardly consonant either with the inscription or with her youthful appearance: in terms of costume and style and the sitter's apparent age the content of the inscription seems right. Its relationship to 30 is not clear.

17. *Lady Jane Maitland* (1612–1631)
Canvas: 27½ × 22½ in.
*Collection.* The Earl of Lauderdale, Thirlestane Castle, Berwickshire.
*Provenance.* Probably family ownership since painted.
*References.* Probably Earl of Buchan's MS., p. 16: 'Lady Jane Maitland an Authoress in the reign of Charles 1st whose Eulogy is written & printed by Dr. Arthur Johnston Ditto' (the last word presumably referring to 'Hatton the Earl of Lauderdales').

Nearly half-length to the right; the decolletage largely filled in by lace strips converging at a large pink bow. She has a narrow, youthful face, the flesh pale pink with greenish shadows.

The sitter was daughter of the 1st Earl of Lauderdale. On her early death, unmarried, she was the subject of two obituary epigrams by Arthur Johnston (see Sir William Geddes (editor), *Musa Latina Aberdonensis*, vol. ii, New Spalding Club, 1885, pp. 34 and 77). The sitter's air of melancholy is echoed by Johnston: 'Fructus erat praecox, carptus et ante diem.'

18. *Sir Thomas Hope* (d. 1646)
Canvas: 48½ × 37 in. (Plate 46).
Inscribed top left: *Anno 1627*. Inscribed (later) bottom left: *Sir Thomas Hope/1st Bar^t of Craighall*.
*Collection.* Edinburgh, Scottish National Portrait Gallery, no. 953.
*Provenance.* Anne Bruce, mother of Sir William Hope, 6th Baronet of Craighall, had estates in Kinross which passed, not to Hope's brother and heir, but to her own heirs male (*Complete Baronetage*, vol. ii, p. 343). The portrait had probably become attached to the Kinross properties (see *References* for 20) and descended thence to Thomas Bruce who owned it in 1889; in possession of the executors of Sir Charles Bruce, Arnot Tower, Leslie, in 1923, when purchased.
*References.* Earl of Buchan's MS., p. 8, may refer to the present or another version: 'Sir Thomas Hope of Craighall Lord Advocate Mr. Scott of Rossies knee picture . . .'; J. M. Gray, 'Pinkie House—Part II', *Scottish Art Review*, August, 1889: 'A good [version] is in the possession of Thomas Bruce, Esq., of Arnot Tower'.
*Copies.* There is a later copy in the collection of Major Hope Johnstone of Raehills; a copy done by Colvin Smith in 1859 belongs to the Faculty of Advocates. There are also head and shoulder copies at Hopetoun and Raehills.

Generally dark, the face a dull orange; the back of the chair and the tablecloth are dark red. There is a good deal of minor retouching.

Hope was appointed Lord Advocate in 1626 and this may have occasioned the portrait. The inscribed date seems reliable and it would be difficult to place the picture any later. Hope does seem to record a portrait by Jamesone in his diary, but in 1638 (Documents, 53). The fact that he there mistakenly calls the painter 'William' Jamesone might suggest that Jamesone's brother William, who had settled in Edinburgh as a writer by 1626, could have been an intermediary in the commission.

A replica in the possession of direct descendants of the sitter (Catalogue, 19; Plate 45) has generally been accepted as the prime version, as its ownership might suggest (see J. M. Gray, loc. cit.); but the quality of the present (and even its likely provenance) give it rather a strong claim to being the original portrait.

19. *Sir Thomas Hope* (d. 1646)
Canvas: 46 × 37½ in. (Plate 45).
*Collection.* Sir Archibald Hope, Upton Grey Lodge, Hampshire.
*Provenance.* Probably family ownership since painted; removed from Pinkie House after 1946.
*Exhibitions.* Edinburgh, *Scottish National Portraits Loan Exhibition*, 1884, no. 41 (in possession of Sir John D. Hope).
*References.* J. M. Gray, 'Pinkie House—Part II', *Scottish Art Review*, August, 1889: 'the Drawing-room . . . Over the fire-place, let into the panelling, is the portrait of the founder of the family, Sir Thomas Hope . . . painted by Jamesone in 1638'; Robert Paul (editor), *Twenty Four Letters*

*of Sir Thomas Hope*, Scottish History Society, 1893, frontispiece.

A close replica of 18 above. A strip of about 3½ inches along the top seems to have been cut off and replaced.

Gray associates the picture with the diary entry of 1638 but admits that the sitter seems 'a somewhat younger-looking man than we should have expected' (i.e., in 1638). He knew of the existence of 18, but apparently not of its inscription, which would have gone some way to resolve his doubts. The question of primacy is probably insoluble.

20.    *Sir John Hope, Lord Craighall* (c. 1605–1654)
Canvas: 29¼ × 24½ in.
Inscribed (later) top left: *LORD HOPE/OF CRAIGHALL.*
*Collection.* The executors of T. F. Bruce of Arnot (on loan to the Scottish National Portrait Gallery, no. L 94).
*Provenance.* See 18 above for likely descent; but see also 21 below.
*References.* Earl of Buchan's MS., p. 8, may refer to this and its companion (Catalogue, 22): 'Sir John Hope a Lord of Session with his wife Margaret Murray of Black barony belongs to Mr. Scot of Rossie near Montrose'; typewritten list of the late 19th century of pictures at Arnot Tower which 'came from Kinross House . . . Sir John, Lord Craighall, 2nd Baronet—two portraits the one no doubt—or I might say evidently—by Jameson, the other apparently a copy either by Jameson or some other Artist of the period' (SRO, GD 242/26).

Head and shoulders, to the right; wears a plain white falling ruff over a dark doublet. The paint is thin throughout and the broad strokes of the priming are quite visible.

The sitter was knighted and made a Lord of Session in 1632.

There is a replica by Jamesone (Catalogue, 21) in possession of descendants of his father, Sir Thomas Hope of Craighall.

21.    *Sir John Hope, Lord Craighall* (c. 1605–1654)
Canvas: 28½ × 23½ in.
Inscribed top left: *Anno 1627/Ætatis 25.*
*Collection.* Sir Archibald Hope, Upton Grey Lodge, Hampshire.
*Provenance.* Against the assumption that the present has always been in Hope possession must

be placed the two versions in Bruce of Arnot possession in the late 19th century. One of these might have entered Hope possession soon before 1884 (when the present was exhibited) but there is no evidence for this. It is also not clear whether the picture owned by Scot of Rossie is identical with any of these or whether it is another version or copy, perhaps of the type of the *Sir Thomas Hope* at Raehills (see 18 above).
*Exhibitions.* Edinburgh, *Scottish National Portraits Loan Exhibition*, 1884, no. 37 (in possession of Sir John D. Hope); Edinburgh, *Scottish National Exhibition*, 1908, no. 1 (in possession of Sir Alexander Hope).
*References.* Earl of Buchan's MS., p. 8, may refer to this (quoted at 20 above); perhaps one of the two items in the typewritten list of pictures at Arnot Tower (SRO, GD 242/26); Bulloch, no. 109; J. M. Gray, 'Pinkie House—Part I', *Scottish Art Review*, July, 1889.

A close replica of 20 above. A strip of about 2 inches on the right is new canvas. The original, though strengthened, inscription might suggest that this is the first version, but see below.

22.    *Margaret Murray, Lady Hope* (d. 1641)
Canvas: 28¾ × 24¼ in.
Inscribed (later) top left: *MARGARET MURRAY LADY HOPE/OF CRAIGHALL.*
*Collection.* The executors of T. F. Bruce of Arnot (on loan to the Scottish National Portrait Gallery, no. L 95).
*Provenance.* See 18 above for descent of Bruce of Arnot pictures.
*References.* Earl of Buchan's MS., p. 8, may refer to this (quoted at 20 above); a typewritten list of the late 19th century of pictures at Arnot Tower which 'came from Kinross . . . Margaret Murray, Lady Hope, wife of the second Baronet—no doubt also by Jameson—two portraits' (SRO, GD 242/26).

Nearly half-length, to the right; wears a grey standing band, a necklace, a pendant jewel and ear-strings. Her gown is heavily ornamented with braiding, the yellow pigment of which is clearly original.

The costume agrees with the date of 1627 which appears on the companion (Catalogue, 21) to the replica in Hope possession.

The sitter's death is movingly described in her father-in-law's diary: 'About 9 of nycht (6 October 1641), my deir dauchter D. M. Murray,

spous to my sone Craighall, deceissit in child-birth, scho and the barne in her womb. God in mercie pittie me, and my sone and his children, for it is a sore straik' (*A Diary of the Public Correspondence of Sir Thomas Hope*, Bannatyne Club, 1843, pp. 152–3).

23. *Margaret Murray, Lady Hope* (d. 1641)
Canvas: 28½ × 23½ in.
*Collection.* Sir Archibald Hope, Upton Grey Lodge, Hampshire.
*Provenance.* See 21 above, and second item in *References* to 22.
*Exhibitions.* Edinburgh, *Scottish National Portraits Loan Exhibition*, 1884, no. 43 (in possession of Sir John D. Hope); Edinburgh, *Scottish National Exhibition*, 1908, no. 5 (in possession of Sir Alexander Hope).
*References.* Earl of Buchan's MS., p. 8, may refer to this (quoted at 20 above); perhaps one of the two items in the typewritten list of pictures at Arnot Tower (SRO, GD 242/26); Bulloch, no. 110; J. M. Gray, 'Pinkie House—Part I', *Scottish Art Review*, July 1889.

A replica of 22 above. The colour scheme is rather different: the face is suffused with bluish grey and the gown is purple rather than brown and yellow.

24. Called *Jane Gray, Countess of Wemyss* (d. 1639)
Canvas: 26 × 22½ in. (Plate 37).
*Collection.* Sir Archibald Hope, Upton Grey Lodge, Hampshire.
*Provenance.* Certainly in Hope possession by 1889 but probably in that collection much earlier (see below); removed from Pinkie House after 1946.
*References.* Bulloch, no. 111; J. M. Gray, 'Pinkie House—Part I', *Scottish Art Review*, July 1889, and the same writer in MS. in SNPG (JMG, 8) of about the same date: 'a good deal injured, but still a good Jamesone'.

Nearly half-length, to the right; wears a fan-shaped standing ruff and a necklace with blue stones; bodice dark grey with black embroidery. Rather damaged but there appears to be little repaint. In terms of costume it falls somewhere between 1625–30.

The identification is traditional. The presumed sitter was eldest daughter (third child) of Patrick, Lord Gray, by his second wife whom he married after 1585. Jane Gray contracted to marry Sir John Wemyss of Wemyss in September 1609 (he was created Earl of Wemyss in 1633); one of their daughters, Elizabeth, married in 1636 John Aytoun of Aytoun; their daughter Elizabeth married Sir Thomas Hope, the 3rd Baronet. It may be that in this way her portrait was carried into Hope possession.

25. *James Graham, 1st Marquess of Montrose* (1612–1650)
Panel: 26 × 22 in. (Plates 52–5).
Inscribed top left: *Anno 1629/Ætatis 17*. Signed lower right: *Jamesone Fec*.
*Collection.* The Earl of Southesk, Kinnaird Castle, Angus.
*Provenance.* Family ownership since painted.
*Exhibitions.* Aberdeen, *Archaeological Exhibition*, 1859, no. 153; Edinburgh, Scottish National Portrait Gallery, on loan, 1921–8; Royal Academy, *Exhibition of Scottish Art*, 1939, no. 10; Royal Academy, *British Portraits*, 1956–7, no. 67; Glasgow, *Scottish Painting*, 1961, no. 5.
*References.* See Documents, 23; engraving by R. C. Bell in Mark Napier (editor), *Memorials of Montrose and his Times*, Maitland Club, 1848, vol. i, which records the signature as 'Jamesone Fec.': the engraving is lettered 'From the original in the possession of Sir James Carnegie Bart of Southesk'; Mark Napier, *Memoirs of the Marquis of Montrose*, Edinburgh, 1856, vol. i, Appendix, pp. ii–v; William Fraser, *History of the Carnegies*, 1867, vol. i, p. xv and p. 132; Bulloch, no. 179 (the signature read as 'Jamesone fecit'; James L. Caw, *Scottish Portraits*, 1903, p. 78; Ellis Waterhouse, *Painting in Britain 1530 to 1790*, Harmondsworth, 1962, p. 41.
*Copies.* Earl of Buchan's MS., p. 9, may refer to a version or a copy: 'The Marquis of Montrose when Young—(Bognie)'; Carnegie to Musgrave, fo. 124, records a portrait belonging to 'Morison of Bognie in Aberdeenshire', presumably the same (Brockwell, p. 33, mistakenly assumes this to be Bulloch's no. 179).

A copy by J. Douglas belongs to the Marquis of Graham (exhibited in Glasgow, *International Exhibition*, 1901, no. 1013).

The flesh pinks and creams have an implication of impasto, though in fact the paint is very thin; the wood grain is evident throughout the picture. The doublet is a gold olive green, with the only really thick areas of pigment, yellow,

cream, and white, on the edges of the braiding. The background varies from dark to a pale version of the doublet colour on the right.

Painted (or begun) between 3 and 5 November 1629 during Montrose's stay in Aberdeen to be made an honorary burgess, and delivered to Kinnaird Castle on 2 December, the price of £26 13s. 4d. apparently paid by Sir Robert Graham of Morphie. The portrait must be connected with Montrose's marriage on 10 November to Magdalen Carnegie, daughter of the future 1st Earl of Southesk, with whom the couple took up residence. It shows Jamesone at the peak of his powers in the period just before his renewed contacts with Edinburgh. There is an assurance in the drawing which he rarely attained and a rarely subtle interpretation of character.

26.  *Sir Robert Carnegie of Dunnichen* (*c.* 1588–1632)
Canvas: 26¾ × 23¾ in.
Inscribed top left (strengthened): *Anno 1629/ Ætatis 41.*
*Collection.* The Earl of Southesk, Kinnaird Castle, Angus.
*Provenance.* Family ownership since painted.
*References.* Carnegie to Musgrave, fo. 125; William Fraser, *History of the Carnegies*, Edinburgh, 1867, vol. ii, p. 551, records this and Jamesone's portraits of his three brothers at Kinnaird (Catalogue, 116–18); Bulloch, no. 177; Brockwell, p. 35.
*Copies.* A MS. Catalogue of Pictures at Kinnaird made by the 10th Earl of Southesk in 1904 (transcript in SNPG) mentions a copy at Ethie.

Head and shoulders, to the right; white falling band and dark slashed doublet; brown hair, moustache, and long pointed beard. There is some very obvious repaint on the face.

Carnegie was a younger brother of the Earl of Southesk, Montrose's father-in-law; perhaps to be connected with Montrose's visit to Aberdeen in November 1629.

27.  *Arthur Johnston* (*c.* 1577–1641)
Panel: 25¼ × 22¾ in. (Plate 57).
Illegible inscription top left.
*Collection.* Marischal College, University of Aberdeen.
*Provenance.* See below: although the Earl of Buchan's statement is not verifiable, almost certainly in the College since the 17th century.

*Exhibitions.* Aberdeen, *Archaeological Exhibition*, 1859, no. 135 (in possession of Marischal College); Edinburgh, *Scottish National Portraits Loan Exhibition*, 1884, no. 58; perhaps Glasgow, *Scottish Exhibition*, 1911, no. 44 (Catalogue, vol. i); perhaps London, Whitechapel Art Gallery, *Scottish Art and History*, 1912, no. 95.
*References.* Walpole, p. 5; Earl of Buchan's MS., p. 7: 'Dr. Arthur Johnston ... a very fine portrait was presented by Jamesone to the Marischal College at Aberdeen 1637'; Carnegie to Musgrave, fo. 124v.; John Davidson, *Inverurie and the Earldom of Garioch*, Edinburgh, 1878, p. 168 (stating that the Marischal picture is dated 1623); Bulloch, no. 21; Caw, p. 10 (giving the date as 1621); Brockwell, p. 34.
*Copies.* There is a 19th-century copy in possession of Colonel Allardyce of Caskieben, which bears the date 1623: this may be the same as a copy painted in 1837, once in the possession of William Johnston (see his *The Bibliography and Extant Portraits of Arthur Johnston*, Aberdeen, 1895, p. 32). There is a copy, lacking the hand and rose, by James Wales in the SNPG, no. 329: this was done for the Earl of Buchan who himself made a copy (SNPG, no. 1636) for Pinkerton. Buchan annotates his drawing as being of the King's College version and this is repeated by the engravers of the prints in Pinkerton's *Scottish Gallery* (plate 28) and John Smith's *Iconographia Scotica* (plate 14).

The thinness and transparency of the paint, allowing a red ground to show through the upper layers, accounts for much of the overall warmth.

About 1895 the inscription was read as '1621, Ætat. 42' (Sir William Geddes (editor), *Musa Latina Aberdonensis*, vol. ii, New Spalding Club, 1895, p. xiii). The competence, as well as the costume, tend to suggest a date nearer the 1629 on the King's College portrait (Catalogue, 28) where the sitter certainly looks no older. The frontispiece to the 1739 edition of Johnston's *Psalmarum Davidis Paraphrasis*, engraved by R. Cooper and lettered 'Geo: Jamison pinxit', shows a hatted sitter very different from 27, but clutching some kind of branch in his left hand which suggests an obscure iconographical link. Further, the frame round the engraving is lettered '. . . Ætat. 52. 1629', and as the inscription read in 1895 must have even then been obscure, it could well be a misreading of this form. However, it must be

added that the Middelburg edition of Johnston's poems of 1642 carries an engraving lettered '1639. Ætat. 52'. This has given the traditional date of Johnston's birth (e.g., in *DNB*), but as shown by Sir William Geddes (op. cit., pp. xxvi–xxxi), he is much more likely to have been born in 1577. He was for instance Professor of Philosophy at Heidelberg by 1601.

Johnston was later at the University of Sedan where he became Professor of Physic in 1610: in the same year he had the degree of Doctor of Medicine of Padua. He had returned to Aberdeen by 1622 when he was made burgess, and most of his poetical work was produced in the following years.

Johnston referred to Jamesone twice in his poetry (see pp. 3–4); he also baptized his son Alexander in 1636 (Documents, 51).

28. *Arthur Johnston* (c. 1577–1641)
Canvas laid on panel: 26 × 22 in.
Inscribed top left: *Anno 1629/NOSCE TE IPSVM.*
*Collection.* King's College, University of Aberdeen.
*Provenance.* Unrecorded before 1885.
*Exhibitions.* Perhaps Glasgow, *Scottish Exhibition*, 1911, no. 44 (Catalogue, vol. i); London, *Exhibition of the Works of British-born Artists of the 17th Century*, 1938, no. 1 (clearly identified but the references to other exhibitions seem to refer to the Marischal portrait).
*References.* Bulloch, no. 14 (giving the inscription as 'Anno 1623. Ætatis 36. *Nasce te ipsum*': it is Colonel Allardyce's copy which has this date and age—and perhaps 27—but neither bears the motto); Sir William Geddes (editor), *Musa Latina Aberdonensis*, vol. i, New Spalding Club, 1892, frontispiece and p. xiii, as in the Senatus Room of King's College (but the description taken from Bulloch); William Johnston, *The Bibliography and Extant Portraits of Arthur Johnston*, Aberdeen, 1895, p. 31 (correcting Bulloch's reading of the inscription).

Head and shoulders, to the right; wears lace standing-falling ruff. High forehead, short hair, and long pointed beard; moustache rather sparser than in 27 above.

Often confused with 27.

29. *Charles de Montpensier, Duc de Bourbon* (1490–1527)
Canvas: 50 × 37½ in. (Plate 58).

Inscribed lower right: *SERENISS: CAROLI DVCIS B[OURBONIÆ] COMITIS [MONPEN]/SERIÆ AVERNIÆ MAGNI*—remainder illegible. Numbered bottom left (twice, one deleted): 33.
*Collection.* Unknown.
*Provenance.* See remarks on the 3rd Earl of Lothian's collecting habits under 143, and notes on the provenance of the group 40–65. Sold from the Lothian collection at Dowell's, Edinburgh, 18 July 1952, lot 9.
*References.* Catalogue of the Paintings in Newbattle Abbey, 10 March 1798 (transcript in SNPG): 'Red Chamber 2nd floor ... Charles Duke of Bourbon, Great Constable of France'; Newbattle Inventory of March 1833 (transcript in SNPG), annotated 'Jamesone'.

This is a copy from an engraving by Lucas Vorsterman I (Plate 59) after a portrait attributed to Titian (see M. Corbett and M. Norton, *Engraving in England*, Part III, Cambridge, 1964, p. 197) but more probably by Giampietro Silvio (see Harold E. Wethey, *The Paintings of Titian*, II, London, 1971, p. 156). The relative size of the head has been reduced and the features softened. The incomplete left side of the helmet in the engraving has been completed; the table top has been extended and a front and side edge introduced to take up the portion of the engraving occupied by the letters.

The small head on large shoulders (the reverse in fact of the engraving) and the small, softened facial features which are quite different from the planar angularity of those in the engraving, clearly point to Jamesone. The rich light and shade of the print has been replaced by a series of mid-tones which flatten the face in a way seen in many of his portraits. It has a good deal in common with the *Sir Thomas Hope* of 1627 (Catalogue, 18; Plate 46) and a date of 1627–30 seems likely. The series of sharp highlights on the sleeve of the left arm, which derive directly from the engraving, were to become a stylistic feature of some of Jamesone's works of the mid-1630s: e.g., in the 'fancy' portraits of Lady Margaret Douglas and Lady Katherine Ruthven (Catalogue, 74-(2) and 78-(6); Plates 87 and 90).

30. Called *Anne Campbell, Marchioness of Huntly* (1594–1638)
Canvas: 23½ × 20 in. (Plate 38).
Inscribed top left: *A[nno] 1630/ [Ætat]is 18.*

*Collection.* The Earl of Haddington, Mellerstain, Berwickshire.

*Provenance.* Musgrave's note below is, besides the Gordon portrait (Catalogue, 16), the only early reference to a portrait of this subject. There is, however, no record of pictures passing from Kinnoull to Haddington possession: Lord Haddington has no knowledge of its early history.

*References.* Musgrave (list for Dupplin House, seat of the Earl of Kinnoull) records a portrait of 'Lady Anne Campbell married Geo. Gordon, 2d. Marq. of Huntley': the MS. is not clear but seems to attribute the portrait to 'Jamieson'.

The pale yellow/orange bodice now shows only mere traces of embroidery; on the right breast is a series of little parallel highlights of a kind found in other Jamesone portraits. The ribbon sash tying the dark gown at the waist is now almost invisible. Although the background is badly damaged, the remaining parts of the inscription are contemporary.

The attribution is supported by a comparison with the *Montrose* (Catalogue, 25; Plate 52) where the contours of the eyes and the foreshortenings of the left side of the face are similar. They also share the same mood of reticence.

Composition and costume are close to 16 (the jewels are different but these may be conventional). It is difficult, however, to accept that the same subject is depicted and the inscription on 16, and the biographical facts quoted there, make the identification equally uncertain.

31. Called *Catherine Erskine, Lady Binning* (d. 1635)

Canvas: $26\frac{1}{2} \times 21\frac{1}{4}$ in. (Plate 60).

Inscribed top left: *Anno 1630/Ætatis 23* (perhaps altered from 27). Inscribed (later) top right: *Geo: Jamesone, pinx!.*

*Collection.* The Earl of Stair, Oxenfoord Castle, Midlothian.

*Provenance.* If correctly identified the picture could have descended thus: Sir Patrick Hamilton, 2nd of Little Preston and cousin of the 2nd Earl of Haddington, married Elizabeth Macgill daughter of the 1st Viscount Oxfurd; their grandson, Thomas Hamilton Macgill, succeeded to the Oxenfoord property in 1758; his daughter and heir, Elizabeth, married her cousin Sir John Dalrymple, ancestor of the present owner (see Sir William Fraser, *Memorials of the Earls of Haddington*, 1889, vol. i, pp. 377–9). Walpole's

statement (below), though about different pictures, gives some support to this line of descent.

*Exhibitions.* Edinburgh, *Loan Exhibition of Old Masters*, 1883, no. 55, no. 75, or no. 77; Royal Academy, *Exhibition of Scottish Art*, 1939, no. 2.

*References.* Bulloch, no. 174 (the age read as '23'); Sir Hew Dalrymple, *Pictures at Oxenfoord Castle*, 1911, no. 51 (the age read as '27'): Dalrymple wrongly assumes that this and two similar portraits (Catalogue, 32 and 33) are referred to by Walpole as 'Three small portraits of the house of Haddington . . . in the possession of Thomas Hamilton, Esq. of Fala'—these, however, are three very much smaller panels of the early 17th century (including one of Sir Patrick Hamilton, 1st of Little Preston), still at Oxenfoord.

The face colours are cool and there is a tendency to green in the shadows. The light brown hair is frizzed out at the sides in the style of 1620–35. The structure of the spreading standing band is not very clearly understood. There is some rubbing but not a great deal of repaint. Some damage between inscription and head, and bottom right.

The rather gentle expression, the smallish head and broad shoulders are characteristic: the drawing of the eyes is very close to the *Montrose* of the previous year (Catalogue, 25; Plates 52, 53).

Catherine Erskine, daughter of the Earl of Mar, married Lord Binning (succeeded in 1637 as 2nd Earl of Haddington) in 1622. The sitter bears a close resemblance to the Lady Binning in the *Haddington Family Group* which, in her case, is probably posthumous (Catalogue, 130; Plate 101). She is also like a portrait of Lady Binning at Tyninghame of about 1635, although there both the pigment and the characterization are much more forceful. On the other hand the resemblance to the subject of 13 is not particularly close.

32. *Unidentified Man*

Canvas: $26\frac{3}{4} \times 21\frac{3}{4}$ in. (Plate 61).

Inscribed top left: *[Anno] 1[6?30] /Ætatis 21*. Inscribed (later) top right: *Geo: Jamesone, pinx!.*

*Collection.* The Earl of Stair, Oxenfoord Castle, Midlothian.

*Provenance.* Unrecorded before 1883 but see 31.

*Exhibitions.* Edinburgh, *Loan Exhibition of Old Masters*, 1883, no. 55, no. 75, or no. 77.

*References.* Bulloch, no. 172; Sir Hew Dalrymple, *Pictures at Oxenfoord Castle*, 1911, no. 50.

The face follows a colour scheme often found in Jamesone: a small area of pink spreading up towards the right eye from the corner of the nose, brown shadows under the eyebrows and grey shadows under the eyes, nose, and mouth. There are various small damages, e.g., the left shoulder and the inscription; there is blistered discoloured varnish lower left.

Both the picture's appearance of being a companion to 31, and the costume, favour the date being read as *1630*. The inscribed age is also acceptable. This rules out the possibility of the sitter being the 2nd Earl of Haddington (b. 1600), a traditional identification. The sitter has considerable facial resemblance to Jamesone's portrait of Henry Erskine, Lord Cardross (Catalogue, 34), Catherine Erskine's brother, though in that portrait the sitter is bearded and a little older. At about this time Henry Erskine acted as a trusted intermediary between his sister's father-in-law, the 1st Earl of Haddington, and the Earl of Roxburghe (see Sir William Fraser, *Memorials of the Earls of Haddington*, Edinburgh, 1889, vol. ii, pp. 151–3).

33. Called *Thomas Hamilton, 3rd Earl of Haddington* (d. 1645)
Canvas: $25\frac{1}{2} \times 19$ in. (sight).
Illegible date inscribed top left. Inscribed (later) top right: *Geo: Jamesone pinx!.*
*Collection.* The Earl of Stair, Lochinch Castle, Wigtownshire.
*Provenance.* Unrecorded before 1883 but see 31; removed from Oxenfoord Castle to Lochinch Castle after 1911.
*Exhibitions.* Edinburgh, *Loan Exhibition of Old Masters*, 1883, no. 55, no. 75, or no. 77.
*References.* Bulloch, no. 173; Sir Hew Dalrymple, *Pictures at Oxenfoord Castle*, 1911, no. 49.

Head and shoulders, to the right, with long straight, fair to reddish, hair. Wears black doublet with long slashes; the sleeves similarly paned. The sitter is perhaps thirty years of age.

Costume, style, provenance, and the form of the late inscription suggest a link with 31 and 32. The damaged date may therefore have been 1630. The traditional identification is thus impossible as Thomas Hamilton's parents did not marry until 1622. If the identification of 31 is accepted it may be that this, as is suggested of 32,

is a brother of Catherine Erskine. However, comparison with the later portrait of Catherine's husband, the future 2nd Earl of Haddington, from the studio of Van Dyck, at Tyninghame, shows (allowing for the relative grossness of middle-age) similar fair, long hair, the same exceptionally high, square eyebrows, and the same sensitive mouth, the upper lip slightly gathered towards the centre.

34. *Henry Erskine, styled Lord Cardross* (d. *c.* 1636)
Canvas: $27\frac{1}{2} \times 22$ in.
*Collection.* Unknown.
*Provenance.* Probably in the collection of the Earls of Buchan from 1781 (or earlier) until later than 1890.
*References.* Probably the first item in a list of Jamesone's works in the Earl of Buchan's MS., p. 7: 'Henry Erskine 1st Lord Cardross in Lord Buchan's Collection. & in Lord Alva's'; probably Carnegie to Musgrave, fo. 123 v.: 'Henry Erskine of Dryburgh—Earl of Buchan'; probably Pinkerton's *Scottish Gallery*, as plate 40; probably Bulloch, no. 50 (in possession of the Earl of Buchan at Almondell, stating that it was painted in 1626); probably Catalogue of Pictures in Almondell House, 1890 (copy in SNPG), no. 17, annotated: '$\frac{1}{2}$ length, light rich dress, rich lace collar . . .': this is the source of the dimensions; Brockwell, p. 32.

It is not quite certain, though it is likely, that the above references are to the same painting. Nor are the references certain proof of the existence of a painting specifically by Jamesone, though the engraving in Pinkerton's *Scottish Gallery* is very much a Jamesone type. Apart from 14 (which see), a portrait of the subject is recorded in 1926 at Cardross House, in the collection of the late Sir David Erskine (see Mrs. Steuart Erskine, *The Memoirs of Sir David Erskine*, London, 1926, pp. 74–5). The picture, which is illustrated (opp. p. 30), is said to be 'a copy of one by Jamesone'. Whether or not this is strictly correct, it is sufficient evidence that a portrait by Jamesone did exist. It is remarkably close to the two portraits of about 1630 at Oxenfoord (Catalogue, 31 and 32). It also agrees with the engraving in Pinkerton and with Bulloch's verbal description.

The sitter is clearly the same as in 14, and it is of exactly the same pattern, with these

exceptions: band-strings and tassles are shown and the doublet and sleeves have long vertical slashes. One curious factor is that the description in the 1890 Almondell Catalogue tends to fit 14 rather better. Some degree of confusion between these two pictures should not be entirely discounted but the existing evidence points to the picture formerly at Cardross being either a close record of the Buchan original or, just conceivably, the original itself.

35. *Alexander Forbes, 1st Lord Forbes of Pitsligo* (d. 1636)
Canvas: 27× 22 in.
*Collection.* Mrs. P. Somervell, Fettercairn House, Kincardineshire.
*Provenance.* After the son of the 4th Lord Forbes died childless in 1781, the estate of Pitsligo was acquired by Sir William Forbes, heir of line of the 3rd Lord Forbes. The daughter and heir of Sir William Forbes's grandson, Sir John Hepburn-Stuart-Forbes, married the 20th Baron Clinton in 1858. By descent through these families.
*Exhibitions.* Aberdeen, *Archaeological Exhibition,* 1859, no. 130 (in possession of Sir John Stuart Forbes of Pitsligo); London, *Exhibition of National Portraits,* 1866, no. 559 (in possession of Sir John H. Forbes).
*References.* Bulloch, no. 65 (in possession of Lord Clinton).

Head and shoulders, to the right. A young man, with thick hair to his collar. He wears a lace-edged falling band over a dark doublet slashed on body and arms.

A particularly expressive head, the simple, fluent drawing of the face near to the *Montrose* of 1629 (Catalogue, 25; Plate 52): the line of the body is more upright. It also has much in common with the *Unidentified Man* at Oxenfoord (Catalogue, 32; Plate 61).

The sitter was raised to the peerage in 1633 but the date of the portrait must be nearer 1630. About this time he married Lady Jean Keith, daughter of the 6th Earl Marischal and Mary Erskine.

36. *Unidentified Man*
Canvas: 29× 23½ in.
Inscribed (later) on right: *Sʳ Hairy Nisbet of Dean/Lord Provost of Edinburgh.*
*Collection.* Unknown.
*Provenance.* If a Nisbet (see below), the picture

could have descended with Janet, daughter of Sir William Nisbet of Dean, who married before 1644 John Murray of Touchadam and Polmaise; in collection of Col. John Murray, 1885; sold by the trustees of Major A. B. Murray of Polmaise through Dowell's, Edinburgh, at Polmaise Castle, 10–11 April 1956, lot 276.
*References.* Bulloch, no. 152.

Head and shoulders, to the right; a man of about forty with receding hair, pointed beard, and moustache. Wears falling ruff over dark, greenish, slashed doublet; the sleeves of the doublet have wider slashes.

Very badly damaged. The rather small head, the drawing of the eyes, and the expression are all characteristic of Jamesone.

As this is a portrait of the early 1630s the inscription is erroneous, as that Sir Harry Nisbet died in 1607 (see Andrew Ross and Francis J. Grant, *Alexander Nisbet's Heraldic Plates,* Edinburgh, 1892, p. li). If a record of a confused tradition, it could represent his grandson, Sir Henry Nisbet of Craigentinnie (d. 1667): Nisbet's own son James is discounted as he died in 1621.

37. *Dr. Patrick Dun* (d. 1649)
Panel: 29¾× 22¼ in. (Plate 62).
*Collection.* Rubislaw Academy (Aberdeen Grammar School).
*Provenance.* In possession of the Bissets of Lessendrum from the late 18th century; presented to the Grammar School in 1864 (inscription on frame).
*Exhibitions.* Aberdeen, *Archaeological Exhibition,* 1859, no. 38 (in possession of Archdeacon F. Bisset).
*References.* Earl of Buchan's MS., p. 9: 'Doctor Dunn founder of the Grammar School of Aberdeen belongs to Mr. Bisset of Lessendrum'; Carnegie to Musgrave, fo. 123v. (in possession of Miss Bisset of Lessendrum); Bulloch, no. 26; Brockwell, p. 33.
*Copies.* There is a 19th-century copy by John Moir in the Aberdeen Town House.

The paint on the rather warm face is very thin and transparent, the vertical wood-grain visible throughout. The eyes are drawn with considerable control of form, and though much of the tonal variation of the face must have been rubbed away, the existing forms have a rightness which survive the damage.

There are small splits at the top and bottom of

the panel and narrow openings on either side of the face. A 19th-century photograph (in SNPG) shows clumsy and extensive restoration: this was removed c. 1950.

The frame to which the panel is screwed is inscribed '*MDCXXXI* Patrick Dune *MD*': this date is an acceptable tradition. Dun was Principal of Marischal College 1621–49. In 1629 he was godfather to Jamesone's first son, William (Documents, 22), which tends to reinforce the attribution to Jamesone.

38. *Archibald Napier, 1st Baron Napier* (1576–1645)
Canvas: 25 × 22 in.
Inscribed (later) top right: *ARCH.D LORD NAPIER 1.*
*Collection.* The Lord Napier and Ettrick, Normandy, Surrey.
*Provenance.* Probably family ownership until sold about 1900 (information from present owner); acquired by the grandfather of Gordon Heath of Englefield Green in Surrey and to the latter by inheritance; acquired from him by the present owner in 1972.
*References.* Musgrave (Wilton Lodge list): 'in Wilton-lodge, Lord Napiers ... 6. Sir Archibald Napier ... Painted by Jamieson'; Bulloch, no. 154.
*Copies.* There is a good 19th-century copy in Parliament Hall, Edinburgh.

Head and shoulders, to the right. The sitter has a vigorous head with high forehead, powerful nose, beard, and upturned moustache. He wears a fine, standing-falling ruff; the faintly embroidered doublet has long slashes. Slight overcleaning on the ruff, considerable retouching on the face.

39. *Andrew Murray of Blackbarony* (c. 1561–1587)
Canvas: 26 × 21½ in.
Inscribed upper left: *Ætatis 26./1587.* Coat of arms top right. Inscribed (later) top left: *Mr. Murray of BlackBaromy*; numbered (later) bottom right: 132.
*Collection.* Unknown.
*Provenance.* Unrecorded before appearing at Newbattle; sold from the 11th Marquess of Lothian's estate at Christie's, 19 October 1951, lot 40.
*References.* Catalogue of the Paintings in Newbattle Abbey, 10 March 1798 (transcript in

SNPG): 'Great Room ... Murray of Blackbarrony, aged 26, 1587'; Newbattle Inventory of 1833 (transcript in SNPG), no. 132: 'Mr. Murray of Blackbarony Aetat 26 1587'; Christie's Sale Catalogue (loc. cit.): 'in black doublet lined with pink ...'.

Head and shoulders, to the right. A small face with fair moustache and short beard. He wears a high cap and a wide closed ruff with figure-of-eight sets. The doublet is turned back to reveal a waistcoat which has short slashes similar to those on the right arm.

The costume is an unhistorical attempt to place the sitter in the late 16th century. A rather feeble portrait but comparison with the *Arthur Johnston* (Catalogue, 27; Plate 57) establishes Jamesone's authorship. The head has rather more individuality than is usual in a 'fancy' portrait and Jamesone may have worked from an earlier portrait in which little but the face remained. This appears to have been a rare activity for Jamesone.

The subject was the second son of Andrew Murray of Blackbarony and Grissel Bethune (married after a contract of 1551); he died, presumably shortly before 2 June 1587 when his brother was retoured his heir (see *The Scots Peerage*, vol. iii, p. 503). The portrait (or its original) may therefore have been commemorative.

## A HISTORICAL SERIES OF SCOTTISH MONARCHS

THE following twenty-six Catalogue entries make up a series (or the survivors of a series) which the evidence suggests Jamesone painted for the Council of Edinburgh on the occasion of Charles I's visit to the city in 1633. They are given here in the order in which they are listed in the earliest numbered Lothian inventory: these numbers are inscribed on the canvases. The order is in fact chronological, with some exceptions, but in reverse. Notes and commentary on the series are given at the end of 65.

40. *Mary, Queen of Scots* (1542–1587)
Canvas: 28½ × 25 in.
Inscribed top left: *MARIA REGINA/Anno 1543*; and bottom left (later): 65 (twice).
Head and shoulders, to the left; face pale,

shadows pink to light brown. A tall crown with pearls sits on twin masses of brown hair; dress grey with yellow embroidery. Background thin and freely brushed.

### 41.　James V (1512–1542)
Canvas: $26\frac{3}{8} \times 22\frac{3}{4}$ in. (sight). (Plate 69).
Inscribed top right: *IACOBVS.5./Anno.1542*; and bottom left (later): 66.

Doublet ochre/brown; the sleeves of the gown are red to crimson with yellow embroidery.

### 42.　James III (1457–1488)
Canvas: $26\frac{5}{8} \times 22\frac{5}{8}$ in. (sight). (Plate 67).
Inscribed top right: *IACOBVS 3./Anno 1488*; and bottom left (later): 67 (twice); also bottom right (later): 386.

Face warm, with tendency to greenish shadows. The dark doublet is worn over a vermilion vest.

In condition probably the best of the more 'complete' group of the series (see commentary below).

### 43.　James II (1430–1460)
Canvas: $26\frac{3}{4} \times 22\frac{1}{2}$ in. (sight). (Plate 70).
Inscribed top left: *IACOBVS 2./Anno 1460*; and bottom left (later): 68 (twice). Signed lower left: *Jameson[e]/Fec.*

Face warm, hair brown. The rather confused gown is worn over what appears to be a low-necked doublet, which is red. The chain across the shoulders is made up of red and blue/green jewels.

Red ground visible bottom left; areas of damage on right forehead, under nose, and on right shoulder.

### 44.　James I (1394–1437)
Canvas: $26\frac{1}{2} \times 23$ in. (sight).
Inscribed top left: *IACOBVS I/Anno 1430*; and bottom left (later): 69; also (later): 385.

Head and shoulders, to the right. Wears a black hat with jewel; face warm, with typical elongated Jamesone nose; brown hair and full red lips. The red doublet has traces of yellow embroidery.

Some flaking on right forehead and damage on right jaw.

### 45.　Robert III
Canvas: $26\frac{7}{8} \times 22\frac{1}{4}$ in. (sight).

Inscribed top left (strengthened): *ROBERTVS.3/ Anno 1390.*; and bottom left (later): 70.

Head and shoulders, to the left; clean shaven. Wears a crimson bonnet; his body is wrapped in some form of green/blue, low, square-necked 'doublet', the sleeves just visible bottom left and right; over this is a red gown with elaborately embroidered borders.

Face badly skinned.

### 46.　Robert II
Canvas: $27 \times 22\frac{7}{8}$ in. (sight). (Plate 71).
Inscribed top left: *ROBERTVS STVARTVS.1./ Anno.1370.*; the same below this (later); and bottom left (later): 71 (twice).

The freely painted face is rather red. The pink 'doublet' is covered by a black to blue/green gown which has traces of the same pink in the highlights on the sleeves. The background is warm and thin, and painted with some verve.

Largely undamaged and not repainted, this gives the clearest idea of what the less 'finished' group of the series must originally have looked like.

### 47.　David Bruce
Canvas: $27\frac{1}{2} \times 23\frac{1}{4}$ in.
Inscribed top right (strengthened): *DAVID BRVSIVS./Anno.1330.*; and bottom left and right (later): 72. Signed bottom right: *Jamesone/F.*

Head and shoulders, to the right; face very warm, hair and beard fair. Wears flat red bonnet with white feather; 'doublet' dark yellow with ermine at throat; over this a type of jerkin which is red with a band of blue round the borders. A creamy pink ribbon holds a medallion on the breast.

The paint is thin and tending to flake; though thinly painted the face appears to be rubbed.

### 48.　Robert Bruce
Canvas: $27\frac{1}{4} \times 23\frac{1}{2}$ in. (Plate 75).
Inscribed top right: *ROBERTVS BRVSIVS./ Anno.1306.*; and lower and bottom left (later): 73 (three times). Signed lower left: *Jamesone/F.*

The face is very warm, the cloak purplish red. The face and background are treated similarly to the less 'finished' group of the series, while the armour and cloak have more in common with the more 'complete' group.

Paint samples have been scientifically studied:

for the results and comments on the technique see pp. 53–4 above. Cleaned and restored 1973.

### 49.  *Alexander III*

Canvas: 26⅝ × 22¼ in. (sight).
Inscribed top left: *ALEXANDER.3./Anno.1249.*; the same below this (later); and bottom left (later): 74 (twice). Signed lower left: *Jamesone/F*; inscribed (later) below the signature: No. 74.

Head and shoulders, to the left, shoulders almost profile; face warm, with short hair and pointed beard. Wears flat blue cap, and 'doublet' with reddish gorget, decorated with black jewels; blue/green gown across shoulders; the 'doublet' sleeve bottom right is red ochre with red and yellow embroidery.

### 50.  *Alexander II*

Canvas: 26¾ × 22½ in. (sight).
Inscribed top right: *ALEXANDER.2/Anno.1214.*; the same below this (later); and bottom left and lower right (later): 75.

Head and shoulders, to the right; face very warm, short brown hair, beard and moustache. Wears a red, ermine-trimmed cap; 'doublet' a mixture of strong greens and blues; gold neckband has red central jewel; gown red with ermine borders.

### 51.  *William the Lion*

Canvas: 27⅜ × 23½ in.
Inscribed top right: *GVLIELMVS/COGNO-MENTO LEO/Anno.1165*; the same below this (later); and bottom left (later): 76 (twice).

Head and shoulders, in profile, to the left; red face, black hair, and long moustache. Wears grey armour, with dark blue garment beneath; this has gold strip on breast with red jewel; also wears red ribbon with badge.

### 52.  *Malcolm* (1153)

Canvas: 26⅝ × 22¼ in. (sight). (Plate 72).
Inscribed top left: *MILCOLVMBVS/NEPOS/DAVIDIS/Anno 1153*; the same below this (later); and bottom left and right (later): 77.

The square-necked 'doublet' (or partlet) is a strong vermilion; over this is worn an open jerkin of lime green.

Though in bad condition, this is nearer the usual type of Jamesone life-portrait and has a degree of personality not particularly evident in the series.

### 53.  *Edgar*

Canvas: 26⅝ × 23 in. (sight).
Inscribed top right: *EDGARVS/Anno.1098*; and bottom left and right (later): 78.

Head and shoulders, in profile to the right; face rather pale, fair moustache and dark brown hair. Wears ermine partlet with red top border studded with blue jewels; 'doublet' green to olive green, with prominent highlights on sleeve.

### 54.  *Donald*

Canvas: 27¼ × 23¼ in.
Inscribed top right: *DONALDVS/Anno 1092*; the same below this (later); and bottom left and right (later): 79.

Head and shoulders, to the right; short curled yellow hair and fair moustache; eyes pale blue. Wears dark blue bonnet trimmed with ermine; small area of ermine on breast over which is worn a brown/red jerkin with dark blue borders and traces of grey embroidery.

Thinly painted; in quite good condition except for two major tears.

### 55.  *Malcolm Canmore*

Canvas: 26⅜ × 21⅞ in. (sight). (Plate 73).
Inscribed top right: *MILCOLVMBVS/CAN-MORE/Anno.1057*; the same below this (later); and bottom left (later): 80 (twice).

Reddish face and beard and dark brown hair. The 'doublet' or partlet is a thinly applied yellow, with traces of embroidery, and has upper borders of red and blue; the sleeves of the gown are dark blue.

### 56.  *Kenneth*

Canvas: 27⅜ × 23⅜ in.
Inscribed top left: *KENNETHVS./Anno 970*; the same below this (later); and lower left (later): 81 (twice).

Head almost full-face, shoulders to the left; wears an 8-pointed crown with dark blue jewels. A rotund, rather Bacchanalian face with long moustache and fair hair; wears a brown 'doublet' with dark blue jewel, and a blue/black cloak on the shoulders, held by a clasp on the left breast.

### 57.  *Duffus*

Canvas: 26⅞ × 22⅞ in. (sight).
Inscribed top left: *DUFFUS/Anno 961*; the same

below this (later); and bottom left (later): *Jameson/F/82.*

Head and shoulders, in profile to the left; clean-shaven, quite warm face, brown hair. Wears pink and white bonnet and pink/crimson gown with large ermine collars; narrow strip of blue at neck.

### 58. *Malcolm* (943)

Canvas: 27⅞ × 23¼ in.
Inscribed top right: *MILCOLVMBVS/ Anno.943.*; the same below this (later); and bottom left (later): 83; and bottom right (later): 83 (twice).

Head and shoulders, in profile to the right; face livid, with short fair hair, moustache and beard. Wears cloak of olive green topped with ermine 'partlet' held by gold band with alternating red and green jewels.

### 59. *Fergus II*

Canvas: 26⅝ × 22¾ in. (sight).
Inscribed top left: *FERGVSIVS.2./Anno.404.*; and bottom left (later): 84; and bottom right (later): 84/*Jameson/F.*

Head and shoulders, in profile to the right; pinkish face, thick brown hair, beard and moustache. Wears armour, with lion-head mask on shoulder; over the armour a dark blue/ green 'partlet' from throat to waist.
Considerable damage lower right.

### 60. *Corbredus Galdus*

Canvas: 27¼ × 24 in.
Inscribed top right (strengthened): *COR-BREDVS GALDVS./Anno.76.*; and bottom left (later): 85; and bottom right (later): 85 (twice).

Head and shoulders, in profile to the right; face very warm, with short beard and moustache. Wears black helmet and armour which have thick white highlights; leaf pattern engraved on right shoulder; a vermilion doublet appears at lower arm level.

### 61. *Donald*

Canvas: 26¾ × 22½ in. (sight).
Inscribed top right: *DONALDVS PRIMVS QVI/CHRISTI FIDEM AMP[LEXUS] /EST ANNO [...]*; and bottom left and right (later): 86.

Head and shoulders, in profile to the right; bearded face with mass of red/brown hair to

shoulders. Wears velvet-lined crown and brown/ black gown with chain round shoulders.
Almost completely ruined.

### 62. *Caratacus*

Canvas: 27¼ × 23¼ in.
Inscribed top right: *CARATACVS/Anno 35*; the same below this (later); and lower left (later): *Jameson/F/87* (twice). Signed above this: *Iamesone/Fec.*

Head and shoulders, in profile to the left; rather livid face with short black hair and beard. Wears gold helmet and armour over blue/black doublet; row of pearls on breast, and ribbon with medallion.

### 63. *Metellanus*

Canvas: 26⅞ × 22¾ in. (sight).
Inscribed top right (strengthened): *METEL-LANVS/ANNO CHRISTI.1.*; and bottom left and right (later): 88.

Head and shoulders, in profile to the right; reddish face, fair hair to shoulders, moustache and beard. Wears dark armour, with red strip at neck, over chain-mail.
Considerable paint loss, especially on right half.

### 64. *Feritharis*

Canvas: 27½ × 23¼ in.
Inscribed top right (strengthened): *FERITH-ARIS./Anno.305.*; and bottom left and lower right: 89.

Wears deep blue bonnet and gown; small areas of red sleeve of another garment emerge from gown. Background an even, light ochre.

### 65. *William Wallace*

Canvas: 26¾ × 22⅝ in. (sight).
Inscribed (?later) top right: *GVLIELMVS WALACE/Anno 1300*; the same below this (later); and bottom left and right (later): 90.

Head and shoulders, to the right; face warm, with thick beard and moustache. Wears armour and helmet with yellow serpent on crest; a cloak is gathered across the shoulders.
In very bad condition, the face almost entirely repainted.

Although not a monarch, this certainly formed part of the series, and is treated as such both here and in the main text.

*Collection.* At Newbattle Abbey College, Midlothian, until 1971.

*Provenance.* Their history between 1633 and their appearance at Newbattle *c.* 1720 is not known. They could have been acquired by the 3rd Earl of Lothian who, especially during the Commonwealth, collected such series (e.g., groups of Continental historical figures by Louis-Ferdinand Elle). They may not, however, have entered the collection until after de Witt had made use of them at Holyrood. With no apparent understanding of their historical significance as a series, they were, with the exception of 40–4, dispersed at Dowell's, Edinburgh, 2 July 1971.

*Exhibitions.* Robert II, Robert III, James I, James II, James III, and James V at London (New Gallery), *Royal House of Stuart*, 1889, nos. 1–6.

*References.* Newbattle Catalogue of *c.* 1720 (transcript in SNPG), nos. 65–90, 'all done by Jamesone'; Newbattle MS. of late 18th century (transcript in SNPG): 'A collection of Scots Kings—Jameson'; Walpole, p. 3; Catalogue of the Paintings in Newbattle Abbey, 10 March 1798 (transcript in SNPG): nine in the House-Keeper's room (eight called 'Copies by Jamison'), one in the Low Parlour, four in Lord Ancram's tool room, seven in Room No. 3 (four called 'Kings of Scotland & copies by Jamison'), and one in the Servants' Hall: *Mary* is probably 'Mary of Guise' in the Blue Dressing Room, while *Kenneth*, *James II*, and *James V* are unidentifiable; Musgrave (Newbattle list) gives nine in the Ground Floor Room (nos. 112, 118–25), one in the Low Parlour (no. 165), five in Lord Ancram's room (nos. 169–70, 172–3, 193), and seven in Room No. 3 (nos. 224, 229–232, 241–2); Newbattle Inventory of March 1833 (transcript in SNPG), all under *c.* 1720 numbers; Brockwell, pp. 23–4.

Twenty of these pictures have been painted with great rapidity and with little consideration for other than bright, decorative effects. The four Jameses, Robert III, and Feritharis have been painted with a great deal more attention to detail and individuality, and prototypes certainly existed for the Jameses. This might suggest that the two groups played rather different roles within an overall decorative scheme—it could for instance mean that the more 'complete' group were to be more visible.

Although generally of considerable crudity there are stylistic affinities with other paintings by Jamesone. In their bright colour and free handling they look forward to the Glenorchy ladies (Catalogue, 71-(i) to 78-(6); Plates 83 and 86–91), and to the three queens in the same collection (79–81). The *Robert Bruce* (48; Plate 75) is comparable to some of the figures in the *Glenorchy Family Tree* (93; Plate 94), e.g., the forms of his gathered cloak are close to those of the reclining figure. *Malcolm* (52; Plate 72) displays the slight smile and the tendency to pull the rear of the head towards the picture plane which tend to recur throughout Jamesone's work. Generally, smallish heads on wide shoulders, and a lack of calculation in relating the figure to the picture area, are also typical.

Jamesone's involvement in the preparations for Charles I's ceremonial entry into Edinburgh in the summer of 1633 is documented, but not in detail (Documents, 32). An 18th-century description of these events is based on contemporary documents and has the ring of truth (William Maitland, *The History of Edinburgh*, Edinburgh, 1753, pp. 64–6). The general impression is of colour and a rather bucolic classicism, as well as constant reminders of the antiquity of the kingship. William Drummond of Hawthornden, in his welcoming speech, speaks of the goodwill borne by the nation to 'the Desarts of your Ancestors, and shall ever to your own and your Royal Race . . .'. The King entered the city by the West Port where there was a large 'beautifully depicted . . . View of Edinburgh'. The nymph Edina stepped down from this and presented Charles with the keys of the city. The procession moved eastwards through streets 'hung with Tapestry, Carpets, &c.' to the Overbow where, at the first triumphal arch Caledonia made a speech: 'Pray, that those crowns his Anscestors did wear,/His Temples long (more orient) may bear.' Then, 'At the Western End of the Tolbooth, in the High-street, stood the second triumphal Arch, whereon were painted the Portraits of the Hundred and nine Kings of Scotland; within the Arch, Mercury was represented conducting Fergus, first King of Scotland, who, in a grave speech, gave many paternal and wholesome Advices to Charles as his Royal Successor.' This description agrees closely with that of the contemporary observer, Spalding (see p. 6 above).

The first clear link between Jamesone's name

and the painted part of these decorations is found in David Wedderburn's poem *Vivat Rex*, published in 1633 as a welcome to the King (reprinted by William Leask (editor), *Musa Latina Aberdonensis*, vol. ii, New Spalding Club, 1910, p. 402):

> Ecce Iamesoni tabulam pictoris!
> ab alto
> Sanguine Fergusi proavos per
> stemmata pictos.

Even more convincing evidence linking the above pictures with these decorations is found in the diary of Sir John Lauder of Fountainhall (printed as *Historical Observes of Memorable Occurrents in Church and State*, Bannatyne Club, 1840, p. 156). Writing in 1685 of the series of kings by de Witt, which still decorate Holyroodhouse, he remarks: 'In our gallery of the Abbey their is set up the pictures of our hundred and eleven Kings since Fergus I, 330 before Christ, which make a very pretty show.... They have guessed at the figure of ther faces before James the I. They got help by thesse pictures that ware used at Charles I's coronation in 1633, wher they all met and saluted him, wishing that as many of ther race might succeed him in the throne as had praeceded him.' Comparing de Witt's kings with Jamesone's, the following have the same basic pattern: *David Bruce, Robert Bruce, Alexander III, William the Lion, Malcolm* (1153), *Edgar, Malcolm Canmore, Malcolm* (943), *Corbredus Galdus*, and *Donald*. In some cases de Witt is so close to certain stylistic features of Jamesone that they almost appear to be reincarnations.

The sources of Jamesone's images are more difficult to establish. The line of purely imaginary kings (those prior to Malcolm II, 1004) was well established and an important element in the national consciousness. The programme probably derived from books such as the Aberdonian John Jonston's *Inscriptiones Historicae Regum Scotorum*, published at Amsterdam in 1602; or Hector Boece's *A brief Chronicle of all the Kings of Scotland*, reprinted by Edward Raban in Aberdeen in 1623. The dates inscribed on the pictures, the presumed first regnal year, agree in almost every case with those given by these authors. In the case of the four Jameses, however, Jamesone has inscribed the date of death.

As Fountainhall implies, there were established images for these monarchs from James 1 onwards. Jamesone's *James I* is close to the engraving in Jonston's *Inscriptiones*, and also to a small panel in the SNPG (no. 682) which is one of a series of the first five Jameses, probably painted in the latter part of the 16th century. The *James II* (Plate 70) is also close to Jonston, but it is an even clearer echo (though reversed) of the image in the so-called 'Seton Armorial', a manuscript of 1591 (in possession of Sir David Ogilvy of Winton Castle). It is reminiscent of the panel in the SNPG series (no. 683) but is close to a similarly small painting in the Wittelsbach collection.

The established pattern for James III can, however, be traced to much nearer its source. The Scottish heavy groat coin of *c.* 1485 (Plate 65) bears what is perhaps the earliest true portrait in the coinage of northern Europe (see Ian Stewart, 'The Heavy Silver Coinage of James III and James IV', *The British Numismatic Journal*, 1954, vol. xxvii, pp. 182–94). The King is depicted as young and clean-shaven, wearing a crown and turned towards the left. He has thick waving hair on either side of his face, wears a doublet with a low collar and has a gown or jerkin across his shoulders. All these features are present in Jamesone's portrait: the similarity between the heavy masses of hair is particularly pronounced. Though it is not suggested that Jamesone worked directly from the coin, this particular image had a long and varied life. It can be traced through the kneeling King in the *Trinity Altarpiece* by Hugo van der Goes, painted in *c.* 1478 (National Gallery of Scotland; Plate 64) to the panel in the SNPG series (no. 684; Plate 66) and the engraving in Jonston. The drawing in the Seton Armorial is also closely related.

The *James V* (Plate 69) is also of the same basic type found in the SNPG panel (no. 686), the Seton Armorial and Jonston.

The remainder of the series seem to be purely inventions. The costume makes little sense, the best having a vague similarity to English costume of the early 16th century. Unidentified engraved iconographies may well have been used: some of the profile heads are close to the vapid classical heads on some Italian maiolica of the 16th century.

The triumphal entry of a monarch had, by 1633, a fairly long history in Scotland (see p. 26 above), presumably derived from the Flemish *Blijde Intrede*. In the present context it is diffi-

cult to overlook the similarities to the triumphal entry of the Cardinal-Infante Ferdinand into Antwerp less than two years later, for which Rubens prepared the decorative schemes (see John Rupert Martin, *The Decorations for the Pompa Introitus Ferdinandi*, London, 1972). Though on an entirely different aesthetic level, the second triumphal arch confronting Charles, into which portraits of the 109 monarchs were set, may have appeared a humbler version of one of the Antwerp arches. One specific parallel can be drawn: a fragment of a portrait of Philip I by Cornelis de Vos from Rubens's Arch of Philip has, though it is more competent, the same vapid, ephemeral quality, and even a surprising degree of similarity in its looseness of handling, to many of those in the present series (Plate 68). As the idea of the triumphal arch decorated with portraits must have found its way to Scotland from the Continent it is conceivable that the function carried with it traces of a common style.

66. *Isabel Hamilton, Countess of Airlie* (1596-after 1664)
Canvas: 29 × 27 in. (Plate 79).
Inscribed top left: *Anno 1634*.
*Collection.* The Earl of Airlie, Cortachy Castle, Angus.
*Provenance.* Probably family ownership since painted.
*Exhibitions.* Glasgow, *Scottish Exhibition*, 1911, no. 57 (Catalogue, vol. i).
*References.* Probably the picture called by Sir Hew Dalrymple, Helen Ogilvy, in the King's Room at Cortachy Castle: 'Anno 1634 ... almost certainly by Jamesone' (MS. in SNPG, HD Notebook, pp. 28-9).

The colour is generally warm. Her reddish brown hair is crimped, brushed back from the forehead and fluffed out at the sides. She wears a small black caul and the hanging sleeve of a gown falls from its insertion under the wing of the bodice. Rubbed and thin but with little repaint.

It repeats the compositional pattern of the *Mary Erskine* of 1626 (Catalogue, 9; Plate 39). The inscription, which may have been gone over, agrees with the dating of the costume.

Isabel Hamilton was second daughter of the 1st Earl of Haddington and was born on 18 February 1596 (see Sir William Fraser, *Memorials of the Earls of Haddington*, Edinburgh, 1889, vol.

i, p. 187). She married James Ogilvy (created Earl of Airlie in 1639) after a contract dated 22 November 1610. The apparent age of the sitter agrees with these facts. She has occasionally (see above) been called Helen Ogilvy, wife of the future 2nd Earl of Airlie, who married in 1629. In view of the current fashion of youthful first marriage a much younger-looking sitter would be required to make this identification likely.

67. Called *James Crichton of Frendraught* (*c.* 1598-after 1667)
Canvas: 28 × 25 in.
Inscribed lower right: *Anno 1634/Ætatis 36*.
*Collection.* The Morison of Bognie Trustees, Frendraught, Aberdeenshire.
*Provenance.* The widow of James Crichton, 2nd Viscount Frendraught (d. *c.* 1674/5) married George Morison of Bognie; presumably by descent in these families.
*References.* Probably Earl of Buchan's MS., p. 8: '1st Viscount of Frendraught & his wife belongs to Mr. Morrison of Bognie in Aberdeenshire'; probably Carnegie to Musgrave, fo. 124: 'Crichton, Viscount of Frendraught—Morison of Bognie in Aberdeenshire'; Bulloch, no. 138; Brockwell, p. 33.

Head and shoulders, to the right; a rather concave, beardless face with thick moustache; rather short hair, with fringe on forehead. Wears broad lace-edged falling band over dark, slashed doublet which has some darker embroidery.

A good deal of repaint on the face. There are some traces of Jamesone's drawing and the method of lighting arm and breast is characteristic. The inscription is untouched and shows the same calligraphy as the *Mary Erskine* (Catalogue, 9; Plate 39).

Crichton's date of birth is not otherwise known but he was made a Justice of the Peace for Aberdeenshire in 1610 at an apparently remarkably early age (*The Scots Peerage*, vol. iv, p. 126). His son was created Viscount Frendraught in 1642, during his own lifetime, which has caused some confusion. He married Elizabeth Gordon, eldest surviving daughter of the 12th Earl of Sutherland, in 1619 (see 115 below).

68. Called *Sir Robert Montgomery of Skelmorlie* (*c.* 1565-1651)

Canvas: 29 × 24½ in.
Inscribed top left: *Anno 1634/Ætatis 69.*
*Collection.* Unknown.
*Provenance.* Probably in Halkett of Pitfirrane possession from 17th century (see below); certainly with Sir Peter Arthur Halkett by 1874; sold by the executors of Miss Madeline Halkett through Dowell's, Edinburgh, at Pitfirrane House, 20 December 1951, lot 682.
*References.* Catalogue of Paintings, etc., at Pitfirrane, 1874 (copy in SNPG), no. 62: 'A Baronet of Nova Scotia'.

Nearly half-length to the right; an old man wearing skull-cap with long, narrow head, sunken eyes and cheeks; a large spade beard falls on a standing-falling ruff. On his breast is worn the ribbon and escutcheon of a baronet of Nova Scotia: the motto is still legible.

Features typical of Jamesone are the massive shoulders and relatively small head, the near smile created by the upcurving of the corners of the mouth, and the 'floated' highlights on the right arm. It has a good deal in common in drawing and sentiment with the *Sir William Nisbet of Dean* (Catalogue, 122; Plate 121) and the *1st Earl of Northesk* (Catalogue, 117; Plate 118).

Baronets of Nova Scotia were first created in 1625 but it was not until 17 November 1629 that Charles I, in a letter to the Council, described the order to be worn: 'ane orange tauney-silk ribbane, whairon shall hing pendant in scutchion argent a saltoire azeuer, thairon ane inscutcheine of the armes of Scotland, with ane imperiall croune above the scutchone, and incircled with this motto, Fax Mentis Honestae Gloria' (Francis W. Pixley, *A History of the Baronetage*, London, 1900, p. 177). This agrees exactly with the order worn here: the date '1629' is also included, as it was in all examples of the order.

Sir Robert Montgomery was created baronet in 1628. A daughter, Margaret, married James Halkett of Pitfirrane: their son, Charles, was created baronet in 1662. This latter baronetcy merged with that of Wedderburn (cr. 1697) in 1705 under the name Halkett of Pitfirrane (*Complete Baronetage*, vol. iii, p. 334, and vol. iv, pp. 373–4).

69. *Margaret Douglas, Marchioness of Argyll* (1610–1678)

Canvas: 28½ × 25 in. (Plate 80).
Inscribed top left (later, but probably on the basis of a contemporary inscription): *Anno 1634/ Marchioness of Argile.*
*Collection.* Edinburgh, Scottish National Portrait Gallery, no. 1413.
*Provenance.* Not clear when it entered the Lothian collection; there were, however, close family ties with the Argylls (the sitter's second son married a daughter of the 3rd Earl of Lothian in 1668: her second daughter married the 1st Marquess of Lothian). When the 9th Earl of Argyll was forfeited and executed in 1685 some Argyll pictures are known to have entered the Lothian collection. Acquired in 1941 by bequest of the 11th Marquess of Lothian.
*Exhibitions.* Edinburgh, *Scottish National Portraits Loan Exhibition*, 1884, no. 86.
*References.* Catalogue of the Paintings in Newbattle Abbey, 10 March 1798 (transcript in SNPG): 'Great Room ... Marchioness of Argyle, 1634'; Musgrave (Newbattle list): 'Ly. Margt. Douglas, Marchioness of Argyle, 1634'; Newbattle Inventory of 1833 (transcript in SNPG), no. 211: 'Marchss. of Argyll, 1634'; Bulloch, no. 125 (wrongly called 'Ann' Douglas).

The sleeves of the dress are a pale gold to olive colour. The flesh colours are exceptionally pale and are permeated with traces of the colour of the dress. Though the paint on the hair is thin, on the rest of the figure it is unusually fatty, the flesh painted in a kind of stippling technique. There is little prominent repaint. There have been slight additions on either side and along the top, but even if these were removed the figure would still tend, characteristically, to shrink within the picture area.

Stylistically, and in its rather gentle, pensive mood, it is near to the *Lady Binning* of 1630 (Catalogue, 31; Plate 60). The well understood drawing of the left eye is close to that in the *Montrose* of 1629 (Catalogue, 25; Plate 52): indeed, it is characteristic of Jamesone that this eye in this position, usually the more difficult to effect, is often more convincingly treated than the right.

The sitter married her cousin Lord Lorne (later 8th Earl and 1st Marquess of Argyll) in 1626. There was certainly a portrait by Jamesone of her husband (Catalogue, 105) but that remained in the Argyll collection. It is possible that Archibald Campbell, who arranged Jame-

sone's Edinburgh commissions from Sir Colin Campbell, played a part in this commission, for he also acted as an agent for Lord Lorne and his father, the 7th Earl of Argyll (see Documents, 41). While the inscribed date is acceptable, the inscription must have been modified as Lord Lorne did not succeed his father until 1638.

70.  *David Calderwood* (1575–1650)
Canvas: 30 × 25 in.
Inscribed top left: *Anno 163[?5]* /*Ætatis 6[?0]*.
*Collection.* Sir John Clerk, Penicuik House, Midlothian.
*Provenance.* Probably in Clerk of Penicuik possession since 1750.
*Exhibitions.* Aberdeen, *Archaeological Exhibition*, 1859, no. 37.
*References.* Probably 'The picture of Mr. Calderwood the historian done by Jamesone a scholar of Rubens' in a Mavisbank (Clerk of Penicuik) inventory of February 1750 (transcript in SNPG).

Head and shoulders, to the right. An old man, he wears a skull-cap and has a thick brown moustache and a full, square 'cathedral' beard. Dark, much rubbed, a good deal of incidental damage and a fair amount of retouching on the face.

The picture is of the same type as the *Patrick Dun* which is probably of 1631 (Catalogue, 37; Plate 62). The cast of the features and what remains of the original handling in the lower part of the face and collar are characteristic of Jamesone and it is certainly by the same hand as the portrait called *Alexander Skene of Skene* (Catalogue, 110).

### A HISTORICAL SERIES OF THE LADIES OF GLENORCHY

THE following eight Catalogue entries belong to a clearly defined and documented group which until recently remained virtually intact. Notes and commentary on the series are given at the end of 78-(6). The numbers in brackets relate them to companion portraits by a different hand.

71-(i).  *Lady Marjory Stewart*
Canvas: 34½ × 28¼ in. (Plate 83).
Inscribed on painted oval: *DOMINA MARIOTA STEVART FILIA ROBERTI*

*COMITIS DE FYFFE ET MONTEITH EIVS SPONSA ANNO DOM̄ M.CD.VI.*

She has gold to brown hair, held by a form of upper billiment. The face is very pale cream with greyish shadows. The highlights of the eyes are thick horizontal flecks of white. Her dress, of an indeterminate period, is a strong pinkish vermilion, with a grey border to the decolletage; the dark panel across her breast consists of traces of dark blue and ochre on black. A brown drape (perhaps oversleeves) encircles both arms. The corners outwith the oval are lightly marbled.

The paint is thin throughout, but rubbing is limited and there seems to be little repaint.

72-(ii).  'Countess of Argyll' (lost)

73-(1).  *Lady Janet Stewart*
Canvas: 34 × 29 in. (Plate 86).
Inscribed on painted oval: *DOMIN[A] IONETA STVART FILIA WILLIELMI DOMINI LORNE EIVS SPONSA ANNO DOM̄ M CD XL.*

The style of costume is indeterminate. She wears a yellow coif with a criss-cross pattern; behind this is a loose dark hood. The border of the decolletage of her dark dress is grey and is filled with the same black floral embroidery as appears on the chemise frills at the right wrist. A broad ochre panel runs down the front of the dress.

Some repaint on the face, though this hardly accounts for the unfortunate drawing of the eyes.

74-(2).  *Lady Margaret Douglas*
Canvas: 33½ × 28¼ in. (Plate 87).
Inscribed on painted oval: *DOMINA MARGARETA DOVGLAS FILIA ANGVSIAIE COMITIS EIVS SPONSA ANNO DOM M CD XCVI.*

The embroidered object in the sitter's right hand is certainly not a book as stated by Bulloch (p. 149). At the breast of the blue/grey dress is a similar border of black embroidery (repeated at the wrist) to that in the *Lady Janet Stewart*; most of this is, however, hidden by what appears to be a broad fur edging to an outer cloak. The highlights on the right sleeve are of the sharp, zigzag form noted in the *Charles de Montpensier* (Catalogue, 29; Plate 58).

The background is probably repainted. The paint is generally thin, with many minor repairs, especially near the perimeter.

### 75-(3). *Lady Marjory Stewart*
Canvas: $33\frac{3}{4} \times 28$ in. (Plate 88).
Inscribed on painted oval: *DOMINA MARI-OTA STEVART FILIA IOANNIS ATH-OLIE COMITIS EIUS SPONSA ANNO DOM̄ M. D. XIII.*

Pale yellowish hair and pale cream face with faint suggestions of green. The eyes are greyish blue, the lips between vermilion and light red. Her dress is vermilion; the grey area behind the lacing may be intended to represent a kirtle bodice.

The paint is generally thin and unemphatic; there is little sign of repaint.

### 76-(4). *Lady Marjory Colquhoun*
Canvas: $32\frac{1}{2} \times 28\frac{1}{4}$ in. (Plate 89).
Inscribed on painted oval: *DOMINA MARI-OTA COLQVHOVN FILIA DOMINI DE LVS EIVS SPONSA ANNO DOM M. D. XXXVI.*

The face varies from a strong pink to dark grey in the shadows; the band at the back of the head has a vaguely classical look. The dress is now featureless and rather dark.

Generally very dark, colourless, and dirty. Rubbed but largely free of repaint, except the left hand, which has been clumsily altered.

### 77-(5). *Lady Marjory Edmonstone*
Canvas: $29 \times 22\frac{1}{4}$ in. (Plate 91).
Inscribed on painted oval: *DOMINA MARI-OTA EDMESTOVN FILIA DOMINI DE DVNTRAITH EIVS SPONSA ANNO DOM̄ M. D. L.*

The subject wears a vague type of 'Marie Stuart' hood over brown hair. Most of the breast is covered by two grey panels, either a fill-in or, more likely, the yoke of the vermilion bodice. The yoke rises into a frilled stand-up collar of the type worn about 1540–50. The composition has a slight diagonal bias similar to the *Montrose* (Catalogue, 25; Plate 52); the recessions on the left sides of their faces are also similar in drawing.

Very badly rubbed, the fine fibres of the canvas widely exposed and a brown ground visible in many places. Reduced on all sides.

### 78-(6). *Lady Katherine Ruthven*
Canvas: $33 \times 27\frac{1}{2}$ in. (Plate 90).
Inscribed on painted oval: *DOMINA KATH-ERINA RVTHVEN FILIA WILLIELMI DOMINI RVTHVEN EIVS SPONSA ANNO DOM̄ M. D. LXXXIII.*

The face is cream in colour, the lips a warm pink. The costume is very confused: the collar has a vague similarity to the 'Medici' collar of about 1540; the top edge of the dress is a silvery grey, the panels down the front a warm pink; the dark drapery covering the shoulders is possibly a misunderstood oversleeve. The zigzag series of folds and highlights on the left sleeve are pale blue and yellow ochre. The quite sensitively drawn hand is rather chalky in effect.

In rather better condition than the others in the series.

*Collection.* Until 1969 the series, with the exception of 72-(ii), was in possession of Armorer, Countess of Breadalbane, Invereil, East Lothian. 78-(6) is still in that collection.

*Provenance.* Family ownership since painted, until 1969. The series with the exceptions of 72-(ii), lost at an early date, and 78-(6), still in family possession, was dispersed at the Invereil House sale on 3 March 1969, as follows: 71-(i) as lot 82 (bought Stone: sold Sotheby's, 10 May 1972, lot 27(1), bought G. Tucker); 73-(1) as lot 78 (bought Tempest, Lydden, Dover); 74-(2) as lot 83 (bought Bromfield); 75-(3) as lot 88 (bought Bromfield); 76-(4) as lot 77 (bought Bromfield); 77-(5) as lot 71 (bought Notman: sold Sotheby's, 10 May 1972, lot 27(2), bought G. Tucker).

*References.* Documents, 47; almost certainly included in inventory of Sir Colin Campbell's possessions dated 17 September 1640: '... pictures of the Lairds and Ladies of Glen-vrquhy . . .' (source and fuller quotation at p. 30, note 104); Inventory of the house of Balloch, 1679: 'In the Dyning Roume Nyntine pictures nine quhairof are the first Nyne Lairds of the Family of Glenvrchy other nyne are ther Ladies'—this must include three pictures not part of this particular series (SRO, GD 112/22/4); Walpole, pp. 3–4; Pennant (1769), p. 101, saw at Taymouth 'about twenty heads of persons of the family; among others, that of a lady, so very ugly, that a wag, on seeing it, with lifted hands pronounced, that she was fearfully and wonderfully made'; Earl of Buchan's MS., p. 5:

'1st Countess of Argyle & six Ladies of the Glenorchy Family by Jamieson at Taymouth'; Pinkerton's *Correspondence*, vol. i, p. 136, contains the list made by Robert Johnson who was copying them in 1786 for Pinkerton: Johnson lists them as hanging in pairs at Taymouth; Musgrave (Taymouth list) gives Johnson's list; Pinkerton's *Scottish Gallery*, p. 33: 'This second set is in the lobby, and consists of large portraits arranged in couples of man and wife. In Mr. Johnson's opinion . . . Jameson . . . only painted the women'; *The Black Book of Taymouth*, p. vii; Inventory of Taymouth of 1863, nos. 374, 368, 372, 357, 347, 375, and 345 (SRO, GD 112/22/10); Bulloch, no. 106 (at Langton), no. 34, no. 105 (at Langton), no. 108 (at Langton)—76-(4) is not listed by Bulloch—no. 31, no. 107 (at Langton: see *Provenance* for 94 below).

*Copies.* Robert Johnson's water-colour drawing of 71-(i) is in the SNPG (no. 2075).

This series was painted by Jamesone for Sir Colin Campbell, 8th Laird of Glenorchy, in 1635 (Documents, 47), as companions to a historical series done in 1633 by an unnamed 'Germane' painter (see p. 29). This latter series can certainly be equated with eight portraits, until recently in the family collection, representing Duncan Campbell of Lochow, his grandson Archibald, 1st Earl of Argyll (Plate 81), Lochow's younger son Colin, who became the 1st Laird of Glenorchy, and the succeeding five lairds. All are head and shoulders within an inscribed oval, those of the six lairds bearing the date of death and the numbers 1 to 6.

The genealogical programme was provided by the manuscript family chronicle known as the Black Book of Taymouth. At the back of this small volume is a series of brightly coloured illuminations of these subjects, plus the 7th and 8th Lairds. These are full-lengths but the upper part of the image is basically that of the eight large portraits. It seems likely that these were also done by the 'Germane' painter, concurrently with the larger portraits. The 7th Laird seems also by this hand but the 8th by a different hand (see Catalogue, 92).

Sir Colin Campbell continued, on a far greater scale, an interest in the arts already shown by his father, Sir Duncan Campbell (see *The Black Book of Taymouth*, pp. iv–vi). His interests were perhaps primarily in family and national history, and it was into this ambience that

Jamesone was called to provide, along with some royal portraits, companions to Campbell's male ancestors.

The source of Jamesone's programme is not so clear. The dates on 71-(i), 73-(1), and 74-(2) have no obvious significance, but the dates on the last four are the dates of death of the respective lairds. The names, and families to which the wives belong, seem to be derived directly from the Black Book.

It is only possible to speculate on the manner in which these portraits were originally 'sett up in the chalmer of deas of Balloch'. It seems unlikely that they were horizontally paired for, while Lochow and Argyll face right, the 1st to the 6th Lairds all face left. The women are much more varied, and if the missing Countess of Argyll, second in the set of eight, faced left, Jamesone's series might well have hung above or below their companions in a symmetrical row, thus: r.[l.]r.r.  l.l.r.l.

Jamesone had little clear conception of how to costume these imagined figures, but made haphazard and rather meaningless use of features which approximated to the styles of about a hundred years earlier, the low square neckline being used most frequently to give an air of antiquity. In so far as the 'sitters' have any individuality it seems conceivable that the portrait of Lady Katherine Ruthven, the nearest subject in time to Jamesone, might have been based on an already existing image.

79. *Margaret of Denmark (c. 1457–1486)*
Canvas: 29 × 26 in.
Inscribed on painted oval: *MARGARETA FILIA CHRISTIANI DANIE REGIS REGINA SCOTORUM ANNO DOM̄ M. CD. LX.*

Nearly half-length, to the left, left hand on breast. Her fair hair is held by a red upper billiment; face pale cream with greyish shadows, breast rather warmer. Dark dress with a vermilion border on the decolletage; an ochre drape, or outer sleeve, encrusted with embroidery, covers her arms.

The paint is generally thin, but there is little repaint.

Notes and commentary on this and 80 and 81 are given at the end of 81.

80. *Mary of Guise (1515–1560)*
Canvas: 29 × 22¼ in.

Inscribed on painted oval: *MARIA DVCESSA DE LONGEVILLE. REGINA SCOTORUM ANNO DOM̄. M. D. XIIII.*

Nearly half-length, to the right, right hand holding a ring by her breast. Her dark brown hair is held by a richly jewelled upper billiment; face cold but with red outlines. Dress warm ochre with pink and yellow embroidery; black sleeves covered by brown oversleeves. Corners marbled.

81. *Henrietta Maria* (1609–1669)
Canvas: 28 × 24 in.
Inscribed on painted oval: *MARIA MAGNÆ BRITTANIÆ REGINA ANNO DOM̄ M DC XXV.*

Head and shoulders, to the left; a rather meaningless crown sits uncomfortably on her head. The face is chalky with grey/brown shadows, the drawing harsh and schematic. Dress of rich blue with white rubbed into the highlights.

Generally in poor condition, rubbed and dirty, but relatively untouched.
*Collection.* Until 1969, 79–81 were in possession of Armorer, Countess of Breadalbane, Invereil, East Lothian.
*Provenance.* Family ownership since painted, until 1969. Dispersed at the Invereil House sale on 3 March 1969, as follows: 79 as lot 72 (bought Stone: sold Sotheby's, 10 May 1972, lot 26(1), bought G. Tucker); 80 as lot 74 (bought Stone: sold Sotheby's, 10 May 1972, lot 26(2), bought G. Tucker); 81 as lot 93 (bought Lamin).
*References.* Documents, 47; almost certainly included in inventory of Sir Colin Campbell's possessions dated 17 September 1640: 'Item off pictures of the kings and Queenes of Scotland—xxiiii' (source and fuller quotation at p. 30, note 104); Inventory of the house of Balloch, 1679: 'In the outter waiting Roume . . . Twelve kings of Scotland there twelve Queens' (SRO, GD 112/22/4)—the significance of the total of twenty-four in both these inventories is not clear since Jamesone appears to have painted thirteen and the 'Germane' painter thirty-two; Walpole, pp. 3–4; Pinkerton's *Correspondence*, vol. i, p. 138, contains the copyist Johnson's list: nos. 55, 56, and 58; Musgrave (Taymouth list), nos. 54, 55, and 62; Pinkerton's *Scottish Gallery*: Margaret as plate 9, p. 41; Inventory of Taymouth of 1863, nos. 382, 348, and 379 (SRO, GD 112/22/10);

Bulloch, nos. 35, 30, and 33 (all at Taymouth); Brockwell, p. 25: Margaret and Mary only.

These three 'fancy' portraits are presumably all that have survived of the thirteen royal portraits painted by Jamesone for Campbell of Glenorchy in 1635 (Documents, 47): there is some evidence of the appearance of three of the others (see 82–4 below). There are many formal and stylistic similarities to the Glenorchy Ladies.

Jamesone's sources were probably engravings: Margaret is very close to an engraving of Lady Jane Gray in Holland's *Herwologia* of 1620 (see M. Corbett and M. Norton, *Engraving in England . . .*, Part III, Cambridge, 1964, p. 138): the rather strange device worn by Henrietta is found in an engraving of her by Jan Barra, prior to 1634 (ibid., pl. 48b).

82. 'Robert Bruce'
Inscribed on painted oval: *ROBERTVS.1.REX SCOTORVM ANNO DOM M. CCCVI.*
*Collection.* Unknown.
*Provenance.* In Campbell of Glenorchy (Breadalbane) possession until at least 1799.
*References.* First three references as for 79–81 above; Earl of Buchan's MS., p. 5: 'King Robert & King David Bruce Copies by Jamieson when young at Taymouth. where are the Originals?'; Pinkerton's *Correspondence*, vol. i, pp. 138–9, contains the copyist Johnson's list of the contents of the Antichamber Writing-office at Taymouth: '47 David 2nd, King of Scotland, dated 1330, seemingly a fine original, but rather defaced by time . . . [In the] Large East Room . . . 65 Robert 1st, King of Scotland, 1306—seemingly original, or a very good copy; but in bad preservation'; Musgrave (Taymouth list) similar to Johnson, nos. 48 and 66; Pinkerton's *Scottish Gallery*, as plate 1.

There is no record of this picture later than the plate in Pinkerton's *Scottish Gallery*, published in 1799. Pinkerton (op. cit., p. 21) gives some colour notes derived from the drawing done by Robert Johnson for the engraver. The pattern is almost identical to the *Robert Bruce* from Newbattle which was painted almost two years earlier (Catalogue, 48; Plate 75): an arm grasping an upraised halberd has been added.

83. 'David II'
Inscribed on painted oval: *DAVID II. REX SCOTORUM ANNO DOM M. CCCXXX.*

*Collection.* Unknown.

*Provenance.* In Campbell of Glenorchy (Breadalbane) possession until at least 1885.

*References.* As for 82 above (but plate 2 in Pinkerton's *Scottish Gallery*), adding: Inventory of Taymouth of 1863: 'Low Parlour Portraits of eight Kings of Scotland including . . . David II' (SRO, GD 112/22/10); Bulloch, no. 36; Brockwell, p. 25.

There is no record of this picture later than Bulloch and no visual record later than the plate in Pinkerton's *Scottish Gallery*. The pattern is different from the *David Bruce* from Newbattle (Catalogue, 47).

84. 'Annabella Drummond, Queen of Robert III'

Inscribed on painted oval: *ANNABELLA DRVMOND FILIA MILITIS DE STOBHALL REGINA SCOTORVM ANNO DOM__M. CCC.XC.*

*Collection.* Unknown.

*Provenance.* In Campbell of Glenorchy (Breadalbane) possession until at least 1885.

*References.* First three references as for 79–81 above; Pinkerton's *Correspondence*, vol. i, p. 138, contains the copyist Johnson's list of the contents of the Antichamber Writing-office at Taymouth: '57 Annabella Drummond, daughter of the Knight of Stobhall, and Queen of Scotland, dated 1390—appears to be original'; Pinkerton's *Correspondence*, vol. i, p. 138, contains the copyist Johnson's list: no. 57; Musgrave (Taymouth list), no. 61; Pinkerton's *Scottish Gallery*, as plate 3; Inventory of Taymouth of 1863, no. 377: 'Annabella Drummond in a green dress and brown jewelled robe 1390' (SRO, GD 112/22/10); Bulloch, no. 32; Brockwell, p. 25.

There is no record of this picture later than Bulloch and no visual record later than the plate in Pinkerton's *Scottish Gallery*.

85–91. 'Charles I' and six unidentified Queens

The Black Book of Taymouth (Documents, 47) records that in 1635 Jamesone was paid for portraits of Robert I, David II, Charles I, the latter's Queen, and nine other Queens of Scotland. Three Queens survive (Catalogue, 79, 80, and 81). Robert I, David II, and Annabella Drummond are known only from engravings published in 1799 (Catalogue, 82, 83, and 84).

The remaining seven may be included in the Inventory of the house of Balloch of 1679 which records 'Twelve kings of Scotland there twelve Queens'. Although Jamesone's ten Queens and the 'Germane' painter's two agree with these totals, there is an unexplained discrepancy in the total of the Kings since the latter is said to have painted thirty.

Pinkerton's *Scottish Gallery* (pp. 14–15) says specifically of the Queens: '. . . only four remain . . . the others seem to have perished from neglect'; a portrait of Charles I is not referred to.

92. 'Sir Colin Campbell of Glenorchy' (1577–1640)

The Black Book of Taymouth (Documents, 47) records that in 1635 Jamesone was paid for, in addition to the items already discussed, 'the said Sir Colin his awin portrait'. There are no further records of this portrait. The engraving of a portrait of Campbell in Pinkerton's *Scottish Gallery* (plate 31) includes the date 1633; it is almost certainly from a portrait done in that year by the 'Germane' painter.

The miniature full-length portrait of Sir Colin in the Black Book has already been alluded to in the commentary to 71-(i) to 78-(6). It has a degree of characterization and precise modelling not found in the others, which do not even have rudimentary cast shadows, and could well be by Jamesone. It is not very likely, however, that these portraits are the same, since the one referred to above appears to belong with those 'sett up in the chalmer of deas of Balloch'.

93. *Genealogy of the House of Glenorchy*

Canvas: $92\frac{3}{4} \times 59$ in. (Plate 94).

Inscribed on *cartellino* bottom right: The Genealogie of the/hous of Glenvrquhie/Quhairof is descendit/sindrie nobill and/worthie houses/ *1635*. Signed bottom right of *cartellino*: G Jamesone faciebat.

*Collection.* Edinburgh, Scottish National Portrait Gallery, no. 2167.

*Provenance.* Family ownership since painted; purchased from Armorer, Countess of Breadalbane, Invereil, East Lothian, 1969.

*References.* Inventory of Sir Colin Campbell's possessions dated 17 September 1640: 'Item ane great Lairge paintit genealogie broad of the Lairds of Glenvrquhy and these that ar come of the house of Glenvrquhy' (source and fuller quotation at p. 30, note 104); Inventory of the

house of Balloch, 1679: 'In the Dyning Roume . . . Ane Large picture being the Genolegie of the family of Glenvrchy' (SRO, GD 112/22/4); Walpole, p. 4; Pennant (1769), p. 101; Earl of Buchan's MS., p. 5: 'This curious piece is in the possession of the Earl of Breadalbane at Taymouth where Lord Buchan perused it in the Year 1761'; Carnegie to Musgrave, fo. 123: 'Genealogical picture of 20 heads of the family of Campbell of Lochow'; Inventory of Taymouth of 1863, no. 121: 'Portrait Tower—Jameson—The Genealogical Tree of the House of Glenorchy 1635 in carved oak frame'; Bulloch, no. 48: '. . . has lately been put into the most perfect state of repair and relined'; Brockwell, p. 31.

*Copies.* No. 367 in the Inventory of Taymouth of 1863 is 'Jameson The original sketch for the Genealogical Tree in the portrait tower'. This must refer to a large water-colour copy made by an engraver, George Cameron, in 1774; his account to John Campbell includes '2½ yds linen for a family tree . . . 4 Sheets strong paper . . . Drawing 10 Portraits . . . Drawing a full Figuar . . . Ornamenting a Genealogical Tree of the family of Glenorchy . . . £2:10:3' (SRO, GD 112/35/2).

The reclining figure wrapped in a dark red cloak, and founder of the family, is Duncan Campbell of Lochow. The plaque beside him is inscribed: *Sir Duncan/Cambpell Knicht of/lochow Called Duncan/in A. Mariet Margaret/Steuart Dochter to Robert/Earlle of Fyff & Mon/teith Seconndlie he ma/riet Jeane Steuart/doc*<sup></sup>*. to ye Laird/argowan.* On the ground below is inscribed: *1 vyf 2 sons/2 vyf 3 sons.* The portrait on the offshoot is Archibald, Earl of Argyll, while the first seven figures on the trunk are the first seven lairds of Glenorchy, each inscribed on a circular frame with his name and the number of years he 'lived laird'. A rectangular placard above each records the names of wives and the numbers of children. The eighth figure on the trunk is the 8th Laird, Sir Colin Campbell, who commissioned the picture. Above him is a rubbed and indistinct (or perhaps incomplete) portrait of a young man without a frame. The 8th Laird's heir in 1635 was his fifty-six-year-old brother Robert: it may have been felt that a more likely successor, and therefore occupier of the ninth position, would be Robert's son John.

The tree trunk varies from yellow ochre on the lit side to grey on the shaded right side; the leaves are dark grey or creamy white but in some cases contain a good deal of dull blue. Each of the dark red cherries has a carefully placed white highlight. The 150 roundels containing the genealogical information do not appear to be coloured to any system: they are white (usually with red letters), ochre (generally with white inscriptions), dark red, and turquoise (with ochre letters). The background is an airy and freely brushed silvery grey, warmer in the lower part of the picture, becoming a warm olive green at the bottom.

The Black Book of Taymouth is apparently not the main source of the information contained in the picture. There are marked discrepancies though these tend to lessen with the later figures: even here, however, the picture occasionally supplies details not found in the Black Book.

Jamesone's lairds, with one exception, show no relationship either to the illuminations in the Black Book or to the 'Germane' painter's set. The exception is the only portrait which could have been, and almost certainly was, an *ad vivum* image, that of Jamesone's patron, Sir Colin Campbell. Though reduced to a head and shoulders, the armour changed to a doublet, and a skull-cap added, this is very close to the shapes and lively personality of the portrait in the Black Book (see Catalogue, 92 above). The portrait of the 7th Laird, Sir Duncan Campbell, appears to be derived from a three-quarter length of 1619 which was certainly in the collection at the time (now SNPG, no. 2165; Plate 14).

Genealogies and the importance (even mysticism) of family connections obsessed Sir Colin Campbell in the 1630s, perhaps as a result of his growing infirmity, perhaps because of his expectation (to be disappointed) of an earldom on the King's visit to Edinburgh in 1633. Growing prosperity gave these ideas forms and expressions in artistic patronage not before attempted in Scotland and Jamesone's tree is perhaps the most interesting single manifestation of them. In another sense, Jamesone is here looking back to the decorative tradition from which he had partly sprung and with which he maintained contacts. Indeed it is not unlikely that a decorative painter worked on the more repetitive parts

of the picture for Jamesone (see Documents, 29).

**94.** *William Keith, 7th Earl Marischal* (1614–1661)
Canvas: $25\frac{1}{2} \times 22\frac{1}{4}$ in. (Plates 95–7).
Inscribed top left: *WILIAME EARL/MAIR-SCHALL,/1636.*
*Collection.* Edinburgh, Scottish National Portrait Gallery, no. 994.
*Provenance.* In Campbell of Glenorchy (Breadalbane) possession until 1925. The Inventory of the house of Balloch of 1679 (SRO, GD 112/22/4) lists together the Marchioness of Hamilton, the Duke of Hamilton, the Earl of Airth and 'Eight noblemen': this seems to be the group dated 1636–7 (by then reduced to ten), first clearly listed by Robert Johnson, which includes the present picture. In 1863 the 2nd Marquess of Breadalbane's estate was divided between five heirs, and in 1867 one of these, his sister Lady Elizabeth Pringle, as 'heir of entail in possession of the estate of Langton', took possession of the works of art, declaring that they 'be kept and retained as heir looms in the family' (SRO, GD 112/22/1); passed by bequest to Lieut.-Col. Thomas Breadalbane Morgan-Grenville-Gavin and sold by him at Christie's, 27 March 1925, lot 82(2).
*References.* Almost certainly in inventory of Sir Colin Campbell's possessions dated 17 September 1640: '... pictures of the Lairds and Ladies of Glenvrquhy and uther noblemen come of the house of Glenvrquhy—xxxiiii' (source and fuller quotation at p. 30, note 104); almost certainly included in the Inventory of the house of Balloch, 1679: 'Eight noblemen all which are Descended of the family of Glenvrchy'; Walpole, p. 4: '... Lord Breadalbane has at Taymouth ... eleven portraits of Lords and Ladies of the first families in Scotland, painted in 1636 and 1637'; Pennant (1772), pp. 30–1, records among nine portraits at Taymouth dated 1636 or 1637: 'much injured ... William Earl Marishal, 1637' (*sic*); Earl of Buchan's MS., p. 5: 'The Lord Napier ... and ten other Portraits of the Principal Nobility of Scotland Anno 1634–35.36 by Jamieson all at Taymouth. There were eleven but Lord Breadalbane gave the Portrait of James Erskine Earl of Buchan Son to the Treasurer Mar to Lord Buchan his representative'; Pinkerton's *Correspondence*, vol. i, p.

135, contains the copyist Robert Johnson's list which included among ten portraits of 1636–7: 'William, Earl Marishall dated 1636 half length by Jameson'; Musgrave (Taymouth list), no. 3; Carnegie to Musgrave, fo. 123; Inventory of Taymouth of 1863, no. 177 (SRO, GD 112/22/10); Bulloch, no. 102 (in possession of R. Baillie Hamilton, Langton, and wrongly called 6th Earl); Brockwell, pp. 24, 30.

This picture has recently been cleaned, with the result that the sitter, who previously seemed middle-aged, has had his youth restored. The face is warm, the darks rather brown due to the ground showing through: there is some green in the shadows. The rather 'floated' highlights on the right sleeve are a typical Jamesone feature. Cleaning has shown that even originally the paint must have been applied thinly and also quite freely. Paint samples have been scientifically studied: for the results see pp. 53–4, and Appendix A.

Jamesone appears to have been intimate with the Earl's family (see the notes on his mother Lady Mary Erskine, whom Jamesone had painted in 1626, Catalogue, 9). His part in an embassy to the Covenanting Earl has already been noted (p. 37).

The portrait was not painted for the Earl, though it may duplicate such a portrait. Its provenance indicates that it was one of those pictures ordered by Campbell of Glenorchy which, in October 1635, Jamesone had 'yeit to make ... bot it will be in Januarij befoir I can begin theam, except that I have the occasione to meit with the pairties in the North' (Documents, 46). In June 1636 Jamesone again writes to Glenorchy about portraits of contemporaries and says of some of them: 'I shall double theam, or then giwe yowr worship the principall' (Documents, 49).

**95.** *Thomas Hamilton, 3rd Earl of Haddington* (d. 1645)
Canvas: $27 \times 22\frac{1}{2}$ in.
Inscribed (later) top left, the date possibly contemporary: *THOMAS, LOIRD OF BINING./1636.*
*Collection.* The Earl of Haddington, Tyninghame, East Lothian.
*Provenance.* In Campbell of Glenorchy (Breadalbane) possession until 1863; inherited in that year by Lady Elizabeth Pringle (see *Provenance*

of 94). The latter's daughter married Robert Baillie Hamilton, younger brother of the 11th Earl of Haddington and succeeded to Langton in 1878.

*References.* First three references as for 94 above; Pennant (1772), p. 31; Earl of Buchan's MS., p. 5 (quoted at 94 above); Pinkerton's *Correspondence*, vol. i, p. 135, contains the copyist Johnson's list: 'Thomas, Lord of Binning dated 1636 half length by Jameson'; Musgrave (Taymouth list), no. 11; Carnegie to Musgrave, fo. 123; Inventory of Taymouth of 1863, no. 383 (SRO, GD 112/22/10); Bulloch, no. 101 (in possession of R. Baillie Hamilton, Langton); Sir William Fraser, *Memorials of the Earls of Haddington*, Edinburgh, 1889, vol. i, p. 375; Caw, p. 11; Brockwell, pp. 25, 30.

Almost half-length, to the left. The face is pale and luminous, the cheeks a feverish pink, the shadows grey. The doublet is pale ochre with flecks of brighter yellow; traces of floral embroidery. Rubbed and thin throughout. The right arm, which is darkly outlined, has either been bungled or altered.

This portrait appears to have been the basis for the figure of the 3rd Earl in the *Haddington Family Group* (Catalogue, 130; Plate 101). A portrait at Newbattle inscribed 'Lord Hadington', though more assured and of about 1640, shows a sitter reasonably close in appearance. He did not in fact become Lord Binning until 1637 when his father succeeded as 2nd Earl of Haddington. He succeeded his father in 1640.

Provenance suggests that it was painted for inclusion in Campbell of Glenorchy's gallery (see 94 above), though there is no obvious reason why it should have been.

96. *William Graham, 7th Earl of Menteith and 1st Earl of Airth* (1589–1661)

Canvas: $42\frac{1}{8} \times 50\frac{5}{8}$ in. (includes 97). (Plate 98).

Inscribed (later) at the top: *WILLIAM ERLE OF ÆIRTH/1637.*

*Collection.* Edinburgh, Scottish National Portrait Gallery, no. 1834.

*Provenance.* In Campbell of Glenorchy (Breadalbane) possession until sold at Christie's, 23 March 1956, lot 169; sold there again 1 June 1956, lot 88.

*References.* First reference as for 94 above; Inventory of the house of Balloch, 1679: 'In the outter waiting Roume . . . My Lord Grand-

father the Earle of Airth his picture' (SRO, GD 112/22/4); Walpole, p. 4 (quoted at 94 above); Pennant (1772), p. 30; Earl of Buchan's MS., p. 5 (quoted at 94 above); Pinkerton's *Correspondence*, vol. i, p. 135, contains the copyist Johnson's list: 'William, Earl of Airth dated 1637 half length by Jameson'; Musgrave (Taymouth list), no. 2; Carnegie to Musgrave, fo. 123; Inventory of Taymouth of 1863, no. 183 (SRO, GD 112/22/10); Bulloch, no. 42 (under its companion, no. 43, Bulloch writes: 'These two pairs of portraits [the second pair are 140 and 141 in this Catalogue] flank the great window'); Brockwell, pp. 24, 30.

Brown hair, face warm with greenish shadows; eyeballs flecked with red; lips strong red. The back of the head is typically brought towards the picture plane. At some time, probably in the early 19th century, it was relined and paired with the portrait of the 1st Baron Napier on a single canvas in the shape of an ogee arch (Catalogue, 97).

Menteith, though at some enmity with the King because of his claim to the earldom of Strathern (see Documents, 38), was very much in the anti-Covenanting party. He was Sir Colin Campbell of Glenorchy's cousin and the portrait must be one of those which, in the middle of 1636, Jamesone had still to produce for Glenorchy (Documents, 49).

97. *Archibald Napier, 1st Baron Napier* (1576–1645)

Canvas: $42\frac{1}{8} \times 50\frac{5}{8}$ in. (includes 96). (Plate 98).

Inscribed (later) at the top: *IOHNE LORD NEPER/1637.*

*Collection.* Edinburgh, Scottish National Portrait Gallery, no. 1833.

*Provenance.* As for 96 above.

*References.* First three references as for 94 above; Pennant (1772), p. 31; Earl of Buchan's MS., p. 5 (quoted at 94 above); Pinkerton's *Correspondence*, vol. i, p. 135, contains the copyist Johnson's list: 'Lord Napier dated 1637 half length by Jameson'; Musgrave (Taymouth list), no. 6: 'Archibd. Napier, 1st Lord Napier, ob. 1645, 1637 N.B. *John* on the picture but should likely be Archibald . . .'; Carnegie to Musgrave, fo. 123; *The Black Book of Taymouth*, p. viii; Inventory of Taymouth of 1863, no. 184 (SRO, GD 112/22/10); Bulloch, no. 43; Brockwell, pp. 24, 30.

Face warm with greenish shadows. The collar is particularly thin and there are areas of damage above the sitter's right eye and on the right cheekbone.

The error in the inscription (presumably copied from an earlier one) may stem from the fact that John Napier of Merchiston's eldest son by his *second* wife was called John; or simply by confusion with the better-known father. Napier was a descendant of Sir Duncan Campbell, 4th Laird of Glenorchy, which explains his presence in the gallery of 'noblemen come of the house of Glenvrquhy'. There is a similar, earlier version (Catalogue, 38) which shows the sitter at the same apparent age but in earlier costume; the present picture is probably derived from it, the costume up-dated.

98. *John Lyon, 2nd Earl of Kinghorne* (1596–1646)

Canvas: 26 × 22 in.

Inscribed (later) top left: *IOHNE ERLE OF KINGORN/Anno 1637.*

*Collection.* The late Earl of Strathmore and Kinghorne (d. 1972), Glamis Castle, Angus.

*Provenance.* In Campbell of Glenorchy (Breadalbane) possession until at least 1863; by 1885 at Langton (see *Provenance* for 94); sold at Christie's, 27 March 1925, lot 82(1), (bought Leggatt).

*References.* First three references as for 94 above; Earl of Buchan's MS., p. 5 (quoted at 94 above); Pinkerton's *Correspondence*, vol. i, p. 135, contains the copyist Johnson's list: 'John, Earl of Kinghorn dated 1637 half length by Jameson'; Musgrave (Taymouth list), no. 5; Inventory of Taymouth of 1863, no. 178 (SRO, GD 112/22/10); Bulloch, no. 103 (in possession of R. Baillie Hamilton, Langton); Brockwell, p. 24.

Head and shoulders, to the right; longish hair, pointed beard; wears broad lace collar. The face is warm but the picture is permeated with a greenish hue.

Kinghorne was tutor to the Earl of Erroll in 1643 when Jamesone acquired Esslemont from the latter as security for 16,000 merks (Documents, 67). Jamesone painted Kinghorne's wife in the 1620s (Catalogue, 12). Kinghorne was brother-in-law to another subject in this series, the 7th Earl Marischal (Catalogue, 94).

99. 'Anne Cunningham, Marchioness of Hamilton' (d. 1647)

Probably inscribed '1636'.

*Collection.* Unknown.

*Provenance.* In Campbell of Glenorchy (Breadalbane) possession until at least 1885 but not recorded thereafter.

*References.* First reference as for 94 above; Inventory of the house of Balloch, 1679: 'In the outter waiting Roume . . . My Ladie Marquis of Hamiltoune her picture . . .' (SRO, GD 112/22/4); Walpole, p. 4 (quoted at 94 above); Pennant (1772), p. 31; Earl of Buchan's MS., p. 5 (quoted at 94 above); Pinkerton's *Correspondence*, vol. i, p. 135, contains the copyist Johnson's list: 'Anne, Marchioness of Hamilton dated 1636 half length by Jameson'; Musgrave (Taymouth list), no. 10; Carnegie to Musgrave, fo. 123; Pinkerton's *Scottish Gallery*, as plate 29; Inventory of Taymouth of 1863, no. 180 (SRO, GD 112/22/10); Bulloch, no. 44; Brockwell, pp. 25, 30.

There is no record of this picture later than Bulloch and no visual record later than the plate in Pinkerton's *Scottish Gallery*. It belongs to the group of at least eleven pictures painted by Jamesone for Sir Colin Campbell in 1636–7. According to both Johnson and Musgrave, six were dated 1636 and four 1637: of the first group two certainly survive (Catalogue, 94 and 95 above); of the second group three survive (Catalogue, 96–8 above). The present portrait and 100–4 are the six items presumed to be lost.

100. 'James Hamilton, 3rd Marquess and 1st Duke of Hamilton' (1606–1649)

Probably inscribed '1636'.

*Collection.* Unknown.

*Provenance.* As for 99 above.

*References.* First reference as for 94 above; Inventory of the house of Balloch, 1679: 'In the outter waiting Roume . . . Duick James Hamiltoune his picture . . .' (SRO, GD 112/22/4); Walpole, p. 4 (quoted at 94 above); Pennant (1772), p. 31; Earl of Buchan's MS., p. 5 (quoted at 94 above); Pinkerton's *Correspondence*, vol. i, p. 135, contains the copyist Johnson's list: 'James, Marquis of Hamilton dated 1636 half length by Jameson'; Musgrave (Taymouth list), no. 9; Carnegie to Musgrave, fo. 123; Inventory of Taymouth of 1863, no. 179 (SRO, GD 112/22/10); Bulloch, no. 45 (confusing the sitter with the 2nd Marquess (d. 1625) and stating: 'It is not suggestive of Jamesone's work'); Brockwell, pp. 25, 30.

There is no record of this portrait later than Bulloch and no visual record other than his comment: 'A bearded middle-aged man, with a blue ribbon.' This agrees with other portraits of the 1st Duke. Son of Anne Cunningham (Catalogue, 99 above), he was prominent in the ceremonial at Charles I's coronation in Edinburgh in 1633, an event which greatly interested Campbell of Glenorchy.

101.   'John Leslie, 1st Duke of Rothes' (c. 1630–1681)
Probably inscribed '1636'.
*Collection.* Unknown.
*Provenance.* In Glenorchy (Breadalbane) possession until at least 1863; by 1885 at Langton (see *Provenance* for 94). Pictures from Langton were sold at Christie's, 27 March 1925: this may be lot 81(2): 'G. Jamesone Portrait of a Youth, in black dress, with embroidered sash' (bought Leggatt).
*References.* First three references as for 94 above; Pennant (1772), p. 30; Earl of Buchan's MS., p. 5 (quoted at 94 above); Pinkerton's *Correspondence*, vol. i, p. 135, contains the copyist Johnson's list: 'John, Lord Leslie dated 1636 half length by Jameson'; Musgrave (Taymouth list), no. 12; Carnegie to Musgrave, fo. 123; Inventory of Taymouth of 1863, no. 386: 'Jameson Johne Lord Leslie in a blue and white dress' (SRO, GD 112/22/10); Bulloch, no. 104 (in possession of R. Baillie Hamilton, Langton); Brockwell, pp. 25, 30.

There is no record of this portrait later than Bulloch, who describes the sitter as 'a young boy of ten or twelve years of age'. There is no clear reason why the son of a father still living should have been included in the series, though this also happened in the case of Lord Binning (Catalogue, 95).

102.   'John Erskine, 3rd Earl of Mar' (d. 1654)
Probably inscribed '1636'.
*Collection.* Unknown.
*Provenance.* As for 99 above.
*References.* First three references as for 94 above; Pennant (1772), p. 31; Earl of Buchan's MS., p. 5 (quoted at 94 above); Pinkerton's *Correspondence*, vol. i, p. 135, contains the copyist Johnson's list: 'John, Earl of Mar dated 1636 half length by Jameson'; Musgrave (Taymouth list), no. 1; Carnegie to Musgrave, fo. 123 (annotated by

Musgrave: 'it is his son'—i.e. the son of Treasurer Mar); Inventory of Taymouth of 1863, no. 185 (as dated 1637) (SRO, GD 112/22/10); Bulloch, no. 47 (as dated 1637 and apparently confusing the sitter with Treasurer Mar (d. 1634)); Brockwell, pp. 24, 31.

There is no record of this portrait later than Bulloch who states that he is wearing 'a fine rich collar, and the blue ribbon of Councillor of State and Treasurer'.

103.   'John Campbell, 1st Earl of Loudoun' (1598–1663)
Probably inscribed top left '*LORD* of *LAVDEN*/ 1637'.
*Collection.* Unknown.
*Provenance.* As for 99 above.
*References.* First three references as for 94 above; Pennant (1772), p. 31; Earl of Buchan's MS., p. 5 (quoted at 94 above); Pinkerton's *Correspondence*, vol. i, p. 135, contains the copyist Johnson's list: 'Lord of Loudon dated 1637 half length by Jameson'; Musgrave (Taymouth list), no. 4; Carnegie to Musgrave, fo. 123; Pinkerton's *Scottish Gallery*, as plate 29; Inventory of Taymouth of 1863, no. 186 (SRO, GD 112/22/10); Bulloch, no. 46; Brockwell, pp. 24, 30.

There is no record of this portrait later than Bulloch and no visual record later than the plate in Pinkerton's *Scottish Gallery*. Though a mediocre engraving, the original obviously had Jamesone characteristics: the pulling of the back of the head towards the picture plane, the curve of the mouth, and the lighting on the right arm and breast.

Loudoun was nephew of Archibald Campbell of Glencarradale, who played a major role in commissioning this series from Jamesone, as indeed he probably did in arranging all the work that Jamesone did for his cousin Sir Colin Campbell (see Documents, 38, 39, 41, and 50: see also pp. 27–31).

104.   'James Erskine, 6th Earl of Buchan' (d. 1640)
Canvas: 26½ × 22¼ in.
*Collection.* Formerly A.L.P.F. Wallace of Candacraig, Aberdeenshire.
*Provenance.* In Campbell of Glenorchy (Breadalbane) possession until given to David, 11th Earl of Buchan prior to 1781; perhaps included

in a sale of pictures from Almondell at Dowell's, Edinburgh, 22 January 1944; subsequently acquired by William Young, dealer in Aberdeen, and sold by him to the last owner; destroyed by fire in 1955.

*Exhibitions.* Perhaps Edinburgh, *Scottish National Portraits Loan Exhibition*, 1884, no. 182 (in possession of Lord Cardross); Aberdeen, *Paintings from North-East Homes*, 1951, no. 58.

*References.* First three references as for 94 above; Earl of Buchan's MS., p. 5 (quoted at 94 above); Carnegie to Musgrave, fo. 123v. (recording it in the Earl of Buchan's collection); Smith's *Iconographia Scotica*, as plate 18 (after the Earl of Buchan's copy); Bulloch, no. 49 (stating that it is dated 1636 and describing the dress as grey); Catalogue of Pictures in Almondell House, 1890 (copy in SNPG), no. 48, annotated: '½ length in rich blue dress, lace van Dycke collar, ¾ face looking to front, auburn hair, moustache and pointed beard'; MS. notebook of A. Haswell Miller, 1934, in SNPG (HM, 20), with sketch.

*Copies.* A chalk drawing by the 11th Earl of Buchan is in the SNPG (no. 1635).

See notes and commentary to 94 above. It belongs to the series of eleven noblemen painted by Jamesone for Campbell of Glenorchy in 1636–7 but it subsequently passed into Buchan possession.

Head and shoulders, to the right. The sitter is less than middle-aged; rather flattened head with hair curling over forehead; rather long moustache and short pointed beard. He wears a scalloped lace band across his shoulders.

This description is of the Earl of Buchan's copy: his drawings of portraits are invariably accurate. The quality of the shapes and even the expression make it quite clearly a record of a portrait by Jamesone.

105. 'Archibald Campbell, 8th Earl of Argyll' (1607–1661)

The visual evidence that a portrait by Jamesone existed is the engraving dated 1834 in Lodge's *Portraits*, vol. vii, London, 1835, plate 13: the painting was then in possession of the Duke of Argyll at Inveraray Castle. Even at this distance from the original, certain marked characteristics of Jamesone have survived, e.g., the rather underscaled head and the distortion of the rear part of it, the expression, and the forms and grouping of the highlights on the dark doublet.

The costume suggests a date near 1636. It is conceivable that the Inveraray picture was the original of a portrait 'doubled' by Jamesone for Sir Colin Campbell during 1636–7. A portrait of Argyll (Lord Lorne until 1638 when he succeeded as Earl: made Marquess 1641) was never listed as a member of the group of noblemen, discussed above (94–104), but one was recorded in the Inventory of the house of Balloch, 1679: 'The Leat Marquis of Argyle his pictur in a gilded frame' (SRO, GD 112/22/4). Further, a portrait of him, specifically given to Jamesone, is no. 126 in the Inventory of Taymouth of 1863: 'Archibald Lord of Lorn in a black dress and white collar 1636' (SRO, GD 112/22/10). This is presumably Bulloch's no. 39.

Jamesone had painted the subject's wife, Margaret Douglas, in 1634 (Catalogue, 69) and a companion seems to have existed at Newbattle (Bulloch, no. 124): that may therefore have been a third version. The picture catalogued here was not traced at Inveraray in 1959.

A portrait which could have been one of these was exhibited at Aberdeen in *Paintings from North-East Homes*, 1951, no. 57 (canvas, 26¾ × 22½ in., dated 1636). It was then in possession of A. L. P. F. Wallace of Candacraig (who acquired it about 1950 from William Young of Aberdeen); it was destroyed by fire in 1955.

A supposed 18th-century copy was sold at Highcliffe Castle (Earl of Abingdon) on 8 July 1949.

106. *William Ramsay, 1st Earl of Dalhousie* (d. 1672)

Canvas: 78 × 46 in. (Plate 100 (detail)).

*Collection.* Unknown.

*Provenance.* Presumably in Dalhousie possession until sold from Brechin Castle at Christie's, 25 October 1957, lot 81 (as Hanneman); bought Carfrae.

*References.* List of Pictures at Brechin Castle, Brechin, 1952 (copy in SNPG): 'William, 1st Earl of Dalhousie, full length, in brown jerkin, lace collar, dark breeches and high boots.'

Full-length standing figure, to the right; the right arm is crooked against his hip and holds a staff, while the left is against his body holding a sword hilt. A heavy featured, vigorous face with clumps of dark hair topped by a skull-cap; large moustache and small pointed beard. He wears a lace falling band tied by four

bandstrings over a sleeveless leather jerkin; an embroidered belt crosses his right shoulder. The sleeves of his doublet are slashed and the shirt pulled out. Not much detail is visible in the breeches but the lighter coloured boots are cup-topped and have 'butterfly' spur leathers.

The sitter appears to stand in a room with a large opening behind him, to the right. This reveals a landscape, mainly a rather finely varied sky above rocky hills; at the foot of the hills a large house with towers and sunlit fields.

This picture, clearly rather damaged, is here attributed to Jamesone purely on the basis of a photograph. On the evidence of costume it must be dated c. 1635, that is, about ten years later than the only other strictly comparable picture by Jamesone, the *6th Earl of Rothes* (Catalogue, 6; Plate 23): with this it shares an awkward, unsophisticated aping of the Jacobean full-length, the body impossibly tilted back and the scale confused. The light which picks out details of lace, embroidery, and strings and de-fines the folds on the doublet and shirt sleeves is of exactly the same quality as in portraits like the *Sir John Campbell* (Catalogue, 141; Plate 124); so also is the manner in which it spreads across the right elbow, the jerkin, and the boots. The structure of the face, and its expression, are very close to the *Lord Napier* of 1637 (Catalogue, 97; Plate 98) and also to the Aberdeen *Self-portrait* (Catalogue, 111; Plate 1). The unusual landscape, especially the area of sky, is paralleled in the *Haddington Family Group* (Catalogue, 130; Plate 101).

If the attribution is accepted, it is the only existing full-length to complement the many head and shoulders portraits painted at the peak of Jamesone's activity, and confidence, in the later 1630s. Despite the patent failure of the stance there are felicities, especially of lighting, which suggest that Michael Wright, apprenticed to Jamesone in 1636, did indeed learn something from him.

William Ramsay, eldest son of Sir George Ramsay, must have been born later than 1593. He succeeded his father in 1629 and became Earl of Dalhousie in 1633: the portrait might celebrate this latter event. In 1617 he had married the eldest daughter of the 1st Earl of Southesk and is thus placed in the orbit of those around Southesk—Montrose, Southesk's brothers, Stir-ling of Keir, and the Napiers—all painted by Jamesone in these years.

107.  *Sir Thomas Burnett of Leys* (d. 1653)
Panel: 28¾ × 22¾ in. (Plate 92).
*Collection.* The National Trust for Scotland, Crathes Castle, Kincardineshire.
*Provenance.* Probably family ownership since painted.
*References.* Bulloch, no. 54; Col. James Allardyce (editor), *The Family of Burnett of Leys*, New Spalding Club, 1901, pp. 71-2.

The face is very warm, the mouth almost vermilion, with dark grey/brown shadows; beard a dull ochre/brown. The skull-cap and shoulder area are a rather bluish black.

The panel is rather badly split; the paint is thin and transparent and the wood grain is widely visible.

In drawing, colour, and expression it has a good deal in common with the *Arthur Johnston* in Marischal College (Catalogue, 27; Plate 57) and the *Patrick Dun* (Catalogue, 37; Plate 62). The costume is rather old-fashioned for it seems that the picture must be of the same date as the other pictures at Crathes with which it is associ-ated, 108-10: a rather late date seems to be de-manded by the fact that Burnett appears as a matriculated student at King's College, Aber-deen, as late as 1603 (Allardyce, op. cit., p. 41). The significance of Jamesone reverting to panel at this stage in his career is not obvious.

108.  Called *Sir William Forbes of Monymusk* (d. after 1661)
Panel: 28¾ × 23¼ in. (Plate 93).
*Collection.* The National Trust for Scotland, Crathes Castle, Kincardineshire.
*Provenance.* Probably family ownership since painted.
*References.* Bulloch, no. 56 (as 'a son of Sir Thomas Burnett').

The youthful face is surrounded by a mass of dull brown hair, the highlights dull ochre. The face is not especially warm, though the cheeks are rather pink; the shadows, only a trace lower in tone, are greyish green. The broad falling band tends to be a grey/lemon colour. The doublet is dark but lit rather subtly on shoulder and breast.

In drawing and expression the head is close to that of the *7th Earl Marischal* (Catalogue, 94;

Plate 97) but, because of its rubbed condition, it is drained of much of that picture's vitality. Costume suggests a date of *c.* 1636.

The supposed sitter married, perhaps in 1632, Jean Burnett, daughter of Sir Thomas Burnett. The picture certainly appears to be a companion to 109 below, which is usually called Jean Burnett. However, lacking a firm traditional identification, it could conceivably represent Alexander, Sir Thomas's eldest son, burgess of Aberdeen in 1633 and husband of Jean Arbuthnot: he died in 1648.

109. Called *Jean Burnett, Lady Forbes of Monymusk* (married *c.* 1632)
Panel: 28¾ × 23½ in.
*Collection.* The National Trust for Scotland, Crathes Castle, Kincardineshire.
*Provenance.* Probably family ownership since painted.
*References.* Bulloch, no. 57 (as 'a daughter of Sir Thomas Burnett').

Head and shoulders, to the right. A smallish, round-featured head with rich brown hair; fringe on forehead. The face is creamy with brown in the shadows. Wears a dark-coloured dress with bows on the inside of each elbow; the square decolletage is filled in by a two-layered tucker fastened by three black bows.

The panel is rather badly split; thin and transparent, the wood grain widely visible.

Costume suggests a date in the later 1630s and the picture appears to be a companion to 108. Given the vagueness of identity of the Crathes portraits this could be a portrait of Jean Arbuthnot, Sir Thomas Burnett's daughter-in-law.

110. Called *Alexander Skene of Skene* (d. 1634)
Panel: 28½ × 23½ in.
*Collection.* The National Trust for Scotland, Crathes Castle, Kincardineshire.
*Provenance.* Probably family ownership since painted.
*References.* Bulloch, no. 55 (as 'a son of Sir Thomas Burnett').

Head and shoulders, to the right. A hot, sharp-featured face with mass of brown hair, fair moustache, and pointed beard. He wears a broad, scalloped lace falling band over a dark doublet with slashed sleeves.

The panel is in poor condition; the paint is rubbed thin and a red ground is widely visible.

It shows certain infelicities of drawing (e.g. the flattening of the face) which were to gain ground in Jamesone's work of the later 1630s (e.g., in the *4th Earl of Haddington* (Catalogue, 129)). Stylistically a date near 1637 seems appropriate and this is supported by the costume (cf., the collar in the *Sir George Stirling*, dated 1637 (Catalogue, 119; Plate 112)). This casts doubt on the traditional identification, as Alexander Skene died in 1634 (William F. Skene, *Memorials of the Family of Skene of Skene*, New Spalding Club, 1887, pp. 29–35).

Besides 107–110, there is a fifth panel portrait at Crathes, usually attributed to Jamesone, which purports to represent Janet Burnett, a sister of Sir Thomas Burnett and wife of Alexander Skene. It is so altered that there is really no trace of Jamesone left.

111. *Self-portrait, holding a Miniature*
Canvas: 28 × 21½ in. (Plate 1).
*Collection.* Aberdeen Art Gallery.
*Provenance.* By inheritance from the Thomsons of Portlethen to Alexander Carnegie; by descent from Carnegie to his grandson Major John Ross, from whom purchased 1923.
*Exhibitions.* Aberdeen, *Archaeological Exhibition*, 1859, no. 49 (in possession of Miss Carnegie, Aberdeen); Aberdeen, *Art Exhibition*, 1873, no. 59; Glasgow, *International Exhibition*, 1888, no. 347 (in possession of Major John Ross); Aberdeen, *Art Exhibition*, 1890, no. 21; London, *Loan Exhibition of Scottish Art and Antiquities*, 1931, no. 1152.
*References.* Earl of Buchan's MS., p. 6: 'George Jamiesone painted by himself in the possession of his descendant Mr. Carnegy Town Clerk of Aberdeen, who inherited it with some other pictures of the Family of Jamiesone from the Thomsons of Portlethen'; *The Statistical Account of Scotland*, vol. 19, Edinburgh, 1797, p. 231 (Carnegie's list): 'Jamieson, a single figure, with a miniature in his hand, supposed his wife's picture' (in Carnegie's possession: it does not appear in his list sent to Musgrave); Pinkerton's *Iconographia Scotica*, p. 102 and plate 55; Bulloch, no. 161 (in possession of Major John Ross of Kincorth); *Permanent Collection Catalogue*, Aberdeen Art Gallery, 1968, p. 59.
*Copies.* A copy by James Wales was sold at Dowell's, 17 November 1955, lot 42; it was inscribed on the back: 'From an original painting by Jamieson 1637.... Copied by Mr. Wales

of Aberdeen for David Stewart Earl of Buchan A.D. 1779...' (now in possession of H. R. H. Woolford).

The colour is generally very brown, the exceptions being the blue eyes, with rather pink rims, and the red lips; there are also spots of red and white on the palette, bottom right.

There is a good deal of damage, especially on the lower part of the face and the area of light background to the right of the face.

In some ways it seems a reminiscence of Rubens's self-portraits of the mid-1620s, notably of the pattern of the version at Windsor. The hat, the tilt of the head and the confident glance, the poise of the shoulders, are all repeated, though on a different aesthetic level. Burckhardt says of the Rubens self-portrait, 'that handsome, vivid face was familiar far and wide in replicas and copies' (*Recollections of Rubens*, English edition, London, 1950, p. 134). Jamesone presumably knew the type at some remove.

112.   *Self-portrait, in a Room hung with Pictures*
Canvas: 27 × 33 in. (Plates 108, 109).
*Collection.* The Earl of Seafield, Cullen House, Banffshire.
*Provenance.* Unrecorded before 1781 when in possession of the Earl of Findlater; by descent to the present owner. The Earls of Findlater descended directly from the two Grants of Freuchie, Sir John and Sir James, who were patrons of Jamesone's master, John Anderson (see p. 52). As Anderson, who outlived his better-known pupil, might well have owned a portrait of Jamesone, it is conceivable that the picture entered Grant possession through his agency.
*Exhibitions.* Aberdeen, *Archaeological Exhibition*, 1859, no. 122; Edinburgh, *Loan Exhibition of Old Masters*, 1883, no. 2; Glasgow, *International Exhibition*, 1901, no. 992; Glasgow, *Scottish Exhibition*, 1911, no. 26 (Catalogue, vol. i); Royal Academy, *Exhibition of Scottish Art*, 1939, no. 3 (stating, inexplicably, that the picture was painted in 1644); Glasgow, *Scottish Painting*, 1961, no. 11.
*References.* Walpole, p. 3: '...another of himself in his school, with sketches both of history and landscape, and with portraits of Charles 1st, his Queen, Jamesone's wife, and four others of his works from the life'; Earl of Buchan's MS., p. 6: 'Jamesone by himself in the possession

of the Earl of Findlater; there are several of his pictures represented hanging in the room where he painted all the portraits ... in imitation of his Master Rubens one painted with a large Beaver'; Carnegie to Musgrave, fo. 123: 'Jamieson in his painting room, which is adorned with pictures of Charles 1st and Henrietta Maria—Jamieson's wife, another head'; Pinkerton's *Correspondence*, vol. ii, contains the following references: pp. 21–22, a letter from Lord Findlater's manager to Sir John Sinclair, 17 February 1798, giving a description of the picture: p. 90, a letter from John Ross of Elgin to Pinkerton, 26 August 1799, stating that he is unlikely to get a local artist to copy it: pp. 149–50, Ross to Pinkerton, 16 April 1800, stating that, on Lord Findlater's instructions, he is sending it to London 'to get drawings made'; Walter Thom, *The History of Aberdeen*, Aberdeen, 1811, p. 202, expanding Carnegie's description: '... two sea-views; Perseus and Andromeda'; Bulloch, no. 169; Brockwell, p. 30.

The figure of the painter is basically the same motif as the Aberdeen *Self-portrait* (Catalogue, 111; Plate 1); except that the right hand seems to indicate the pictures hanging behind: these consist of seven portraits, a seascape, a landscape, one indecipherable, and, much the largest, a mythology.

The face is rather orange/brown in the shadows, though the shadow under the right eye is grey, and the mid-tone down the right side of the nose is lemon to bluish grey; the bridge of the nose and the right cheek are quite a strong pink.

There has been much damage (partly by fire). Areas of canvas have been replaced, notably almost the entire dark area of the painter's body; a vertical wedge to the right of the palette, rising into the lowest female portrait, is also new, as is a strip about one half-inch broad running horizontally across the sky of the seascape and through the faces in the two portraits beyond the hour-glass.

Old photographs show the picture in a quite different 'restored' condition. These accretions have been removed, and though the picture now looks rubbed and much less 'complete', it is probably nearer the painter's intentions. The considerable retouching is fairly easily detected, being in the form of minute cross-hatchings (e.g., on the painter's collar).

Now more an archaeological fragment than a work of art, it nevertheless indicates an extraordinarily varied conception for someone with horizons as limited as Jamesone's seem to have been. The picture appears to mean that Jamesone painted the pictures on the wall. Of these, the mythology is by far the most interesting, the subject apparently the chastisement of Cupid (Plate 109). A picture of this subject, perhaps by Simon de Vos, in the Berlin-Dahlem Gallery (KFM 704), contains a motif very similar to the armoured figure and the Cupid; the nude figure, though reversed and held by another man, is also similar (Plate 110). The Berlin picture was painted before 1632 (see Helmut Börsch-Supan, 'Die Gemälde aus dem Vermächtnis der Amalie von Solms und aus der Oranischen Erbschaft in den brandenburgisch-preussichen Schlössern', *Zeitschrift für Kunstgeschichte*, 1967, pp. 152–3 and 193), and while there could hardly have been any direct link, it is clear that Jamesone, by some means, was aware of the products of northern mannerism.

### 113. *Self-portrait*

Canvas: $11\frac{3}{8} \times 9\frac{1}{8}$ in. (Plate 111).
*Collection.* Edinburgh, Scottish National Portrait Gallery, no. 592.
*Provenance.* With John Jamisone of Leith between 1763 and *c.* 1796; in 1890 in possession of Mrs. Mary Lawrie of Edinburgh; later in possession of the Hon. Hew Dalrymple, who gave it to the Gallery in 1900.
*References.* Letter from John Jamisone to John Campbell, 5 July 1762, stating that there is 'a miniature in my possession of and by himself' (SRO, GD 112 (unsorted paper): see also p. 5 above); Walpole, p. 2: 'Mr. John Jamisone wine merchant in Leith [Walpole's informant] ... has another portrait of this painter by himself, 12 inches by 10'; Earl of Buchan's MS., p. 6: 'George Jamiesone painted by himself of the closet Size 12 inches by 10 was in the possession of Mr. Jamesone Wine Merchant in Lieth'; Carnegie to Musgrave, fo. 124.

Basically of the Aberdeen pattern but softened, prettified, and tidied up, presumably as a result of the attentions of John Alexander, of whom a seemingly reliable tradition exists that he restored the picture in 1763 (*Catalogue* of SNPG, 1909, p. 120).

### 114. *Self-portrait, with Wife and Child*

Canvas: $31\frac{1}{4} \times 26\frac{1}{16}$ in. (Plate 85).
*Collection.* The Fyvie Trustees, Fyvie Castle, Aberdeenshire.
*Provenance.* In possession of the painter John Alexander in the 18th century and later with his son-in-law, the painter Sir George Chalmers; in 1859 in possession of John Gregory, who was a descendant of Chalmers; by 1885 with Mrs. Leith of Canaan Lodge, Edinburgh, a cousin of Gregory: Mrs. Leith was a cousin of Lord Leith whose grandson, Sir Ian Forbes-Leith, was the latest owner.
*Exhibitions.* Aberdeen, *Archaeological Exhibition*, 1859, no. 48 (called 'A Copy by Alexander from the original by Jameson...'); Edinburgh, *Scottish National Portraits Loan Exhibition*, 1884, no. 106; Aberdeen, *Paintings from North-East Homes*, 1951, no. 50.
*References.* Walpole, p. 2; Earl of Buchan's MS., p. 6: 'George Jamiesone with his Wife Isabella Tosch or Tosh & their young son in one piece painted Anno 1623 was lately in the possession of his descendant Mr. John Alexander Limner in Edinburgh now in that of Sir George Chalmers Bart: Portrait Painter'; Carnegie to Musgrave, fo. 123; Bulloch, pp. 56, 57 and no. 119; Brockwell, p. 30.

The picture has been almost entirely repainted, and though it affords a good deal of evidence about Jamesone's conception of himself, it can say very little about his painting: it does, however, show him organizing a fairly unusual pattern. A suspicion that it might indeed be a copy by Alexander is dispelled by a close examination of the outlines of the flesh areas and the strips of lace on the woman's breast, where the original paint surface is still visible. The restoration, apparently carried out at some time between 1859 and 1885, evoked the remark from Bulloch, who had seen it before restoration: '... the most regrettable example of the evils of restoration. To look at the bright, fresh painting ... it is most difficult to believe that it is not an entirely new picture. ...'

The restorer may have been helped by the engraving done by John Alexander in 1728, which points to the 'surface' picture being a fairly close copy of what was originally underneath, though the strong reds and greens of the rather 'tartanized' head-rail are quite unconvincing.

The dominant figure of Isobel Tosche is basically Jamesone's single figure portrait: behind this pyramid are fitted, with some success, the child and the figure of the painter, which is largely of the Aberdeen pattern.

Costume would date the picture about 1635, though the date '1623' in Alexander's engraving may be an error for 1633. The child could be a boy but the only male child still living between January 1631 and 30 January 1635 was George who died on the latter date, almost exactly two years of age (see Documents, 31 and 40). This seems too young: it is more likely to be Marjory, who must have been about seven in 1635. If, however, the picture is later, it would have to be dated near to 1640, so that the child could be Andrew or Alexander, born in the summers of 1635 and 1636 respectively and both dead by the autumn of 1641. This seems less likely.

115. Called *Elizabeth Gordon, wife of James Crichton of Frendraught* (b. *c.* 1603)
Canvas: 28½ × 25 in.
Inscribed top left: *Anno 1637.*/*Ætatis 34.*
*Collection.* The Morison of Bognie Trustees, Frendraught, Aberdeenshire.
*Provenance.* As for 67 above.
*References.* Probably Earl of Buchan's MS., p. 8 (quoted at 67 above); probably Carnegie to Musgrave, fo. 124: 'Sutherland, Viscountess Frendraught—Morison of Bognie in Aberdeenshire'; Bulloch, no. 139; Brockwell, p. 33.

Head and shoulders, to the right; a round face, curling hair, and fringe on forehead; wears head-rail. Her dress has square décolletage edged with deep strip of lace; breast filled in with gauze and lace strips.

Almost entirely repainted; only recognizable as Jamesone by the structure and outline of the figure. The inscription is surprisingly untouched.

Presumably painted as a companion to 67. Elizabeth Gordon was the second daughter of the 12th Duke of Sutherland, who married in 1600 and had a daughter in 1601. This gives some support to the traditional identification.

116. *Sir David Carnegie, 1st Earl of Southesk* (*c.* 1575–1658)
Canvas: 26¾ × 23¾ in. (Plate 117).
*Collection.* The Earl of Southesk, Kinnaird Castle, Angus.
*Provenance.* Family ownership since painted.

*Exhibitions.* Aberdeen, *Archaeological Exhibition*, 1859, no. 137.
*References.* Carnegie to Musgrave, fo. 125; William Fraser, *History of the Carnegies*, Edinburgh, 1867, vol. ii, p. 551; Bulloch, no. 175; a MS. Catalogue of Pictures at Kinnaird made by the 10th Earl of Southesk in 1904 (transcript in SNPG) mentions copies of the portraits of the four brothers at Ethie (see below); Caw, p. 11; Brockwell, p. 35.

The picture is rather warm in colour; the outlines of forms have a distinctly reddish character. The lighting, which is from the left, falls across the shoulder and breast of the spotted doublet with a finely calculated precision.

It was apparently at one time inscribed *Ætatis 62*/*Anno 1637* and also signed (evidence of label and note in SNPG files), but this is no longer visible. The companion portraits, 117 and 118, have inscriptions of this sort. Jamesone had painted Sir Robert Carnegie, the third of the four brothers, in 1629 (Catalogue, 26), the same year in which he painted the present sitter's son-in-law, Montrose. The opportunity presumably presented itself in 1637 to complete this small family gallery.

The picture's certainty of drawing, firmness of modelling, and sense of occasion, give it an eminent position among Jamesone's surviving paintings. It has considerable affinities with the much damaged *Patrick Dun*, painted some six years earlier (Catalogue, 37; Plate 62).

117. *Sir John Carnegie, 1st Earl of Ethie and Northesk* (b. *c.* 1579)
Canvas: 26¾ × 23¾ in. (Plate 118).
Inscribed top left: *Anno 1637*/*Ætatis 58.* Signed lower right: *Jamesone.*
*Collection.* The Earl of Southesk, Kinnaird Castle, Angus.
*Provenance.* Family ownership since painted.
*References.* As for 116 above, except: Fraser, op. cit., add p. 341; Bulloch, no. 178.

Now rather warm in colour; a certain linearity in the repaint round the eyes and mouth may be the cause of the slightly comic appearance. The thick, rather straggling beard was unfashionable by this date.

Companion to 116 and 118.

118. *Sir Alexander Carnegie of Balnamoon* (*c.* 1587–1657)

Canvas: $26\frac{3}{4} \times 23\frac{3}{4}$ in. (Plate 119).
Inscribed top left: *Anno 1637/Ætatis 50.*
*Collection.* The Earl of Southesk, Kinnaird Castle, Angus.
*Provenance.* Family ownership since painted.
*References.* As for 116 above, except: Bulloch, no. 176.

The details of the hair, face, and beard have been softened by abrasion, but there is little repaint; now rather warm. The lighting of the dark doublet is painted with rather fine precision. The well-understood bony structure of the head, the finely arched nostril, and the feeling of the drawing generally, despite the damage, add up to an image of considerable power and subtlety of expression.

Companion to 116 and 117.

119. *Sir George Stirling of Keir* (1615–1667)
Canvas: $27 \times 24$ in. (Plate 112).
Inscribed top left: *Anno 1637/Ætatis 22.* Signed lower right: *Jamesone/[?F].*
*Collection.* Col. W. J. Stirling of Keir, Dunblane, Perthshire.
*Provenance.* In 1856 in possession of William Stirling of Keir, who succeeded to the Maxwell baronetcy in 1865 as Sir William Stirling-Maxwell. He was succeeded by his eldest son John in 1878, with whom the picture is recorded in 1885 (Bulloch); his second son, Archibald Stirling, latterly succeeded to Keir.
*Exhibitions.* London, *Exhibition of National Portraits*, 1866, no. 528; Glasgow, *Scottish Exhibition*, 1911, no. 38 (Catalogue, vol. i).
*References.* Mark Napier, *Memoirs of the Marquis of Montrose*, Edinburgh, 1856, vol. i, Appendix, pp. xxiv–xxv, stating that the present picture and its pendant 'originally occupied one frame with a slip between': vol. ii, opp. p. 381, engraving by R. C. Bell; Bulloch, no. 133; typescript Catalogue of Pictures at Keir House by R. Langton Douglas, no. 226 (copies at Keir and SNPG).

The long brown hair is now rather lacking in detail. The thick, dull pink paint on the face, not properly integrated with the grey shadows, and the outlined, schematic forms of the mouth, point to a good deal of repaint. The doublet is blue/grey with elaborate embroidery in dull ochre and white.

In 1637 the sitter married, as his second wife, Margaret Napier, daughter of the 1st Baron Napier and Margaret Graham, who was sister to the 1st Marquess of Montrose. Jamesone had already painted members of this circle, notably Montrose in 1629. It is quite likely that the present picture and its companion were painted to mark the marriage, repeating the example of Montrose eight years earlier.

120. *Margaret Napier, Lady Stirling* (b. *c.* 1620)
Canvas: $27 \times 24$ in. (Plate 113).
Signed lower right: *Jamesone/[?F].*
*Collection.* Col. W. J. Stirling of Keir, Dunblane, Perthshire.
*Provenance.* As for 119 above.
*Exhibitions.* London, *Exhibition of National Portraits*, 1866, no. 535; Glasgow, *Scottish Exhibition*, 1911, no. 43 (Catalogue, vol. i).
*References.* As for 119 above, except: Napier, op. cit., vol. ii, opp. p. 511, engraving by R. C. Bell; Bulloch, no. 134; typescript Catalogue . . . by R. Langton Douglas, no. 225.

Hair brown, with vermilion ribbon on crown of head; matching ribbon on breast. The face varies between dull cream in the highlights to grey/green in the shadows; eyes grey, nostril and lips pink. Her dress is brown to green, the highlights yellow ochre.

Not repainted to the same extent as its companion, 119. A warm ground is visible where the paint is thin.

121. *Archibald Napier, 2nd Baron Napier* (d. 1658)
Canvas: $25 \times 22$ in.
Inscribed (later) top right: *ARCH.ᴰ LORD NAPIER 2.*
*Collection.* The Lord Napier and Ettrick, Normandy, Surrey.
*Provenance.* As for 38 above.
*References.* Musgrave (Wilton Lodge list), no. 8; Mark Napier, *Memoirs of the Marquis of Montrose*, Edinburgh, 1856, vol. i, Appendix, p. xxiii, giving an obviously thoughtful account of its condition: vol. ii, opp. p. 667, engraving by R. C. Bell; Bulloch, no. 155.

Nearly half-length, to the right; a youthful, almost feminine face with hair to shoulders. Wears a broad lace-edged collar over a plain doublet; sleeves of doublet slashed.

Rather badly over-cleaned on lower face, hair, and collar.

The lighting of the right arm and breast and the manner in which the figure shrinks to the

left within the canvas are typical of James-one.

The sitter was brother of Lady Stirling of Keir, to whom he shows considerable resemblance (Catalogue, 120). Costume supports the likelihood that the present portrait was painted in the same year as his sister's, and its pendant (Catalogue, 119) which is dated 1637.

122.  *Sir William Nisbet of Dean* (1569–1639)
Canvas: 30×25 in. (Plate 121).
Coat of arms top right surrounded by initials: *WN*; motto inscribed on arms: *HIC MIHI PARTVS HONOS*; inscribed top left: *Anno 1637/Ætatis 68.*
*Collection.* Sir David Ogilvy, Winton Castle, East Lothian.
*Provenance.* Unrecorded before 1892 when in possession of Mr. and Mrs. Nisbet Hamilton Ogilvy at Archerfield; by descent to the present owner.
*References.* Andrew Ross and Francis J. Grant, *Alexander Nisbet's Heraldic Plates*, Edinburgh, 1892, p. lvi.

The sitter's rather 'puffy' face is florid, the pigment freely and sensitively handled, indicating the structure of bone and flesh with considerable accomplishment. The standing-falling ruff is a thin transparent blue/grey, showing reddish brown at the rubbed outlines. The remainder of the painting is rather dark.

Besides sharing features of drawing, it has the same direct approach to character as the *Montrose* (Catalogue, 25; Plate 52). A possibly rather coarse, bucolic individual is embodied with sympathy and humour. He was Provost of Edinburgh at various times between 1616 and 1623. In 1637, and this may have provided the occasion for the portrait, he was appointed Sheriff-principal of Edinburgh. The motto is that of Edinburgh Castle.

123.  *John Erskine, 3rd Earl of Mar* (d. 1654)
Canvas: 28×24½ in. (Plate 114).
*Collection.* The Earl of Mar and Kellie (on loan to Glasgow Art Gallery).
*Provenance.* Probably family ownership since painted.
*References.* *Family Portraits in Alloa House*, privately published, 1884, no. 5; Bulloch, no. 131.

The flesh colours are a mixture of low pinks and creams. The plain falling band is a quite

intense blue/grey in the shadows. There is some embroidery on the subdued brown doublet; the upper right arm and breast are lit with a series of close horizontal yellow strokes of pigment, the surface of the material subtly modulated. A broad red sash crosses the right shoulder: it is tied below the left breast and carries the circular order of the Bath, with the motto, *TRIA IUNCTA IN UNO.*

Small patches of repaint are visible but there is no widespread repainting.

Costume suggests a date between 1635 and 1640. Eldest son of Treasurer Mar by his first wife, he was made a Knight of the Bath in 1610; served heir to his father in 1635 and fell under the King's displeasure in 1640. The portrait gives as clear an indication as any of Jamesone at the height of his self-confidence.

124.  *John Henderson of Fordell* (*fl.* 1620–1655)
Canvas: 25×22¾ in. (Plate 115).
Inscribed (later) lower right: *SIR JOHN HENDERSON of FORDEL/who having travelled in the early part of/his life thro' many remote Countries in/ASIA & AFRICA and distinguished himself/in the Wars of EUROPE returned to his/ native COUNTRY in the Reign of CHARLES/the FIRST & had a COMMAND in the ROYAL army.*
*Collection.* Edinburgh, Scottish National Portrait Gallery, no. 1600 (on permanent loan from the Earl of Buckinghamshire).
*Provenance.* This and four other portraits purporting to be Hendersons of Fordell (Catalogue, 125, 136–8) make up a group which, though not all of quite the same date, seem to have been together since the late 18th century when they were inscribed with identities in the same hand. The baronetcy of Fordell became extinct in 1833; the last baronet's heir was his sister Jean Henderson, wife of Lt.-Col. George Mercer. Their granddaughter inherited the property of her brother George William Mercer-Henderson of Fordell; her daughter, Georgiana, married Sidney, 7th Earl of Buckinghamshire (d. 1930). In 1939 the pictures were in possession of the son of these two, John Hobart-Hampden-Mercer-Henderson, 8th Earl of Buckinghamshire (d. 1963 and succeeded by a second cousin). Catalogue, 124 was given to the SNPG in 1963 and 138 was on the London art market in 1973: the others can no longer be traced.
*References.* None.

Hair dark brown; face warm and rather transparent with green in the shadows. The plain falling band is blue/grey; the dark doublet has black embroidery at the joint between wing and body. The open, light grey/green area on the right is a sky and water on which floats an oar-driven sailing vessel.

The way in which grey light spreads across the shoulder, breast, and collar, and the gentle, hesitant statement of character are typical of Jamesone but the seascape is unusual: it presumably symbolizes the exotic career of the sitter. The division of the picture into a near, rocky surface against which the sitter is posed, and a smaller strip of open background, is strangely reminiscent of another provincial portrait, the self-portrait of Nicholas Lanier at Oxford (Plate 116): Lanier in fact derived the idea from Van Dyck's portrait of himself of *c.* 1630–2 in Vienna.

It is stated in Sir Robert Douglas, *The Baronage of Scotland*, Edinburgh, 1798, p. 519, that Henderson 'had a command upon the coast of Africa, where, after a defeat, he was taken prisoner by the barbarians, and when he was upon the point of being destroyed by them, was ransomed by a lady, whose picture, with a coronet on her head, and a landscape, representing his deliverance, is still preserved in the family' (retold at length in an 18th-century MS. in the Fordell muniments (SRO, GD 172, unsorted) which claims to draw on a contemporary document). A picture which purports to be a copy done by a W. Frier in 1731 of an earlier picture, and which largely agrees with this description, did indeed belong to the family (now SNPG, no. 1604). This, however, introduces a negress on the right, which Douglas would hardly have failed to note, and it may be that Frier developed his picture from a single figure portrait. It is noticeable that the left half of Frier's picture contains a figure against a rocky wall, which opens onto a sea with a sailing vessel. This may point to a 'fancy' portrait done by Jamesone as a companion to the present picture.

Although his father was knighted and his son made baronet, there is no indication in the Fordell muniments that the sitter ever had a title. He seems to have been the only child born to his father by Agnes Balfour, first mentioned in the muniments in 1601; he married Margaret

Menteith in 1624. This accords with his apparent age and the likely date of the picture, *c.* 1635–7.

125.   Called *Margaret Menteith, Lady Henderson* (*fl.* 1624–1650)
Canvas: size unknown.
Inscribed (later) lower right: *MARGARET WIFE of SIR JOHN HENDERSON/THE TRAVELLER. DAVGHTER of W./ MENTEATH of RANDIFORD and his WIFE JANE/ daughter of BRUCE of BLAIRHALL.*
*Collection.* Unknown.
*Provenance.* As for 124 above.
*References.* None.

This portrait is unrecorded after 1939, and is only known in a photograph of that date.

Nearly half-length, to the right. A young woman of delicate features with pearl necklace at her throat; low decolletage, sleeves ballooned and slashed above elbow; narrow belt dipping from waist.

The following colour notes were made by A. E. Haswell Miller in 1939 (SNPG photograph files): 'Red ribbon and white bow in hair.... Pink bow at breast. Black and white slashed bodice, pink bow at elbow.'

Presumed companion to 124: the date of the costume would support this.

126.   Called *Arthur Erskine of Scotscraig* (d. 1651)
Canvas: 24½ × 22½ in.
Inscribed (later) at top: *Hon^ble Arth? Erskine of Scots Craig.*
*Collection.* Lord Elibank, Sunningdale, Berkshire.
*Provenance.* As for 10 above.
*References.* Musgrave (Drumsheugh list), no. 6: 'Sir Arthur Erskine of Scotscraig'; Carnegie to Musgrave, fo. 123v.; Bulloch, no. 149; Brockwell, pp. 16, 31.

Head and shoulders, to the right. A youngish man with oval face, thick reddish brown hair, and slight moustache. Wears a quite broad falling band edged with scalloped lace over dark doublet, open at the front and with slashed sleeves.

Close in feeling to the *7th Earl Marischal* of 1636 (Catalogue, 94; Plate 97). In date it is perhaps a year or two later, but rather earlier than 129, the *4th Earl of Haddington*, which it also resembles: it clearly does not, however, despite its battered condition, share the peremptoriness in drawing of the latter, which began to take over in these years.

The sitter married Margaret Buchanan of Scotscraig in 1628 and was killed at Worcester.

For the group of portraits to which this belongs, see the commentary to 9.

127.  *William Erskine* (d. 1685)
Canvas: 25 × 23 in.
Inscribed (later) top left: *Cup Bearer to Charles the 2^d*; and top right (in a different, perhaps earlier, hand): *W^m Erskine Master of/the Charter House.*
*Collection.* Lord Elibank, Sunningdale, Berkshire.
*Provenance.* As for 10 above.
*References.* Musgrave (Drumsheugh list), no. 7: 'William Erskine, Cupbearer to King Charles 2d. and Master of the Charter House, London: died 1685'; Carnegie to Musgrave, fo. 123v.; Bulloch, no. 150; Brockwell, pp. 16, 31.

Head and shoulders, to the right. A young man with thick reddish hair and clean-shaven rather warm face. Costume almost identical to 126, to which it is also close in pattern and style.

The pigment is thin and probably rubbed; some obvious repaint on right cheek and upper lip.

See the commentary to 9.

128.  Called *Anne Erskine, Countess of Rothes* (d. 1640)
Canvas: 26½ × 21¾ in.
*Collection.* Lord Elibank, Sunningdale, Berkshire.
*Provenance.* As for 10 above.
*References.* Earl of Buchan's MS., p. 8 (quoted at 9 above); Musgrave (Drumsheugh list), no. 9: 'Lady Anne Erskine wife of John sixth Earl of Rothes'; Carnegie to Musgrave, fo. 123v.; Bulloch, no. 144 (describing it as a 'characteristic and untouched sample of Jamesone'—either an indication of the unreliability of Bulloch's eye or of later disastrous treatment); Brockwell, pp. 16, 31.

Head and shoulders, to the right. The sitter has a round head and thin, fair hair with fringe; face grey/cream with greenish shadows and isolated patches of pink. Wears large double earring and pearl necklace; dark dress with low decolletage with broad lace edge. The corners have been blanked off.

In so far as any comparison with 7 is possible, this could be the same sitter. The costume suggests a date about 1635–40.

See the commentary to 9.

129.  *John Hamilton, 4th Earl of Haddington* (1626–1669)
Canvas: 28 × 23 in.
Inscribed at top (later, *Thomas* added subsequently): *Thomas 3d Earl of Hadinton.*
*Collection.* The Earl of Haddington, Tyninghame, East Lothian.
*Provenance.* Probably family ownership since painted.
*Exhibitions.* Probably Edinburgh, *Loan Exhibition of Old Masters*, 1883, no. 72.
*References.* Perhaps Musgrave (Tyninghame list), no. 12: 'Thomas 3d. Earl of Haddington in a black cloak'; probably Bulloch, no. 99 (as 3rd Earl).

Head and shoulders, to the right, within painted oval. A youth with rather oval head and mass of dark hair falling to his collar. The face tends to orange, with characteristic grey/green shadows. He wears a broad, lace falling band over a dark doublet, open at the front and with slashed sleeves.

Rubbed and thin throughout, which increases the impression of brownness.

Despite the inscription, it is clearly related to the figure of the 4th Earl in the *Haddington Family Group* (Catalogue, 130; Plate 101). It is also recognizably the same sitter as that in a more accomplished portrait, also at Tyninghame, showing a sitter of about the same age in armour, which is inscribed as the 4th Earl (see p. 73; Plate 107).

It has some appearance of being a companion to 95, but this is doubtful. Though the painted oval may be an addition, there is no record of it ever having been in the Glenorchy collection.

130.  *Haddington Family Group. The Family of Thomas Hamilton, 2nd Earl of Haddington* (1600–1640)
Canvas: 43½ × 52 in. (Plate 101).
Inscribed (later) beneath the four principal figures: *John/4^th E: Hadinton—Thomas/3^d E: Hadinton—Thomas Lord Binning/2^d E: of Hadinton—Lady Katharine Erskine Lady Binning*; and bottom right: *Jameson P.*
*Collection.* The Earl of Haddington, Tyninghame, East Lothian.
*Provenance.* Probably family ownership since painted.

*Exhibitions.* Edinburgh, *Loan Exhibition of Old Masters*, 1883, no. 101.

*References.* Inventory of goods belonging to Thomas, 6th Earl of Haddington at his death in October 1735: 'In the picture Closet ... Item the family peice of Hadington by Jamieson' (SRO, Edinburgh Register of Testaments, vol. 98, under 22 April 1736); Musgrave (Tyninghame list), no. 7: 'A family piece, less than life, of the 2d. Earl of Haddington, his wife, two sons and two daughters, said to be done by Jameson'; Sir William Fraser, *Memorials of the Earls of Haddington*, Edinburgh, 1889, vol. i, p. 375; Bulloch, no. 97; Brockwell, p. 26; Ellis Waterhouse, *Painting in Britain 1530 to 1790*, Harmondsworth, 1962, p. 41.

The picture is a rather naïve amalgam of poor drawing and rich colour. The 2nd Earl wears a dark crimson cloak over grey armour. His right hand, curiously out of scale, indicates his two sons: the future 4th Earl, whose face is painted with miniature-like delicacy, wearing doublet and breeches, yellow ochre in colour with a degree of strong olive green; and the future 3rd Earl, dressed in pale pink with dark crimson shadows. The younger child in the centre, holding a chaplet of red flowers towards Lady Binning, wears a long blue/green dress; Lady Binning, whose hair is quite yellow, wears a dress of a similar but rather paler colour. The dwarf is dressed in a pinkish vermilion suit, while the youngest child, at Lady Binning's side, wears a dress of a similar colour.

The sky is a warm grey crossed by bars of yellow to dark pink. The foliage is brown to black, flecked with green on its edges. The dark area behind Lady Binning tends to obscure water falling in a fountain. The foreground lightens from a brown/black at the bottom edge, through brown to a light red in the middle distance.

The picture is probably retrospective and may have been painted when the principal figure succeeded to the earldom in 1637: his wife had died in 1635. The head of the future 3rd Earl is taken from another portrait by Jamesone, that done in 1636 for Campbell of Glenorchy (Catalogue, 95), but in the present picture the body has been turned inwards, with extreme awkwardness; while his younger brother appears to derive from 129. Haddington himself is taken more or less directly from a full-length at Tyninghame from Van Dyck's studio.

This is the earliest Scottish conversation piece. Family groups were not unknown: there was, for example, the group of the *5th Lord Seton and his Family* of 1572 by Frans Pourbus (National Gallery of Scotland, no. 2275; Plate 3), or the *3rd Earl of Winton and his two Sons* of 1625 at Keith Hall, attributed to Adam de Colone (Plate 34), but in both there is little action and the figures are confined in a shallow, unspecified space. Jamesone's own *Countess of Rothes with her Daughters* (Catalogue, 7; Plate 24) is a move towards a family in its setting.

There are marked stylistic parallels with other works by Jamesone. The same miniature-like technique and colouristic effects (the use of pink and turquoise accents) are found in parts of the *Glenorchy Family Tree* (Catalogue, 93; Plate 94): the drawing of Haddington is close to the reclining figure, especially the underscaled and misunderstood hands, and the deflected light on the cloaks of both figures is also close. Similar colouristic features are found in the earlier group of 'fancy' kings from Newbattle. Specifically, the portrait of *Robert II* (Catalogue, 46; Plate 71) shares with the dwarf a similar misunderstanding of the bony structure of the lower part of the face and the same large, liquid eye with a similarly placed dart of white for the highlight.

Further afield, a rather close parallel to the pattern is Mytens's *Charles I and Henrietta Maria* of *c.* 1630–2 at Hampton Court (Plate 102). This also consists of two halves, a dais closed in by pillars and an open landscape, in reverse from the present picture. Again, in the Hampton Court picture, the dwarf Jeffrey Hudson enters bottom left, while a single angel top centre sprinkles the royal couple with flowers. Also close is an engraving by William Marshall of Charles and Henrietta with five children, where two angels celebrate the family and where, as in the Haddington group, the children are dwarf-like adults rather than children (Plate 103).

131. Called *Sir John Sinclair, 1st Baronet of Stevenston* (d. 1648/9)

Canvas: 25 × 21 in. (sight).

Inscribed (later) lower left: SIR JOHN SIN-CLAIR 1st BART.

*Collection.* Lady Broun Lindsay, Colstoun, East Lothian.

*Provenance.* See below.

*References.* None.

Head and shoulders, to the right; a rather irregularly shaped head, the face very warm; greyish hair, brown beard and moustache. He wears a squarish grey lawn collar trimmed with lace over a dark doublet.

Thin and rubbed (red ground visible at top) with a good deal of repaint on the face.

A portrait of the late 1630s with pronounced Jamesone characteristics, e.g., the outline of the head. Probably a companion to 132.

Sinclair, a merchant, was created baronet on 18 June 1636 (*Complete Baronetage*, vol. ii, p. 421). The present owner states that the picture came from Stevenston but it has no recorded history; the identity is doubtful since its similarly inscribed companion is clearly wrongly identified.

132. Called *Sir John Sinclair, 2nd Baronet of Stevenston* (1642–1652)
Canvas: 24⅞ × 21⅛ in. (sight).
Inscribed (later) lower left: *SIR JOHN SIN-CLAIR 2nd BART.*
*Collection.* Lady Broun Lindsay, Colstoun, East Lothian.
*Provenance.* See 131 above.
*References.* None.

Head and shoulders, to the right. A young man with moustache, long hair to his shoulders, and fringe on forehead; the face very warm. Wears grey collar edged with lace over a dull gold doublet, slightly open at front and sleeves slashed. The dark, sweeping shadows on the sleeves are characteristic of Jamesone.

A portrait of the late 1630s, and apparently a companion to 131. The sitter cannot be John, 2nd Baronet, who was grandson of the 1st Baronet; he was not born until 1642 and lived only ten years. It could conceivably be John Sinclair, the 2nd Baronet's father, who died in 1643.

133. *James Graham, 1st Marquess of Montrose* (1612–1650)
Canvas: 28⅞ × 24¾ in.
Inscribed (later, probably following an older inscription) top left: *Anno. 1640.*
*Collection.* The Marquis of Graham, Auchmar, Stirlingshire.
*Provenance.* On the evidence of the label on the back (see below) it belonged to the Colquhouns of Camstraddan until the 19th century. Accord-ing to Bulloch it was acquired by the Duke of Montrose in 1871.
*Exhibitions.* Glasgow, *International Exhibition*, 1901, no. 1014; Glasgow, *Scottish Exhibition* 1911, no. 47 (Catalogue, vol. i).
*References.* Mark Napier, *Memoirs of the Marquis of Montrose*, Edinburgh, 1856, vol. i, Appendix, p. v, and opp. p. 289, engraving by R. C. Bell; William Fraser, *The Chiefs of Colquhoun and their Country*, Edinburgh, 1869, vol. ii, pp. 245–6 (as in possession of Sir Robert Gilmour Colquhoun); Bulloch, no. 135.

Head and shoulders, to the right. A serious but faintly smiling face, with slight moustache and tuft under lower lip; brown hair in thick curls to shoulders; black skull-cap on head. He wears a broad scalloped lace falling band over a buff leather jerkin crossed by a buckled shoulder belt; the sleeves of the doublet are decorated with strips of silver and brown/red.

The picture has been extensively repainted, presumably since Bell's engraving of 1856 (Plate 120) which suggests something much closer to Jamesone—there are now unfortunate pinks, yellows, and pale purplish blues on the face.

A label on the back, apparently a later copy of the version quoted by Napier and Bulloch, which was signed by Margaret Haldane Colqu-houn on 2 March 1833, gives the history of the picture as told to the writer by her father, Robert Colquhoun of Camstraddan (1716–87). Accord-ing to this, Montrose, when in England in 1640, took refuge in the house of a clergyman, Mr. Colquhoun of the Camstraddan family. Jame-sone was also in the house and when his presence was revealed Montrose, who was assured by their host that Jamesone was 'a man of Honour, a friend who might be trusted', agreed to have his portrait painted. In 1776 the portrait was taken for cleaning to London by Lord Frederick Campbell where it was 'greatly admired by Sir Joshua Reynolds and the judges of painting'.

The first part of this story is curious and should perhaps be given some credence. Jamesone, it will be recalled, fell foul of the Covenanting party in 1640 (see Documents, 58–60) and spent the second half of that year imprisoned, or more likely under some form of loose restriction, in Edinburgh.

134. *Unidentified Man* (perhaps James Crichton,

1st Viscount Frendraught (*c.* 1620–*c.* 1664/5))
Canvas: 27½ × 20 in.
*Collection.* The Morison of Bognie Trustees, Frendraught, Aberdeenshire.
*Provenance.* As for 67 above.
*References.* Probably Earl of Buchan's MS., p. 8, as 'Sir Thomas Urquhart of Cromarty'; probably Carnegie to Musgrave, fo. 124, as 'Urquhart of Cromarty'; Bulloch, no. 141 (as John Urquhart of Craigston, d. 1631); Brockwell, p. 33.

Head and shoulders, to the right. A young man with long flowing hair to shoulders and T-beard and moustache. Wears a dark doublet, open at the front and with slashed sleeves, and a deep, plain falling band, one side overlapping the other.

Very much repainted, but the underlying shapes typical of Jamesone. The picture is cut down all round, considerably at the bottom. Old photographs show highlights on the right arm very like those in the *7th Earl Marischal* (Catalogue, 94; Plate 97) and a relationship of figure to picture area much nearer the usual Jamesone forms.

Costume suggests a date of about 1640. The suggested identification is based on provenance and on the picture's appearance of being a companion to 135, traditionally called Lady Frendraught. Crichton (made Viscount in 1642) had contracted to marry Janet Leslie, third daughter of the 1st Earl of Leven, by 10 October 1639 (*The Scots Peerage*, vol. iv, p. 130). The portrait could be connected with the marriage.

135. Called *Janet Leslie, Lady Frendraught* (d. 1640)
Canvas: 28 × 23½ in.
*Collection.* The Morison of Bognie Trustees, Frendraught, Aberdeenshire.
*Provenance.* As for 67 above.
*Exhibitions.* Aberdeen, *Archaeological Exhibition*, 1859, no. 51.
*References.* Probably Earl of Buchan's MS., p. 8, as 'wife of Sir Thomas Urquhart of Cromarty'; probably Carnegie to Musgrave, fo. 124: 'His wife' (i.e. Urquhart of Cromarty's wife); Bulloch, no. 140 (as Lady Frendraught).

Nearly half-length, to the right. A young woman with ovoid face and thick hair. A many-layered but plain neckerchief covers her breast and neck. The sleeves of the laced bodice are

quite full and these areas seem free of repaint: the 'floated' highlights are those seen in many of Jamesone's paintings.

The costume must be of about 1640. The picture appears to be a companion to 134. Janet Leslie had a daughter who was baptized on 20 November 1640, but the mother died four days later (*The Scots Peerage*, vol. iv, p. 130).

136. Called *Sir John Henderson of Fordell* (d. before 1620)
Canvas: size unknown.
Inscribed (later) lower right: *SIR JOHN HENDERSON/eldest son of JAMES/HENDERSON of FORDEL,/by his Wife JANE daughter/of Wm. MURRAY of Tullibardine.*
*Collection.* Unknown.
*Provenance.* As for 124 above.
*References.* None.

This portrait is unrecorded after 1939, and is only known in a photograph of that date.

Head and shoulders, to the right. A man of perhaps forty with a narrow, rather pointed head and long thin nose; turned-up moustache and tuft of hair under lower lip; hair thickens at neck. He wears a broad falling band, edged with lace, over an elaborately embroidered doublet with slashed sleeves.

Light spreads across the right arm and shoulder in a manner very similar to that in the *3rd Earl of Mar* (Catalogue, 123; Plate 114). Costume implies a date in the late 1630s.

The inscription must be erroneous. Although the parentage is correct, the Fordell muniments show that this Henderson, knighted in 1606, was dead by 1620 (SRO, GD 172, unsorted). If the identity inscribed on 124 were mistaken this portrait could be that John Henderson (it is certainly not another portrait of the same sitter). The only other possibility from this generation of Hendersons appears to be John's half-brother James, son of — Halkeid, but born later than 1613 when his father was divorced by his first wife. His apparent age makes this rather unlikely.

137. Called *Margaret Henderson, Lady Blantyre* (*fl. c.* 1640)
Canvas: size unknown.
Inscribed (later) lower right: *MARGARET, daughter of/SIR JOHN HENDERSON BAR^T/ & LADY of ALEXANDER 5^th/LORD BLANTYRE.*
*Collection.* Unknown.

*Provenance.* As for 124 above.
*References.* None.

This portrait is unrecorded after 1939, and is only known in a photograph of that date.

Nearly half-length, to the right. Perhaps twenty years of age, with elongated, rather mournful face; fringe on forehead, thick hair loosely covered by dark hood; small white collar under chin. The neck, breast, and shoulders are swathed in two layers of scalloped lace, the upper dark, the lower light; sleeves puffed and tied with large bows at elbows.

Costume suggests a date in the early 1640s. The inscription may be erroneous. Her apparent age makes it unlikely that she is a daughter of the John Henderson knighted in 1606 and dead before 1620, while John Henderson the Baronet did not marry Margaret Menteith until 1624. The portrait might represent Margaret Henderson, a sister of the Baronet, who had married Sir Harie Wardlaw before 1654 (SRO, GD 172, unsorted).

138.   Called *Sir James Henderson* (b. 1613–20)
Canvas: 27¾ × 23 in.
Inscribed (later) lower right: *SIR JAMES HENDERSON/a CAPTAIN in the FRENCH/ARMY. Anno 1643.*
*Collection.* Unknown.
*Provenance.* As for 124 above; sold Sotheby's, 23 May 1973, lot 108 (bought S. Ryan).
*References.* None.

Head and shoulders, to the right. A young man with thick hair covering forehead and curling onto cheeks and shoulders. He wears a short lace band over a dark doublet open at the front and with slashed sleeves; a shoulder belt crosses the right shoulder.

This is a rather more likely candidate than 136 to be Sir James Henderson, half-brother to John Henderson. The sitter's apparent age accords with James's year of birth, sometime between 1613 when his father was divorced by his first wife and 1620 when he was dead. (There is little reliable and easily available genealogical information on the Hendersons of Fordell: the details used in 124–5 and 136–8 are taken from writs in the Henderson of Fordell muniments, SRO, GD 172, unsorted.)

139.   *John Leslie, 6th Earl of Rothes* (1600–1641)
Canvas: 30 × 25 in.

Inscribed on right: *I* ᴱ *R/1642/Ætatis. 42.*
*Collection.* Unknown.
*Provenance.* Probably family ownership until the sale of Leslie House to Sir Robert Spencer-Nairn; sold by Alastair Spencer-Nairn at Christie's, 8 December 1967, lot 14 (bought Pawsey & Payne).
*References.* Bulloch, no. 162.

Head and shoulders, to the right. Rather small head with light brown hair, ochre moustache, and squarish beard; face pallid but cheeks and lips quite vermilion. Wears grey, broad falling band, over darker grey doublet; traces of braiding on sleeves. The background is black turning to ochre around the head. May originally have been a painted oval.

The slightly exaggerated rotundity of the rear part of the head and the soft lighting are characteristic of Jamesone.

The inscribed date may be marginally late and is mistaken, for Rothes died on 23 August 1641. Comparisons with the full-length of 1625 (Catalogue, 6; Plate 23), and a very fine miniature of Rothes at Tyninghame, bear out the identification.

140.   *Sir Robert Campbell of Glenorchy* (1579–1657)
Canvas: 42⅛ × 50⅝ in. (includes 141). (Plate 123).
Inscribed (later) at the top: *SIR ROBERT CAMPBELL/1641.*
*Collection.* Unknown.
*Provenance.* Formerly in Campbell of Glenorchy (Breadalbane) possession; later in possession of H. R. H. Woolford; sold at Dowell's, Edinburgh, 1 May 1964, lot 111; later with Fyffe Antiques, Edinburgh, and latterly with Morphet and Morphet, Harrogate.
*References.* Probably included in the Inventory of the house of Balloch, 1679: 'In the outter waiting Roume Other tuo of the Lairds of Glenvrchy', i.e., two pictures *other* than the 'Germane' painter's set (SRO, GD 112/22/4); Pennant (1772), p. 32; Pinkerton's *Correspondence*, vol. i, pp. 135, 137, contains the copyist Johnson's list: 'Sir Robert Campbell dated 1641 half length by Jameson': he also lists the copy (see below); Musgrave (Taymouth list), no. 7; Carnegie to Musgrave, fo. 123; Inventory of Taymouth of 1863, no. 181: the copy no. 127 (SRO, GD 112/22/10); Bulloch,

no. 40 (described as a replica by Jamesone: of his no. 37—here called the copy—he says, '. . . much repainted, and Jamesone's thinnish painting has been quite overlaid . . .'); Brockwell, pp. 25, 31. *Copies.* The copy listed by Johnson was sold at the Invereil House sale, 3 March 1969, lot 76 (bought Essex). Always accepted as the work of Jamesone, but close inspection does not bear this out. The paint (which is not repaint) has a body and coarseness foreign to him. It is nearer the style of portrait associated with the Scougalls later in the century.

Thinly painted, with little obvious repaint. A square-cut white collar is worn over a dark brown doublet. The rotundity of the rear of the head is a typical Jamesone feature.

Relined and paired with 141 in the same manner as 96 and 97.

The sitter succeeded Jamesone's patron, Sir Colin Campbell, in 1640. He and his son John Campbell were signatories of the 1640 inventory of Sir Colin Campbell's possessions which was drawn up in terms of Sir Colin's will of 4 May 1638, where he 'constitutes my brother Roberte Campbell of Glenfalloche my onlie executore . . . the tyme of my deceis out of this mortall Lyfe' (SRO, GD 112/3/1). After Robert succeeded there were indications that he would no longer use the services of Sir Colin's agent in Edinburgh, Archibald Campbell, who had been the intermediary in the contacts with Jamesone (SRO, GD 112/40/2/1640–9 bundle). However, his son John smoothed out the differences, and it is likely that Archibald Campbell again arranged the painting of Glenorchy portraits, some three to four years after Jamesone had completed the set of noblemen.

141. *Sir John Campbell of Glenorchy* (1606/7–1686)
Canvas: $42\frac{1}{8} \times 50\frac{5}{8}$ in. (includes 140). (Plate 124). Inscribed (later) at the top: *SIR IOHN CAMPBELL/1642.*
*Collection.* Unknown.
*Provenance.* As for 140 above.
*References.* First two references as for 140 above; Pinkerton's *Correspondence,* vol. i, pp. 135, 137, contains the copyist Johnson's list: 'Sir John Campbell dated 1642 half length by Jameson': he also lists the copy (see below); Musgrave (Taymouth list), no. 8; Carnegie to Musgrave, fo. 123; Inventory of Taymouth of 1863, no.

182: the copy no. 125 (SRO, GD 112/22/10); Bulloch, no. 41 (described as a replica by Jamesone: of his no. 38—here called the copy—he says, '. . . a genuine, untouched Jamesone'); Brockwell, pp. 25, 31.
*Copies.* The copy listed by Johnson was sold at the Invereil House sale, 3 March 1969, lot 87 (bought Bromfield). The remarks under 140 also apply here.

Condition similar to 140 with which it is joined. Under the broad white collar the sitter wears a subdued pink/crimson doublet. The inscription can only be a partial record of a contemporary one as he did not become baronet until 1657.

Clearly by the same hand as the far feebler *4th Earl of Haddington,* which is perhaps a year or two earlier (Catalogue, 129). The quality (as of 140) is surprisingly high and shows that, at this late stage of his over-productive career, Jamesone could still produce a perceptive and credible portrait with few obvious lapses in drawing.

In early 1658, just after the death of his own father, his son John (later 1st Earl of Breadalbane) wrote to him from London: 'My wyf taiks it for a great complement that your honour should demand her pictur. The season is so extream cold with frosts great snowes that it puts ladyes in ane ill mode to be drawn however shee promises to send it with all convenience but shee is thairby feared to be dislyked before shee be seen . . .' (SRO, GD 112/39/907). One senses here a continuity in the Glenorchy interest in family iconography, which Jamesone had fulfilled, and in a sense formed, for almost a decade.

142. 'Sir John Scot of Scotstarvet' (1585–1670)
*Collection.* Unknown.
*Provenance.* See below.
*References.* Documents, 79(b); almost certainly Earl of Buchan's MS., p. 27: 'Sir John Scott of Scotstarvet (The Laird of Scotstarvet has it) 'tis by Jameson'; Pinkerton's *Correspondence,* vol. ii, pp. 15–17, contains a letter of 1 December 1797 from Pinkerton to the Earl of Buchan which includes, in a list of paintings (with locations) he still required to be copied for engraving, what is almost certainly the same picture: 'Balcolmy—Scott of Scotstarvet'.

There is no visual record of this portrait and no record later than Pinkerton. That Jamesone painted Scot can be gathered from a series of

epigrams addressed to Jamesone by a William Forbes on the subject of painting Scot; these, dated 21 June 1642, were sent to Scot. Scot, Director of the Chancery of Scotland, brother-in-law of William Drummond of Hawthornden and close friend of Arthur Johnston, was a frequent recipient of poems of this kind.

143. *Anne Kerr, Countess of Lothian* (*c.* 1613–1667)

Canvas: 27×24½ in. (Plate 125).

Inscribed (later, but probably based on a contemporary inscription still faintly visible) top left: *Anno 1644/Anne Countess of Lothian.*

*Collection.* The Marquess of Lothian, Monteviot House, Roxburghshire.

*Provenance.* As it is not certainly identifiable in the earliest Lothian inventories it may formerly have been with its presumed pendant at Yester.

*Exhibitions.* Edinburgh, *A Virtuous and Noble Education*, 1971, no. 2.

*References.* Probably in Newbattle MS. of late 18th century (transcript in SNPG): 'a head Anne, Countess of Lothian' (it does not, however, appear in the 1798 Catalogue); Newbattle Inventory of March 1833 (transcript in SNPG), no. 209.

Generally a rather dark picture, the only colour notes the rather warm face with full pink lips, the brown hair, and the grey neckerchief over shoulders and breast.

The treatment is schematic, e.g. the regular eyes and the stylized hair; stylistically these features are found, though less extremely, in the *Lady Marjory Stewart* (Catalogue, 71-(i); Plate 83). The typical enlarging and pulling of the rear of the head towards the picture plane is here also taken to an extreme degree, and the figure seems more than ever to be quite overwhelmed by the picture area.

Countess of Lothian in her own right, she married William Kerr son of the 1st Earl of Ancram, in 1630: he became Earl of Lothian the following year. There are no records of Lothian patronizing Jamesone but the series of Scottish monarchs, which accorded with his taste, may have entered the collection in his lifetime. He was an avid collector, at this time buying books, silverware, and pictures in Paris through John Clerk of Penicuik. On 27 May 1644 he acquired two portraits, supposedly by Tintoretto (SRO, GD 40/XVIII/1./1). A probable pendant to the present portrait is at Yester (see 144 below).

144. Probably *William Kerr, 3rd Earl of Lothian* (*c.* 1605–1675)

Canvas: 30×24 in. (Plate 126).

Inscribed top left: *1644.*

*Collection.* P. W. Morris, Esq., Yester House, East Lothian (formerly Tweeddale collection).

*Provenance.* Conceivably in Lothian possession in the 17th century (see below); probably in Tweeddale possession since the early 18th century.

*References.* Probably no. 6 in a list of pictures belonging to Lord Tweeddale in Pinkie House 1739: 'A Gentleman in Armour a ¾ Jamieson' (Edinburgh University Library, La. IV. 26.); Bulloch, no. 184.

Higher in tone than its presumed companion, 143, but quite warm. The sitter's long, curling hair is light brown, the armour grey, and the sash across his right shoulder pale blue.

The drawing of the eyes is faintly reminiscent of the method used in the *Montrose* of 1629 (Catalogue, 25; Plate 52) but the subtlety in that picture is here a mere trace element. Both the date (it is the only other known portrait of 1644) and its schematicism suggest a link with 143, and this is borne out by comparing the sitter with the full-length of the 3rd Earl from Newbattle, attributed to David Scougall, or the oval derived from it, also at Yester.

# DOCUMENTS

THE documents are arranged chronologically. As a document of a certain date may contain a reference to another significant date, the latter is listed in date order with a cross-reference to the actual source. The majority of the documents are from manuscript sources: for the sake of completeness those few which are from published sources are included. In the longer documents, and in particular the legal ones, a good deal of compression has been necessary, with omissions indicated. Some are given in summary only.[1]

1. *6 August 1573*
Contract between Gilbert Menzies of Cowlie and Andrew Bethlem, mason in Aberdeen, binding Andrew Jamesone, son of the late William Jamesone, apprentice to Bethlem for seven years and to remain in his service for a further two years.
AR, Register of Contracts 1569–1575, vol. i, pp. 94–5. Printed (with minor inaccuracies) in *Scottish Notes and Queries*, Aberdeen, 1888, vol. i, pp. 24–5.

2. *17 August 1585*
'Thair is promes of mareage betuix Andro Jameson Mariore Anderson.' Numbered '1 2 3' in the margin (the necessary three callings of banns) and annotated '17 August 1585' (the date of marriage, added subsequently).
GRO(S), Parochial Registers, Aberdeen, 168A, vol. 12, under date. This and 5, 16, 22, 25–7, 40, and 61 are printed with minor variations in *Analecta Scotica*, First Series, Edinburgh, 1834, pp. 289–90.

3. *27 May 1586*
Instrument of sasine in favour of Andrew Jamesone, mason, following on resignation by Andrew Watson, carpenter, of a dwelling-house (foreland) 'in vico Scholari ex boreali parte eiusdem vici Inter terram Dauidis Indeaucht ex orientali ex vna terram olim Adami Mayr nunc vero heredum quondam magistri Vilhelmi Carmichaell ex occidentali partibus ab altera

[1] Much fuller transcriptions of many of the documents can be found in the writer's thesis of the same title (vol. i, pp. 175–298, under the same reference numbers) of which there are copies in Edinburgh University Library and the library of the Scottish National Portrait Gallery.

Terram Interiorem dicti Andree Watsoun versus boream et communem viam regiam versus austrum', but with exclusion from the 'passagio et Introitu sub eadem quo Ingruditur ad dictam terram Interiorem'.
AR, Register of Sasines, vol. xviii, fos. 284v.–285.

4. *27 May 1586*
Instrument of sasine in favour of Andrew Watson, of an annual feu-duty of twelve merks from the dwelling-house (foreland) of Andrew Jamesone, described in 3 above.
AR, Register of Sasines, vol. xviii, fo. 285–285v.

5. *30 July 1586*
'The penult day Julij 1586 Andro Jameson Mariore Anderson doithar in mareage callit Elspaitt James Robertson Edward Donaldson Elspat Cultes Elspait Mydalton witnesses.'
GRO(S), Parochial Registers, Aberdeen, 168A, vol. 1, under date.

6. *17 October 1588*
'The xvii day October 1588 Androw Jameson Mariore Anderson sone in mareage callit David David Anderson William Wederburne Mariore Endieche Isbell Red witnesses.'
GRO(S), Parochial Registers, Aberdeen, 168A, vol. 1, under date.

7. *9 May 1591*
'The ix day May 1591 Andro Jameson Mariore Anderson sone in mareage callit William William Hay Jon Sanderis Margaret Anderson Isbell Loremer witnessis.'
GRO(S), Parochial Registers, Aberdeen, 168A, vol. 1, under date.

**8.** *3 December 1607*
Instrument of sasine in favour of Marjory Anderson in liferent, following on resignation by Andrew Jamesone, of (i) a dwelling-house (foreland) 'in vico Scholari ex boreali parte eiusdem vici Inter terram anteriorem quondam Dauidis Indeaucht nunc vero Roberti Forbes commendatarii de Monymusk ex orientali ex vna, terram quondam Adami Mair ex occidentali partibus ab altera, terram Interiorem Andree Watsoun fabri lignarii versus boream et communem viam regiam versus austrum'; and (ii) a dwelling-house 'de novo adificatam cespitibus coopertam de presente Inhabitaⁱ per dictum Andream Jaceñ in australi latere dicti vici Scholaris Inter terram quondam Joannis Robertsoun nunc vero [blank] ex occidentali ex vice cimeterium dicti burgi ex australi partibus ab altera et communes vias regias versus oriens et boream'.
AR, Register of Sasines, vol. xxxi, fos. 39v.–40.

**9.** *3 December 1607*
Instrument of sasine, following on resignation by Andrew Jamesone, in favour 'delecti filii sui senioris legitimi Andree Jamesoun', of the dwelling-house described in 8(ii) above (the blank completed by 'heredum quondam Thome Straquhan'), reserving the liferent and use of the said dwelling-house to Andrew, resigning, and Marjory Anderson his wife, and the longer liver of the two.
AR, Register of Sasines, vol. xxxi, fo. 40–40v.

**10.** *3 December 1607*
Instrument of sasine, following on resignation by Andrew Jamesone, in favour 'delecti filii sui secundo geniti Georgii Jamesoun', of the dwelling-house (foreland) described in 8(i) above ('tegulis coopertam'), with the same reservation stipulated in 9 above; and also paying Andrew Watson, carpenter, an unspecified (but see 4 above) annual feu-duty.
AR, Register of Sasines, vol. xxxi, fos. 40v.–41.

**11.** *27 May 1612*
'Vigesimo septimo Maij [1612] The quhilk day in presens of Richard Dobie dene of gild and the gild counsell George Jamesoune sone to Andro Jamesone burges in Aberdeine enteris prenteis to Johne Andersone paynter for aucht zeiris con-

forme to thir Indentors schawen and payit of entres silver xiij s. iiij d.'
SRO, Burgh of Edinburgh Apprentice Register 1583–1647, under date. Listed in Francis J. Grant (editor), *The Register of Apprentices of the City of Edinburgh 1583–1666*, Scottish Record Society, 1906, p. 98.

**12.** *26 November 1617*
Instrument of sasine (under reversion on payment of 100 merks) in favour 'Georgii Jamesoune pictoris filii senioris legitimi quondam Andree Jamesoune', following on resignation by Alexander Jamesone, tailor, with consent of his wife Katherine Oglay, of a dwelling-house 'in Viridi de presente occupaⁱ per dictum Alexandrum Jamesoun et eius sponsam Inter terram heredum quondam Walteri Watsoun ex boreali ex vna terram quondam Alexandri Harper textoris nunc vero Andree Harper eius filii ex australi partibus ab altera terram magistri Patricii Dvn versus oriens et communem viam regiam versus occidens'. Sasine was given to David Anderson, younger, procurator for Jamesone.
AR, Register of Sasines, vol. xxxiv, fo. 29–29v.

**13.** *19 May 1623*
Date on which Alexander Jamesone assigned his right of reversion of the dwelling-house described in 12 above to David Anderson. The source of this date is 14 below.

**14.** *12 March 1624*
Renunciation by George Jamesone of his rights in the dwelling-house described in 12 above, on receipt of 100 merks from David Anderson, 'Assignay lawfullie constitute be Alexander Jamesone . . . in and to the reversioun and redemption . . . be vertew of ane act Inactit in this present auditorie the nyntein day of Maii last bypast. . . .'
AR, Baillie etc. Court Book (Council Register), vol. 50, pp. 871–2.

**15.** *12 March 1624*
Instrument of sasine, following on resignation by George Jamesone ('Juvenis Georgius Jamesone pictor filius legitimus primo genitus quondam Andree Jamesone'), in favour 'dilecti sui avunculi Dauidis Andersone', assignee to the reversion of the dwelling-house described in 12 above.
AR, Register of Sasines, vol. xxxvi, fo. 2.

**16.** *12 November 1624*

Under the general heading 'Ane promeiss of mariagis Betuix . . . the 12 of November [1624] Georg Jamesoune Issobell Tosche.' Numbered '1' in the margin (the first calling of banns: the necessary second and third callings are not entered).

GRO(S), Parochial Registers, Aberdeen, 168A, vol. 12, under date.

**17.** *25 January 1625*

Retour of inquest to the effect that the late Andrew Jamesone, 'filius senior quondam Andree Jameson latomi . . . frater germanus Georgii Jamesone pictoris latoris presentium', died infeft in the dwelling-house described in 8(ii) above (the blank completed by 'postea quondam Thome Straquhan et nunc Joannis Caddell'); and that George Jamesone is the nearest lawful heir of the late Andrew Jamesone his brother, in the said dwelling-house.

AR, Baillie and Guild Court Acts (Council Register), vol. 51², pp. 129–30.

**18.** *25 January 1625*

Instrument of sasine in favour of George Jamesone, painter burgess of Aberdeen, heir to the late Andrew Jamesone his brother, of the dwelling-house described in 8(ii) above (see also 17 above) in which the late Andrew was infeft by resignation of the late Andrew Jamesone his father; followed by an instrument of sasine and conjunct infeftment in favour of George Jamesone and Isobel Tosche, following on resignation by George Jamesone 'pro per impletione certe partis sui contractus matrimonialis cum Issobella Toshe filia legitima quondam Alexandri Tosche burgeñ de Aberdeñ, ac Intuita matrimonii inter ipsos celebrandi', of the dwelling-house aforesaid, and also of the dwelling-house (foreland) described in 8(i) above (adjusted as 'Inter terram quondam Dauidis Endeauch nunc vero heredum quondam Thome Forbes de Rubislaw ex Orientali ex vna, . . . Terram interiorem quondam Andree Watsone carpentarii nunc vero Jeanne Liddell versus Boream . . .'). Sasine was given to George Jamesone in person and to James Tosche 'patruo ac procuratori et eo nomine dicte Issobelle Toshe future sponse ['in sua pura virginitate existeñ'] ipsius Georgii'.

AR, Register of Sasines, vol. xxxvi, fos. 71v.–72v.

**19.** *7 June 1627*

Instrument of sasine in favour of Isobel Tosche, wife of George Jamesone, sister and heir of the late Elizabeth Tosche one of the two coheirs of the late Alexander Tosche of a half share of a dwelling-house (foreland) 'in vico superiore ecclesie ex Boreali parte eiusdem vici, Inter terram Anteriorem heredum quondam Henrici Robertsone calcearii ex orientali ex vna, Terram quondam Joannis Arthure nunc vero heredum quondam Magistri Ricardi Irvying ex occidentali partibus ab altera, Terram Interiorem et claustrum Roberti Alexander versus Boream, et communem viam regiam versus austrum', reserving the liferent and use of the said dwelling-house to Marjory Meassone, widow of the late Alexander Tosche and mother of Isobel.

AR, Register of Sasines, vol. xxxvi, fo. 225–225v.

**20.** *7 June 1627*

Instrument of sasine and conjunct infeftment in favour of George Jamesone and Isobel Tosche, following on resignation by Isobel Tosche 'pro per impletione cuisdam partis sui contractus matrimonialis cum dicto Georgio Jamesone, ac cum eius consensu', of the dwelling-house (foreland) described in 19 above, excepting, however, the 'Throchgang Intrañ ad dictam, Terram Interiorem sub dicta terra anteriore eiusdem altitudinis prout de presenti per dictum Robertum Alexander possidetur', with the same reservation stipulated in 19 above.

AR, Register of Sasines, vol. xxxvi, fo. 226–226v.

**21.** *7 June 1627*

Instrument of sasine in favour of George Jamesone, following on resignation by Alexander Gray, reader in the parish church of Aberdeen, with consent of his wife Janet Murray, of a dwelling-house (foreland) 'in vico Scholari ex australi latere eiusdem vici, Inter terram communitatis dicti burgi vocat ly kirkludge ex australi ex vna, Terram Roberti Alexander ex Orientali partibus ab altera et communes vias regias versus Boream et occidens'.

AR, Register of Sasines, vol. xxxvi, fos. 226v.–227.

**22.** *27 July 1629*

'1629 yeeris . . . George Jamesone & [blank] Toche ane sone baptized be Mr. Robert Baron the 27 day of Julij callet William. Mr. Patrick

Done. Robert Alexander. Andrew Meldrom. William Gordone godfathers.'
GRO(S), Parochial Registers, Aberdeen, 168A, vol. 2, under date.

23. *3–5 November 1629*
'Maister Johne Lambyes Compts. . . . Item for my Lords portrait drawen in Aberdeen, 26 lib. 13sh. 4d. Item to ane going to Aberdeen for it, 12sh. . . . Item December the second day 1629 to ane who brocht my Lords portrait from Aberdeen, 12sh.'
Quoted from Mark Napier (editor), *Memorials of Montrose and his Times*, Maitland Club, 1848, vol. i, p. 199. Of the first two items Napier notes: 'In the MS. a line is drawn through these two items relating to the portrait, and on the margin is written, "This was given by Morphie".'

24. *26 May 1630*
Instrument of sasine in favour of George Jamesone, following on resignation by Alexander Rolland and his wife Besseta Tullidaff, of a dwelling-house (east foreland), presently occupied by Robert Straquhan and Isobel Leith, 'in vico castri ex australi parte eiusdem vici, Inter terram quondam Magistri Georgii Johnestoun nunc vero Wilhelmi Ingrahame ex orientali ex vna, Terram anteriorem occidentalem ipsius Alexandri pro presenti per seipsum occupaẗ ex occidentali partibus ab altera, Terram Interiorem heredum quondam Alexandri Gray versus austrum et communem viam regiam versus Boream'.
AR, Register of Sasines, vol. xxxviii, fos. 30v.–31.

25. *27 October 1630*
'October 1630 yeeres George Jamesone & Issobell Toche ane sone baptized the 27 day callet Pawll. Pawll Mengzies of Kinmundie prowost. Mr. Alexander Jaffray balzie. Mr. Dawid Wederburne. Mr. Robert Patrie. Patrick Jack. Patrick Fergusone. Androw Straquhin godfathers.'
GRO(S), Parochial Registers, Aberdeen, 168A, vol. 2, under date.

26. *6 January 1631*
'The 6 of Januarie 1631 ane berne of George Jamesouns burit iii lib.'

This must refer to either William or Paul.
AR, Kirk & Bridge Works Accounts 1571–1670, under date.

27. *20 January 1631*
'The 20 day of Januarie [1631] ane vther berne of George Jamesouns burit iii lib.'
This must refer to either William or Paul.
AR, Kirk & Bridge Works Accounts 1571–1670, under date.

28. —— *1631/32*
Note of moneys mortified by fifty-four burgesses of Aberdeen for the maintenance of one of their ministers at the Kirk of Futtie: 'George Jamiesone—Thriescoir ten pundis'.
AR, Council Register, vol. 52¹, on leaf inserted at front.

29. —— *1632/33*
Records of payment for work done in the 'ald kirk' of Edinburgh (St. Giles) between the terms of Michaelmas. The following three items are consecutive: 'Item to John Levingstoun for xx bookes of gold and sundrie cullors of payntre and Oyle to paynit the kyngis loft conforme to his compt—Liiii lib. xi s. ii d. Item to George Jamiesones painter his man for paynting the kyngis loft for the spaice of xx dayes xxx lib. Item to the wrytis for upsetting of the scaffold to the paynter and downetaking thereof againe—Liii s. iiii d.'
ER, Dean of Guild's Revenue Accounts from Michs. 1626 to Michs. 1720, p. 12.

30. *23 January 1633*
Delivery by George Jamesone, painter burgess of Aberdeen, as 'ar, and executor to umquhill Williame Jamesone, writtar in Edinburghe, his brother germane', of the late William's mathematical instruments and books left in legacy to the town of Aberdeen, for the use of the Professor of Mathematics in the College. Delivery was made to Mr. William Johnstone, present Professor, according to his inventory.
*Extracts from the Council Register of the Burgh of Aberdeen 1625–1642*, Scottish Burgh Records Society, 1871, p. 55.
A later 17th-century copy of the inventory of William Jamesone's books lists some twenty-seven items.
'Ane Catalogue of William Jamison's books

mortified to the Liberary of Aberdein', Aberdeen University Library.

### 31. *31 January 1633*

'31 Januarie [1633] George Jamesone and Isobell Tosche ane sone his name George Bap. be Mr. Robert Barrone docter of divinitie George Keyth secound sone to the earle of Mershell Mr. Robert Paip Mr. Alexander Davidsone Robert Skeyne Mr. Robert Martine John Alexander Georg Wilsone godfathers.'
GRO(S), Parochial Registers, Aberdeen, 168A, vol. 3, under date.

### 32. *23 August 1633*

'The quhilk day the Proveist baillies dene of gild thesaurer counsall and deaconis of craftis being convenit in counsall ordanis the thesaurer to pay to George Jamiesoun painter for his extraordiner paynes taiken be him in the Tounes affaires at his Maiesties entrie within this burgh thriescore dolloris and fyve dolors to his servand in drink-silver and the same salbe allowit to him in his comptes.'
ER, The Minutes of the Town Council, vol. 14, p. 547. Partially printed in Marguerite Wood (editor), *Extracts from the Records of the Burgh of Edinburgh 1626 to 1641*, Edinburgh, 1936, pp. 129–130.

### 33. *28 August 1633*

'The same day ordanis the deane of gild to admitt George Jamiesoun painter burges and gild brother of this burgh for payment of the ordiner soumes of money and to repay the same bak againe & the said soume salbe allowit to him in his comptes.'
ER, The Minutes of the Town Council, vol. 14, p. 548. Partially printed in Marguerite Wood (editor), *Extracts from the Records of the Burgh of Edinburgh 1626 to 1641*, Edinburgh, 1936, p. 130.

### 34. *28 August 1633*

'The same day ... George Jamesone paynter comperand is maid Burges and gild brother of this burgh conforme to ane act of counsell of this dait of thir presentis and hes gevin his aith in maner abone writtin and hes payit for his dewtie to the deyne of gild the soume of ane hundrethe thriescore sex punds threttine schillings four pennyis.'
ER, The Guild Register 1617 to 18 February 1669,

under date. Listed (with inaccuracies) in Charles B. Boog Watson (editor), *Roll of Edinburgh Burgesses and Guild-Brethren 1406–1700*, Scottish Record Society, 1929, p. 273.

### 35. *29 October 1633*

Instrument of sasine in favour of George Jamesone, painter burgess of Aberdeen, of the towns and lands 'de Fechill cum lie cowbleseit coblecroft cum privilegio lie transportandi lie ferrying super aqua de Ithane et procktoures croft, quae sunt propriae partes et pendiculis ... de Fechill ... pro presenti per Jacobum Gordone Alexandrum Johnstoune Gulielmum Cassie et Andream Sympson occupantur Jaceñ per annexationem infra dominum de Altrie parochiam de Ellone et vicecomitatum de Aberdein', following on a precept in a charter of alienation dated 26 and 28 October 1633, granted by John Gordon of Buckie with consent of Mr. Robert Gordon of Straloch; the lands to be redeemable from Jamesone on payment of 14,000 merks, only after the expiry of three years. Witnessed by (with others) 'Magistro Roberto Petrie agente Edinburgi ... et Andrea Straquhan pictore in Aberdein.' The instrument was presented by Jamesone for registration on 25 November 1633.
SRO, Particular Register of Sasines, Aberdeen, vol. 8, fos. 367v.–369v.

### 36. *29 October 1633*

Instrument of sasine in favour of Isobel Tosche, wife of George Jamesone, in liferent 'duorum aratrorum ... de Fechill vocat Craighall ... durañ non Redemptione dictarum terrarum', following on a precept in a charter of liferent dated 28 October 1633, granted by George Jamesone. Witnessed by (with others) 'Andrea Strachauchin pictore'. The instrument was presented by Jamesone for registration on 25 November 1633.
SRO, Particular Register of Sasines, Aberdeen, vol. 8, fos. 369v.–371v.

### 37. *Post-July 1633*

'In the month of January [*sic*], 1633, the King being then to come to Edinburgh to be crowned, I [Alexander Jaffray] went over and attended that ceremony.

In July thereafter I came home, my wife being, before my coming, brought to bed of her first son, called Alexander. Shortly thereafter, I went

again to London, in company with Robert Skene, Andrew Birnie and George Jamieson. I staid some time longer, and . . . on my return, went off the road, and visited the University of Cambridge by the way.'
Quoted from John Barclay (editor), *Diary of Alexander Jaffray*, Aberdeen, 1856, p. 44.

### 38. *25 October 1634*
Letter from Archibald Campbell in Edinburgh to Sir Colin Campbell. 'Ryght honnorabill I ame speiring [looking] out for yowr hingingis the best I cane and shall acquant yow quhan I hawe fand them boith of thair worth and pryce. Jamesone the painter will wndertak your broids boit I could not speik with the wreicht becaus the measures are not sent heir. The rest of your affaires ye may be assured they shall be done god willing. . . . The church men rewlis all for the present His Maiestie hes recallit his warrandis in favouris of The erle of Airth and hes ordained Comissioneris to haue proces against hime.'
SRO, GD 112/40/Box 1.

### 39. *28 October 1634*
Letter from Archibald Campbell in Edinburgh to Sir Colin Campbell. 'Right honorabill . . . I haue spokin with Jemisone the penter And hes caused him set doun at the teill of your memorandum quhat he vill haue for your portratis quhich is tuentie merkis for drawing of them And ten merkis for furnisching all necessaris. Therefore gif ye vill haue him to do them send bak the not vith the first beirar For les he sweiris to me he can not teike. . . .'
SRO, GD 112/40/Box 1.

### 40. *30 January 1635*
'30 Januar 1635 Mair ane bairne of George Jamiesounes buried in the auld kirk iii lib.'
    This must refer to George.
AR, Kirk & Bridge Works Accounts 1571–1670, under date.

### 41. *15 March 1635*
Letter from Archibald Campbell in Edinburgh to Sir Colin Campbell. 'Right honnorabill . . . The painter will hawe all your portraits readie within tuo or thrie dayes And desyres earnestlie they may be takin frome hime and assures me that thrie or four horssis will easilie carie them and that he sall pack them wpe as they can haw

no harme He desyre that ye may send with the horssis some canvessis or packing sheittis I can assure yow on my crydit they are werie weill done and all as ye desyrit . . .'
SRO, GD 112/40/Box 1.

### 42. *1 May 1635*
Extent Roll for 1635, compiled to carry out a taxation of about $4\frac{1}{3}$% imposed by the Privy Council in 1634 for the maintenance of the ministers. 'North-east quarter: last thrid part therof . . . *Landlord* Robt. Maissone mt. *Tennants* Robt. Maissone forsaid the topmost house within the easter turnpike on the former stair head *Maill* 66. 13. 4. *Anuitie* 2. 17. 10. George Jamesone painter the second hous within the former turnpike *Maill* 66. 13. 4. *Anuitie* 2. 17. 10. Clement Tours a heigh hous on the former stairwhead east side thereof east of the joyning the former turnpike foote there *Maill* 40. –. –. *Anuitie* 1. 14. 8. Mongo Burrell a laiche fore hous with a little Shop above east of & joyning under the former staire foote *Maill* 26. 13. 4. *Anuitie* 1. 3. 2. John Harvie a laiche fore Sellar east of & joyning the former fore laiche hous with two heigh forebooths there above *Maill* 70. 13. 4. *Anuitie* 3. 1. 3.'
ER, Extent Roll for 1635.

### 43. *13 May 1635*
Consideration by the Council of Aberdeen of a petition by George Jamesone 'that for sameikle as a greate pairt of the Playfeild belongeing to the toune whair comedies were wont to be actit of auld besyde the well of Spa, is spoilled, brockin, and cariet away be speat and inundation of watter, . . . the said George tacking notice of the tounes prejudice heirin, and withall havand consideratioun how this little plott of ground may be vsefull to the toune heirefter, out of his naturall affectioun to this his native citie, he is content wpon his awin chairges, not onlie to mak some fortificatioun to withstand the violence of speattis . . . bot lykewayes to mak some policie and planting within and about the said Playfeild for the publict vse and benefitt of the toune . . . humblie desyiring for this effect . . . libertie . . . to mak sic building, policie, and planting within and about the said plott of ground . . . to the effect the same may redound to the publict wse and benefitt of the toune. . . . he desyiris . . . that he may have a lease of this plott of ground . . .

during his lyftyme allanerlie, and eftir his deceas, he is content that the . . . councell . . . intromett thairwith, and apply the same in all tyme thaireftir in the publict vse . . . without any recompense to be sought be him, his aires' (etc.).

The lease is granted to Jamesone on these terms for a yearly payment (if asked) of 3s. 4d.
AR, Council Register, vol. 52¹, pp. 206ff. Printed in *Extracts from the Council Register of the Burgh of Aberdeen 1625–1642*, Scottish Burgh Records Society, 1871, pp. 74–6.

### 44.  *29 May 1635*

Instrument of sasine in favour of George Jamesone, of an annual feu-duty of £8 from a dwelling-house (foreland) pertaining to Jamesone 'in vico montis Scholaris ex Boreali parte eiusdem vici, Inter terram heredum quondam Thome Forbes de Rubislaw ex orientali ex vna, Terram aliquando Andree Howat et nunc Joannis Nwn ex occidentali partibus ab altera, Terram Interiorem quondam Andree Watson nunc vero . . . Magistri Thome et Davidis Melvillis versus Boream et communem viam regiam versus austrum'; and also a portion of a close pertaining to the two Melvilles, lying next to Jamesone's dwelling-house, 'et comprehendeñ Tres vlnas in Longitudine a muro posteriore dicte Terre anterioris, versus australe gabulum vulgo the south galbill predicte Terre Interioris', reserving free entry and exit to the Melvilles (or other possessors) to their dwelling-house: following on a procuratory of resignation, dated 22 May 1635, by the Rev. Thomas Melville, minister of Dyce, David Melville, burgess, and Jean Liddell, widow of Alexander Rutherford, former Provost (their procurator, Rev. Andrew Mylne, minister of Maryculter).

The dwelling-house is that described in 3 and 8(i) above.
AR, Register of Sasines, vol. xxxviii, fos. 324v.–325.

### 45.  *12 June 1635*

'12 Junij 1635 George Jamesone and Issobell Tosche ane sone his name Andro Bap: be docter Barroun Mr. James Sibbald Doctor of divinitie. Alexander Jaffray William Gordon James Tosche Alexander Gray Thomas Thomsone and Robert Skeine godfathers.'
GRO(S), Parochial Registers, Aberdeen, 168A, vol. 3, under date.

### 46.  *13 October [1635]*

Letter from George Jamesone in Edinburgh to Sir Colin Campbell. 'Richt Honorable,—I receawed the hundreth merkis fra this berar, for the quhilk I shall indewor to do your worship better service heirefter; and as for the picturis quhilk I am yeit to make I shall do all diligens to gett theam with the first occasione, bot it will be in Janvarij befoir I can begin theam, except that I have the occasione to meit with the pairties in the North, quhair I mynd to stay for tuo monethes; and if ether ther or heir I can be able to do yowr worship service, I shall be moist willing, and ewer to remane Yowr worships servand, George Jamesone
Edinburgh, 13 October.'
Quoted from Cosmo Innes (editor), *The Black Book of Taymouth with other papers from the Breadalbane Charter Room*, Edinburgh, 1855, p. 440, who places it in the year 1634: for reasons given in the main text (p. 30) it is here dated 1635. The original has not been traced.

### 47.  *— — 1635*

'Anno Domini 1635 Item, the said Sir Coline gave unto George Jamesone painter in Edinburgh, for king Robert and king David Bruyses, kingis of Scotland, and Charles the first, king of Great Brittane, France and Ireland, and his Maiesteis Quein, and for nyne more of the Queins of Scotland, thair portraits, quhilks ar sett up in the hall of Balloch, the soume of tua hundreth thriescor pundis.

Mair, the said Sir Coline gave to the said George Jamesone for the knight of Lochow's lady, and the first Countes of Argyle, and sex of the ladys of Glenvrquhay, thair portraits, and the said Sir Coline his awin portrait, quhilks ar sett up in the chalmer of deas of Balloch, ane hundreth fourscoir punds.'
Quoted from Cosmo Innes (editor), *The Black Book of Taymouth with other papers from the Breadalbane Charter Room*, Edinburgh, 1855, p. 77.

### 48.  *6 April 1636*

'Sexto Aprilis [1636] The quhilk day In presens of Johne Sincler deyne of gild and gild counsell Michaell Wryt Lawfull sone to James Wryt tailyeor citizen of Londoun enteris prenteis to George Jamiesoun paynter for fyve yeiris Conforme to thair Indentouris schawen & payit of entres silver—xxx sh.'

SRO, Burgh of Edinburgh Apprentice Register
1583–1647, under date. Listed in Francis J. Grant
(editor), *The Register of Apprentices of the City of
Edinburgh 1583–1666*, Edinburgh, 1906, p.
203.

### 49.  *23 June [1636]*

Letter from George Jamesone in Edinburgh to
Sir Colin Campbell. 'Richt honorable, I re-
ceawed yowr worships letter with ane measure
concerning the maiking of soume picturis,
quhairof sextine of theam ar set doune in not.
I will werie willinglie serwe yowr worship,
and my pryce shall be bot the ordinarie, since
the measure is just the ordinarie. The pryce qu-
hilk ewerie one payes to me, abowe the west,
is twentie merkis, I furnishing claith and coul-
leris; bot iff I furniss ane double gilt muller,
then it is twentie poundis. Thes I deal with all
alyk: bot I am moir bound to hawe ane gryte
cair of your worships service, becaus of my
gouid payment for my laist imployment. Onlie
thus your worship wold resolwe at quhois
charges I mist go throwe the countrey to maik
thir picturis, for all that are heir in town neidis
onlie yowr worships letter to theam to causs
theam sitt, and for theam quhois picturis I
hawe allreadie, I shall double theam, or then
giwe yowr worship the principall. So, leawing
this to yowr worships consideration and ansuer,
I shall ewer remaine, Your woirships willing
servand, George Jamesone.
Edinburgh, 23 Junii
Iff I begin the pictures in Julii, I will hawe the
sextine redie about the laist of September.'
Quoted from Cosmo Innes (editor), *The Black
Book of Taymouth with other papers from the
Breadalbane Charter Room*, Edinburgh, 1855, p.
440, who places it in the year 1635: for reasons
given in the main text (pp. 30–1) it is here dated
1636. The original has not been traced.

### 50.  *24 June 1636*

Letter from Archibald Campbell in Edinburgh
to Sir Colin Campbell. It is mainly on business
affairs and ends with a series of short notes,
including: 'Pleis yow receave the painteres
answer  As for newis we hawe none herie. . . .'

From the circumstances noted in the main text
(pp. 28–31) the painter whose answer is enclosed
must be Jamesone, and his letter 49 above.
SRO, GD 112/40/2.

### 51.  *18 August 1636*

'George Jamesoune and Issobell Tosche ane
sonne his name Alexander Bap: be doctor
Arthour Johnstoune  doctour Alexander Ross
James Smythe  William Andersoune  James
Andersone and Mr. Adam Andersoune god-
fathers.'
GRO(S), Parochial Registers, Aberdeen, 168A,
vol. 3, under date.

### 52.  *23 January 1638*

Assignation and discharge of reversion by Mr.
Robert Gordon of Straloch, in favour of his
second son John Gordon, of a letter of reversion
containing 14,000 merks made by John Gordon
of Buckie in favour of Mr. Robert Gordon upon
the redemption of the lands and towns of Fechil
(described in 35 above), dated 26 May 1618; also
assigning the right of redemption of the lands
from 'Johne Gordoun of Hiltoun eldest laufull
sone and appearand air To the said Johne
Gordoun of Buckie . . . or frae the handis of
George Jamesone painter burgess of Aber-
dein . . .'. Presented for booking in the Register
of Sasines by Straloch's son, Mr. James Gordon,
on 8 March 1638.
SRO, Particular Register of Sasines, Aberdeen,
vol. 11, fos. 3v.–5.

### 53.  *20 and 27 July 1638*

'20 Julij 1638, Fryday  This day William [*sic*]
Jamesoun, painter, (at the ernest desyr of my sone,
Mr. Alexander,) was sufferit to draw my pictur.'
'27 Julij 1638  Item, a second draucht be
William [*sic*] Jamesoun.'
Quoted from *A Diary of the Public Correspon-
dence of Sir Thomas Hope of Craighall*, Bannatyne
Club, 1843, pp. 75–6. The quotation has been
checked against the original diary belonging to
Sir Archibald Hope, Bt., and is correct.

### 54.  *6 February 1639*

'George Jamesone and Isobell Tosche ane dochter
hir name Elizabeth Bap. be doctor Baroune  Mr.
Thomas Gray  George Morissone  Lait bailzies
Williame Cutberd  Richart Alexander  Johne
Ingrame and James Farquhar godfathers.'
GRO(S), Parochial Registers, Aberdeen, 168A,
vol. 3, under date.

### 55.  *20 March 1639*

'The Samen day Doctoris Williame Johnstoune

and George Moresoun ar chosin commissionares to pass to the Nobilitie of the Covenant conveinit at Montrois and to capitulat with thame vpoun sic articles as shalbe gewin in commissioun to the said commissionares anent the repairinge of thair armie to this burghe, As lyikwayes to confer be the way with the Erll Marshall wpoun the same busienis that his lordship wald be pleased to contribute his assistance to the saidis commissionares for the peace and quyett of this Toune and George Jamesoun is appoyntit to accumpanie and assist thame in the said commissioun quhilk is gewin to the effect following Viz to petition and desyre the Nobilitie that thay send in a peaceabill maner ane hundreth men at the most for holding of thair committie in the auld college and publicatioun of the actis of the generall assemblie in the cathedrall kirk of this diocis, and if the College and Cathedrall kirk be not made patent to thame for that effect To declair wnto thame that thay salhawe oure Paroche kirk patent for the said Intimatioun The Nobilitie alvayes keipand thameselffis and thair forces als far distant frome this burghe as the Marqueis of Huntlie sall do with his forces.'
AR, Council Register, vol. 52[1], p. 452. Printed with minor variations in *Extracts from the Council Register of the Burgh of Aberdeen 1625–1642*, Scottish Burgh Records Society, 1871, pp. 151–2.

### 56. 19 May 1640
Instrument of renunciation by George Jamesone, with consent of Isobel Tosche, in favour of John Gordon (second son of Mr. Robert Gordon of Straloch), of the town and lands of Fechil (described in 35 above), in terms of a contract of wadset, dated 26 October 1633, by John Gordon of Buckie as principal and John Gordon of Hiltoun as cautioner and with consent of Mr. Robert Gordon of Straloch, to George Jamesone of John Gordon of Buckie's wadset right of the town and lands of Fechil for 14,000 merks; John Gordon, Straloch's son, being assignee to a letter of reversion containing 14,000 merks in terms of a contract of alienation and wadset, dated 26 May 1618, by Mr. Robert Gordon of Straloch with consent of Katharine Irvine his wife, to John Gordon of Buckie.
SRO, Particular Register of Sasines, Aberdeen, vol. 11, fos. 426–8.

### 57. 19 May 1640
Renunciation by Isobel Tosche, wife of George Jamesone painter in Aberdeen, of 'all richt and titill aither of conjunctt sie Lyfrent tearces or wther richt & titill quhatsumevir' in the town and lands of Fechil, wadset by Mr. Robert Gordon of Straloch to John Gordon of Buckie under reversion of 14,000 merks, which wadset right John Gordon of Buckie disponed to George Jamesone under reversion of the same sum.
Records of the Sheriff-Clerk, Aberdeen, Minute Book of Judicial Enactments 1638–1648, under date.

### 58. 10 June 1640
'Vpon the tent of Junij ... wes holdin ane counsall of warr in the tolbuith of Abirdein, be Marschall and Monro, and thair complices. Thair wes brocht befoir thame the lairdis of Culter, Ochterellon, Burnet of Campbell, Gordoun of Nethermvre, Irving of Fornet ... Thomas Nicolsone, George Johnstoun, George Moresoun, George Jamesoun, Georg Gordon, Robert Forbes, Mr. Alex[r] Reid, Dauid Rikard, and William Patrie, tounes men and burgessis of Abirdein ... [who were] accusit for thair outstanding, and being contrarie myndit to the good causs. Thay maid thair owne ansueris, bot wes not weill hard. ...

Vpone the morne thay took thair leive from Abirdein ... gairdit and convoyit be soldiouris as throtcutteris and mvrtheraris. ... The first nicht thay cam to Cowy, and sua furth to Edinbrugh. ...

Howsone thay cam to Edinbrugh, thay war all wairdit in the tolbuith, and schortlie our tounes men ar first brocht in befoir the Tables. Thay ar accusit as contrarie to the good causs. Thay maid there owne ansueris, whiche wes not weill hard, quhairvpone thay ar committit agane to waird. ...'

After separate examination of the five lairds, 'all wes forsit to stay during the space of six monethis ... with gryte charges and expenssis. At last it pleissit the estaites to fyne thame as follouis; ... Thomas Nicolsone ... 2000 merkis, George Johnstoun 1000 pundis, Robert Forbes 1000 lib., Dauid Rikard 1000 merkis, William Patrie 1000 merkis, George Morisone and George Jamesone be moyan wan frie, and payit no fyne, George Gordoun 1000 merkis. Mr. Alex[r] Reid, ... 2000 merkis, ...' (The lairds' penalties follow.)
John Spalding, *Memorialls of the Trubles in*

*Scotland and in England 1624–1645*, Spalding Club, 1850, vol. i, pp. 284–5. Spalding, a contemporary observer from an Aberdonian and episcopalian viewpoint, and usually specific, is confused on the outcome of this event. He writes later (op. cit., p. 352): 'The lairdis of Watertoun, Ochterellon, with sum vtheris, Thomas Nicolsoune, Robert Forbes, alias Dobrie, George Jamesoun, burgessis of Abirdein, cums hame about the 4th of November, efter payment of there fynes.' Later still, Spalding (op. cit., p. 355) states that about 21 November Johnstone, Morison, Rickard, and Petrie were released on payment of fines, Morison's being of 1000 merks. The evidence of 59 below suggests that Spalding's first account is the correct one: Morison may, however, have paid a fine.

59. (i) *11 June 1640*
Letter from the Council of Aberdeen to the Council of Edinburgh. 'It hes pleased the erll Marishall and generall Maior Monro to select some of our nightbors and fellow citizens and summarlie without any accusation . . . to charge thame to go south and compeir befoir the tables. . . . As for thair bygane careage in the commoun caus Our commissionar of parliament there present can informe you sufficientlie. . . . we have made bold to entreat . . . that ye will contribute your best assistance with our commisionar for thair liberation. . . .'
Quoted from Louise B. Taylor (editor), *Aberdeen Council Letters*, vol. ii, London, 1950, pp. 212–13.
(ii) *11 June 1640*
Letter from the Council of Aberdeen to Alexander Jaffray, Commissioner to Parliament (ibid., pp. 213–14). 'The berares heirof our kynd and loving nichtbors being convenit yisterday befoir the Earle Marischall and Generall Maior Monro . . . wer chargit to go south this day to the Tables . . . and ar presentlie at the wreitting heirof preparing thame selffis for thair journey Ye know thair bygane cariage And that all of thame subscryvit the covenant in aprill 1639 . . . these ar to entreat yow that ye will contribute your best help . . . for thair good and releiff. . . .'
(iii) — *August 1640*
Instructions (first in a list) from the Provost and four bailies of Aberdeen to Alexander Jaffray, Commissioner to the Estates (ibid., p. 224). 'Imprimis deall with the committee of estait as effectuallie as possibilie ye can in favor of our

nightbors that ar lying in ward within the tolbuith of Edinburgh. . . .'
(iv) *29 October 1640*
Instructions from the Council of Aberdeen to William Moir, Commissioner to the Estates (ibid., p. 247). '. . . When ye salbe at Edinburgh advyse with your freyndis [MS. faded] Mr. Johne Cheyne be what meanes ye may procure liberatioun of our nightbors frome ward upoun the best conditiounes ye can. . . .'
(v) *13 November 1640*
Instructions from the Council of Aberdeen to Patrick Leslie, Commissioner to Parliament (ibid., p. 253). '. . . Item ye ar to use your best moyen with the estates of parliament for liberation of our nightbors out of ward furth of the tolbuith of Edinburgh for sic reasons as thay thame selffis will shaw to your lordship and as ye can furnishe your selff. . . .'
(vi) *22 November 1640*
Letter from Patrick Leslie to the Council of Aberdeen (ibid., p. 257). '. . . Al our nightbors in ward ar weill and thay stay in on serimonies.'
(vii) *1 December 1640*
Letter from Patrick Leslie, Provost and Commissioner to Parliament, to the Council of Aberdeen. (This is not quoted from the version printed in *Aberdeen Council Letters*, which contains substantial mis-readings, but from the original: AR, Letters from 1634 to 1644 (vol. 2), no. 208.) '. . . our nightbours hes it in ther wils to come furth quhen thay pleas, for that feild [*feid*, meaning a quarrel or feud, or perhaps a trial] was to gin yister night at aught at night, both in heat & suet, bot god be thanked we ended fair without blood, sum ar stifer nor others, & so al ther decreits ar not alyk, Georg Morrison hes libertie to stay in Edinburgh til the 22 off this munth & then to compon [*compone*, to settle or compound] or reenter, George Jemison hes libertie to goe quhair he pleaseth til a new sitation, on aught days, George Jonstoun is fynd til 1000 lib. William Pettrie & Dauid Rickard ar fynd ich off them in 1000 merks quhich I think thay sal pay this day, This is al I culd doe altho thay had bein my neirest kinsmen bot I mynd this day to mak a new onset for them.'

60. — — *1641*
'The Roll Delinquents, 1641.' The roll contains 222 names. It includes the Marquesses of Huntly

and Douglas and the Earls of Tullibardine, Carnwath, Stirling, Traquair, Airth, Linlithgow, Crawford, Airlie, and Nithsdale. It also includes the 'pretendit' Bishops of Brechin, Edinburgh, Aberdeen, Ross, Glasgow, Galloway, and Moray. There are many minor barons, knights, and lairds, the latter including all those in Spalding's list except Ochterellon. Aberdeen is the only burgh mentioned by name and eighteen burgesses are specified, including those in Spalding's list with the exception of Nicolson, Gordon, and Reid: also included is 'George Jamesone paynter', which is the only specification of trade in the document.

P. Hume Brown (editor), *The Register of the Privy Council of Scotland, 1638–1643*, Edinburgh, 1906, Second Series, vol. vii, pp. 511–13.

### 61. *13 September 1641*

'Charge off Buriall siluer . . . George Jamesoun ane bairne buried 3 lib.'

This and 62 below must refer to Andrew and Alexander (see 45 and 51).

AR, Kirk & Bridge Works Accounts 1571–1670, under date.

### 62. *5 October 1641*

'Chearge of the buirells within the kirk . . . Octo: 5 Ane berne of George Jamesonis 3.'

AR, Kirk & Bridge Works Accounts 1571–1670, under date.

### 63. *8 October 1641*

'George Jamesone and Isobell Tosch ane dochter namitt Isobell Bap. be Mr. William Robertsone Mr. Alexander Meingzies Georg Mengzies Mr. Jon Alexander and Mr. Adame Andersone godfathers.'

GRO(S), Parochial Registers, Aberdeen, 168A, vol. 3, under date.

### 64. *5 November 1641*

Instrument of sasine in favour of George Jamesone, painter burgess of Edinburgh (his attorney, Robert Alexander), following on resignation by Mr. Alexander Davidson as procurator for James Tosche, merchant burgess of Aberdeen, in terms of a procuratory of resignation contained in letters of disposition dated 20 October 1641 at Leith, of a dwelling-house (foreland) 'per dictum Jacobum Toshe pro presenti occupat . . . in vico Lemurum ly Gestraw nuncupat ex

occidentali parte eiusdem vici Inter terram quondam Gulielmi Wormett, nunc vero heredum quondam Joannis Howyson ex australi ex vna, Terram quondam Davidis Porter nunc vero heredum quondam Georgii Pacok ex Borealis partibus ab altera Terram Interiorem quondam Gulielmi Vrquhart postea quondam Joannis Ray et nunc Andree Birny versus occidens et communem viam regiam versus oriens'; to be held in free burgage, paying yearly 7 merks to the Provost of Aberdeen. The witnesses include Mr. Adam Anderson, son of John Anderson, painter burgess of Aberdeen.

AR, Register of Sasines, vol. xxxix, fo. 179–179v.

### 65. *7 June 1642*

Contract of wadset by which Robert Mason, carver in Edinburgh, son of the late Robert Mason, merchant burgess of Edinburgh, wadsets to John Dawson, tailor burgess of Edinburgh, for 3,000 merks, a foretenement of land acquired by his late father from the late John Landis and Helen Crawford and which previously pertained to the late Archibald Primrose, writer, 'Lyand within . . . Edinburgh one the Northe syde of the street thairof neer the Nethirbow, betwix the land of umquhill Robert Hendersone one the eist The Landis of vmquhill Jon Turnor one the west, The Kingis street one the southe and the Landes perteneing to vmquhill Jon Foullis one the Northe pairtis'; excepting the liferent right of Jean Kellie (or Kello), mother to Robert, 'off the lodgeing of the said foretenement quhilk is possest be George Jamesone painter . . .'.

Other tenants of the foretenement are 'Clemens Touris glasenwricht Thomas Quhyte armorar and David Fergussone merchand burgess of Edinburgh', while Dawson leases 'the heiche house of the said foretenement'.

ER, Moses Bundle 23, no. 950.

### 66. *6 September 1643*

Date of charter granted by Gilbert, Earl of Erroll, with consent of John, Earl of Kinghorne, at Huntly, to George Jamesone, of the lands of mains of Esslemont and half-lands of Bourhills. The source of this date is 67 below.

### 67. *12 September 1643*

Instrument of sasine in favour of George Jamesone, painter burgess of Edinburgh, of the lands of mains 'de Essilmont . . . pro presenti per

Gilbertum Johnstoune ... occupa�049 sunt cum maneriei loco turre fortalicio hortis pomariis et pertineñ ejusdem necnon de tota et integra illa dimidietate ville et terrarum de Bowrehilles pro presenti per [blank] Lidgertwood ... occupaͭ ... Jaceñ infra barroniam de Essilmont et infra vicecomitatum de Aberdein', following on a precept in a charter, dated 6 September 1643, at Huntly, granted by Gilbert, Earl of Erroll, with consent of his tutor, John, Earl of Kinghorne (their bailie, Mr. John Alexander, advocate); the lands to be redeemable from Jamesone on payment of 16,000 merks, redemption being suspended until 1648. SRO, Particular Register of Sasines, Aberdeen, vol. 12, fos. 514v.–516v.

### 68.   17–23 July 1644

'[The said day George Ja]mesone and Issobell Tosch ane daughter nam[ed Mary baptized be Mr.] Johne Row  Mr. John Gregorie  Mr. Tho[mas ?Gray  ?Thomas Car]gill  Thomas Melling  James Tosch  Alexander Alsch[ioner      ]  Gilbert Skeyne Godfathers.'

The parts within square brackets have been torn away and are replaced here largely from the evidence of other parts of the register which concern Jamesone: on the evidence of 54 and 63, and the names of Jamesone's daughters in 69 and 71, as well as the fact that Marjory was married before 1645 (see p. 23), the child here must be Mary.
GRO(S), Parochial Registers, Aberdeen, 168A, vol. 3, under date.

### 69.   11 December 1644

Date on which Marjory, Isobel, and Mary Jamesone were served heirs to the late George Jamesone their father, in the lands of mains of Esslemont and half-lands of Bourhills, at the Sheriff Court of Aberdeen. The source of this date is 70 below.

### 70.   4 January 1645

Instrument of sasine in favour of Marjory, Isobel, and Mary Jamesone (their procurator, Thomas Martin in Esslemont), daughters and heirs of the late George Jamesone, burgess of Edinburgh, in the lands of mains of Esslemont and half-lands of Bourhills (described in 67 above), following on a retour of general service, obtained in the Sheriff Court of Aberdeen on 11 December 1644, proving their character as

'legitimae et propinquiores heredes dicti quondam Georgii Jamesone eorum patris', in the said lands: and a precept of *clare constat* by Gilbert, Earl of Erroll, with consent of his tutor, John, Earl of Kinghorne, dated [blank] 1644, at Glamis and [blank]; the lands to be redeemable on payment of 16,000 merks, in terms of a contract between Erroll, with consent of Kinghorne, and the late George Jamesone.
SRO, Particular Register of Sasines, Aberdeen, vol. 13, fos. 173v.–175.

### 71.   6 January 1645

Instrument of cognition and sasine in favour of Elizabeth, Isobel, and Mary Jamesone (their procurator, Mr. John Alexander, advocate in Edinburgh), daughters and coheirs of the late George Jamesone, painter burgess of [blank], in (i) the dwelling-house (foreland) described in 64 above; in (ii) the dwelling-house (foreland) described in 21 above; and in (iii) the dwelling-house (foreland) described in 3, 8(i), 10, and in the second part of 18 above.
AR, Register of Sasines, vol. xl, under date.

### 72.   15 January 1645

Agreement by the Council of Aberdeen, following on the assent of the inhabitants given on 7 January 1645, to a 'supplication gevin in be Mr. John Alexander, advocat in Edinburgh, makand mention that quhair that peice of ground callit the Playfeild, besyd the Womanhill (quhilk wes set to vmquhill George Jameson, painter, burges of Edinburgh, in liferent, and buildit be him in a garden), is now vnprofitable, and that the said Mr. John Alexander, son-in-law to the said vmquhill George, is desyreous to have the same peice of ground set to him in feu heretable ...': a feu-charter to be expede in favour of Alexander, of the garden, for payment of an annual feu-duty of £4.
AR, Council, Baillie, and Guild Court Book (Council Register), vol. 53, p. 36. Printed in *Extracts from the Council Register of the Burgh of Aberdeen 1643–1747*, Scottish Burgh Records Society, 1872, p. 40.

### 73.   12 September 1645

'The charge of the colections of the buriells in the kirk [from Michaelmas 1644 to Michaelmas 1645] 12 September  Ane chyld of Geo. Jamesons 3 — —.'

This almost certainly refers to Elizabeth.
AR, Kirk & Bridge Works Accounts 1571–1670,
under date.

**74.  2 January 1650**
Disposition by George Mason, merchant burgess
of Edinburgh, heir of provision to his brother
the late Robert Mason, carver, of the foretene-
ment described in 65 above, to John Pollock,
cordiner burgess of Edinburgh, reserving the
liferent right of Jean Kello (or Kellie), mother to
George, 'of the ludgeing of the said foretene-
ment sumtyme possest be vmquhill George
Jamiesone painter . . .'.
ER, Moses Bundle 32, no. 1300.

**75.  15 September 1653**
Instrument of sasine in favour of Marjory and
Mary Jamesone (their procurator, Mr. John
Alexander, advocate in Edinburgh, husband of
Marjory and tutor to Mary), daughters and heirs-
portioner of the late George Jamesone, painter
burgess of Edinburgh, in the dwelling-house
(foreland) described in 64 above, following on a
retour of general service, dated 13 September
1653, proving their character as 'neirest and
laufull coairs portioners of the said deceast
George Jamesoun thair faither' in the said
dwelling-house; followed by an instrument of
sasine and conjunct infeftment in favour of
John Ord, merchant, and his wife Catherine
Dun, of the said dwelling-house, following on a
disposition containing a procuratory of resigna-
tion, dated 31 May 1653, by Marjory and Mary
Jamesone, Mr. John Alexander, and James
Tosche.
AR, Register of Sasines, vol. xlii, fos. 202v.–203.

**76.  17 July 1655**
Instrument of sasine and conjunct infeftment in
favour of Alexander Kemp, mason in Aberdeen,
and his wife Bessie Hill (their procurator, Dr.
William Guild), of a 'tenement or hous of old
vaist and without ane inhabitant pertaineing
sumtyme to the deceast Andro Reid of Colli-
soune And therefter conquest from him and
reedified be the deceast Patrik Forbes burges of
Aberdein and therefter acquirit from the said
deceast Patrik be the deceast Andro Jamesoun
meassoun and therefter belonging to . . . George
Jamesoun as sone & air to him Lyand within the
said burghe of Aberdein vpoun the south syd of

the Scoollhill street of the samen neir to the kirk
styll and entrie to the churchyard of Sainct
Nicolas church of the said burghe vpoun the
west syd of the said styll Betuixt the land of the
comunitie of the said burghe which wes of old
vaist wpoun the west The said kirk yard vpoun
the south and the comone hie streets wpoun the
north and eist partis therof now possest be
Elspet Chalmer relict of the deceast Gilbert
Buchane of Robstan', following on a disposition
containing a procuratory of resignation, dated
[blank], by Marjory and Mary Jamesone and Mr.
John Alexander, husband of Marjory and tutor
to Mary (their procurator, Mr. John Kennedy
of Aberdeen).
This is almost certainly the house described
in 8(ii), 9, 17, and the first part of 18 above,
though the house to the west is not included in
the description.
AR, Register of Sasines, vol. xliii, under date.

**77.  16 February 1656**
Instrument of sasine in favour of Marjory and
Mary Jamesone (their procurator, John Ligert-
wood in Bourhills of Esslemont), 'tua douchters
& aires portioners of the deceist George Jame-
sone painter burgess of Edinburgh, and . . . the
onlie tuo laufull sisters and aires portioner of the
deceist Issobel Jamesone thair third sister', of a
third part of the lands of mains of Esslemont and
the half-lands of Bourhills (described in 67
above), following on a precept of *clare constat*
containing a precept of sasine, dated 14 February
1656, at Slains, by Gilbert, Earl of Erroll:
infeftment to be without prejudice to Erroll's
right of redemption contained in contracts
between him and the late George Jamesone, Mr.
John Alexander and Marjory and Mary Jame-
sone.
SRO, Particular Register of Sasines, Aberdeen,
vol. 18, fos. 200–201v.

**78.**  On the following dates George Jamesone is
recorded as a godfather at baptisms in Aber-
deen. The frequency of these duties was not
especially unusual for an eminent townsman;
the number of godfathers normally ranged from
four to six. (1) 9 August 1628. (2) 27 December
1628. (3) 10 January 1629. (4) 24 January 1629.
(5) 16 February 1629. (6) 2 January 1630.
(7) 12 June 1630. (8) 30 October 1630. (9) 19
November 1630. (10) 12 February 1631. (11) 21

February 1631. (12) 13 August 1631. (13) 20 October 1631. (14) 11 November 1631. (15) 10 January 1632. (16) 3 June 1632. (17) 23 October 1632. (18) 6 December 1632. (19) 13 December 1632. (20) 24 January 1633. (21) 24 January 1633. (22) 21 September 1633. (23) 1 October 1633. (24) 16 November 1633. (25) 12 January 1634. (26) 14 April 1634. (27) 6 May 1634. (28) 13 May 1634. (29) 10 November 1634. (30) 20 November 1634. (31) 15 April 1635. (32) 18 May 1635. (33) 3 June 1635. (34) 18 November 1635. (35) 19 January 1636. (36) 26 January 1637. (37) 22 August 1637. (38) 26 November 1637. (39) 5 ` December 1637. (40) 30 December 1637. (41) 7 February 1638. (42) 5 November 1638. (43) 15 November 1638. (44) 17 December 1638. (45) 15 February 1639. (46) 26 August 1639. (47) 2 September 1639. (48) 12 September 1639. (49) 18 September 1639. (50) 2 October 1639. (51) 10 October 1639. (52) 26 October 1639. (53) 14 November 1639. (54) 1 May 1640. (55) 13 March 1641. (56) 3 February 1642. (57) 11 March 1642. (58) 4 October 1642. (59) 20 December 1642. (60) 19 January 1643. (61) 30 January 1643. (62) 6 October 1643. (63) 7 October 1643. (64) 10 November 1643. (65) 14 December 1643. (66) 20 December 1643.

GRO(S), Parochial Registers, Aberdeen, 168A, vol. 2 (1–9), vol. 3 (10–66).

79. Jamesone was addressed or mentioned in contemporary verse on at least five occasions, three of the poems being published during his lifetime and one immediately after his death. That by William Forbes does not appear to have been printed.

He is mentioned incidentally (but significantly) in David Wedderburn's *Vivat Rex* published by Edward Raban at Aberdeen in 1633: the relevant lines are quoted in the commentary following entry 65 in the Catalogue. His name occurs again in Arthur Johnston's 'Aberdonia Nova', published in his complete poems at Middelburg in 1642: the lines are quoted at page 4 above. The remaining three poems, addressed to Jamesone, are given here, with a translation of the latest.

(a) Ad Iamisonum Pictorem, de Anna Cambella Heroina

Illustres, ars quotquot habet tua, prome colores,
    Pingere Cambellam si, Iamisone, paras
Frons ebori, pectusque nivi, sint colla ligustris
    Aemula, Paestanis tinge labella rosis.
Ille genis color eniteat, quo mixta corallis
    Marmora, vel quali candida poma rubent.
Caesaries auro rutilet: debetur ocellis
    Qualis inest gemmis, sideribusque nitor.
Forma supercilii sit, qualem Cypridis arcus,
    Vel Triviae, leviter cum sinuatur, habet.
Sed pictor suspende manum; subtilius omni
    Stamine, quod tentas hic simulare, vides.
Cedit Apollineo vulsus de vertice crinis,
    Cedit Apellea linea ducta manu.
Pinge supercilium sine fastu, pinge pudicos
    Huic oculos, totam da sine labe Deam:
Vt careat naevo, formae nil deme vel adde,
    Fac similem tantum, qua potes arte, sui.

*Epigrammata Arturi Ionstoni Scot, Medici Regii*, Aberdeen, 1632, pp. 20–1. Reprinted (with minor variations) with a summary translation by Sir William Geddes (editor), *Musa Latina Aberdonensis*, vol. ii, New Spalding Club, 1895, pp. 44–5.

(b) Ad Iamisonum pictorem De Nobiliss. et clarissimo
D Joanne Scoto Scototaruatio etc.

### Epigramma

Siste manum pictor vanissime, tolle Colores.
    Pingere Taruatii qui Jovis ora paras.
Pinge tuo Bromium minio; pigmentaque miscens
    Finge Cytheriacas qua potes arte genas.
Saepe sub hoc fuco vitium Latet; Inclyta Virtus
    Emicat, externis incomitata bonis.
Ipsa tamen testes gaudet sibi iungere Musas
    Vtque diu viuat ore Canentis eget.
Pictor abi, tibi nam Laudis spes omnis adempta est,
    Maeonia pingi debuit ille manu.

### Aliud

Creditur huic tabulae patriae Lux prima: Senatus
    Grande decus: phoebi pieridumque parens.
Disce viri ingenium vultu, conspirat in illo
    Ardua maiestas, Gratia, Celsus Honos.
Non pictoris opus fuit hoc, depingere Scotum
    Ars nequit: haec Charitum picta tabella manu est.

### Aliud

Non manus artificis tantum confudit in vno
    Ore decus; pictor pone supercilium,
Scilicet in tabulam diuinae mentis Imago
    Dum fluit; est Sancti pectoris illud opus.

### Aliud

Ora vides Scoto, nec non Communia phoebo,
    Scilicet os idem seruit vtrique Deo.
Pulsus ab Ascraeo nam pridem Cynthius antro,
    Pro templo Scoti pectora Sancta colit.

### Aliud

Ora vides Scoti, Sed quae sibi vendicat Hermes,
    Dum Libet, Hoc Homines flectit, et ore Deos

                  Vilhelmus Forbesius

The poem is preceded by a Latin letter addressed to Sir John Scot of Scotstarvet, Director of Chancery, which begins: 'Lusus hos poeticos (Nobilissime Heros) ad Jamisonum pictorem et remittentis se subinde animi Honesta excercitia tibi offero, . . .' It is dated 21 June 1642.
National Library of Scotland, Adv. MS. 17.1.9 ('Letters from Learned Men to Scotstarvatt'), fo. 8–8v.

### (c) Sub Obitum Viri Spectatissimi, Georgii Jamesoni, Abredonensis, Pictoris Eminentissimi,

### *Lachrymae*

Gentis Apollo suae fuit ut Buchananus, Apelles
Solus eras Patriae sic, Jamesone, tuae.

Rara avis in nostris oris: Tibi mille colores,
    Ora tibi soli pingere viva datum.
At Te nulla manus poterit sat pingere; nempe
    Lampada cui tradas nulla reperta manus.
Quin si forte tuas vatum quis carmine laudes
    Tentet, id ingenii vim superabit opus.
Quicquid erit, salve pictorum gloria, salve:
    Aeternumque vale Phosphore Scotigenum:
Phosphore, namque tua ars tenebris prius obsita caecis,
    Fors nitidum cernet Te praeeunte diem.

### Tumulus Ejusdem

Conditur hic tumulo Jamesonus Pictor, & una
    Cum Domino jacet hic Ars quoque tecta suo.
Hujus ni renovent cineres Phoenicis Apellem;
    Inque urna hac coeant Ortus & Interitus.

### Ejusdem Encomium meritissimum

Si pietas prudens, pia si prudentia, vitae
    Si probitas, omni si sine labe fides;
Partaque si graphio Magnatum gratia, dotes
    Nobilis ingenii siquid honoris habent;
Si nitor in pretio est morum cultusque decori,
    Et tenuem prompta saepe levasse manu;
Aemula si Belgis Italisve peritia dextrae
    Artifici laudem conciliare queat:
Omne tulit punctum Jamesonus, Zeuxe vel ipso
    Teste; vel hoc majus Graecia si quid habet.

*Amoris indissolubilis ergo*
*DAVID WEDDERBURNUS.*

Ad Exemplar Abredoniae Impressum per *Edwardum Rabanum,* 1644
Aberdeen University Library.

On the death of that most illustrious gentleman, George Jamesone
of Aberdeen, the eminent painter,

### A Lament

As Buchanan was the Apollo of his race, so, Jamesone,
    you alone were the Apelles of your native land.
Rare bird within our shores: to you an infinitude of colours
    was granted, to you alone, to paint the features as in life.
But no hand will adequately depict you; indeed no hand
    has been found to which you can pass on the torch.
And if any poet should attempt your praise in verse,
    your achievement will overpower his genius.
Yet howsoever that may be, hail thou pride of painters,
    hail: and farewell for ever, Morning-star of Scotia's sons:
Morning-star, for your art which hitherto lay in darkness
    shall happily see the bright day with you to show the way.

## His Tomb

Here in this tomb lies Jamesone the painter,
    and with her master, here lies Art.
Let not the ashes of this Phoenix give in birth another
    Apelles, but in this urn let birth and death be as one.

## A most deserved Eulogy

If there is wise devotion and devout wisdom, if there
    is righteousness and honour without stain;
if there is gratitude assured for the pencil of the great,
    if the talent of a noble mind command any honour;
if there is esteem for nobility of character and propriety
    of conduct, and for succour given with a ready hand;
if the skill of a hand that emulated the Flemings
    and Italians can win praise for an artist:
then, in all these Jamesone is supreme, as Zeuxis himself
    shall testify, or a greater, if there is such in Greece.

# APPENDIX A

EXAMINATION in the Research Laboratory of the National Museum of Antiquities of Scotland of paint samples from the *7th Earl Marischal* (Catalogue, 94; Plates 95–7).[1] See above, pp. 53–4.

The paint samples were examined in an attempt to identify the paint binder used by Jamesone—oil, glue, egg, etc. The designations and weights of the samples were as follows:

1. White from highlight on collar: $2\frac{11}{16}$ in. from left, $9\frac{5}{8}$ in. from bottom. Approximate weight = 0·3 mg.

2. Grey from subject's right sleeve: $1\frac{3}{16}$ in. from left, $5\frac{7}{8}$ in. from bottom. Approximate weight = 0·5 mg.

3. Flesh colour from subject's right cheek: $10\frac{5}{16}$ in. from left, 1 ft. $6\frac{3}{4}$ in. from bottom. Approximate weight = 1 mg.

4. Grey from extreme lower edge: $7\frac{7}{8}$ in. from left. Approximate weight = 0·5 mg.

5. Brown from background: $3\frac{1}{2}$ in. from right, 1 ft. $6\frac{1}{4}$ in. from bottom. Approximate weight = 0·1 mg.

6. Ground: 10 in. from left, $1\frac{11}{16}$ in. from bottom. Approximate weight = 0·5 mg.

*Results.* The paint samples were examined using a combination of selective solvent extraction, hydrolysis, and thin layer chromatographic analysis.

The analyses showed oil to be present in all six samples, but did not permit a more precise identification of the particular oil or oils. Sample 6 (ground), which would be expected to be least degraded by atmospheric auto-oxidation, had many similar characteristics to an authentic sample of refined linseed oil examined at the same time.

Thin layer chromatographic analysis of the hydrolysate identified fatty acids and glycerol (the hydrolysis products of triglycerides present in oils), thus confirming the presence of oils.

Amino acids and monosaccharides, the hydrolysis products of proteinaceous materials and gums respectively, were not detected in the hydrolysates of the paint samples.

In conclusion, the laboratory examination revealed the presence of an unspecified oil or oils in all six samples, although in the case of sample 6 (ground), the oil could have soaked through from an upper paint layer. No evidence was found for the use of gum or proteinaceous material as a medium.

[1] Grateful acknowledgment is made to J. C. McCawley of the National Museum of Antiquities of Scotland for permission to publish the results of his investigations.

# APPENDIX B

A BRIEF list of portraits attributed to Adam de Colone, fl. 1622–8. See above, pp. 54–9.

1. *Alexander Seton, 1st Earl of Dunfermline* (1556/7–1622)
Canvas, 42 × 32½ in. Inscribed top left: *ÆTATIS. 66/1622.* Three-quarter length standing, to right; fringed curtains top left and top right. Copy of portrait by Gheeraerts dated 1610 (SNPG, no. 2176). *Collection.* Sold Christie's, 19 November 1965, lot 5 (bought Dent).

2. *James VI and I* (1566–1625)
Canvas: 79 × 49 in. Dated next to left arm: *1623.* Full-length standing, to right; fringed curtains on left. *Collection.* Marquess of Salisbury, Hatfield House.

3. *James VI and I* (1566–1625)
Canvas: 83½ × 54½ in. (Plate 28). Dated on right edge opposite left shoulder: *1623.* Same pattern as no. 2. *Collection.* Marquess of Lothian, Newbattle Abbey.

4. *James VI and I* (1566–1625)
Canvas: 43 × 32½ in. Half-length version of nos. 2 and 3. *Collection.* Edinburgh, Scottish National Portrait Gallery, no. 2172; formerly Somerville and Biddulph collections.

5. *James VI and I* (1566–1625)
Canvas: 43 × 33 in. Same pattern as no. 4. *Collection.* Lord Elibank, Sunningdale, Berkshire.

6. *Thomas Hamilton, 1st Earl of Haddington* (1563–1637)
Canvas: 41¾ × 32 in. (Plates 42 and 50 (detail)). Inscribed top left: *ÆTATIS. SVÆ. 61./1624.* Three-quarter length standing, to right. *Collection.* The Earl of Haddington, Tyninghame.

7. *Ian, Patrick, and James Campbell of Ardkinglas*
Canvas: 30 × 42 in. Inscribed by the subjects' heads, from left to right: *ÆTATIS. SVÆ. 9./1624; ÆTATIS. SVÆ. 10/1624; ÆTATIS SVÆ 4/1624.* Three-quarter lengths standing, Ian to right, Patrick and James to left. *Collection.* The Duke of Argyll, Inveraray Castle.

8. *John Fleming, 2nd Earl of Wigtown* (1589–1650)
Canvas: 45½ × 34 in. Inscribed top left: *ÆTATIS SVÆ. 36/1625.* Three-quarter length standing, to right. *Collection.* Lord Elphinstone, Drumkilbo.

9. *Margaret Livingston, Countess of Wigtown* (d. after 1634)
Canvas: 49½ × 40 in. Inscribed top left: *ÆTATIS SVÆ 30/1625.* Three-quarter length standing, to left. Companion to no. 8. *Collection.* Lord Elphinstone, Drumkilbo.

10. *George Seton, 3rd Earl of Winton* (1584–1645) *with two Sons, George and Alexander*
Canvas: 44½ × 33 in. (Plate 34). Inscribed by the subjects' heads: *ÆTATIS 40/1625; ÆTATIS. 5;*

*ÆTATIS*. 12. Father and elder son three-quarter length standing, father to right, son to left; younger son half-length standing, to right; fringed curtains top left and top right.
*Collection.* The Countess of Kintore, Keith Hall.

11.  *Anne Hay, Countess of Winton* (b. *c.* 1592) *with two children*
Canvas: 43¼ × 32½ in. Inscribed top left: *ÆTATIS* 33/1625. Inscribed (later) bottom left: *Jameson pinx/Alex! Pronepos restaur 1765.* Mother and elder child three-quarter length standing, to right; younger child half-length standing, to left; fringed curtains top left and top right. Probably companion to no. 10.
*Collection.* P. Maxwell Stuart, Esq., Traquair.

12.  *Anne Hay, Countess of Winton* (b. *c.* 1592)
Canvas: 43 × 33 in. Inscribed to left of head: *ÆTATIS* 33/1625. Same pattern as Countess in no. 11; fringed curtains top left and top right.
*Collection.* Edinburgh, Scottish National Portrait Gallery, no. 2173; formerly Somerville and Biddulph collections.

13.  *George Hay, 1st Earl of Kinnoull* (1572–1634)
Canvas: 45 × 34¾ in. (Plate 51 (detail)). Inscribed top left: *ÆTATIS.* 54/1625. Three-quarter length standing, to right.
*Collection.* P. W. Morris, Esq., Yester; formerly Tweeddale collection.

14.  *George Hay, 1st Earl of Kinnoull* (1572–1634)
Canvas: 43 × 32 in. Inscribed on right: *ÆTATIS* 5[?4]/162[?5]. Three-quarter length seated, to right; fringed curtains top left and top right. Closely related to no. 13. A version belongs to Lord O'Neill, Ahoghill, Co. Antrim (formerly Somerville collection).
*Collection.* Mrs. Drummond Hay of Seggieden.

15.  *Anne Cunningham, Marchioness of Hamilton* (d. 1647)
Canvas: 23 × 18 in. Dated to left of head: *1625.* Head and shoulders, to right.
*Collection.* The Duke of Hamilton, Lennoxlove.

16.  Called *Alexander Bruce of Alva* (*c.* 1583–1638)
Canvas: 43 × 33 in. Inscribed top left: *ÆTATIS SVÆ.* 43./1626. Three-quarter length standing, to right.
*Collection.* The Earl of Elgin, Broomhall.

17.  Called *Margaret Graham, Lady Napier*
Canvas: 43 × 32 in. Dated to left of head: *1626.* Three-quarter length standing, to right.
*Collection.* Gordon Heath, Esq., Tourrette-Levens, France; formerly Napier and Ettrick collection.

18.  *John Erskine, 2nd Earl of Mar* (1562–1634)
Canvas: 24 × 20½ in. Inscribed top left: *ÆTATIS. SVÆ.* 64./1626. Head and shoulders, to right.
*Collection.* Edinburgh, Scottish National Portrait Gallery, no. 2211.

19.  *James Erskine, 7th Earl of Buchan* (d. 1664)
Canvas: 24 × 20 in. Inscribed top left (strengthened): *ÆTATIS* 14./1627. Nearly half-length, to right.
*Collection.* The Earl of Mar and Kellie, Alloa.

20.  *George Seton, 3rd Earl of Winton* (1584–1645)
Canvas: 42½ × 32 in. Inscribed top left: *ÆTATIS* 42/1628. Three-quarter length standing, to right; fringed curtains top left and top right.
*Collection.* P. Maxwell Stuart, Esq., Traquair.

21.  Called *Margaret Kerr, Lady Yester* (*c.* 1570–1645)
Canvas: 26½ × 21 in. (Plate 41). Dated top right: *1628.* Head and shoulders, to left. Apparent age of sitter makes traditional identification impossible; appears to be companion to no. 22, and therefore

perhaps Tweeddale's sister (not his wife: he was widowed in 1627) Margaret Hay (*c.* 1592–1659), widow of the 1st Earl of Dunfermline.

*Collection.* Hugo Morley-Fletcher, Esq., Padbury, Buckinghamshire; formerly Tweeddale collection.

22. *John Hay, 1st Earl of Tweeddale* (1595–1654)
Canvas: $25\frac{7}{8} \times 21$ in. Inscribed to left of head: *ÆTATIS.* 33/1628. Head and shoulders, to right.
*Collection.* Hugo Morley-Fletcher, Esq., Padbury, Buckinghamshire; formerly Tweeddale collection.

23. *James Erskine, 6th Earl of Buchan* (d. 1640)
Canvas: $25 \times 20$ in. (Plate 49). Inscribed to left of head (scarcely visible): *ÆTATIS.* 26/162[?]. Head and shoulders, to right.
*Collection.* The Earl of Mar and Kellie (on loan to Scottish National Portrait Gallery, no. L 234).

# INDEX OF PAINTINGS BY JAMESONE

Numbers in **bold type** refer to Catalogue numbers: others to page- or Plate-numbers

## PAINTINGS

The principal biographical facts relating to the subject of a portrait will usually be found in the Catalogue entry, or occasionally where the portrait is discussed elsewhere in the text. References to the subject purely as an individual will be found in the General Index.

# COLLECTIONS

# PRINCIPAL FORMER OWNERS AND LOCATIONS

A few paintings which still remain in possession of the families for whom they were painted, or with whom they are historically associated, are referred to if there have been significant changes of name, title, or location.

# GENERAL INDEX

All numbers refer to page- or Plate-numbers

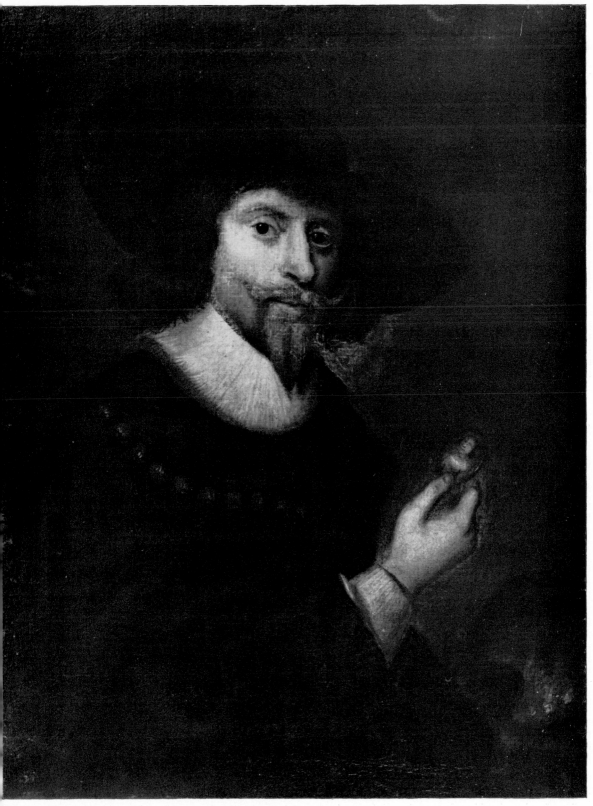

1. Jamesone: *Self-portrait, holding a Miniature, c.* 1637 (Catalogue, 111)

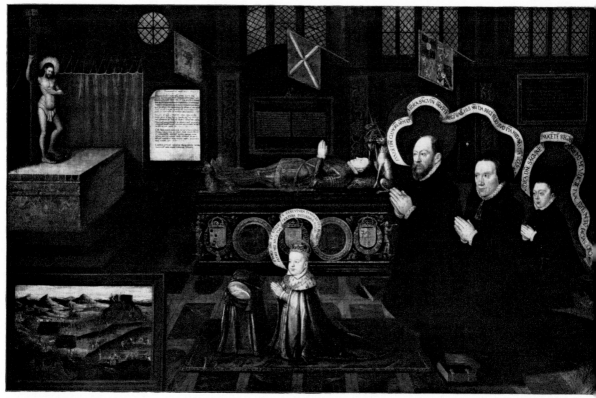

2. Lieven de Vogeleer: *The Memorial of Lord Darnley*, 1568. Holyroodhouse. Reproduced by gracious permission of Her Majesty The Queen

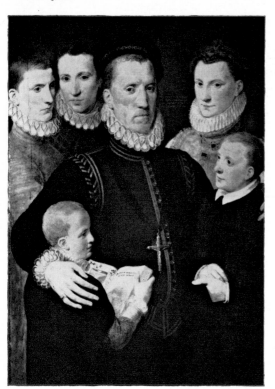

3. Frans Pourbus, the elder: *George, 5th Lord Seton and his Family*, 1572. Edinburgh, National Gallery of Scotland

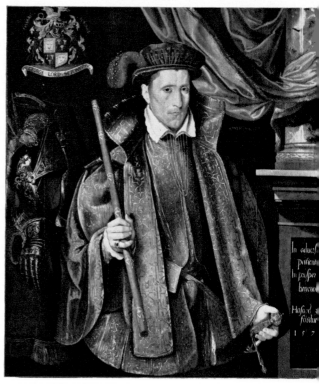

4. Unknown artist: *George, 5th Lord Seton*, c. 1570–9. Edinburgh, National Gallery of Scotland

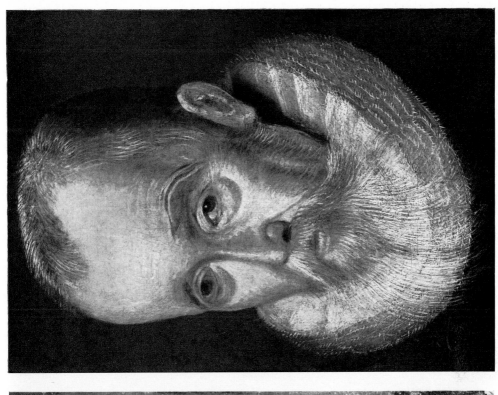

5. Arnold Bronckorst: *Oliver, 1st Baron St John of Bletso*, 1578. The Honble. Hugh Lawson Johnston

6. Unknown artist: *Thomas Hamilton of Priestfield*, c. 1610. The Earl of Stair

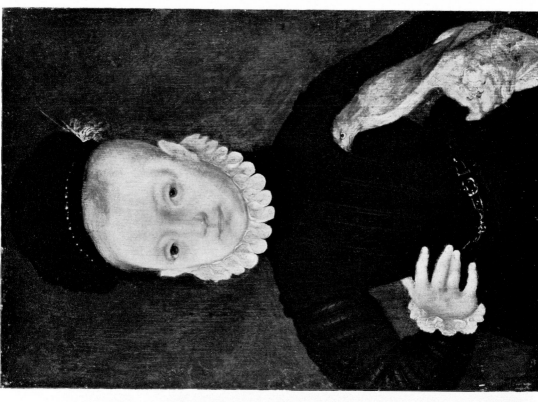

8. Attributed to Arnold Bronckorst: *James VI holding a Falcon. c. 1580.* Edinburgh, Scottish National Portrait Gallery

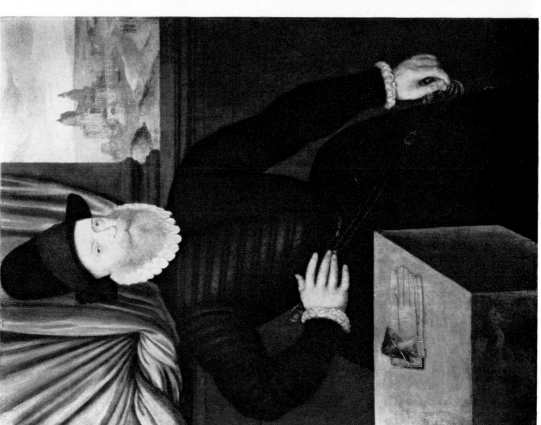

7. Attributed to Arnold Bronckorst: *James Douglas, 4th Earl of Morton, c. 1580.* Edinburgh, Scottish National Portrait Gallery

10. Perhaps after Adrian Vanson: *John Knox, c. 1579–80. Woodcut from Beza's Icones*

9. Perhaps after Adrian Vanson: *James VI, c. 1579–80. Woodcut from Beza's Icones*

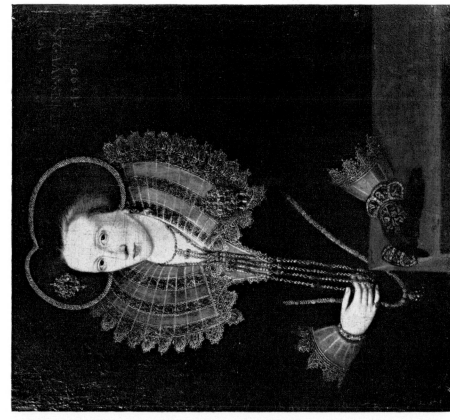

12. Perhaps Adrian Vanson: *Agnes Douglas, Countess of Argyll*, 1599. Edinburgh, Scottish National Portrait Gallery

11. Perhaps Adrian Vanson: *James VI*, 1595. Edinburgh, Scottish National Portrait Gallery

14. Unknown artist: *Sir Duncan Campbell of Glenorchy*, 1619. Edinburgh, Scottish National Portrait Gallery

13. Unknown artist: *James Murray*, 1610. Collection unknown

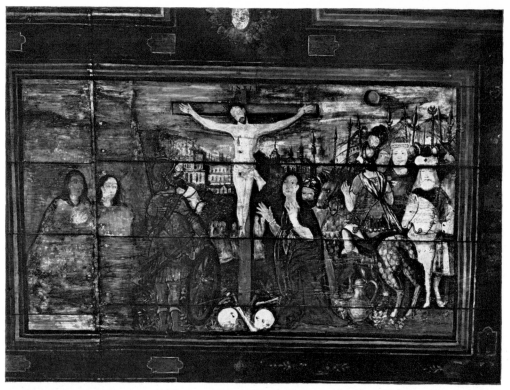

15. Unknown artist: *Crucifixion*, c. 1610–20. Painted ceiling. Provost Skene's House, Aberdeen

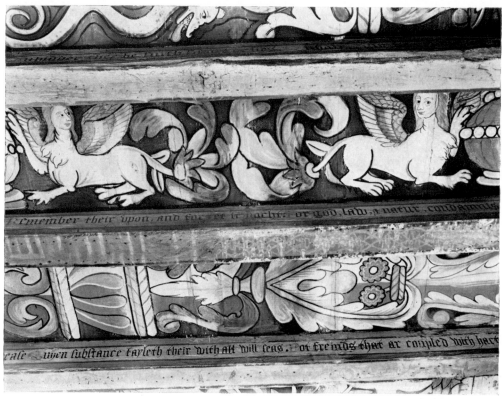

16. Perhaps John Mellin: *Sphinxes*, c. 1592–7. Painted ceiling. Delgatie Castle, Aberdeenshire

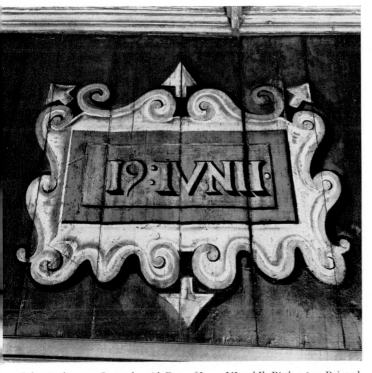

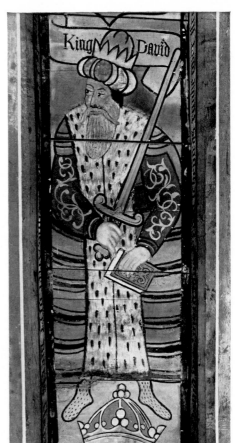

17. John Anderson: *Cartouche with Date of James VI and I's Birth*, 1617. Painted wall-panelling. Edinburgh Castle
18. (*right*). Unknown artist: *King David*, 1602. Painted ceiling. Crathes Castle, Kincardineshire
19. John Anderson: *Royal Arms of Scotland*, 1617. Painted wall-panelling. Edinburgh Castle

21. Jamesone: *Robert Gordon of Straloch, c. 1625* (Catalogue, 4)

20. Jamesone: *Sir Paul Menzies of Kinmundy, 1620* (Catalogue, 1)

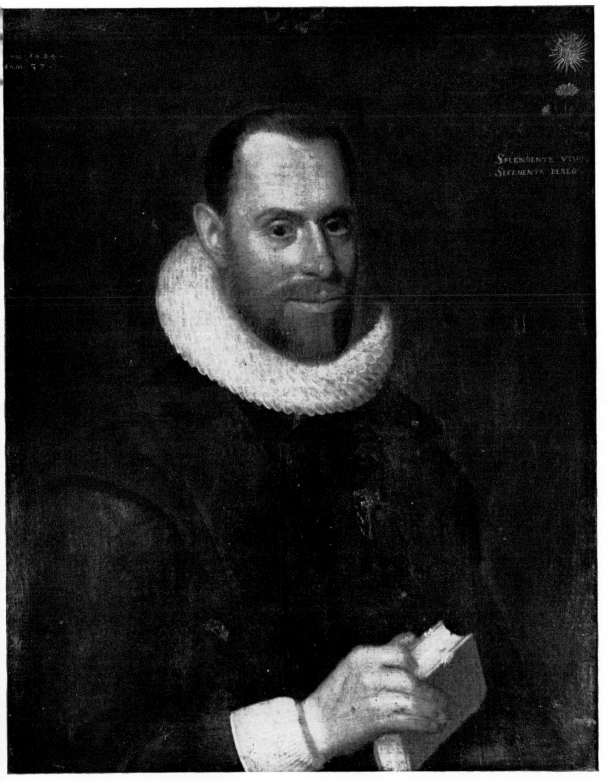

22. Jamesone: *James Sandilands*, 1624 (Catalogue, 2)

24. Jamesone: *Anne Erskine, Countess of Rothes with her Daughters*, 1626 (Catalogue, 7)

23. Jamesone: *John Leslie, 6th Earl of Rothes*, 1625 (Catalogue, 6)

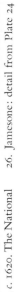

26. Jamesone: detail from Plate 24

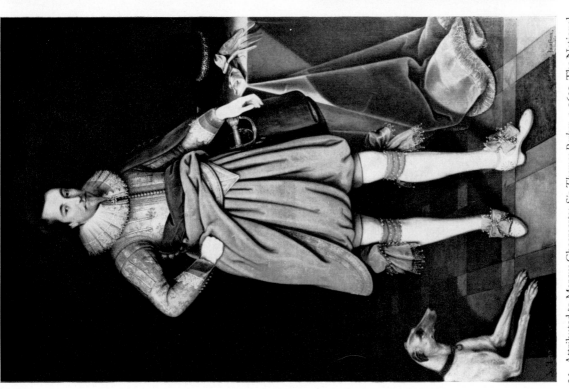

25. Attributed to Marcus Gheeraerts: *Sir Thomas Parker*, c. 1620. The National Trust, Saltram House

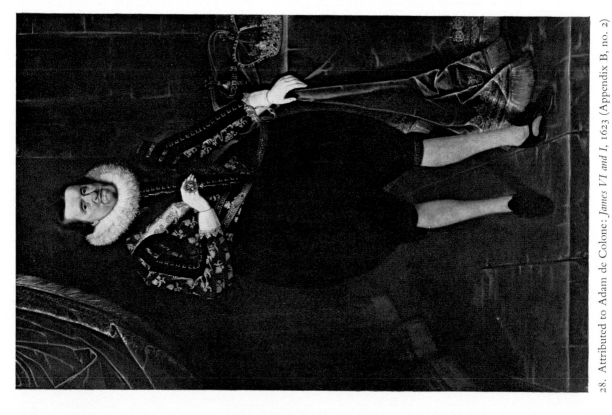

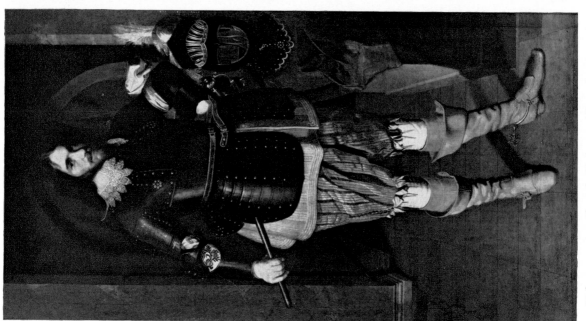

27. Unknown artist: *Alexander Lindsay, 2nd Baron Spynie, c.* 1625.

28. Attributed to Adam de Colone: *James VI and I,* 1623 (Appendix B, no. 2)

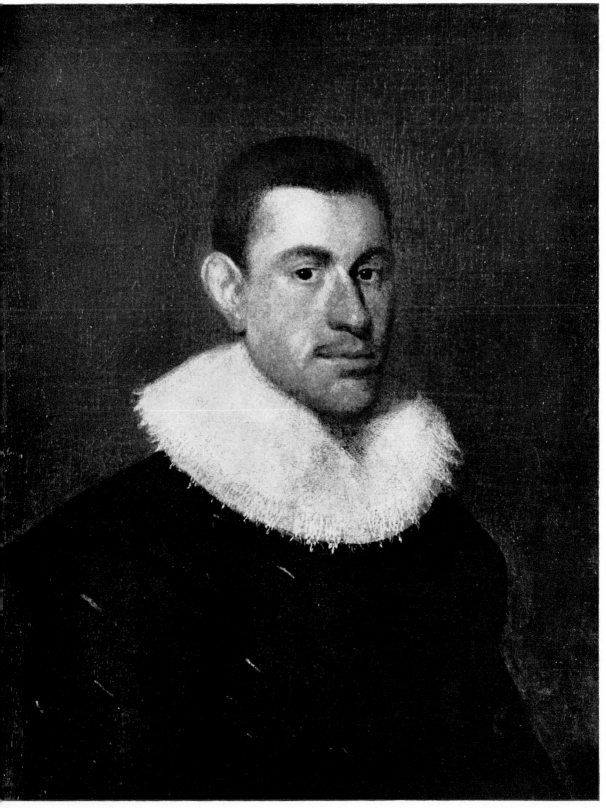

29. Jamesone: *Unidentified Man, c.* 1624 (Catalogue, 3)

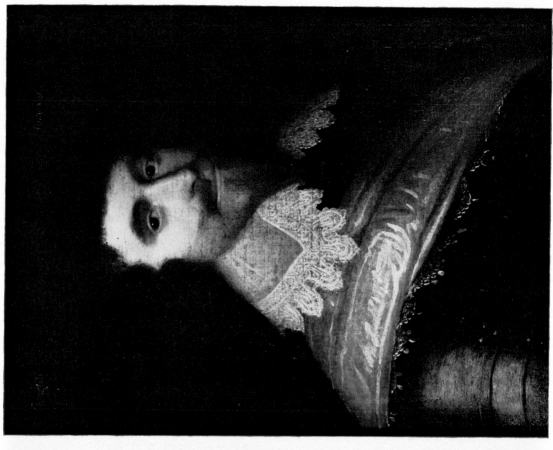

31. Jamesone: called *General Alexander Hamilton, c.* 1627–30 (Catalogue, 15)

30. Unknown artist: called *Robert Erskine,* 1627. Edinburgh, National Gallery of Scotland

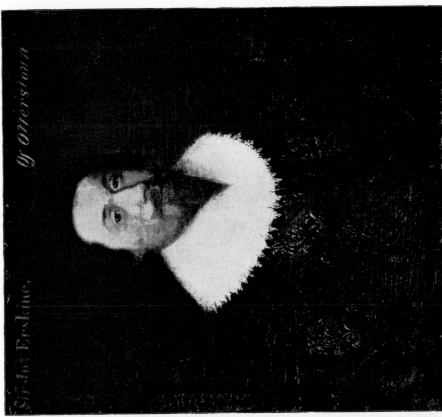

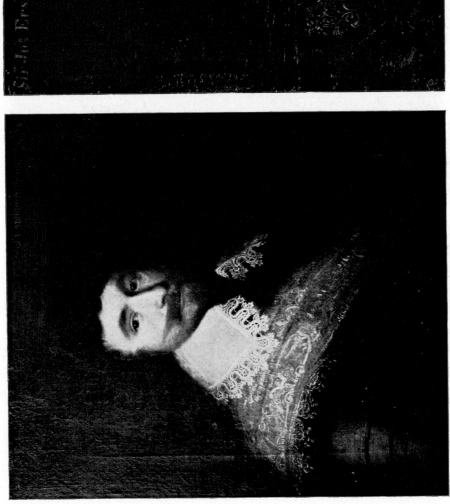

32. Jamesone: called *Colonel Alexander Erskine of Cambuskenneth, c.* 1627 (Catalogue, 10)

33. Jamesone: called *John Erskine of Otterstoun, c.* 1627–30 (Catalogue, 11)

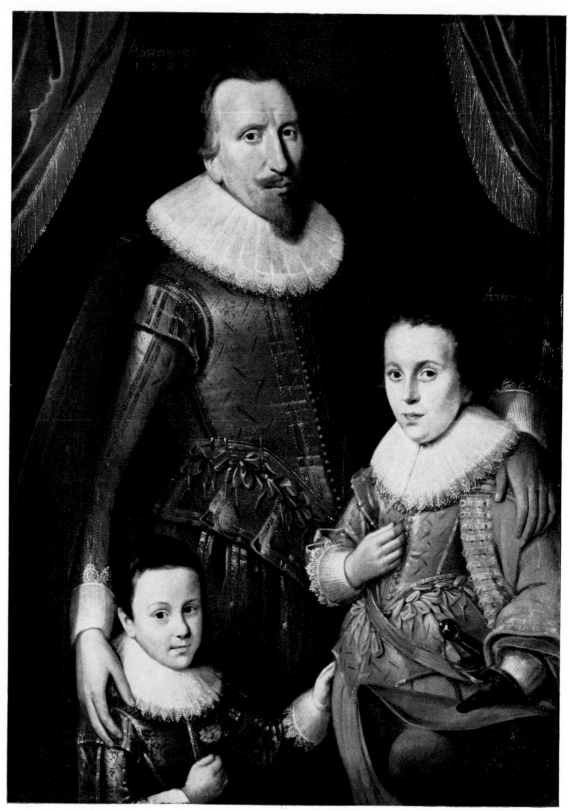

34. Attributed to Adam de Colone: *George Seton, 3rd Earl of Winton with two Sons,* 1625 (Appendix B, no. 10)

36. Jamesone: *Sir William Forbes of Craigievar*, 1626 (Catalogue, 8)

35. Jamesone (with 19th-century additions): *Sir William Forbes of Craigievar*, 1626 (Catalogue, 8)

38. Jamesone: called *Anne Campbell, Marchioness of Huntly*, 1630 (Catalogue, 30)

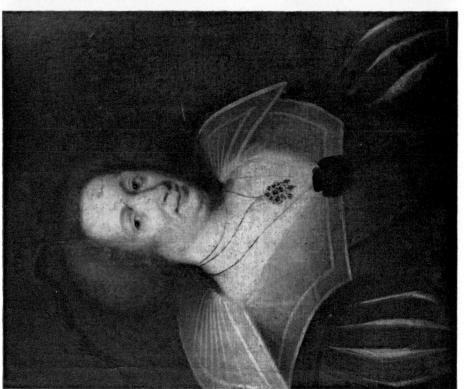

37. Jamesone: called *Jane Gray, Countess of Wemyss*, c. 1625–30 (Catalogue, 24)

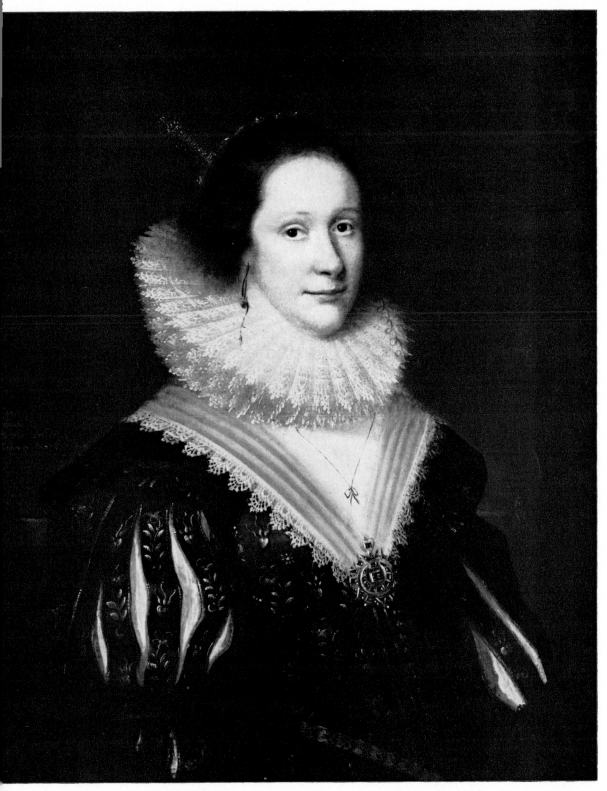

39. Jamesone: *Mary Erskine, Countess Marischal*, 1626 (Catalogue, 9)

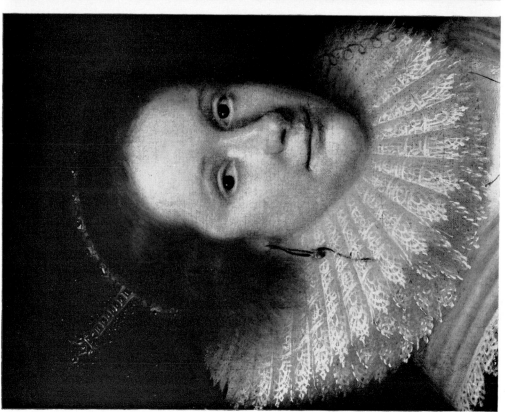

40. Jamesone: detail from Plate 39

41. Attributed to Adam de Colone: called *Margaret Kerr, Lady Yester*, 1628 (Appendix B, no. 21)

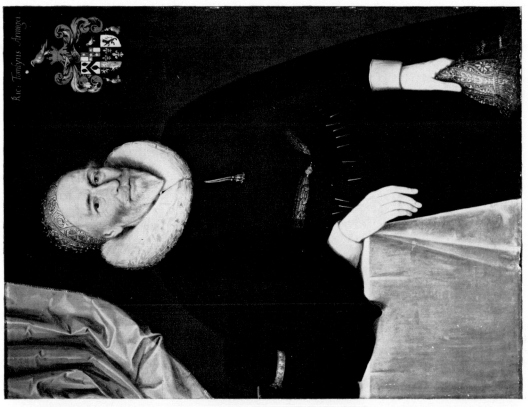

43. Marcus Gheeraerts: *Richard Tomlins*, 1628. Oxford, Bodleian Library

42. Attributed to Adam de Colone: *Thomas Hamilton, 1st Earl of Haddington*, 1624 (Appendix B, no. 6)

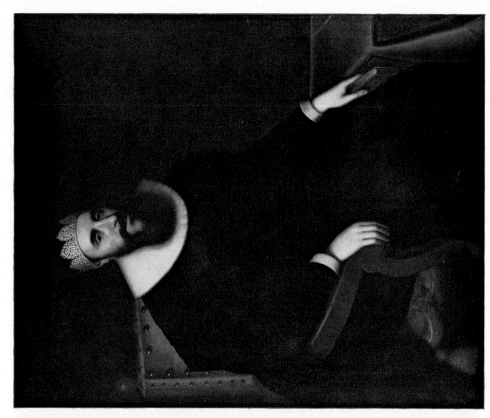

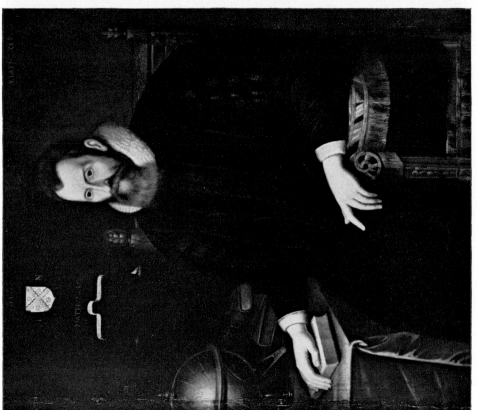

44. Unknown artist: *John Napier of Merchiston*, 1616. Edinburgh, Scottish National Portrait Gallery

45. Jamesone: *Sir Thomas Hope, c.* 1627 (Catalogue, 19)

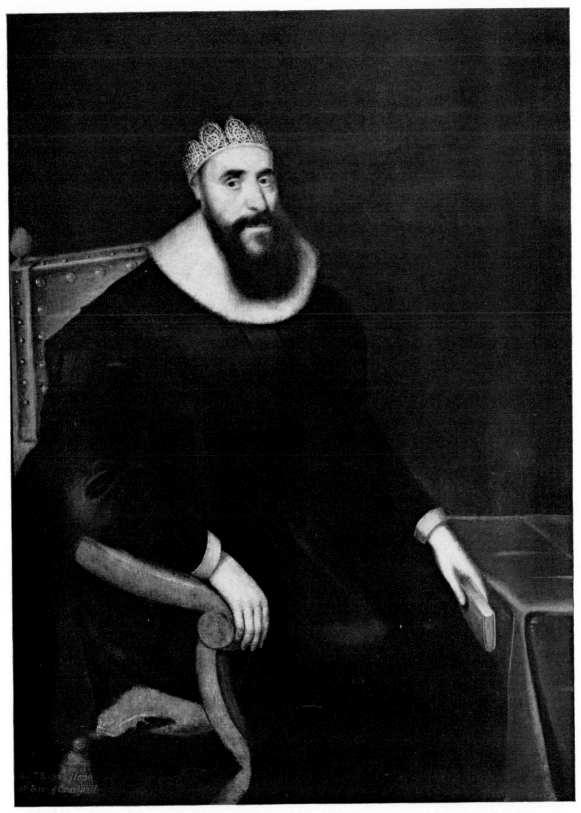

46. Jamesone: *Sir Thomas Hope*, 1627 (Catalogue, 18)

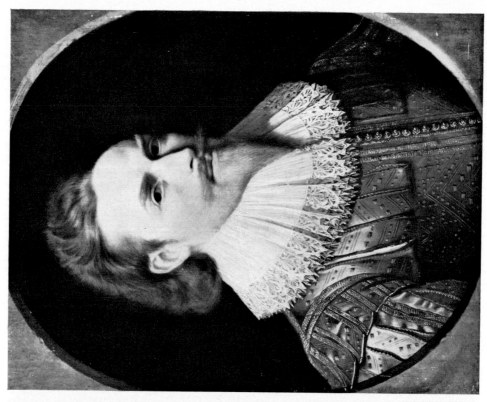

48. Sir Nathaniel Bacon: *Self-portrait, c.* 1625. London, National Portrait Gallery

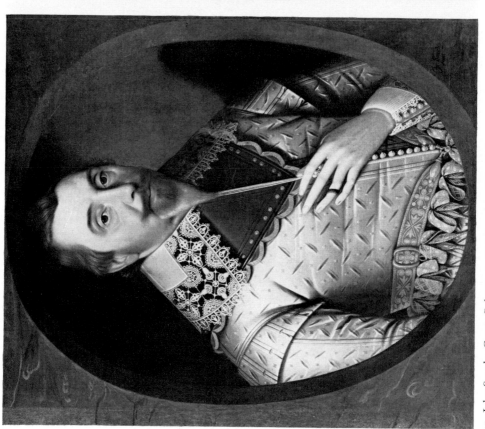

47. John Souch: *George Puleston, c.* 1625. London, Tate Gallery

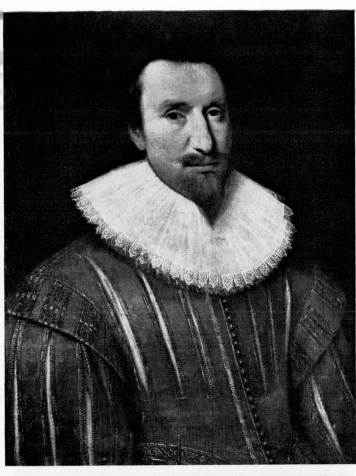

49. Attributed to Adam de Colone: *James Erskine, 6th Earl of Buchan, c.* 1622–8 (Appendix B, no. 23)

50. Attributed to Adam de Colone: detail of inscription from Plate 42

51. Attributed to Adam de Colone: detail of inscription from *George Hay, 1st Earl of Kinnoull* (Appendix B, no. 13)

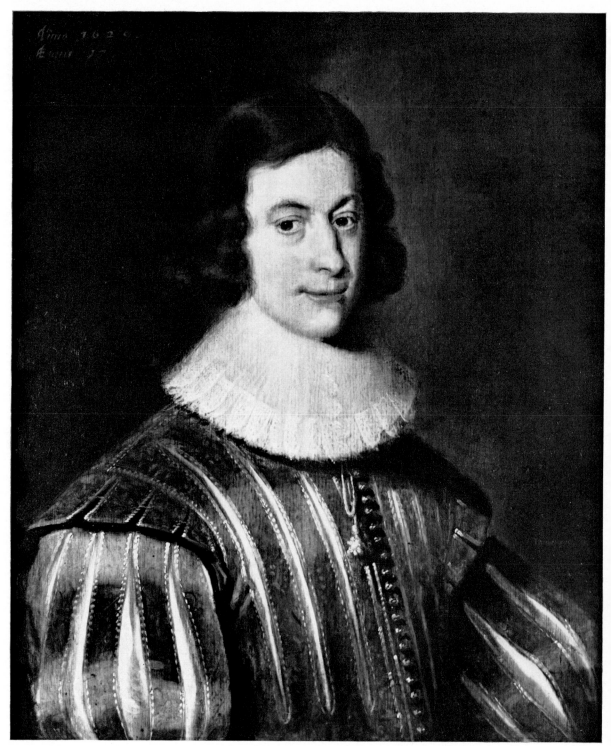

52. Jamesone: *James Graham, 1st Marquess of Montrose*, 1629 (Catalogue, 25)

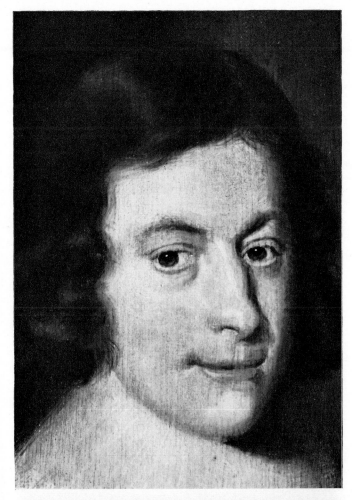

53. Jamesone: detail from Plate 52

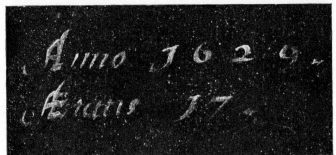

54. Jamesone: detail of inscription from Plate 52

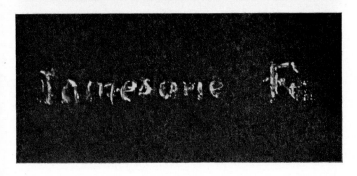

55. Jamesone: detail of the painter's signature from Plate 52

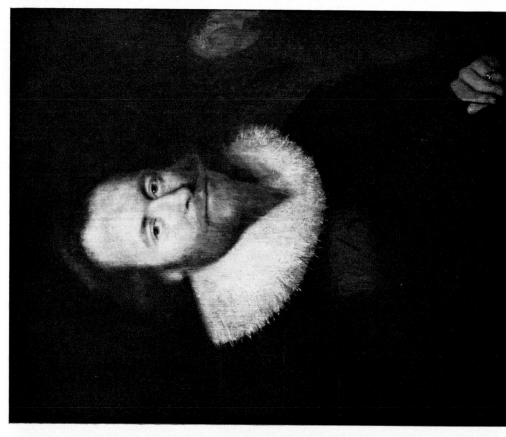

57. Jamesone: *Arthur Johnston, c.* 1629 (Catalogue, 27)

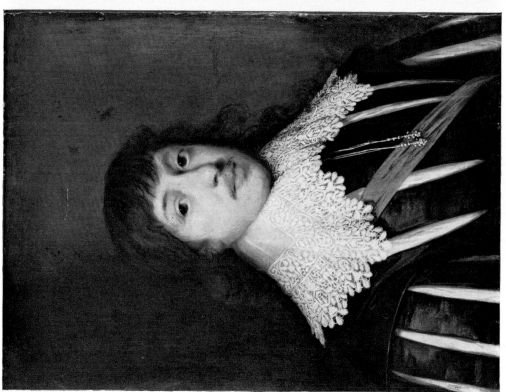

56. Cornelius Johnson: *Unknown Man,* 1629. London, Tate Gallery

Sereniss: Carol: Ducis Borbonÿ, Comitis Montpenserÿ, et Iacÿnu Matrÿ, Galliæ Conestablÿ.
Vir Majus in mangentÿ; Carol: et Imperatorÿ, deputÿ, a Iuuanÿ, quæ utunÿ, sanguÿ inter caruerÿt.
Iudicrÿ, Comitæ Arumdele summ: Angliæ Marÿscalli &c: atÿ, demum Sculptæ a Vorsterman n:
Cum privil: Reÿ

59. Lucas Vorsterman I: *Charles de Montpensier, Duc de Bourbon*. Engraving

58. Jamesone: *Charles de Montpensier, Duc de Bourbon, c.* 1627–30 (Catalogue, 29)

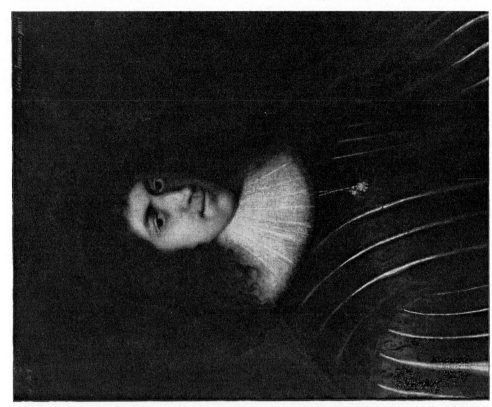

61. Jamesone: *Unidentified Man*, 1630 (Catalogue, 32)

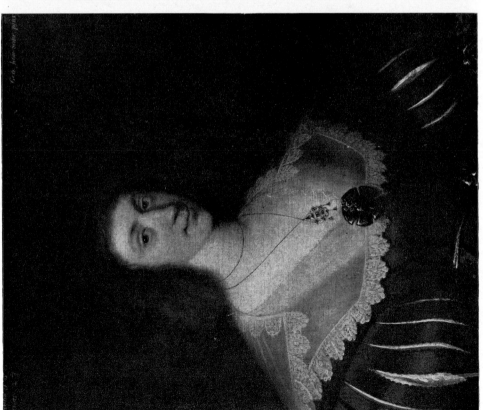

60. Jamesone: called *Catherine Erskine, Lady Binning*, 1630 (Catalogue, 31)

63. Gilbert Jackson: *Robert Burton*, 1635. Brasenose College, Oxford

62. Jamesone: *Dr Patrick Dun*, c. 1631 (Catalogue, 37)

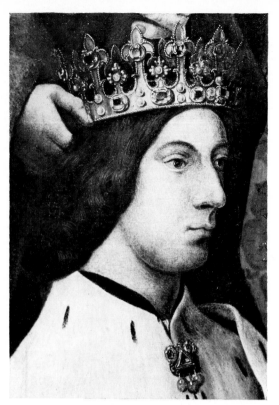

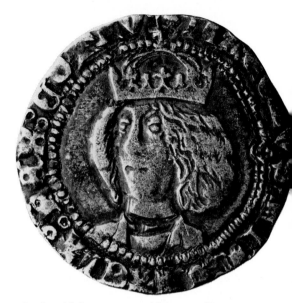

65. Scottish heavy groat, with image of James III, c. 1485

64. Hugo van der Goes: detail of James III from *The Trinity Altarpiece*, c. 1478–9. Edinburgh, National Gallery of Scotland. Reproduced by gracious permission of Her Majesty The Queen

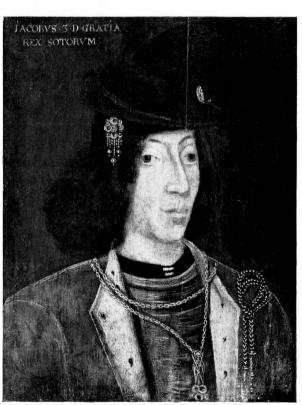

IACOBVS · 3 · D · GRATIA
REX · SOTORVM

66. Unknown artist: *James III*, late 16th century. Edinburgh Scottish National Portrait Gallery

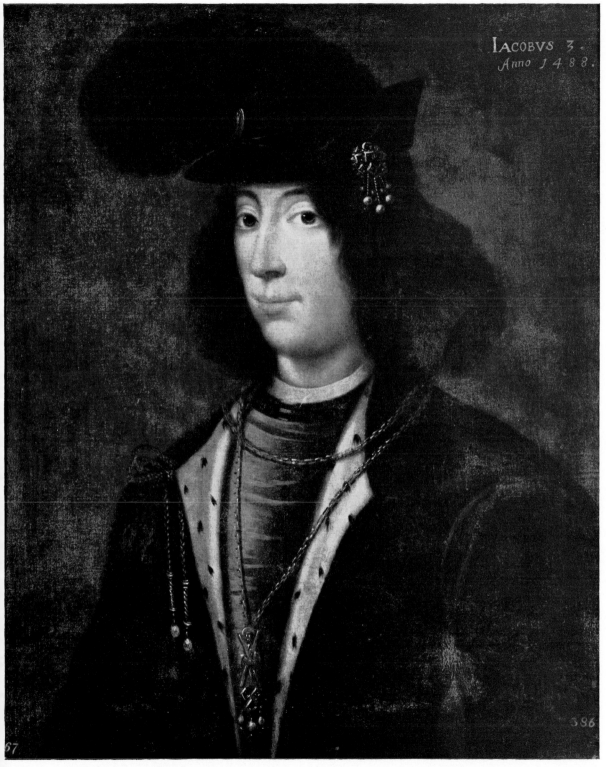

IACOBVS 3.
Anno 1488.

67. Jamesone: *James III*, 1633 (Catalogue, 42)

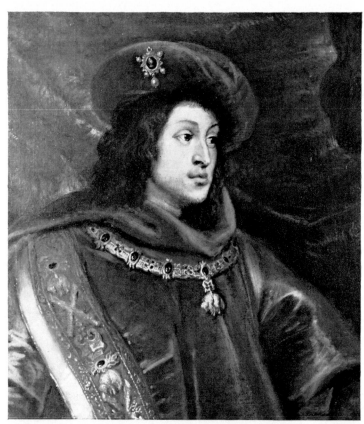

68. Cornelis de Vos: *King Philip I of Spain*, 1635.
F. Gonzales de la Fuente

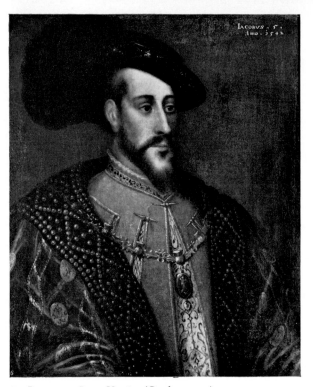

69. Jamesone: *James V*, 1633 (Catalogue, 41)

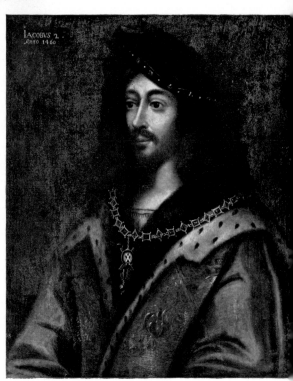

70. Jamesone: *James II*, 1633 (Catalogue, 43)

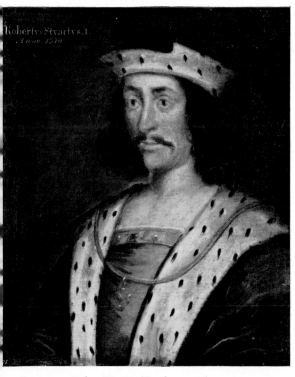

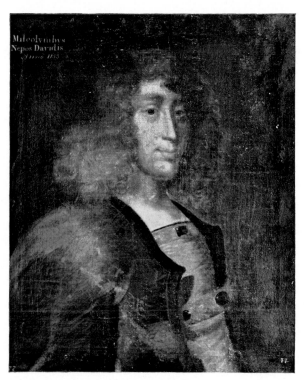

71. Jamesone: *Robert II*, 1633 (Catalogue, 46)

72. Jamesone: *Malcolm*, 1633 (Catalogue, 52)

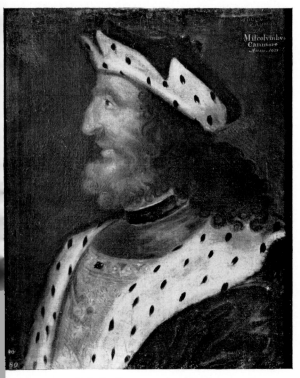

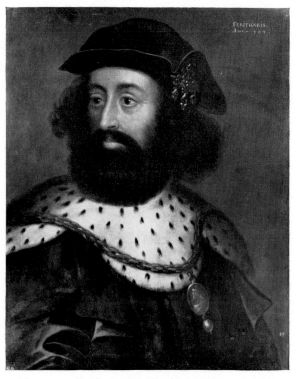

73. Jamesone: *Malcolm Canmore*, 1633 (Catalogue, 55)

74. Jamesone: *Feritharis*, 1633 (Catalogue, 64)

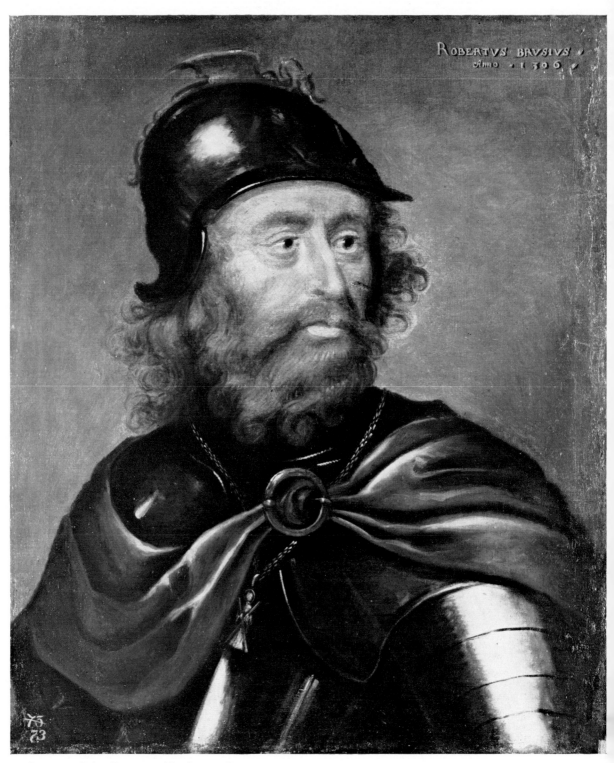

75. Jamesone: *Robert Bruce*, 1633 (Catalogue, 48)

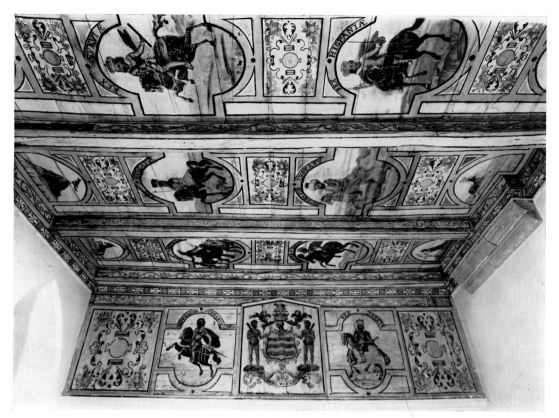

76. Unknown artist: *A Series of Monarchs, c.* 1625–35. Painted ceiling. Stobhall Castle, Perthshire

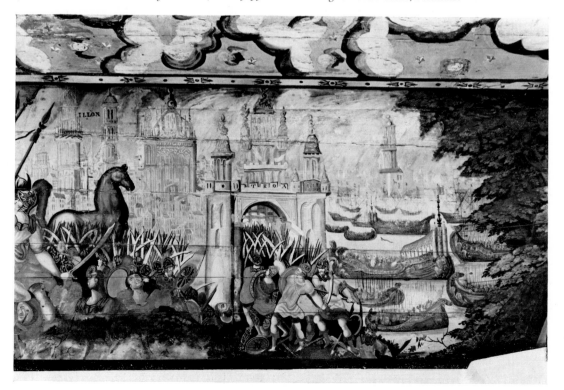

77. Unknown artist: *The Siege of Troy*, after 1616. Painted ceiling. Cullen House, Banffshire

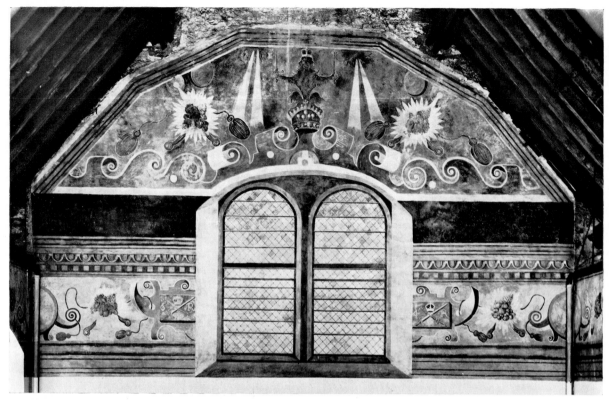

78. Valentine Jenkin: *Feigned Window, Honours of Scotland, Bouquets of Fruit and Flowers*, 1628. Mural. Chapel Royal, Stirling Castle

79. Jamesone: *Isabel Hamilton, Countess of Airlie*, 1634 (Catalogue, 66)

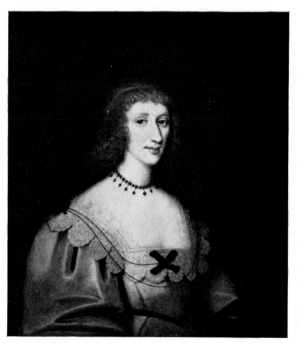

80. Jamesone: *Margaret Douglas, Marchioness of Argyll*, 1634 (Catalogue, 69)

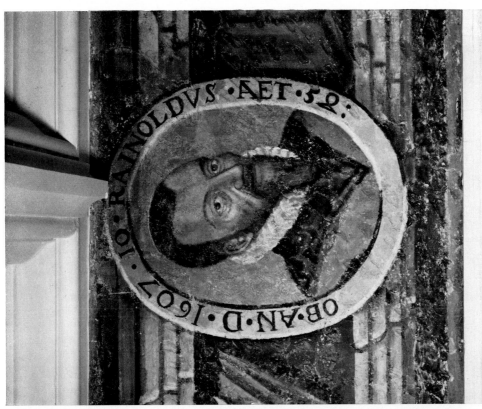

82. Unknown artist: *John Rainolds*, c. 1616–18. Mural. Oxford, Bodleian Library

81. Unknown artist: *Archibald Campbell, Earl of Argyll*, 1633. Collection unknown

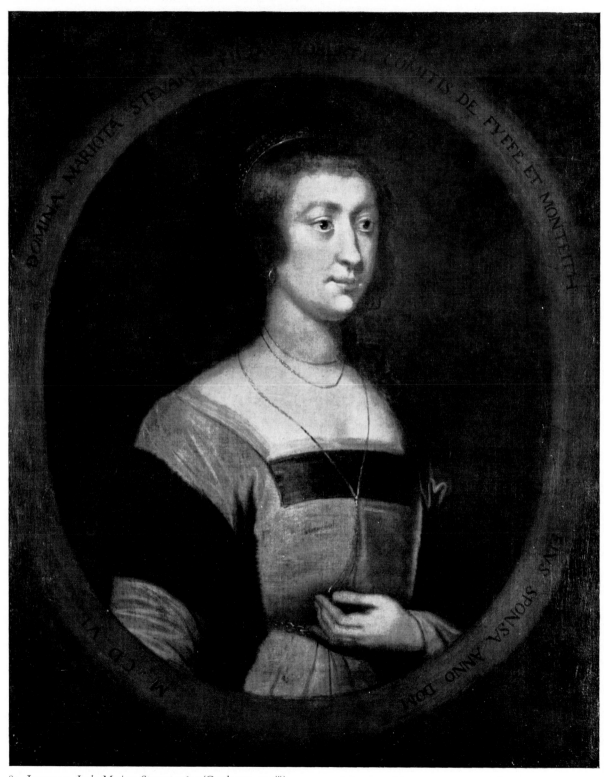

83. Jamesone: *Lady Marjory Stewart*, 1635 (Catalogue, 71–(i))

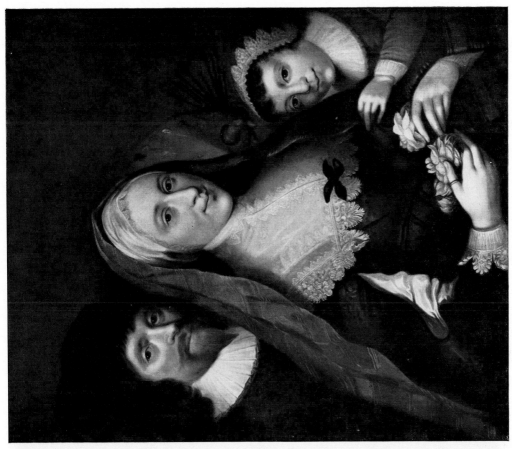

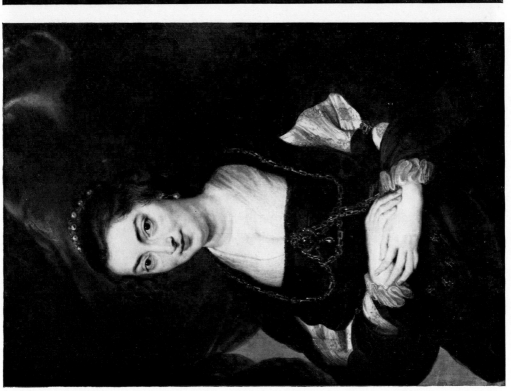

84. Studio of Rubens: *Isabella Brant*, *c.* 1620. The Hague, Royal Picture Gallery, Mauritshuis

85. Jamesone: *Self-portrait, with Wife and Child*, *c.* 1635–40 (Catalogue, 114)

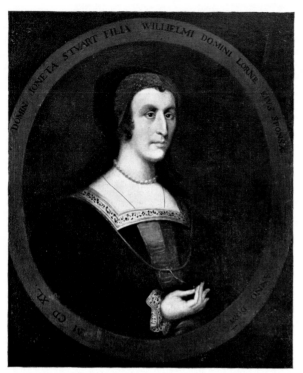

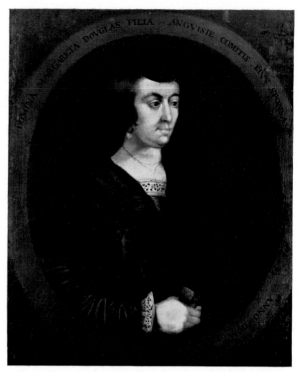

86. Jamesone: *Lady Janet Stewart*, 1635 (Catalogue, 73–(1))

87. Jamesone: *Lady Margaret Douglas*, 1635 (Catalogue, 74–(2))

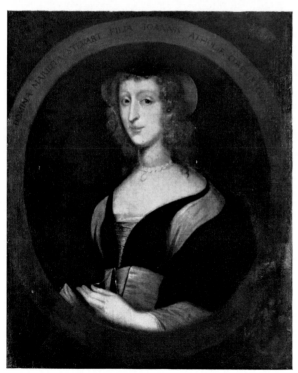

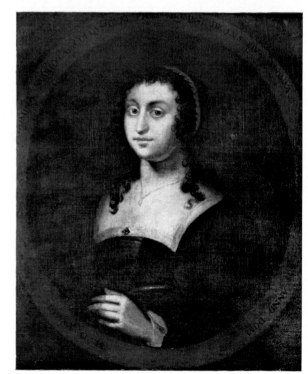

88. Jamesone: *Lady Marjory Stewart*, 1635 (Catalogue, 75–(3))

89. Jamesone: *Lady Marjory Colquhoun*, 1635 (Catalogue, 76–(4))

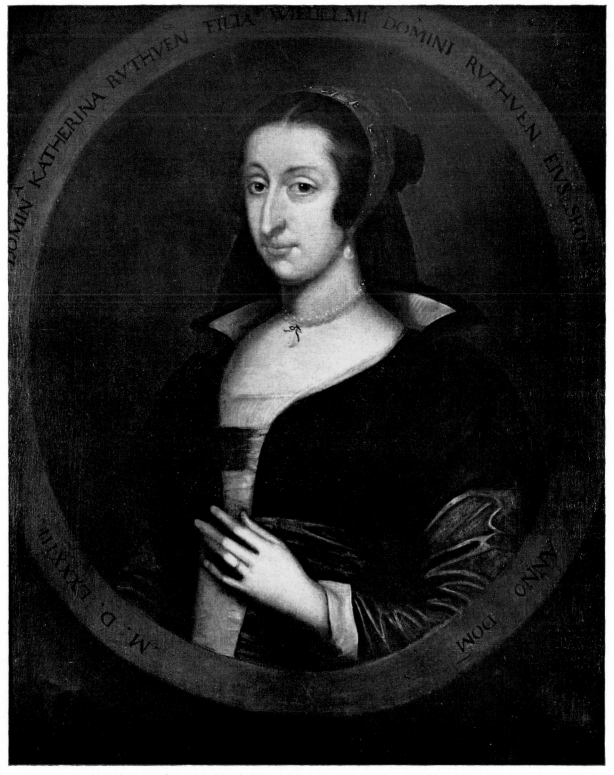

90. Jamesone: *Lady Katherine Ruthven*, 1635 (Catalogue, 78–(6))

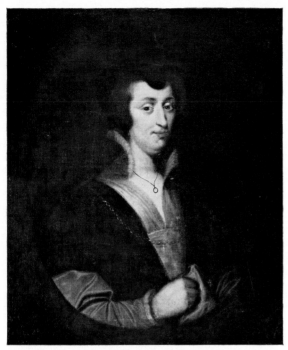

91. Jamesone: *Lady Marjory Edmonstone*, 1635 (Catalogue, 77–(5))

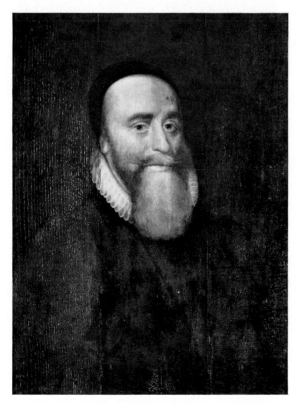

92. Jamesone: *Sir Thomas Burnett of Leys*, c. 1636 (Catalogue, 107)

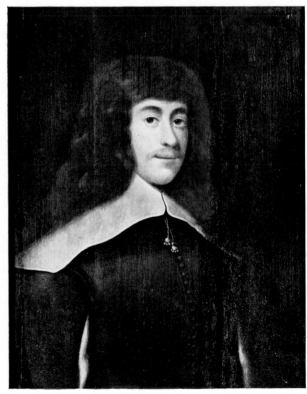

93. Jamesone: called *Sir William Forbes of Monymusk*, c. 1636 (Catalogue, 108)

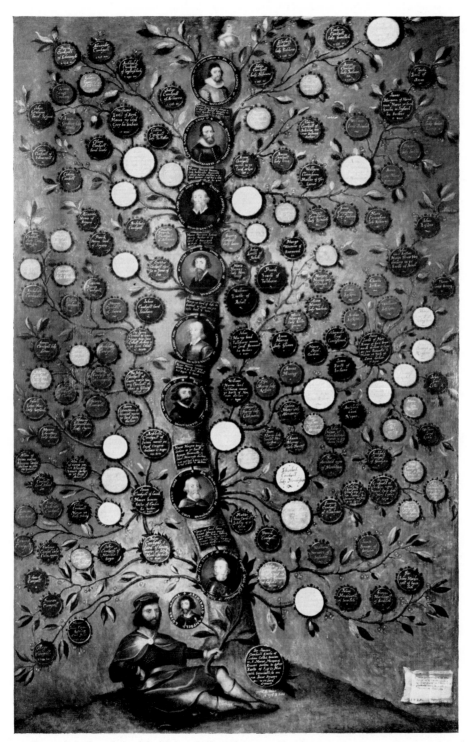

94. Jamesone: *Genealogy of the House of Glenorchy*, 1635 (Catalogue, 93)

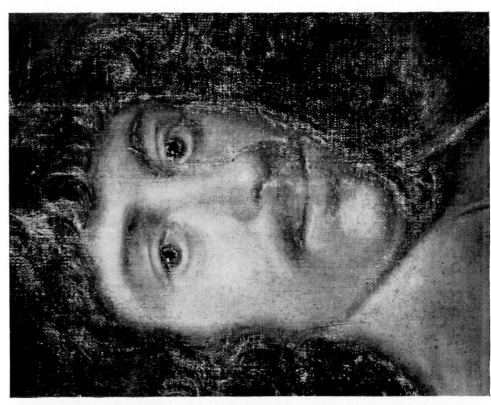

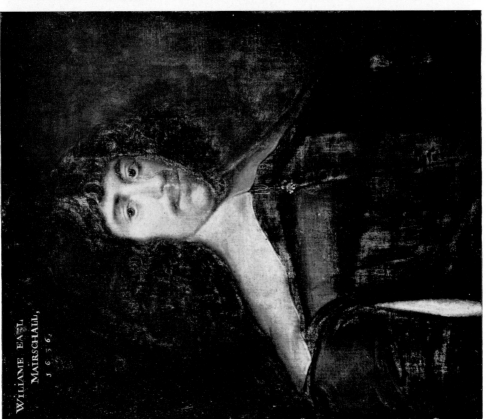

95. Jamesone: *William Keith, 7th Earl Marischal*, 1636 (Catalogue, 94) after removal of old repaint and before restoration   96. Jamesone: detail of Plate 95

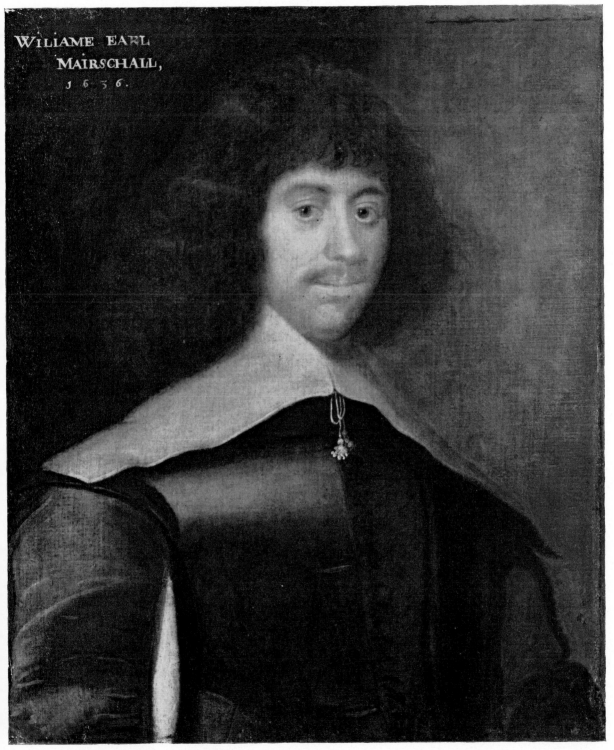

WILIAME EARL
MAIRSCHALL,
1636.

97. Jamesone: *William Keith, 7th Earl Marischal,* 1636 (Catalogue, 94)

98. Jamesone: *William Graham, 7th Earl of Menteith and 1st Earl of Airth, 1637* (Catalogue, 96); *Archibald Napier, 1st Baron Napier, 1637* (Catalogue, 97)

100. Jamesone: detail of *William Ramsay, 1st Earl of Dalhousie, c. 1635* (Catalogue, 106)

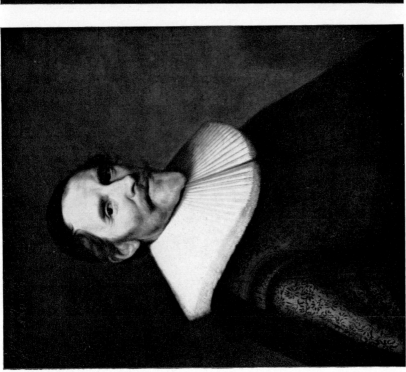

99. Michiel van Miereveld: *François van Aerssen*, 1636. The Hague, Royal Picture Gallery, Mauritshuis

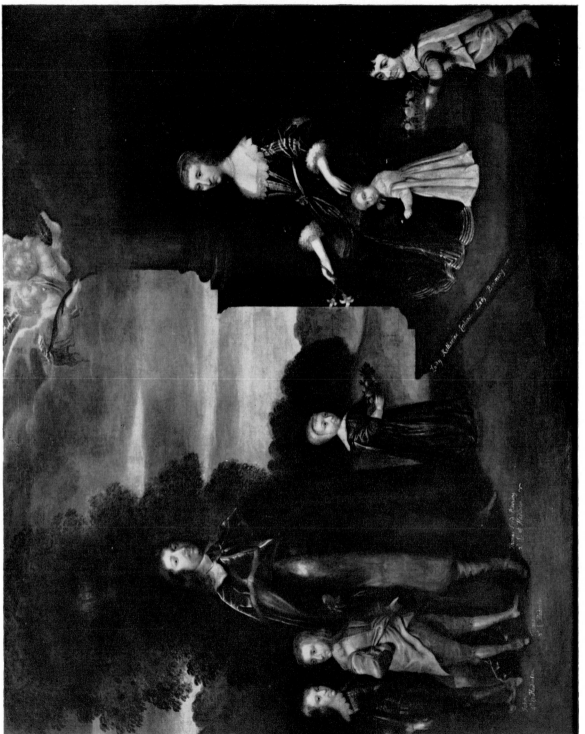

101 Jamesone: *Haddington Family Group, c.* 1637 (Catalogue, 130)

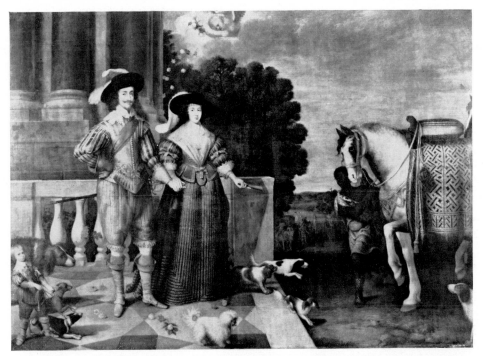

102. Daniel Mytens: *Charles I and Henrietta Maria departing for the Chase*, c. 1630–2. Hampton Court. Reproduced by gracious permission of Her Majesty The Queen

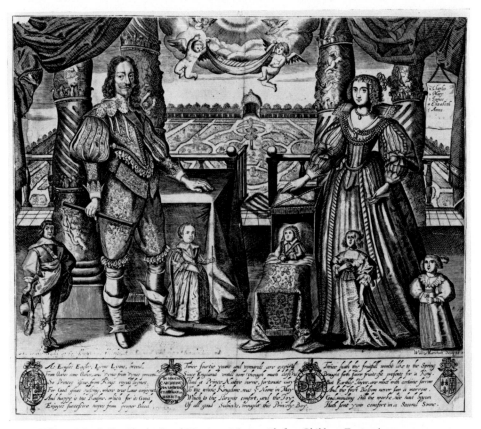

103. William Marshall: *Charles I and Henrietta Maria with five Children*. Engraving

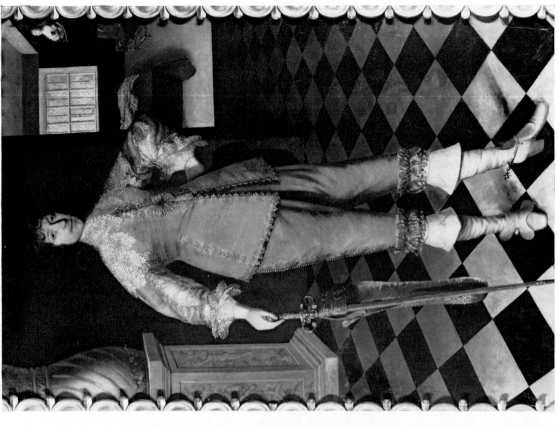

105. Gilbert Jackson: *Lord Belasyse*, 1636. The Duke of Hamilton

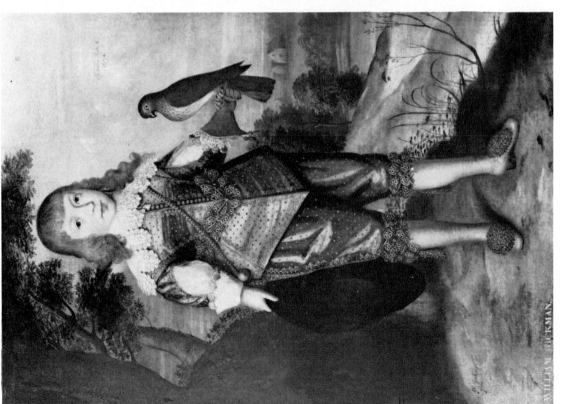

104. Gilbert Jackson: *William Hickman*, 1634. Sir Edmund Bacon

107. Attributed to Michael Wright: *John Hamilton, 4th Earl of Haddington, c. 1641.*
The Earl of Haddington

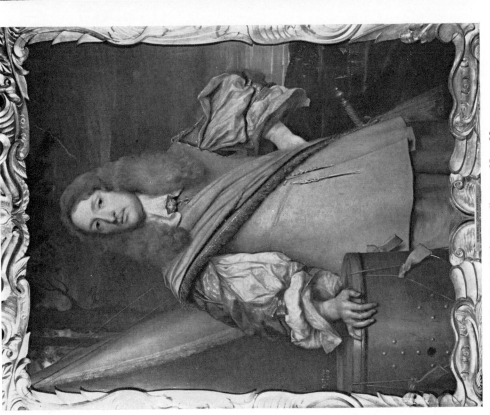

106. Michael Wright: *Colonel John Russell, 1659.* Ham House

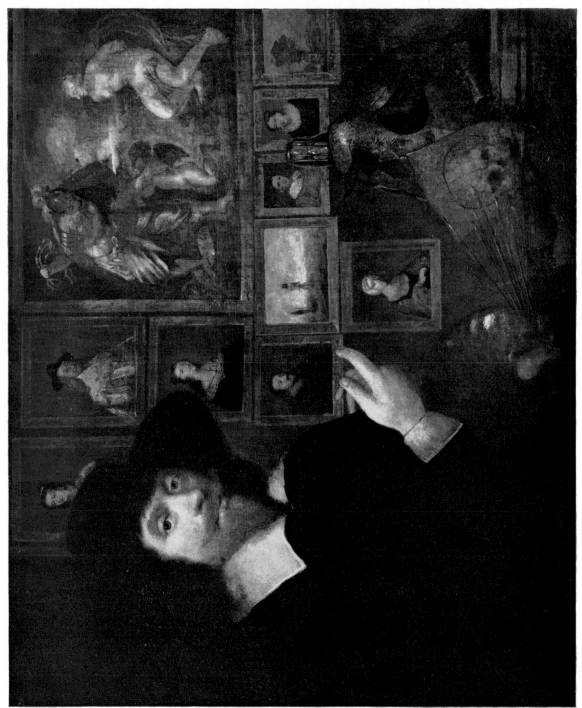

108. Jamesone: *Self-portrait, in a Room hung with Pictures, c. 1637–40 (Catalogue, 112)*

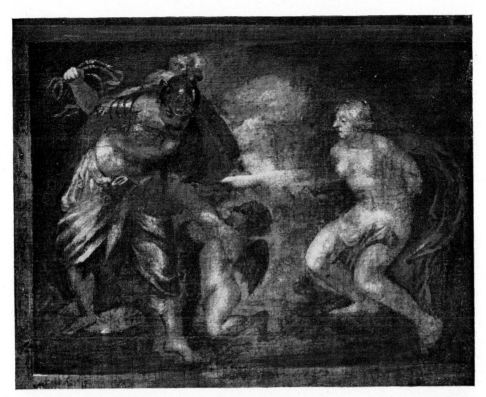

109. Jamesone: detail of Plate 108

110. Attributed to Simon de Vos: detail from *The Chastisement of Cupid*, before 1632. Berlin–Dahlem, Staatliche Museen

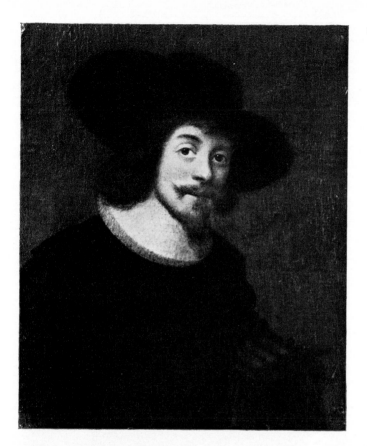

111. Jamesone: *Self-portrait, c.* 1637–40 (Catalogue, 113)

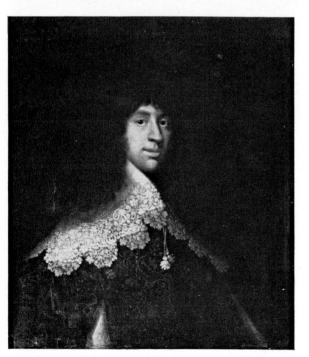

112. Jamesone: *Sir George Stirling of Keir,* 1637 (Catalogue, 119)

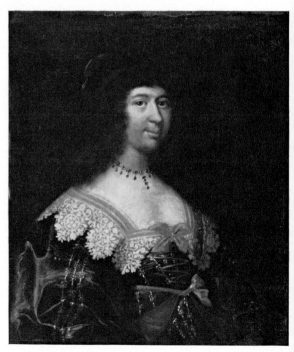

113. Jamesone: *Margaret Napier, Lady Stirling, c.* 1637 (Catalogue, 120)

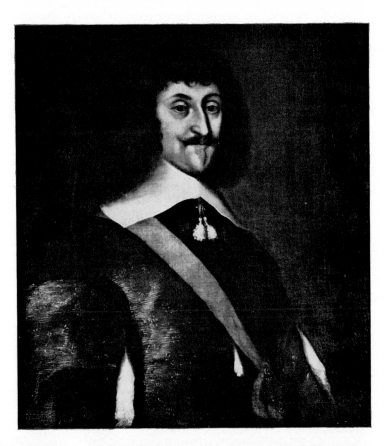

114. Jamesone: *John Erskine, 3rd Earl of Mar,*
     *c.* 1635–40 (Catalogue, 123)

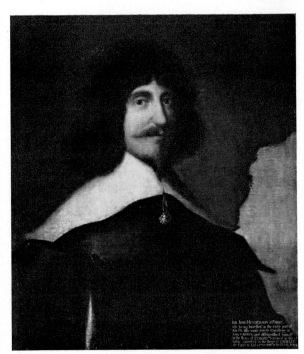

115. Jamesone: *John Henderson of Fordell, c.* 1635–7 (Catalogue, 124)

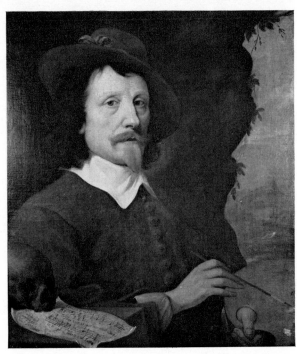

116. Nicholas Lanier: *Self-portrait, c.* 1635. The Faculty of Music, University of Oxford

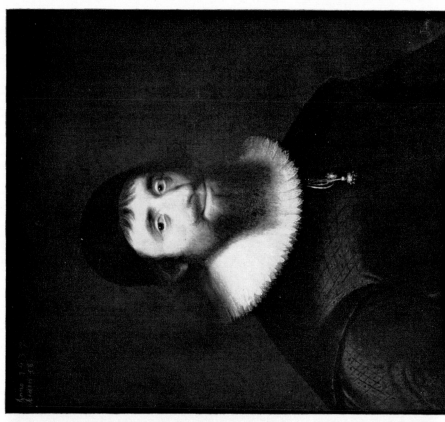

118. Jamesone: *Sir John Carnegie, 1st Earl of Ethie and Northesk*, 1637 (Catalogue, 117)

117. Jamesone: *Sir David Carnegie, 1st Earl of Southesk*, 1637 (Catalogue, 116)

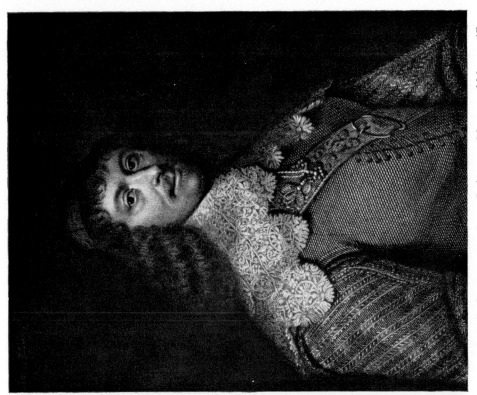

120. R. C. Bell after Jamesone: *James Graham, 1st Marquess of Montrose* (Cata-
logue, 133). Engraving

119. Jamesone: *Sir Alexander Carnegie of Balnamoon*, 1637 (Catalogue, 118)

122. Attributed to Emanuel de Critz: *John Tradescant the Younger*, *c.* 1650–6. Oxford, Ashmolean Museum

121. Jamesone: *Sir William Nisbet of Dean*, 1637 (Catalogue, 122)

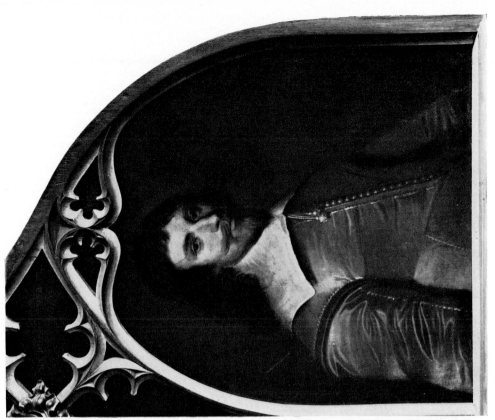

124. Jamesone: *Sir John Campbell of Glenorchy*, 1642 (Catalogue, 141)

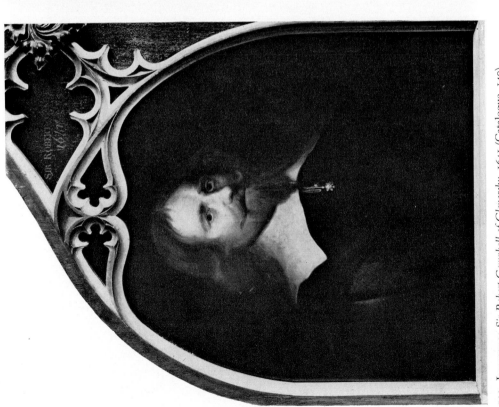

123. Jamesone: *Sir Robert Campbell of Glenorchy*, 1641 (Catalogue, 140)

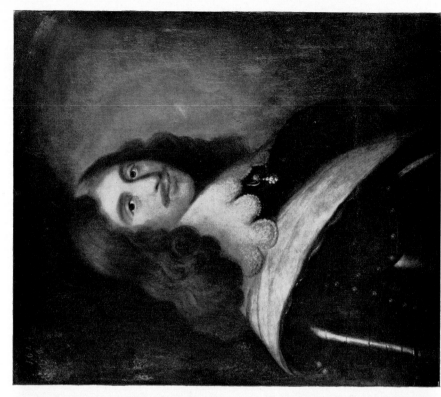

126. Jamesone: probably *William Kerr, 3rd Earl of Lothian*, 1644 (Catalogue, 144)

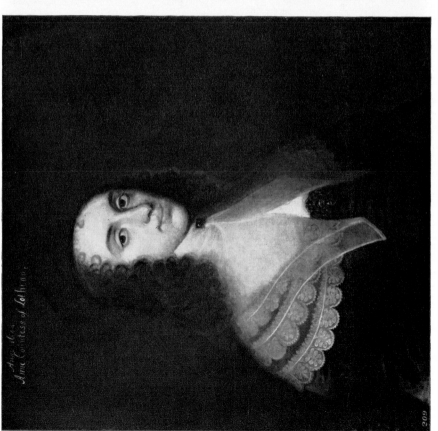

125. Jamesone: *Anne Kerr, Countess of Lothian*, 1644 (Catalogue, 143)